W9-AHN-033

701
J 41a

68802

DATE DUE			
Mar 16 '70			
Dec 16 '70			
Mar 25 '72			
Mar 30 '75			
GAYLORD M-2			PRINTED IN U.S.A.

WITHDRAWN
L. R. COLLEGE LIBRARY

ART
and the HUMAN
ENTERPRISE

is to articulate man's vague apprehensions of the particularity of things, and to embody and present these with great clarity and persuasion. Creativity can fulfill this function only if it keeps itself in close and constant touch with the particulars it is concerned with. The same point might here be urged about art that has frequently been urged about philosophy—and, in fact, about all intense and specialized efforts—that it is their inescapable tendency to become quite remote from the things they deal with, that this is even necessary to their successful prosecution, but that it must nevertheless be remembered that their ultimate obligation is to the materials and problems of common sense, which originally gave rise to them. Creation, whether artistic, theoretic, or technological, should never be the making of objects that are their own excuse for being. This concern with the intrinsic character of what is being done and made creeps into all human activity: even apart from the demands of circumstances, man complicates everything he touches, from government to the rules of whist, because complication makes things more interesting. This concern is legitimate and valuable if not allowed to carry too far. But it becomes unhealthy if it distracts attention from the extrinsic function of what man does and makes. The recognition of this risk is exhibited in man's periodic revolutions against the accumulated complexity of his culture and toward a simplification of life. This is seen alike in recent revisions of the judicial system, in the forms of modern architecture and the vocabulary of modern poetry, in contemporary design in various fields, and in the partial removal of chrome from our automobiles. The classic statement of this claim that common sense has upon creation, at least as it concerns art, still remains Wordsworth's Preface to the *Lyrical Ballads*. Internal elaboration is, within limits, both a necessity and an ornament of man's activities and artifacts; it enhances their effectiveness as well as their interestingness. But if creative activity dissipates too much of its energy in this direction it

ART

and the HUMAN
ENTERPRISE

Iredell Jenkins

WITHDRAWN
L. R. COLLEGE LIBRARY

Archon Books 1969

CARL A. RUDISILL LIBRARY
LENOIR RHYNE COLLEGE

701
J41a

68802
February, 1970

© 1958 by the President and Fellows of Harvard College
Reprinted 1969 by permission of Harvard University Press
in an unaltered and unabridged edition

SBN: 208 00753 9
Library of Congress Catalog Card Number: 69-15793
Printed in the United States of America

For M. D. J.

sense can be awakened or renewed by an acquaintance with things that are striking in themselves and hitherto unfamiliar. The truly great artist finds the challenge of particularity within himself, and is able to transform the most prosaic and ordinary things into vivid entities. But lesser talents need stimulation from the strange, the exotic, and the remote. And they are wise to seek it.

Perhaps the most revealing evidence on this issue is the manner in which artists frequently seek their point of departure — their original aesthetic stimulus — in the work of other artists. Where the sense of particularity has been dulled and weakened, or where it was never too strong and sensitive, the obvious recourse is to nourish it upon things which have already been highly particularized: that is, upon things which art has already transformed into entities. A person may well have and retain an artistic intention, and a high degree of craftsmanship or technical skill, while he does not have an original vision that is adequate to sustain these. It is then natural that the artist should borrow from others the insights upon which to exercise his talents. The best known instances of this reliance upon a secondary artistic source are in music: the most obvious cases are the many compositions that are entitled "Variations on a theme from X"; but many overtures, songs, operas, and hymns illustrate the same principle. Though I cannot here pause over the point, it is significant that this should occur so prominently in music, which is the most abstract and self-contained of the arts, and the one with the most highly organized medium. This suggests that the expressive resources of music — especially instrumental music — are so different in kind from the material they deal with, and have been carried to such a high pitch of internal development, that it is the frequent fate of musicians to have magnificent control of the techniques of artistic embodiment but to have little commerce with the wellsprings of artistic insight. Hence the eager search for a ready-made content, an already particu-

PREFACE

The interpretation of art that is advanced in this book, as well as the presuppositions on which it is based and the contribution that it hopes to make, is set forth in the opening chapter. The justification of the work can only be its total content. So I shall here confine myself to a remark or two in explanation of what might otherwise seem to be oversights in the exposition.

The book deals with many issues around which disagreement rages. I have tried to develop a sound and consistent theory of art, building this from the ground up and dealing with specific problems as they arise in the course of the argument. But I have not, save at a few crucial points, considered or criticized alternative solutions. And I have nowhere entered into a close examination and appraisal of these conflicting views. This does not at all indicate that I regard these debates as either unimportant or uninteresting, nor does it express my belief that I have settled them once for all. It simply means that the exposition of the theory would have been hopelessly prolonged and obscured by such minute analyses. I am painting on a large canvas, and I have had to make some sacrifices for the sake of coherence.

For much these same reasons, I have been sparing in the use of footnotes and the citation of authorities. I think that a theory should plant itself firmly in the facts and then stand on its own feet, without borrowing prestige from other thinkers. This is by no means to say that I have worked in an intellectual vacuum. The sources of many of my ideas, and the references of my remarks, will be obvious to those who are familiar with the fields with which I am dealing. However, I would hope that the book might also have interest and appeal for a

wider audience, including artists, critics, and in general all those who are moved and excited by their encounters with works of art. There are many people who find in painting or sculpture, poetry or music, architecture or the dance, not only a rich enjoyment, but also a heightened sense of the meanings that life and the world contain and of their own participation in these meanings. It is but natural that these people should want to understand the values they have spontaneously found, to hold them in some more secure form than that of immediate apprehension, to know something of the creative process by which they have been brought into being, and to have a rational grasp of the way in which art illuminates experience and contributes to the conduct of life. In a word, to enjoy art is instinctively to be curious about it. With such an audience in mind, I have, whenever it seemed appropriate, cited the best known and most available works that bear on points of fundamental importance.

I have finally the pleasant duty of acknowledging the generous help that I have received from various quarters. My general indebtedness to many thinkers of both past and present is abundantly clear. My friend and former colleague, Professor T. M. Greene, has aided me beyond my own knowing by his detailed criticism of the original version of the book. I have also benefited greatly from the suggestions of several readers who remain anonymous to me. The staff of the Harvard University Press has shown me every assistance and courtesy in preparing the manuscript for publication, and has contributed largely to improving both the content and the style of the book. For whatever misinterpretations of fact and misadventures of logic remain after all of this help, I am alone responsible.

The main body of Chapter XI appeared originally as an article in the *Journal of Aesthetics and Art Criticism*, but it has here been considerably revised. Some of the material composing the latter part of Chapter VII appeared originally in

the *Review of Metaphysics*, again in a somewhat modified form. A very condensed statement of my central argument appeared in the *Philosophical Quarterly*, and parts of that article are interspersed throughout the present book. I am indebted to the editors of these journals for permission to reprint this material.

Several publishers have generously allowed me to quote from material under their copyright; these permissions are acknowledged at the appropriate places in the body of the book.

I am grateful to the Research Committee of the University of Alabama for two grants that gave me the freedom that was necessary for the final writing of the book.

<div style="text-align: right">I. J.</div>

the manner of its occurrence and the consequences that it
entails.

The various arts, in the course of their development, accumulate a large and highly organized body of internal resources.
Media and techniques multiply and are refined; styles are
established; certain themes and subjects become fashionable;
modes of interpret nd treating particulars are widely accepted; canons and rules of formal structure are systematized;
and a common understanding grows up between artists and
audiences. This totality of materials, processes, ideas, and attitudes — what is frequently called a tradition — constitutes
what can most accurately be described as an artistic cosmos:
it has a landscape, a population, and an ecology of its own;
it tends to be a highly closed region, jealous of intercourse
across its borders; and it *seems to be* self-sustaining and self-
 ishing. It is this latter, and deceptive, characteristic that
 re concerned with. There is always present a tendency
 ts and audiences to confine themselves rather closely
 some such artistic cosmos, to isolate this from outside
 s, and to try to live on the resources it affords them.
 is as unsalutary in art as in nature. A geographical and
ecological region, however rich and self-contained it may
appear, is at least dependent on the sun and the ambient
atmosphere to replenish its materials and its energies. Likewise an artistic cosmos needs to have its conventions and traditions, its styles and techniques, its forms and values, refreshed by close and continuous intercourse with the welter
of particularity that the world contains.

Now artists, when they find their primitive aesthetic sense
becoming obtuse and lethargic — when they lose their passion and devotion for the actual character of things — find
their most obvious line of retreat into an artistic cosmos.
Having nothing to excite them to creation, they seek refuge
in the routines of fabrication that such a cosmos gives them.
Having nothing to say, they engage themselves in the elabora-

CONTENTS

ART
and the HUMAN
ENTERPRISE

participate in things and events more closely. We are passionately aroused and keenly interested, we become violently partisan in our devotion to or rejection of aesthetic objects, and we feel ourselves intimately associated with and committed to these objects. In sum, if the aesthetic life is disinterested, tranquil, and passive, it is also intense, turbulent, and passionate.

This paradox of disinterested involvement, or passionate detachment, is the most prominent of the seeming contradictions that the aesthetic life asserts about itself. But it is by no means the only one, nor does it occupy any privileged position of importance and influence. If such priority is to be assigned, it belongs more properly to the paradox that is constituted by the twin assertions that art is unrealistic and yet reveals reality. As art presents things, and as we make their acquaintance in appreciation, they frequently wear a guise that is quite different from that in which we ordinarily discover them. Art distorts and disarranges things; it changes their proportions, inverts their sequences of occurrence, selects and emphasizes some aspects while neglecting or ignoring others, separates things that are normally together and juxtaposes others that are usually remote. In all of this, art seems to have no concern for what common sense calls reality, and deals, as we say, in fiction rather than in fact. But as opposed to this, we often feel that art yields us a revelation of things as they really are, and this point has been insisted upon by most aesthetic doctrines. These tell us that art, in apparently turning its back upon reality, is in fact shattering the disguises — or tearing aside the veil, or piercing the husk, or breaking down the barriers — that usually stand between mind and its object, and so is giving us our only glimpse of the essence or true being of things.

A variant terminology that is often used to describe this same paradox is that of the antinomy of creation and discovery, which occurs especially in our conception of the

Chapter I

THE CONTEXT AND
SOURCE OF ART

I

1. It is the intention of this book to develop a theory of
the nature of art, and of the role of art in human life; and to
give lodgment to this account within a yet more general theory
of man and of man's status in the universe.

Now, any theory is the result of an analysis and explana-
tion of facts: starting with the material that is available to us
in immediate experience, theory means to discover more about
this than is directly disclosed. It goes beyond and behind mat-
ters of fact — gross phenomena or data — in order to seek out
the elements that compose these and the structure that binds
them together. However — and this is a crucial point — the
theoretical enterprise is not a simple one-way journey: the
mind in theorizing does not move massively and deliberately
through a body of fact, up a scale of ordering ideas, until it
arrives finally at the general and abstract concepts that dis-
close the essence of fact and form the keystone of theory. In
thought, if not in architecture, the keystone is set at an early
stage of construction; it is placed with insight and a prayer,
and the arch of theory is built toward it.

Since this is the case, both the elaboration and the exposi-
tion of a theory run the risk of being based on assumptions,
prejudices, and intentions that are hidden from view, operate
unbeknownst to either author or reader, and distort the en-
tire treatment of the subject. In the original development of
a theory there is no safeguard against this save the acumen

and conscientiousness of the thinker. But in its exposition he can take the additional precaution of stating, as fully and explicitly as he is aware of them, the presuppositions — and the predispositions — on which his inquiry is founded. With this aim in mind, I shall commence with a brief synoptic statement of the aesthetic attitude that underlies this theory, the interpretation of art that it seeks to establish, and the line of argument by which this will be unfolded and supported.

I feel that most of our contemporary aesthetic confusions — on both the theoretical and the practical planes — result from our inability to conceive of art as a vital and coherent element within the human context. We certainly honor art, often even excessively. But we do not really respect it; that is, we do not see it as playing a responsible role in the direction of our lives, and we do not have a clear sense of any significant contribution that it makes to the pursuit of our well-being. Particularly, we do not feel art to have at all the same realistic and purposive character as our scientific and technological activities, whose bearing we can grasp so clearly and with which we feel so much at ease. This is the general misapprehension that must be corrected if art is to assume its rightful place in our lives and culture, and if we are to derive from it the sustenance we badly need and it alone can offer.

Hence it is my chief concern to lay bare the genesis of art in the general human situation, and the function of art in the total human enterprise. I propose to develop a theory that can explain art — more broadly, aesthetic and artistic activity — as grounded in man's relation to the world and as a necessary phase of man's transactions with this world. This theory rests upon the fundamental thesis that the aesthetic life springs from its own specific roots, and that these roots are themselves an integrated aspect of man's structure and character. Aesthetic activity, in all of its phases, has its source in a real and vital characteristic of the human spirit; it is initiated

in order to satisfy a basic human need; it is a necessary condition of human development. Men behave aesthetically — they create and appreciate art — because it is only by so doing that they can give expression to certain forces that lie deep within them; and the proper participation of these forces is one necessary step in the process through which man consummates his acquaintance with the environment and secures adjustment to it. In sum, aesthetic activity is grounded in the structure of man and the conditions of life.

All of this I maintain and shall seek to establish. But to maintain this is not to assert the isolation or the autonomy of the aesthetic life. Men are entities, not collections of categories; they behave as organic creatures, not as bundles of diverse instincts, faculties, and impulses. Aesthetic activity is not a segregated mode of behavior, initiated by an independent power in man, supported by separate organic processes, directed toward some special private end. It is an irreducible, integral, and coordinate phase of total human behavior: it is one part of the response with which man meets the things he encounters, and it makes its own unique contribution to the process that is adaptation with these things. There are other equally vital and fundamental characteristics of the human spirit; these also assert their force, seek release in activity, and make their own contributions to response and adjustment. Aesthetic activity occurs always within this total context of human behavior, influencing and being influenced by the other parts and by the whole.

This interpretation of the aesthetic can be most readily clarified by two negations. On the one hand, aesthetic activity is not to be regarded as a casual and adventitious occasion in human development, a late refinement that depends upon leisure and serves as a mere decoration of life. I would argue against any doctrine that explains art by reducing it to a vicarious release for some essentially different and more fundamental drive. On the other hand, aesthetic activity is not

to be regarded as an isolated and esoteric type of behavior, seeking its own end by its own means, indifferent to and separate from the more prosaic and practical interests of "normal" or "real" life. I would argue against any doctrine of art for art's sake. As between these views, it is my thesis that aesthetic activity is a natural and spontaneous phase of man's ordinary response to the environment; that it is a necessary partner in the process of adjustment; that art exists for life's sake, and that life could not exist without art.

The theory that is to support this interpretation of art and the aesthetic life, to justify it and give it substance, must obviously be more than a theory of aesthetics, in the narrow sense of that word. It must first be a theory of man, and of the terms under which man confronts the world. So the original focus of my inquiry will be located at a rather far remove from the usual context of aesthetic discourse. I shall for the first few chapters be concerned not with an analysis of aesthetic phenomena as such — not with a detailed examination of aesthetic experience, the creative process, and works of art — but with a search for the source and location of these phenomena within human nature and human life. Why do men appreciate beauty, and why do they create art? What are the functions of these activities in the human enterprise, their role in man's economy? What is it about the conditions of life that gives rise to aesthetic activity? What is it about man's situation in the world that demands that he create art? These are the problems that have a priority on our attention. In brief, my interest here is in the simple occurrence of art, rather than in the subtleties of its character.

The first, and most fundamental, part of my argument will thus be pre-aesthetic: it will cut behind art to a consideration of the human psyche,[1] of which art is one principal mani-

[1] I shall be using this term throughout my exposition, so I should obviate at once certain misunderstandings to which it might give rise. I do not, in speaking of the psyche, mean to hypostatize some inner, or hidden, or occult entity. I mean only to refer to the fact that man is a unified creature, whose

festation. The line that this argument will follow can be stated briefly.

I shall first depict what I take to be man's past genesis and present status in the universe. I shall infer from this the general problem with which man as a living creature is continually confronted, the pervasive conditions that he is called upon to satisfy. From this there can in turn be inferred the basic capacities that man must develop and exercise if he is to meet these conditions and master this problem. Art will then be defined by reference to the particular function it fulfills in this process; that is, in terms of the specific contribution it makes to the total human enterprise. I shall then trace the relations that hold between art and the other principal forms of man's activities and artifacts. Finally, and as a corrective against the inevitable divisive tendencies of such an analysis, it will be necessary to exhibit the aesthetic impulse as a strand that is woven continuously into the texture of life, playing its part in all of our dealings with things, and emerging sometimes to dominate these dealings, when it issues in works of art.

II

2. The framework within which this argument moves, and upon which it depends, can be most explicitly defined in the form of a series of assumptions. With respect to the fundamental issue, that concerning the nature of man and man's situation in the universe, I shall accept as my point of departure the general theory of evolution. In the closing section of the *Origin of Species* Darwin voiced this anticipation of the direction that inquiry would take as the result of his

behavior is highly organized and integrative. There is, then, some central principle or factor that affords this coherent and integrated control. This is what I mean by psyche. Some terms that are frequently used by different specialists with a roughly equivalent meaning are: mind, central nervous system, integrative centers, higher directive mechanisms, roof brain. In brief, I am using the concept of the psyche not so much substantively, as functionally and operationally. This will be clear in the sequel.

work: "In the distant future I see open fields for far more important researches. Psychology will be based on a new foundation, that of the necessary acquirement of each mental power and capacity by gradation. Light will be thrown on the origin of man and his history." [2]

I intend to take this suggestion very seriously and literally, and to use it as the guiding thread of my inquiry. I am regarding man as a successful evolutionary solution to the problem of adaptation. Certainly the principle that man is the product of organic evolution is now as firmly established as any scientific doctrine well can be. Leaving aside the question of ultimate origin and destiny, it is a safe assertion that man has been fashioned by the continuing necessity to adapt himself to the demands of the environment and the conditions of life. The human psyche has become what it is, and has developed the functions it now exhibits, under the pressure of these demands and conditions. The special mechanisms and processes through which man adapts — the capacities that he employs, the activities that he pursues, the artifacts that he produces — are his peculiar answer to the common problem with which nature confronts all life. So it is my chief methodological thesis that the psyche, and its modes of operation, can best be understood by a consideration of its genesis and function as an evolutionary development and an instrument of adaptation.[3]

For man, the process of adaptation is carried on largely — though by no means exclusively — through the medium of

[2] Charles Darwin, *Origin of Species by Means of Natural Selection, or Preservation of Favored Species in the Struggle for Life*. 1st ed. (London: John Murray, 1859), p. 488.

[3] It is essential that this interpretation should not be immediately and fatally prejudiced by narrow preconceptions about the nature of "evolution" and the character of the "environment" in which it takes place. A fuller discussion of this matter is deferred until the statement of general principles is completed, in order not to interrupt the argument. But it must be insisted at once that an acceptance of evolution does not commit one to a crudely materialistic and reductionistic position, and I would emphatically reject such a doctrine.

conscious experience. The fact that man receives things in consciousness, holds them there, and considers them before taking overt action, plays an important part in his adaptive behavior. So far as we can tell or reasonably conjecture, there are many living creatures that secure adjustment through other means. The behavior of the lower organisms is commonly held to depend upon purely reflex response, which is itself very close to the chemical and electrical phenomena of the inorganic world; and no one pretends to know with any accuracy where in the order of life sentience intervenes. But wherever conscious experience occurs, and clearly in the case of man, it functions significantly. The supplementation of instinct by intelligence, and of immediacy by reflection, exercises a controlling influence upon all but the most elementary physiological processes of human life.

Such complex experience is made possible by the high development of man's central nervous system, and especially of the cerebral cortex. Such experience in turn makes it possible for man to extend his acquaintance with things far beyond the immediate here-and-now of direct encounter. Experience is a vehicle that permits man to confront his surroundings at relative leisure, recognizing actualities, considering possibilities, and determining realizations. As the neurologist would put it, the central nervous system — the structure of which experience is the function — enables man to gain a wider and more discriminating awareness of the environment, and so to prepare more varied and appropriate responses. Experience is a means of carrying on transactions with the world, so it is only reasonable to suppose that it is patterned to the character of the environment and the situation that this imposes upon man. Experience is purposive in precisely this sense, that it has arisen and developed as a means of solving the problem of adaptation. The contents that experience gives us in its simplest and least cultivated occurrence — the elements that we know as sensations, percep-

tions, emotions, ideas, wishes, intentions — are indications of what the world offers and requires. The results that we derive from experience in its most disciplined and sophisticated uses — the products that we know as tools, machines, theories, poems, paintings, modes of worship, laws, moral codes, physical and intellectual and spiritual exercises — are instruments for satisfying the demands of the world and for exploiting its opportunities. What appears in experience, and what emerges from it, is adaptive in origin, in intention, and in function.

The specialized and purposive activities in which man engages, and the artifacts that issue from these activities, are refined employments of experience. They are initiated and carried through in order to improve and extend our dealings with the world: by means of them the quality and reach of experience are supplemented, so that our acquaintance with things becomes more adequate, our understanding more complete, our control more established. Prominent among these activities and artifacts are the significant pursuits that we know as language, science, art, religion, morality, technology, and others. These distinctively human doings and makings are the sophisticated tools through which experience makes itself an effective agent for the satisfaction of human needs and the realization of human purposes.

Hence it follows that these activities and artifacts have arisen as functions of man's continuing effort to adapt to the environment. They are all phases and adjuncts of a single massive process through which man carries on his transactions with things. They are the principal instruments that man employs to come to grips with the world and to solve the problem of adaptation. They are what they are because the adaptive process demands them. So the most realistic way in which to study these activities and artifacts — to probe the nature and to measure the value of art, science, and so on — is in terms of the problem that has engendered them and the functions that they serve.

III

3. I shall not argue further these basic tenets of my doctrine. All hypotheses are provisional. And it is manifest that the hypothesis of evolution leaves a good many crucial questions unanswered: it is utterly mute concerning the ultimate beginnings of man, or of anything else; it leaves highly anonymous the forces or agents that control evolutionary processes; it yields only the most discrete suggestions as to the actual direction in which man is evolving, and even less as to the possible goals he may attain. The doctrine of evolution is ambiguous on all of these matters, and so permits a wide variety of philosophical interpretations; that is, it is quite elastic as to the type of metaphysical theory that it requires or will accept. But I would still insist that evolution is the most massive and pervasive fact about man that is presently available to us.

These tenets serve as the standard guides of inquiry in all of the biological sciences. When scientists study man, whether these scientists are biologists, physiologists, neurologists, psychologists, or anthropologists, they assume that man is an evolutionary product and that his structure, his capacities, and his modes of action all have their basis in the process of adjustment; that is, they seek to understand the facts they discover by reference to their genesis and function as adaptive devices.

All that is here proposed is the systematic extension of these assumptions to those higher and distinctively human activities to which they have hitherto been applied, if at all, in only a random and hesitant manner. The present doctrine intends merely to carry to its logical conclusion a line of argument that is already familiar and well-established, by extending the principle of evolution to the entire range of human phenomena. I am arguing that even the most refined and complex of man's creations have their basis in the process of adaptation, and find their function as instruments of life.

This seems the most promising line of attack upon all of those disciplines that are broadly and vaguely called "humanistic." Unless one supposes a radical disjunction in human nature, then this principle, which has been so fruitful in the investigation of man's biological characteristics, should be equally valuable for an inquiry that seeks to make clearer to us the modes of man's psychic or mental structures and functions.

Evidently, this principle cannot be borrowed and used in a servilely imitative manner; the extension here proposed will require imagination, tact, and restraint. The greatest danger that threatens its employment in this wider human context is the tendency to reduce man to his lowest terms, and then to deny the significance of whatever is extraneous to this fictitious condition. I am very conscious of this frequent error of the genetic method, and equally anxious to avoid it. Whenever I speak of "the environment," of "the conditions and the instruments of life," of "the things" we encounter and deal with in "the world," of "evolution" and "the adaptive situation," I am using these terms in a purposely ambiguous manner, so as to leave their reference undetermined and imprecise. The ontological issue is not essential to the present inquiry, and will be deliberately avoided. We are not so much concerned with the catalogue of man's requirements and aspirations, or with the realms of Being in which he participates, as we are with the general conditions under which he confronts whatever Reality may contain and with the processes through which he deals with this.

But certain reductions and negations have come to be so intimately associated with the concepts mentioned above that they must be denied and guarded against. The "environment" is apt to mean to us only our physical surroundings; the "world" is apt to suggest to us only what exists in space and time, and to contain only such "things" as material objects and events; we are prone to think of "the adaptive situation"

and "successful adjustment" as touching only the problem of biological survival; "instruments of life" and "agents of adaptation" are apt to be conceived by us as merely the physical operations through which we secure bodily well-being. All such closed and a priori interpretations of these concepts must be explicitly disowned.

It is true that science, very properly, does use these terms largely in this way; it must if it is to give them the empirical meaning and verification upon which it insists. And since Darwin transformed "evolution" into a scientific hypothesis, we have been taught to regard it as a materialistic doctrine. But the principle of evolution itself does not at all require such an interpretation; it places no inherent limitations upon the forces and agents that control its processes, upon the destinies to which it might be leading, upon the realms of Being that the environment contains, or upon the powers that are present in man and the possibilities that are open to him. Evolution was a philosophical principle long before it became a scientific hypothesis: during this period it was interpreted in diverse ways by theists, deists, vitalists,.idealists, and rationalists; and we have more recently been familiar with the "creative" or "emergent" evolutions of Bergson, Lloyd Morgan, S. Alexander, and others. As a process, evolution is perfectly hospitable to — though it must also be emphasized that it does not necessarily demand — the concepts of purpose, progress, mind, spirit, and God; of all principles, it should encourage us to approach and use it with an open mind rather than a closed one. The materialistic implications of evolution to which we have grown accustomed have been stipulated by science for its own purposes; this procedure has been justified by the fact that it has given clear and precise empirical meaning to the basic concepts of evolutionary doctrine. Philosophy should now accept what science can teach it about the physical and biological aspects of evolution, and should use this as the basis for a broader — and admittedly more

speculative — theory that will seek to trace the total pattern of man's existence and participation in the universe.

I have digressed at this length only to obviate these common misunderstandings. The metaphysical questions of the origin and end of the evolutionary process, of the forces or powers that direct it, and of the orders of reality involved in it, do not bear at all directly upon my inquiry. But it is important that this inquiry should not be prejudiced at the outset by a narrow interpretation of the terms in which it is cast. So whenever there occur such phrases as "the environment," "things" and "the world," "the conditions of life," "instruments of adaptation," let these carry an open meaning rather than a closed one. It is not necessary to determine here precisely what these terms include, but only the general situation that they define; so they can as well be used to enlarge our view of man as to reduce this. Everything has beginnings. But most things are more than their beginnings, and wiser proponents of evolution insist that man is preeminently of this kind. It is a distorted reading of evolution that holds that what comes later is an incidental and gratuitous excrescence on what came earlier. The logical inference from the principle of evolutionary adaptation is rather that refinements and specializations develop in order to carry out more adequately the processes that life demands.

It is my specific purpose to reach an understanding of man's aesthetic activity, both in itself and in relation to the whole human enterprise. So I am deeply concerned with man's most refined and specialized products. I do not conceive these to be fortuitous or accidental, and I certainly do not seek to undermine their significance for life. To the contrary, I am regarding them in what appear to me to be the most serious and realistic of terms: as adjuncts of the process through which man comes to grips with himself and his surroundings. Man creates art — as he creates science, morality, and all other disciplines and products — because it is only

by so doing that he can consummate his acquaintance with the world and realize the possibilities that life offers him.

The problem of art cannot be settled — in fact, it cannot even be intelligently considered — except in conjunction with the other specialized modes of human doing and making. So the question that has to be investigated is this: why does man do any of the things he does? Or, phrased more inclusively, why does he do all of these things? It is my argument that the general purpose that animates all of man's activities and artifacts is adaptation to the environment and satisfaction of the conditions of life. The precise nature and function of art can then be established by specifying these conditions, and by determining the contribution that art makes toward meeting them.

4. The collection of things that men make must appear at first sight to be a haphazard and chaotic conglomeration. A casual glance at this panorama reveals things as disparate as poems, bridges, and prayer books; the formulae for logical and mathematical procedures rub elbows with the rules of whist, the rituals of sacrifice, and the forms of etiquette; a symphony orchestra, a political debate, an athletic contest, and a drama will occupy the same auditorium on successive nights; a few feet of museum wall will disclose representational paintings, formal designs, decorative maps and pictures, illustrations, and diagrams; the shelves of libraries disgorge legal and moral codes, scientific theories, novels and essays, technical works, and books of practical counsel on the care of everything from our pets to our souls; and our round of daily activities is buttressed by tools, machines, ideas, and methods that are the result of sustained human efforts in the past.

The taxing problem for the philosopher is to find some principle that can disclose a systematic pattern in this conglomeration. We quite easily and naturally make rough classifications within this huge field. There are such familiar dis-

criminations as science, philosophy, art, religion, morality, history, practical activity. But these distinctions tend to be merely descriptive, and even as such they have little precision. They do not explain why human activity exhibits just these modes that it does. And, particularly, they do not clarify the relations that hold among these activities and bind them into a single functional system.

The principle of evolution, employed with a catholicity of view, promises to afford a solution to this problem. For this principle indicates at once and precisely the direction in which inquiry must move: *toward an analysis of the adaptive situation.* Art, science, and the other of man's higher activities and artifacts have their ultimate source in the human effort to adapt to the environment. They are all devices that man has gradually developed as the result of his experience with things, and in order to increase his mastery of the situation with which life confronts him. So it is through a scrutiny of the adaptive situation — of the aspects it presents and the conditions it imposes — that we can best understand the nature of man's activities and the relations that hold among them.

IV

5. Adaptation can be described quite simply as a process through which the living creature adjusts to the separate particular things that exist in the same total environment with itself. The process thus involves three factors: the living creature or individual person; the actual thing, the distinct object or situation or occasion, to which he is presently seeking to adapt; the environment that includes these two and all else that is. These are the elemental participants in the drama of life, the real referents of that dangerously abstract and ambiguous word, "adjustment." It is separate organisms — individual men — who are engaged in adjusting themselves; they do this through transactions with various particular

things; and these encounters take place within an environment that imposes a definite order and connection upon both men and things. Consequently, if our dealings with the world are to be appropriate, and are to culminate in successful adaptation, we must take account of each of these factors.

First, our transactions always involve ourselves: in behavior we commit ourselves as living creatures. We need to weigh carefully our own needs and capacities, and to estimate correctly the possibilities and the limitations that things offer to us. All occasions have import for us, and life demands that this be seized and exploited. It is necessary that we use objects and situations in a way to make good our wants and further our concerns; we cannot afford to ask of these more than they will yield, nor to offer less than they demand. So we must have a regard for the *import of things*, in order that our responses may be commensurate with our requirements and capacities.

Second, our transactions are always with particular things: this physical object or situation, this individual person or organized group, these specific material circumstances, this present event or occasion, this human or social state-of-affairs, this emotional involvement, this moral obligation, this spiritual crisis. A particular thing, or actual occasion, is whatever segment of the total environment we demarcate explicitly in consciousness and act upon purposively in behavior.[4] We deal always with some present thing that confronts us, some real

[4] This notion of "particular thing" will be further elucidated in the next chapter. This brief identification should render the idea sufficiently clear for the purposes of the present exposition. A particular thing may be a tree we notice in our path, a busy or deserted street we are traversing, a flower-bed, a seascape that stretches glittering before us, a desk piled with work, a dog in the hunting field; it may be a love affair, a friend in trouble, a frightened child needing reassurance, a political campaign; it may be a puzzling set of experimental data, a battle, an economic depression, a haunting expression on a face; it may be a transient emotion, a conflict of pleasure and duty, a deep religious conversion; it may be the cosmos as a whole, enthralling us with its vastness and intricacy, challenging us to comprehend it, pressing upon us the anxiety of death or intimations of immortality.

occasion in which we participate, not with what our ideas tell us this might be or ought to be, nor with what our emotions would like it to be. Everything is what it is, having a privacy and individuality utterly its own, and life demands that this be recognized and acknowledged; if it is not, we find ourselves dealing with fictions rather than actualities, and our behavior is not appropriate to the conditions we confront. So we must have a regard for the *particularity of things*, in order that our responses may be patterned to the uniqueness of the things we encounter.

Third, our transactions all take place within a systematic environment. Particular things — including men — are related and connected among themselves; they exhibit similarities; they hold to regular courses. The world has an order and connection, and life demands that we take this into account, exploring its intricacies, anticipating its developments, and shaping our behavior to its contours. We cannot deal with things in isolation, for they all have causes and consequences. So we must have a regard for the *connectedness of things*, in order that our responses may be geared to the structure of reality.

These are ultimate facts of existence, from which there is no escape. These facts, since they describe the essential character of the adaptive situation, define the conditions of life. Life is a complex and continuing process of adjustment, and these are the elements that have to be adjusted: living creatures and particular things set in a total environment that establishes constant and intimate relations among its inhabitants. As we have already seen, the modes of activity by which man satisfies these conditions are largely determined in conscious experience. Consequently, experience must be of a kind to assure man an adequate acquaintance with these three factors of the adaptive situation, and it must be of a kind to yield the highly refined activities and artifacts that are needed to improve the quality of the transactions that we have with the

things we encounter in this situation. If the human effort is to be successful, it must take these elements into account, conforming itself to their demands and appropriating them to its uses.

This entails that there be some provision in the human organism to guarantee that experience will have this character, and so will be able to meet these conditions that life imposes upon it. There must be some factors that control the focus and course of the attention that we pay to things; that determine us to have a due regard for the three moments that compose the process of adjustment; that lead us to explore the world in terms of its basic dimensions of *import*, *particularity*, and *connectedness*; that, finally, enable us to create artifacts that enhance our grasp of things and facilitate our dealings with them. For only so can experience, and all that issues from it, be an effective instrument of life.

V

6. I am explicitly positing the operation of such factors, and shall refer to them as *psychic components*. Psychic components are to be understood as elemental and directive principles or forces that are inherent in the very structure of sentient life. They are elemental in the sense that they are first refinements of the primitive and protean stuff that we call sentience, and so are reducible to no intermediate terms but only to the conditions that sentience confronts. They are directive in the sense that they determine the specific attitudes with which the sentient creature regards things, define the intentions with which he acts, and so govern the course of his behavior as he seeks adjustment. That is, psychic components reflect the character of the adaptive situation, and they operate in a way to keep man's experience and activity appropriate to this situation. They represent the fundamental differentiations of awareness through which we recognize the distinctness of the self, the particular things we encounter,

and the environment in which these encounters take place.

Psychic components are thus conceived functionally rather than structurally. Their manner of being is formal rather than material; their manner of operation is telic rather than mechanical. They are distinct modes of psychic function, but not separate parts of the psyche. These components correspond to the moments of the adaptive situation, and are three in number. The *aesthetic* component focuses our regard upon the particularity of things, the *affective* component upon their import, and the *cognitive* component upon their connectedness. These components, in the same order, keep our attention sensitive to the actual occasion that we confront, the bearing of this upon the self, and its connections with other occasions within the environment.[5] These components, acting always together, constitute the psychic matrix within which all of our conscious dealings with things take place; and they support and determine all of our more specific and familiar psychic operations, such as perception, emotion, thought, intention, and so on. They do all of this because they create the perspectives from which we regard things and the dimensions of experience into which we absorb things. Finally, in the ultimate reaches of their influence, these components are the agents that are responsible for the whole range of human creativity and the whole panorama of human artifacts. All of the enterprises, disciplines, and products that we refer to collectively as culture — art, science, morality, religion, engineering, et cetera — have their origin and assume their character under the directive force of these components.[6]

[5] This bare identification of the specific character of these components, and of their manifestation in experience and life, will be fully elaborated in the next chapter.

[6] Such an analysis as this of mind, and of the modes of psychic action, is obviously but another episode in an enterprise that philosophy has had in hand for over two thousand years. The theme is an old one, and the variations on it have been manifold. No one taking it up at this date would be foolish enough to claim any startling originality as regards the general terms in which it is cast; the precise identification and definition of basic concepts,

The function of psychic components is to direct man to have with the things he encounters just those types of transactions that are necessary to successful adjustment. Psychic components perform this function — they operate — by defining the attitudes that man adopts toward the things of which he becomes aware. They interpret to sentience the demands that things place upon it, and so they arouse in sentience the forward references — the interests, concerns, and intentions — in terms of which it must treat things. Psychic components are the expression of the vital needs of man in relation to the world; they reflect the conditions of life-within-an-environment; they guide man's experience and activity in a manner to meet these conditions.

7. The character and operation of psychic components can be most readily expounded by reference to the field of human consciousness. In this context, these components manifest themselves as the special types of interest — the different kinds of concern — that man takes in the things he encounters in his environment. We quite obviously do experience a variety of interests in the things of which we become aware. This fluctuation of interest is systematically oriented around the three poles of particularity, import, and connectedness;

as well as the development given these, are another matter, and here I hope I have suggested a new approach. It would be a needless interruption to trace even the major steps in the history of this theme. But reference should be made to certain recent doctrines with which the present interpretation has close verbal similarities and intellectual affinities. The work of three men requires special mention: first, that of Franz Brentano, particularly his *Psychologie vom empirischen Standpunkt* (Leipzig: F. Meiner, 1924-25; French trans. by Maurice de Gandillac, *Psychologie du point de vue empirique*, Paris: Aubier, ed. Montaigne, 1944); second, that of F. S. C. Northrop, as contained in several papers and most fully expounded in his *The Meeting of East and West* (New York, The Macmillan Co., 1946); third, that of C. W. Morris, especially his article, "Science, Art, and Technology," *Kenyon Review* 1:409-423 (1939). But it must immediately be added that the approach I have adopted, of grounding and defining the modes of mind's action in the evolutionary process, and the developments consequent upon this, are not found in the work of these men; and I do not mean to imply that they would approve either the method or its results.

this is the schema that represents the basic organization of our regard for things, our transactions with things, and our purposive operations upon things.

Even a cursory examination of the content and course of experience will reveal the influence of psychic components, molding our awareness and concern to the structure of the adaptive situation. Let us take several encounters with the same thing — say, a rugged and secluded mountain valley. On different occasions, this will arouse in us different interests. If this experienced interest occurs at a low level of intensity — if it is but a chance interruption of an attention whose primary focus lies elsewhere — it will probably be casual and hasty. The scene enters awareness as a complex and ill-defined object, it lives there briefly as the center of a vague regard, and then it is reabsorbed into the field from which it emerged — this is the fate of most scenes that we encounter as we are driving hurriedly to a destination. But it may be that this present valley forces its way onto a higher and more intense level of experience; it obtrudes upon our attention, wrenches us from our established course, and centers our regard upon itself. Now the scene stands forth as a distinct and definite entity, and the differentiation of the interests that we take in it becomes immediately apparent.

It may be the mountain valley itself, in its unique particularity, that dominates our experience. The masses of color it displays, the steep rise of its hillsides, the stream coursing through its rocky bottom, the clouds soaring above its ridges, the trees and wild flowers growing in it — some or all of these may seize and hold our attention. Forgetful of all else, we are entranced by the vision afforded us. In such a case, our interest is primarily aesthetic, and it is the particular thing encountered that commands and occupies our regard.

It may, secondly, be the import of this valley for ourselves that dominates consciousness. We realize it as an object that threatens and promises various things to us: its seclusion may

frighten or soothe us; it may make us lonely for human company or glad to be alone; the silence of its trees and rocks may fill us with a sense of awe and mystery or of desolation and waste. At a more purposeful level, we may regard the valley as a means to some end defined by the self, and become interested in the possible ways in which it could be appropriated to our uses: as a fishing preserve, a source of timber, or the site for a resort. In all of these cases alike, our concern is primarily affective, the self is the center of attention, and the thing encountered has meaning in terms of its human impact.

It may, finally, be the connectedness of this valley with other things in a larger environment that dominates consciousness. We recognize similarities between its features and those of other valleys; we view its exact form, and its location just here, as the result of certain causes; we see it as an item whose occurrence and characteristics are related to other items. Regarded in this way, the valley becomes an object to be somehow analyzed and explained: it is a problem demanding a solution, and as such our concern with it is to locate it in some systematic framework. This same generic interest may proceed in many specific directions. The valley as a whole, and even more its different features, can be analyzed in various ways and absorbed into various contexts: the geologist, the botanist, the zoologist, the geographer, the conservationist, the dendrologist, and the highway engineer will describe and interpret the valley in quite different terms. But in all of these cases alike, our interest is primarily cognitive: it is some general frame of reference that stands at the focal point of our regard; the valley becomes an item within this systematic body of ideas, and our concern lies in discerning the place it occupies within this framework, and the relations that bind it to the other parts.

I will soon examine, in detail and systematically, the panorama of life as it takes shape under the impulsion and guid-

ance of these three basic interests. For the moment, the point I wish to stress is merely that these different interests do occur and operate effectively — do make themselves amply manifest — and that they are not explicable simply in terms of such psychological elements as percepts, emotions, ideas, wishes, memories, and so on. For all of these are almost always present. Beyond and behind these we are also conscious of an additional factor that coordinates these common elements into a distinctive sort of whole, that defines our special attitude toward this whole, and that directs our transactions with it toward a definite kind of consummation. This additional factor, when it is recognized in consciousness, is what we call an attitude, interest, or concern. It is clearly experienced as a controlling force in our encounters with things. And the means by which it exercises this control are equally clear: it determines the perspective from which we view things, the manner in which we broach their acquaintance, and the mode of adjustment that we seek to secure with them. The three dominant interests or concerns that I have described are functions of psychic components; they are the agents through which these components operate in conscious life.

But it must be emphasized that this is only the guise under which components appear in awareness; we here know them immediately but superficially. In terms of their actual role in the human economy, these components are to be understood as factors in the human psyche that act upon brute awareness, give to this definite perspectives and directions, and thus create specific kinds of attitude and attention. We can now turn to a closer consideration of these components separately, in order to examine the role that each of them plays in the life of the mind, and the contribution that each makes to the conduct of the human enterprise.

Chapter II

THE ANALYSIS OF
THE PSYCHE

I

1. The nature and the modes of operation of psychic components can be fully exposed only gradually, as we watch them at work in patterning the course of man's experiences and activities, and as we see them embodied in the artifacts that man makes. But it is advisable to clarify at once their specific characters, and the distinctive contributions that they make to life, by tracing their total manifestation in human behavior, from its most casual and spontaneous levels to its most purposive and intense.

To obtain such a panoramic view of the life of the mind, this preliminary account must be very condensed and schematic. Such a procedure runs the risk of making distinctions appear more radical than is really the case or is intended; this account deals with forces, activities, and modes of behavior that in actual life are always conjoined, and it treats these as though they were sharply separate. This is the inevitable effect of such analysis; one can only warn against it by stressing the fact that what happens in the concrete flux of life is always a synthesis of the elements that are here being analyzed. The affective, aesthetic, and cognitive components of the psyche represent the different perspectives from which we necessarily view the world. Considered separately, they focus attention upon the self, particular things, and the surroundings that encompass these. But psychic components always act in conjunction, and the partial views they yield

are integrated into a comprehensive and coherent grasp of things.

2. The primitive biological function of the affective component is to keep response sensitive to our own vital needs and concerns: it focuses attention upon the immediate impact of things and upon their availability to our uses; it directs behavior toward satisfying the demands and realizing the opportunities with which things confront us.

The affective component thus leads us to regard the situation we encounter from the perspective of the self. It interprets things in terms of their *import*, which it presents under the primary guise of *feeling*. Feeling is that strand in awareness, interwoven always with other strands, that reflects our involvement with the world. To feel is to undergo the pressure of our wants, and to sense the movement and the direction of our desires; the quality of feeling changes as these factors vary, as they attach to different objects, as they issue forth unimpeded or encounter obstacles. Pure feeling would be the sheer awareness of self-existence and of the passage of the self through life. But feeling never occurs in a pure form; the import that we feel is always experienced as having its source somewhere outside ourselves, however vaguely and imprecisely this may be localized; and it is always experienced as occurring and requiring release within an ordered context of events, however dimly we may grasp this pattern.

As we sense this import, and attach it to things that sustain constant relations, we seek to realize some of the possibilities that things offer, and to inhibit others; that is, we seek to use things to our advantage and to limit the concessions we must make to them. When our attitude is primarily affective, it is our own needs and desires that dominate the experiential occasion. We are thus led to explore the situation with which we are dealing from the point of view of its impact upon our concerns and pursuits; the situation becomes its effect upon

us. This effect or impact, if our grasp of it is at all precise and explicit, is translated into a more or less specific *emotion*: we undergo fear, anger, hope, dismay, greed, lust, or some other segment of the emotional spectrum. This emotion that we first undergo, that is borne in upon us from the circumstances in which we are engaged, then tends to reverse its direction, to seek release through the thing that has aroused it, to envisage a change of the external situation: that is, the emotion generates an *intention*.

Response is here at a crucial stage: realization of the impact of circumstances is being transformed into a projected course of action, behavior is about to become overt, and the pattern of adjustment is taking shape. All now depends on whether the affective component assumes tyrannical control of response, or acts in harmonious conjunction with the aesthetic and cognitive components. To speak a more familiar language, it is a question of whether emotion suffuses and overpowers us, or whether emotion is tempered and informed by a proper regard for the particular thing that has aroused it and for the total life-situation within which it is occurring.

In the former case, response is unbalanced and aberrant. The awareness of immediate impact — the sense of the self — is so intense that it radically deranges our aesthetic and cognitive grasp of the occasion in which we are involved. Our emotion-and-intention is therefore unable to find a satisfactory outlet; it is isolated both from the particular situation that has called it forth and from the objects and actions through which it could release itself, and so there is nothing for it to do but to expand in a cancerous fashion. We then find ourselves in a condition of either *passion* or *anxiety*. As pathological phenomena, these states differ in important respects. Passion is usually more intense and sudden, it retains an awareness of its cause, and it is more definite and urgent in its demand for action of some sort. Anxiety, on the other hand, is more pervasive and enduring, it is largely ignorant of its

source, and it often issues in either apathy or diffuse restlessness. But passion and anxiety are essentially similar in that they result from the affective component of the psyche overbearing the aesthetic and cognitive components and inhibiting their normal operation. And these states are also alike in their consequences: in both cases, we are so absorbed by the impact of the world upon the self — the felt import of things — that we are incapable of appreciating the true character of the situation we confront or of anticipating its outcome. So we cannot plan or execute, and action is paralyzed.

If response remains balanced, it follows quite another course. The affective component continues dominant: it holds the self at the focus of attention and leads us to regard the thing we are dealing with as an *object to be exploited*. But this component acts in the light of a proper aesthetic and cognitive view of the situation. The emotion that is controlling the response is enlightened by careful attention both to the thing that has aroused it and to the probable consequences of various modes of release. As a result of this consideration, intention becomes *preference*. This defines what we deem the most desirable outcome that can be attained in the situation confronting us; it embodies our judgment and decision concerning the ends that we would like to achieve and the means to their achievement. The thing with which we are dealing, considered as a vehicle for the satisfaction of preference, becomes an *instrument*. We use objects and persons, occasions and circumstances, as instruments when we neglect the claims they make for themselves, or as parts of a larger context, and subordinate them to our own self-satisfaction.

But things do not passively submit to our intentions. Their complacence is limited by their particularity and their connectedness. We often recognize, even when we do not honor, the right of everything to have its integrity respected; and we are forced to accept the stubborn fact that many of our preferences are resisted and frustrated by the order of events.

Furthermore, we soon come to realize that what we presently prefer may not be what is to our eventual best interest: to achieve the highest good that is open to us, many preferences must be sacrificed and those that are retained must be cultivated. Self-estimation needs to be qualified by a regard for norms and ideals which reflect the accumulated experience and wisdom of man. Likewise, our treatment of people and things must acknowledge the obligations and the limitations that these impose upon us. Without this double curtailment of preference, our decisions stand under the shadow of ignorance and egoism, and our transactions with the world become shallow and erratic.

When preference has been subjected to this further criticism and correction, it emerges as *purpose*. And things as conditions for the realization of our purposes become *values*. Here, our original emotions and intentions have been clarified under the pressure of general standards and deliberate commitments. We choose in the light of experience and reason, we accommodate our choices to categorical rules, and what is presently chosen is viewed as a momentary occasion in a far vaster human and cosmic panorama. When we act on the basis of purpose, we submit our subjective preferences to objective determination. When we treat things as values, we consider what they demand of us as well as what we desire of them. This is to say that the value-content of things is defined not merely by human attitudes, but also by the intrinsic character of things and by their place in the total environment. Whenever our regard for things is primarily affective, we envisage them in terms of the satisfactions they can afford us and the fulfillment they bring to the self. When we attain the level of purpose, and treat things as values, our actions are tempered by respect and responsibility, and we are launched in quest of the good.

In order to bend things to our preferences and purposes, we engage in the special kind of activity that can best be

called *technology*. We take steps, and we create artifacts, that will enable us to manipulate things successfully and to transform them as our concerns dictate. The uses we make of our technological skills may be selfish or disinterested, narrowly expedient or profoundly ethical. We may utilize things as instruments, and treat them as sheer means to our own ends. Or we may seek to realize the value-potential of things, with a view to their own integrity and the rights of others. The function of technology is to extend our *control* of things, and in this role it lends itself alike to utilitarian and to moral employments.

The obvious examples of technology are such artifacts as tools, machines, appliances, and the products of the crafts and the engineering sciences; but as the term is used here it also includes moral codes, sermons, rhetoric, medicine, courtship, and such institutions as law, the state, the church, and schools. Technology is all of those devices and practices by which we intervene in the world, change things in such a manner that their impact is closer to what we deem desirable or good, and so implement and refine our native self-assertion.

3. The primitive biological function of the cognitive component is to keep response sensitive to the total environment in which this response takes place: it focuses attention upon the causes and consequences of the present occasion; it directs behavior toward a comprehension of the similarities and connections that pervade things and events.

The cognitive component thus leads us to regard the situations we encounter from the perspective of the systematic relations that hold among them. It interprets things in terms of their *connectedness*, which it presents under the primary guise of *thought*. As a strand in awareness, thought reflects the order that looms behind the separate moments and contents of experience. Some rough pattern of similarities and regularities emerges in even the most untutored mind from its en-

counters with the world. The outline, and yet more the details, of this pattern vary with the power and cultivation of the individual mind, with its cultural inheritance, and with the range and intimacy of its acquaintance with the environment. But life's occasions are never experienced as merely the impact of particular things: there is always some discernment of a structure that connects these occasions.

As we sense this connectedness that binds things together, we want to elucidate it as an organized system within which we can locate things as members of classes and as terms in relations. When our attitude is primarily cognitive, it is our conviction of the orderliness of the environment that dominates the experiential situation. We are thus led to explore the thing with which we are dealing from the point of view of its place in the scheme of things; the thing becomes an element in a body of concepts, a node in a web of meaning.

This sense of the connectedness of things is apt to be at first vague but pervasive: it takes the form of a spontaneous and placid assumption that order does pervade the world, that things are bound together, even though we may not be able to decipher the ties that stretch outward in space and time from the actual situation. As our grasp of this connectedness becomes precise and explicit, it is translated into more or less definite *ideas*; the thing with which we are concerned is brought under class concepts, it is referred to general principles and categories, it is defined and catalogued. The thing has now been recognized: it has been given a name, it has been assigned a location in a familiar frame of reference, and it borrows meaning from this. So the past accumulation of knowledge tells us a great deal about the present situation, and about its antecedents and consequences, without further effort on our part. In the vast majority of cases, the cognitive component has now completed its essential task: it has reduced the thing to a manageable condition, and appropriate action usually follows from well-established habit. But if this

rational assimilation of the thing is in any way impeded or unsatisfactory — if the thing is recalcitrant to our efforts to absorb it into an existent body of idea — then experience must proceed to a higher level as we engage in an intensified attempt to come to grips with the thing cognitively.

Response is here again at a crucial stage. If the cognitive component becomes tyrannical, it centers our attention too exclusively upon ideas: we lose sight of the actual situation we are trying to understand, as well as of the demands that this situation imposes upon us, and become totally immersed in our present body of concepts and in their further logical elaboration. When this occurs we fall into the practice of *dogmatism and rationalization*. Our ideas are isolated from either empirical or pragmatic criticism; they become immune to correction, and are asserted as necessarily true without any regard to their actual verification. Furthermore, these ideas are arbitrarily imposed upon things: we force objects and events into the molds of our concepts, no matter what may be the weight of the evidence and the practical consequences.

If response remains balanced, it moves to a quite different climax. The cognitive component retains its dominance: it leads us to treat the thing we are dealing with as an *object to be explained*. But this component is reinforced by a proper aesthetic and affective view of the situation: we honor the particular characteristics that the thing asserts of itself, and we feel its import for us. We recognize that ideas must be relevant and viable, as well as valid. In the pursuit of this goal of truth, we formulate our ideas as *hypotheses*, we test them by logical and experimental procedures, and we organize them as *deductive systems*. The body of doctrine thus arrived at states what we deem the best explanation of the set of occasions — the segment of the environment — with which we are concerned. Things as accounted for by such doctrines become *facts*.

The factualness of things is of course grounded in the objective order; things do exist and occur within a systematic environment. But it must not be forgotten that the precise factual character and status that we ascribe to things is assigned them by the interpretations that we place upon them. We hope that our conceptual systems reflect accurately and adequately the real order of events, and we take pains that this be so, but we never know the measure of our success or failure. We easily ignore or misconstrue the elements and structure of the environment, and yesterday's fact is often today's superstition. The ultimate ordering of things is a mystery, and it is we who transform things into facts by absorbing them as items into our abstract schemata. To exhaust facts as nearly as we can — to trace out the amplitude of their causes and consequences — we engage in the special kind of activity that we call *theory*: we undertake the major enterprises of science, philosophy, and theology, with all of the disciplines subsumed under these. The function of theory is to arrive at conceptual systems and bodies of knowledge that will *explain* things by clarifying their locations and relations.

II

4. It is unfortunate that the aesthetic aspect of the psyche and of the world is the least amenable to systematic discourse. Language is never adequate to things, and never faithful to our intentions. But the description of our cognitive and affective pursuits does not pose too severe a challenge. Both the life of reason and the life of feeling entail continuity in time and relatedness in space. We transform things into facts and values by processes that are largely analytical; to explain and control things is to treat them as elements that are defined by the general patterns in which they occur. Language can readily enough describe these patterns, and indicate the location of things within them.

The aesthetic life resists such formulation for an obvious reason: it is episodic rather than continuous; its concern is to isolate things, not to connect or manipulate them; it seems intent on surrendering to the world instead of capturing it. To deal with things aesthetically is to be absorbed into them. It is extraordinarily difficult for language to efface itself and describe the process of such an acquaintance without intruding upon it. So the attempt to analyze the aesthetic life is very liable to distortion, and the verbalisms that are employed are apt to seem arbitrary and deceptive. The ensuing account can do little more than define a series of problems that later discussions must attempt to solve.

The primitive biological function of the aesthetic component is to keep response sensitive to the actual thing or situation that we confront: it directs behavior toward clarifying the intrinsic character of occasions and events in all of their richness and concreteness.

The aesthetic component thus leads us to regard each situation we encounter from the perspective of this situation itself. It interprets things in terms of their *particularity*, which it presents under the primary guise of *imaginative apprehension*. This is the first arbitrary verbalism that must be explained. Apprehension is that strand in awareness that reflects the separateness and uniqueness of each of life's occasions. Every situation that we confront is novel, and challenges us to grasp this novelty; it demands of us that at least we be sensitive to its significant individual differences, and it offers us the opportunity to enrich and refine experience by a diligent scrutiny of its features. The objects and events, both external and internal, that we identify and dismiss so casually by merely giving them a name, are all different and distinct. When we call a thing a "house" or a "headache," "murder" or "anger," we are saying something quite pertinent about it, but we are also leaving a great deal out of account; we are ignoring its particularity in order to bring it within the

reach of the generalities that are defined by our ideas and purposes. To apprehend imaginatively is to realize the presence of this unique particularity: it is to be aware of just this combination of physical properties, of just this structure of form and meaning embodied in color or sound, of just this interplay of human motives and actions, of just this concatenation of inner stress and strain. Imaginative apprehension is the informing of experience by the occasion that is actually transpiring.

This primitive aesthetic occurrence of things, while present in all of experience and usually discernible to close introspection, is apt to be so superficial and transient as to pass unnoticed. Our cognizance of particularity is fused so closely and simultaneously with that of import and connectedness that these strands do not appear separately in awareness: we can only disentangle them later, if at all, from the finished product that together they compose and that we call a thing. On numerous other occasions this aesthetic quality is a great deal more conspicuous even if only a little more enduring. Just for a moment the object or situation before us seems to leap out of its own background and to wrench us from our own concerns; it asserts its intrinsic character — its formal and qualitative uniqueness, its private texture and structure — with such sharpness that its relations with other things and with ourselves are thrown into shadow, and disappear from sight. Most often, this is but a momentary flare; then, under the influence of affective and cognitive components, the thing is drawn back into the dimensions of the self and the world. Its particularity, briefly proclaimed, merges again with its import and its connectedness. The aesthetic component has performed its primary function: by holding particularity even briefly before our attention, it keeps us sensitive to individual differences; it prevents us from confusing this actual thing with others that are similar but not the same; it provides that our emotions and ideas will be pertinent to the thing that we

presently confront, and appropriate to the situation in which we are actually engaged.

Our spontaneous acquaintance with things always has this aesthetic moment. And sometimes experience centers around this moment and becomes essentially aesthetic. If our initial sense of particularity is sufficiently vivid and compulsive, the experience that ensues is immediately *appreciative*. These are those happy occasions when, without apparent effort or contribution on our part, particular things are given to us with a freshness and fidelity that they do not ordinarily wear, and the whole quality of life is heightened and intensified. This may happen before either nature or art; it may be the song of a bird, the sweep of a hillside, the sea's restless and relentless surge; or it may be a passage of poetry, the looming grandeur of a façade, the gaiety of music, the human tensions at play in a drama, the design of line and mass and color in a painting. In all of these cases we suddenly see (or apprehend, grasp, intuit, sense, et cetera) the world with greatly enhanced acuteness and intentness. Without forethought or purpose, initiative or volition, we find ourselves enthralled.

But usually, as we sense the particularity of things, we recognize that this does not clearly reveal itself to first acquaintance: it hints at more than it exposes; it is ambiguous and obscure; it is fluid and tentative, resisting the effort to fasten it down. This particularity, which proclaims but does not disclose itself, challenges us. We want to isolate the thing, to detach it from its import and connectedness, to demarcate it from kindred things that are similar but not identical. We seek to invade the privacy of things, and to capture their uniqueness. Art is the special instrument through which we do this.

5. At this point in the argument, a question must be anticipated: what is meant by "particularity," and what is to

be included within the catalogue of "particular things"? This question raises issues that are ontological in nature and that have not yet received a settled solution. Fortunately, the depths of this problem need not concern us; it is the task of metaphysics — as the climax of the cognitive undertaking — to search out the ground and the connectedness of what appear in experience as distinct objects, qualities, and occasions; it is the task of art — as the climax of the aesthetic undertaking — to accept the pretensions of these avowedly distinct things, and to make vivid and articulate what they only vaguely adumbrate about themselves.

From the point of view of art, particularity is whatever can be demarcated in consciousness, and anything upon which mind can fix its attention and fasten its interest is a particular thing. The artist's original identification of particularity is as tolerant and hospitable, as naïve and uncritical, as that of common sense, from which it differs only in being far more subtle and sensitive. The artist knows nothing of the pathetic fallacy, of primary, secondary, and tertiary qualities, of the dualisms of universal and individual, fact and value, substance and attribute, abstract and concrete. For him, the mood of a landscape is as real as its mass and pattern, the feelings of hope and despair that accompany an illness are as important as the disease that causes it, a vision of the destiny of man is as vital as the ambitions that animate men, and the spark of joy that leaps from a happy encounter of tones or colors is as substantial as the paper or canvas on which this encounter is recorded. The original focus of aesthetic particularity is subjective; this status accrues automatically to whatever is noticed in experience. The success of the artist — the "truth" or "sincerity" or "greatness" or "profundity" or "clarity" of his work — then depends on the degree to which he can cultivate this first discernment in such a way as to illuminate the real particularity of things.

So when we speak of aesthetic particulars we refer to a

vast conglomeration within which only the loosest sort of ordering is either possible or desirable. It includes physical objects recognized as units, parts of these, their surface qualities, their structure, the moods that seem to haunt them, the threats and promises they hold for us; the different ways in which Michelangelo, Bernini, Maillol, Rodin, and Epstein have sculptured the human figure exemplify the wealth of particularity that things contain. It includes the emotions, attitudes, passions, and aspirations of men, from the most transient and superficial to the most profound and enduring: a lyric or a song may capture a momentary trace of feeling, while a symphony or an epic may grapple with the sense of anxiety and despair, of hope and faith, that haunts a lifetime. It includes all of the situations and problems that men encounter, the motives these bring into play, the alternatives they offer, the outcomes in which they issue: a short story or a genre painting may isolate a casual episode, while a drama or novel may synthesize the Odyssey of a lifetime. It includes the conditions with which society confronts man, as well as the values that man discovers and the institutions through which he pursues these; Trollope's *Sir Harry Hotspur* is a brilliant picture of a man obsessed with the obligations of property and position, while Eliot's *Wasteland* is an epitaph for a culture that has lost the sense of obligation. It includes the remembrance of occasions that are gone for good, of challenges that were accepted, of opportunities that were lost; it includes the hopes and fears, the determination or indifference, with which we face the future; and it includes the subterfuges to which we resort when we find the past, the present, and the future alike unsatisfactory. Proust's *A la recherche du temps perdu*, Marvell's address "To His Coy Mistress," and Thurber's "The Secret Life of Walter Mitty" exhibit different attitudes that man adopts before the inexorability of time and circumstance.

But it would be a task of Sisyphus to catalogue the realm of particulars, for it is being continually replenished by fresh

aesthetic insights. The metaphysician scrutinizes the credentials of things, for he is concerned with the grounds and connections of facts, and with what they can disclose to him of the structure and economy of Being. The artist accepts whatever proclaims itself and appeals to him, for his concern is with the character of particulars, and with what this reveals to him of the richness and variety of Being.

This emphasis on an interest in particularity as the defining trait of art must be balanced by a recognition of the claim of universality that is so often made for art — and, indeed, that works of art make for themselves in their impact upon appreciation. It is an obvious matter of fact that we frequently do refer the content that we derive from works of art to the "real" objects and events that compose the world; that is, we effect a transfer of meaning from art to life. And it is commonly held that the artist intends that his art should sharpen our powers of apprehension, giving us a clearer vision of the actual things we encounter around us and of our own entanglement in these encounters. We regard works of art as somehow revealing the essential character of things, and so as rewarding attention with a disclosure of reality. This, I presume, is what is meant when it is said that art embodies universal meanings and has a universal reference. Any contradiction that may be felt here is only apparent, and can be explained quite simply, without invoking any special metaphysical or epistemological hypotheses.

The illumination that a work of art casts upon the particular thing it presents is reflected upon other particulars that are similar to this one. Art has a universal relevance because men who participate in a common nature share a world in which various things themselves have much in common. This does not mean that art makes, or tries to make, general statements that are applicable with equal validity and without qualification to a horde of similar particulars; such generalized descriptions, which can refer only

to schematized representations from which all individual differences have been erased, are the product and concern of theory. Art conveys the private quality of a particular thing or occasion; it presents a unique occurrence in a unique way, and in the course of aesthetic experience it is the actual character of this particular that dominates awareness. But symbolic reference is an integral element in art, and our acquaintance with art is not complete and successful until the aesthetic object has been assimilated into the body of our experience as well as discovered on its own terms. The artist cannot but talk about things that are already our familiars: trees and skies and waters, loves and hates and jealousies, hopes and fears and aspirations, adventures undertaken and accidents undergone — in short, the whole range of existence, and all of the pressures that this exerts upon us. This is the *subject matter* of art.

It is what the artist says about these things, as he has encountered them, that is new and revealing: this novel insight into what is generally familiar is the *content* of art. And this content is referable both to the accumulated body of our experience and then to our future encounters with these things. In retrospect, we realize that the content the artist discovers to us can be discerned in things themselves. In articulating his own unique experience of love, Donne clarifies the equally unique — but by no means so clearly realized — loves of other men; for loves have similarities in their objects and their courses, though they certainly are not identical. In articulating his own vision of color and space, Kandinsky illuminates the world of color and space for other men, for his art says something unique about a world that is private to every man but is also our common environment. We will never see just what he saw, and never again what we saw in his work; but what we have discovered there will be assimilated and so will influence what we see in the colored space we all inhabit. Likewise, we will never feel what the poet

felt; but what we feel in his poem accumulates and becomes a part of our experience; so it influences what we may feel hereafter, and it broadens our sympathy for the feelings of others. Art is universal in the sense that it enables us to find enhanced meanings in subsequent encounters with things which, though themselves unique, are similar to the things presented in works of art. Particularity reverberates through experience, generating meanings that perpetuate itself, and so assumes the guise of universality.

6. When our attitude toward things is primarily aesthetic, it is the self-assertion by things of their own individual existence and autonomy that dominates the experiential situation. We glimpse, however transiently and superficially, the aloneness and aloofness of things, their persistence in the ineluctable course of being themselves, their intrinsic detachment from all that surrounds them but is not they.

We are thus led to explore the thing with which we are dealing from its own point of view, and to approach it on its own terms: the thing becomes a unique occurrence that is isolated from its environment, frozen in space and time, and insulated against our own concerns. This search is the activity of imagination, and this grasp of a thing in its own dimension — as being just itself — is translated as an *image*. This is another central notion, later to receive much elaboration, that must now be briefly explained. Images, as a mode of experienced content, are distinguished by their situation in consciousness, not by the elements of which they are composed. The image is constituted as such by its manner of occupying attention, not by the material it gives us to attend to. This is now quite widely recognized; but there is still a strong undercurrent of doctrine that tends to define the image (and so to define aesthetic experience and art) in terms of some one human faculty that mediates or produces images, and in terms of some special sort of material content that is

peculiar to images. The faculty that is usually chosen is perception, distinguished for this function as being of a specific aesthetic kind; and the material that is selected is usually that given to us by our senses, especially sight and hearing.

Such an interpretation, I think, simply will not fit the facts. The act of imagination, like those of feeling and thought, is a synthetic psychic process, occupying all of our faculties and resources; and the images in which this act issues are composites of all of the information and meaning that we glean from things. It is true — and this lends credence to theories of "pure" or "aesthetic" perception — that images tend to have a sensuous or perceptual core: their original appeal and their continued existence are often based on the clarity and force with which they can compel our senses. This is obvious in music, drama, the dance, and all of the plastic arts, as well as in natural beauty; and poets and novelists are much concerned to make us "see" the objects and incidents, the persons and episodes, with which they deal.

But this is not the whole story, or even the most important part of it. The content of images is emotional and ideational as well as sensuous and perceptual. Images are made up partly, and often predominantly, of material that has first been mediated by feeling or thought, and has then been also imagined. Imagination — aesthetic activity — operates upon the total body of material with which awareness supplies it, just as do our affective and cognitive processes; it is one way among others of dealing with all of this, not the sole way of dealing with only one part of it. What is imagined, and presented in an image, is frequently non-sensuous, as the emotions, beliefs, ideals, and purposes that animate people, the psychological circumstances in which people encounter one another, the meanings that the world and life hold for man. This is obvious in the literary arts, and it is a powerful factor in the other arts, where such material is incorporated in images

by all of the elaborate devices of evocation, suggestion, symbolism, and iconography. So the materials that images include, and the contents that they convey, are infinitely various.

The distinguishing characteristic of images as psychic occurrences lies in the fact that they are highly self-contained, isolated, and episodic. They focus attention upon themselves instead of referring it elsewhere, as emotions and ideas normally do. (Of course, as I have indicated, an experiential content that is originally and largely emotional or ideational can appear in the guise — can assume the status — of an image). Images assert a completeness and self-sufficiency that demand only internal clarification, and resist absorption into any prior and independent system. Things as translated into emotions and ideas point spontaneously to their location in the systematic framework of our purposes and theories; they demand to be controlled and explained. Our immediate response to things when they occur in these modes is to pare away their particularity, to shatter their individual subsistence, and to absorb them into our careers or into some established body of doctrine. The self and the world swallow things, as a man rolls up a string that he is following to his destination. Things as translated into images point only to themselves: they demand to be presented and preserved on their own terms. Of course, things-as-imaged appeal beyond themselves to our accumulated affective and cognitive biographies and concerns; we experience things as whole men, so this experience, under whatever mode it may occur, contains large deposits of emotion and idea, as well as of image. Images are not replicas. But when things appear as images, this appeal is not a reference to an established theory nor a citation to an authoritative code of values. Things are enriched by our bringing to bear upon them much of the psychic equipment that we command, but this is here used to illuminate the thing as a unique occurrence, not to reduce it to some ready-

made terms. Seen from the aesthetic perspective — mediated as images — things tend to absorb the self and the world into themselves.

With this translation of things as images, response is again at a crucial stage. If the aesthetic component now becomes tyrannical, the thing with which we are dealing is lifted out of its proper context; isolated from any association with other things or with ourselves, it fills the entire horizon of our interest, excluding all consideration either of the import of the thing for our careers or of its place in the world of things. Seen thus, the thing inhibits any appeal beyond itself; then, since it permits no comparison, it cannot be evaluated; since it permits no reduction, it cannot be explained. When this occurs, we fall into the error of *idolatry*: a single particular thing tends to become the arbiter of all meaning and value, and to impose its conditions upon ourselves and the world. We can and do idolatrize the most various things: a person, a place, a memory, a cause, a dogma, a state-of-affairs, a style or technique, a code of manners, or even a pet. To be victim to idolatry is to make one thing the locus of all significance, and to submit all other things to its canons. Intense aesthetic acquaintance, whether before art or life, approaches this utter absorption as an abstract limit, but it never attains it, and even its approximations to it are not usually enduring.

In the more usual and balanced response of this type, the aesthetic component remains dominant: it leads us to treat the thing we are dealing with as an *object to be apprehended* — that is, accepted on its own terms. But this component receives proper cognitive and affective support: the particularity to which we are attending is brought into the focus of our ideas and emotions, and its reflection upon the life of reason and the life of feeling is brought to light. We are here primarily making the acquaintance of a particular thing — a landscape, a person, a human situation — but in doing this, we also realize the significance of this thing for human

purposes and its demands upon the theories that pretend to explain it. Our primary effort is to grasp and intuit the thing as being just what it is. But in becoming more precisely itself, the thing exhibits more compellingly its presence in the dimensions of the self and the world. In asserting its own character, it demands that these dimensions be adequate to receive it without undue distortion; and so, by its reverberations through experience, it leads us to clarify and correct our interpretations of these dimensions.

This quest for particularity takes shape as *expression*. The defining characteristic of artistic expression is the impetus toward the discovery and articulation of the precise nature of experienced objects and situations and events. What the artist begins with — this is dangerous but unavoidable — is ineffable; it has the status of an intuition. Insofar as the character of such an intuition can be discerned, it appears to consist of a close fusion of insight, excitement, and intention: the artist has a vision of something that seems new and unprepared; this glimpse both entrances and tantalizes him; so he sets forth to clarify and stabilize it. There is only one way in which the artist can do this: *by discovering the conditions of the occurrence of the original apprehension.* He must take what was apprehended as synthetic, and analyze it into its constituent elements. He finds within it sensuous and perceptual properties, such as colors, sounds, textures, rhythms, patterns, formal structures, and designs; feelings and emotions, with their tensions and conflicts and resolutions; ideas and meanings, sequences and relations, dreams and aspirations — he finds some or all of these. He was not necessarily conscious of these in the original intuition, especially not as elements or conditions. But it is because these were there that he was conscious of the apprehended image.

Having found these, the artist's task is to put them together in a way to re-present the original apprehension, but clarified and made concrete. In creation the artist realizes explicitly

what at first he only grasped implicitly. By means of his art, the thing that was first roughly given is now sharply presented. Particularity is apprehended, but works of art are composed.

The thing with which we are concerned has thus been singled out, brought up in clear relief against its surroundings, and relieved of its entanglements with the self; it becomes for the moment a source that illuminates itself with its own light and from which meaning radiates outward upon the world. The thing as thus apprehended and expressed becomes an *entity*. The character of things as entities, like their character as values and as facts, is a blend of what we find in them and what we take to them. The artist is no more able to escape the limitations and distortions of his own sensitivity than are the theorist and the technologist. What he discovers and creates, and makes available to our imaginative apprehension, is no unglossed version of reality; an entity is not a noumenon. The artist does not in some mystical fashion reach in back of the facts and values that mind makes of things, and so recover what things are in themselves. The ultimate particularity of actual occasions eludes us as surely as do their ultimate connectedness and import. The work of art is not a spontaneous and pristine vision, but a cleverly contrived artifact that has been wrought out of the gross matter of experience with much pain and effort. The function of *art* is to *present* things as entities. In doing this, its first great gift is to shatter our preconceptions, our pretentions, and our complacency. Its second is to compel our attention so that it largely succumbs to the immediate encounter; things then assert their own uniqueness, and we attend to them as fully concrete and determinate.

III

7. It is my chief substantive thesis that these three components determine the structure, the course, and the outcome

of psychic life. They reflect the conditions imposed by the adaptive situation. In turn, they define the patterns of response, the specialized activities, and the refined artifacts through which man adjusts to the environment. They are the ultimate architects of the human enterprise.

The preceding account of psychic components has unavoidably treated them in isolation from one another, and has stressed their character as specific and distinctive. It has therefore been highly divisive, tending to reduce life to three segregated compartments, determined by components that act independently of one another. To correct this altogether false impression, two points must be emphasized.

First, psychic components all function at all times. Each of them is involved in every moment of experience and in every act of response, and each of them is incarnate in every human artifact. Attention is at all times a compound of affective, cognitive, and aesthetic moments: everything of which we become aware is in that very process viewed from these perspectives and brought within these dimensions. I have heretofore spoken as though emotions, ideas, and images were utterly independent languages into which the psyche translates things; as though purposes, theories, and expressions were distinct modes of psychic function; as though technology, theory, and art were quite separate devices that we use in separate ways in order to come to grips with things; and as though values, facts, and entities were distinct modes of existence of things. This is emphatically not the case: within these various trichotomies, each element is impregnated with the other two.

It is necessary to insist upon the fact of the cohesiveness and integrality of life; if it is not constantly borne in mind, the theory that is to be built upon the present foundation will be grossly misunderstood. The explanations later to be given of the aesthetic process, of aesthetic experience, of art, of the creative process, of the aesthetic object, and of other

related topics, all hang upon this fact. These aesthetic phenomena have their specific and essential character because the aesthetic component dominates in their occurrence; but these phenomena would not have the full character they do — and art would not have the power and significance it does — without the contributions made by the affective and cognitive components. Save for perhaps rare and aberrant exceptions, there are no pure occurrences in our experiential encounters and transactions with things. Every moment of psychic life is a coalescence of the joint action of these components. Life is an infinitely varied panorama, as we encounter different things and as these components function with different relative forces. Our experiences, activities, and artifacts do cluster around three poles: they tend to be primarily affective, cognitive, or aesthetic in character. But this character is always compound, and the fields that surround these poles merge into one another and intermingle in areas where it is impossible to specify the character of what we are experiencing, doing, or making. It is the whole man who receives things in consciousness, entertains them in experience, and adjusts to them in behavior. Life throughout reflects this wholeness.

The second point to be stressed is that these components are coordinate in status and significance. No one of them has priority of any sort over the others. They are all equally essential to the process of adaptation; they appear and develop concomitantly; each is an indispensable instrument of human behavior, a necessary part of man's equipment if he is to meet the conditions of life. These components supplement one another mutually; each contributes to the operation of the others. Any one, or any two, of them in isolation would yield a distorted view of the world and so would be incapable of directing life to its consummation.

It is the more important to stress this point because of the cavalier manner in which the aesthetic life has usually been

treated. Man has always been addicted to monolithic interpretations of himself; he selects some one of his characteristics, elevates this to the rank of "essence," and then defines his other traits in terms of this essential one. This chosen characteristic has varied, but it has never, save with a few isolated thinkers, been associated with man's aesthetic capacities. The different views of human nature that have been prevalent and influential need not concern us here. From the point of view of aesthetic theory, they have one important feature in common: they all regard aesthetic activity as playing a subsidiary role in life, and they interpret this activity in terms of its relation to man's chosen essence and destiny. They thus give to aesthetic facts an interpretation that is both negative and partial. Art is defined as being *not* something else, be this reason, devotion, will, feeling, or practice. Then art is explained by reference to the contribution that it makes to this essential human pursuit: art translates ideas into a form in which they can be more readily grasped; art is the vehicle by which a way of life is made more attractive; art is surcease from our worldly struggles; art is a harmless way of releasing dangerous emotions; art is play and relaxation. This list could be extended almost indefinitely at no greater pain than turning the pages of a history of aesthetics.[1] Whether art be relegated to the ivory tower or the asylum, it is made subordinate to some other human character and capacity. The formula is standardized: "Art is not X, and it is related to X in this way."

In contrast with all such interpretations, I am arguing that aesthetic activity is to be regarded as a coordinate aspect of

[1] The predominance of this attitude, as well as the variety of doctrines in which it issues, are exhibited clearly and systematically in the original edition of Melvin M. Rader's anthology, *A Modern Book of Esthetics* (New York: Henry Holt and Co., 1935). Professor Rader here classifies theories of aesthetics largely in terms of the special subservient functions that they ascribe to art. The revised edition (1952) modifies this arrangement, but the fact still stands out sharply. The introductory notes to both editions do much to illuminate the workings of this tendency.

the human economy and a coordinate phase of the human enterprise. Consequently, aesthetic activity is to be explained by reference to the conditions of life itself, not by being made dependent upon some other supposedly more important instrument of life. Art has its own generic origin, form, and function; in its strict and proper mode — in the guise that we normally identify as "fine art" — it is the culmination of our primitive aesthetic interest in things; as such, it makes its own contribution to life, which can be made by no other activity. Art also occurs in a variety of mixed modes, where the aesthetic intention is operating in close balance with affective and cognitive intentions; in this way, art can and obviously does serve a great variety of special and limited purposes, including all of those mentioned above as well as many others. This is simply to say that we must recognize and account for such artifacts as industrial and commercial art, decorative art, art with a message, moralistic and religious and propaganda art, art that experiments with media and techniques, art of sheer delight and enjoyment, and entertainment art — all of this, as well as what we call fine art,[2] must be explained.

This completes the abstract statement of the principles on which the present theory is based. In the next chapter, this doctrine will be elaborated by a quite different appeal; I shall there examine the content and the flux of conscious experience, and analyze its pattern, in order to exhibit more concretely the operation of psychic components in actual life.

[2] This problem is treated in detail in Chap. XI.

Chapter III

THE PANORAMA OF
EXPERIENCE

I

1. The most profound and pervasive characteristic of psychic life is that it is always a synthesis of three moments, or phases. The psyche, in the pursuit of its career under the conditions set by the structure of the adaptive situation, constantly employs its three constituent components. We grasp things in immediate awareness in terms of their particularity, their connectedness, and their import. As our conscious dealings with things become more purposive, we press home our acquaintance with them along three paths — we realize that they must be apprehended and expressed as entities, classified and explained as facts, and gauged and controlled as values. Every transaction in life is a composite of these moments, a synthesis of these perspectives.

Further, the operations that we carry on in experience are always supported by our psychic — or neural — mechanism as a whole. We do not, as we change perspective, lay aside some parts of this equipment and pick up others. This notion, a derelict of faculty psychology, suggests that man operates upon things piecemeal, with only one "part" of his psychic equipment at a time, and that these operations take place in isolated compartments. This misinterpretation has seriously inhibited our understanding of man, and especially of the aesthetic life, where it has exercised its strongest and most pernicious influence. For experience, and all that issues from it, is a function of the psyche as a whole, not of distinct

attitudes and interests nor of separate faculties and mechanisms.

If this were not the case, if psychic components were to act exclusively of one another and with only a partial appeal to neural processes, behavior would become erratic and incoherent. Man lives under the constant menace of such psychic disruption, which we all of us undergo in experience when we are swept away by what I have earlier described as passion, dogmatism, and idolatry. But we also recognize that such occasions are pathologic. Experience normally exhibits these moments in close integration, though not necessarily in even balance. Our conscious dealings with things are a series of approaches and retreats: we encircle the things we experience, closing in upon them gradually. Our initial approach may be from any one of these points, and may then move on to any other; and in a good deal of experience our attention is so fine a compound of all three interests, and moves so rapidly from one to another, that any designation of the procession of steps is impossible. But it is still the case that these three perspectives are always present, with some one of them often dominant, and in much of experience we can clearly discern this.

Since this presumes to be a description of the actual character of experience, it will be well to render the argument more vivid by a direct appeal to empirical evidence. So let us consider an occasion where the same thing occupies the center of awareness for some appreciable time, allowing us to watch the process of experiencing as it arises and develops. I shall take a prosaic and familiar instance: our experience of a stomach-ache.

We become aware of this, as an element in consciousness, probably in this conglomerate form: as a localized occurrence of pain, having a certain quality and form, arousing vague emotive and conative states, and loosely conceptualized as to character and kind. The stomach-ache (which "in itself"

is a complicated set of events taking place within the human organism) thus enters awareness, perhaps gradually, perhaps suddenly. It may come surreptitiously and circuitously, bothering our sense of somatic well-being, distracting our concentration, causing us to be restless and uneasy, interrupting us as we try to read, or play bridge, or write a letter; but still not for some time exposing itself in consciousness. Or it may come suddenly, stabbing us with a sharp but transient pang as we sit before the fire or stroll in the garden. But whatever its manner of entrance, when the stomach-ache emerges in awareness it already occupies these three dimensions. It exists aesthetically as this particular pain, having a unique texture and location, exhibiting its own rhythm and pattern of development, and manifesting itself through a special set of pangs, twinges, contractions, and dull poundings. It exists affectively as a threat to our health or even existence, and immediately calls forth a welter of feelings, such as anxiety, fear, irritation, and anger. It exists cognitively as an incident in a system of occurrences, declaring that it has a source in the past and that it presages something for the future, clothing itself tentatively in certain ideas which it at once discards for others, and taunting us to recognize its kind and connections. These are the guises under which the stomach-ache appears, the attributes through which we are aware of it.

Now, what do we do as we experience this stomach-ache and seek to deal with it? For one thing, we attend to its quality and intensity, we follow its pattern of development and decline and recurrence, we are alert for any nuance of change in its texture and content. In this attempt, we vacillate between two quite different procedures. Sometimes we seek to stimulate and excite the pain: we poke and prod it — quite literally — trying to make it hurt "worse" in order that we may see it "better." (The even more familiar case of this is the sore tooth that we push and pull at all day.) Sometimes

we try to relax completely, to feign forgetfulness and in-attention, as though we could surprise the ache with its guard down and catch it without disguise. But in both of these pro-cedures, the object is the same: we are constantly pursuing the ache, seeking to violate its privacy and to see it for what it is. And the ache as constantly eludes us, giving us glimpses of itself but withdrawing just as we seem about to bring it into focus.

For a second thing, we worry about the ache. It may prevent us from going to the theater; it may keep us awake all night; it may even kill us. We feel its impact, and emo-tions are aroused: we become annoyed or impatient or frightened. We have premonitions of its possible import, and various courses that we should perhaps follow suggest themselves to us: bicarbonate of soda, a walk around the block, a call to the family doctor, or to bed with a hot water bottle.

For a third thing, we think about the ache. We try to recognize and identify it, whether it be indigestion, appendi-citis, heart attack; we compare it with other pains we have had in the past, we describe it to anyone who will listen, or we check it against the symptoms and diagnoses that are listed in a medical dictionary. We seek out its causes — did we eat or drink too much or too variously, have we taken too much exercise or not enough, have we sustained an in-jury recently? We consider its possible consequences — an operation, time lost from work, doctors' bills, or even death.

Then we return around the circle. We try to obtain a sharply defined and differentiated image of this pain itself; we fret and worry some more, and start to do something about it; we stop and try to understand it more adequately, so as to know what to do. And so we run around the stomach-ache in experience, jumping and skipping in our attention to it, returning upon ourselves, becoming more purposive

and preparing to take some steps to cure it, growing distraught at its continuance and its possible outcome, calming ourselves and probing again into the individual character of this ache, making a renewed effort to classify it and predict its future course.

Of course, these returns are more than simple repetitions; they normally represent a movement toward a refinement and completion of our grasp of the stomach-ache. Unless the experience is unusually fragmentary and inchoate — unless we become frantic or obsessed — it exhibits a steady development toward clarity and integration. And the manner of this growth toward coherence is apparent: it comes from the mutual illumination that these three attitudes and approaches shed upon one another. As we gain a closer acquaintance with the precise quality and structure of this ache, we are able to refer it more surely and correctly to a system of ideas, and then we are in turn more capable of taking steps toward its cure. And the stages in this process — which might equally well start at any of these points — reflect upon one another. If certain measures do or do not alleviate it, our provisional diagnosis is confirmed or rejected. As we compare this ache with others, as we tentatively assign it a certain place in a scheme of ideas, as we take various steps to mitigate it, its own character stands out more clearly. Facets that were before unrecognized come to light; the recognition that it is not of a certain kind that we thought it might be removes from it, as it were, the shadows cast by concepts, and allows its individuality to assert itself. And so, gradually and cumulatively, our transaction with the ache attains completion. Aesthetically, we exhaust its particularity until we know it on intimate terms; in extreme cases, which are not foreign to the experience of artists, it ceases even to be an "ache" and becomes an absolutely unique and isolated occurrence. Cognitively, we transform it from a pain into a symptom, and so prepare a correct diagnosis. Affectively,

we find the proper means by which to contain it and effect its cure.

Throughout this transition, our experience revolves around these three poles: the unique quality of the ache, its import for us, its location in the world of aches and pains. Always we reduce the thing we are experiencing to the languages of image, emotion, and idea. And always our attention is interrogating the ache for these three answers: reveal yourself just as you are; state your intentions; identify yourself as to cause, kind, and consequence. I think this account of the actual content and structure of experience can be verified in even our most casual 'acquaintance with anything we encounter. This is what experience is like. And experience is like this because it is an instrument of life whose course is controlled by psychic components.

2. Before leaving this case history of experience in its concrete occurrence, there are several points about it that require some elaboration. These have to do with characteristics that experience clearly discloses of itself, but whose importance might be missed unless attention is alerted to them.

In the first place, experience frequently exhibits itself as being a deliberate pursuit after things which seem just as deliberately to elude us. A good deal of common experience has this haunting quality, as though things were beckoning us on and inviting us to grasp them more closely. But usually we ignore this invitation, as casual acquaintance seems to suffice or as newly encountered things clamor for our attention. When our concern is once vividly aroused, this evasiveness of things manifests itself strongly. As we seek to come to grips with the thing, to apprehend and explain and control it, we find that it lies continually just beyond our reach; we almost have it but not quite; we had it a moment ago, but now it is gone. Those who make a special and intensive effort to push home their acquaintance with things, whether

aesthetically, affectively, or cognitively, bear ample and depressing witness to this fact. They are all sometimes seized with the feeling that they are launched upon a quest that is inevitable but hopeless. When the artist rips his canvas or crumples his manuscript, when the theoretician refutes his hypotheses and finds that his experiments yield only more unanswered questions, when the technologist smashes the equipment and destroys the models that have proved incapable of giving the desired results — in all of these cases, homage is being paid to the elusiveness of things. The homage to man's determination to pursue things to their ultimate lair comes when the artist fixes a new canvas to his easel, the theoretician resumes his calculations, and the technologist plans new instruments and procedures.

There is no moment when experience reaches a final consummation. We pursue things as far as we can or as far as seems necessary. But when experience becomes satiated, or is interrupted, it still has not exhausted its object. The thing it is dealing with retains its detachment, and we recognize that a closer acquaintance could be gained though we can not achieve it. Even the most refined transactions of experience are temporary terminations: though we speak of them as "highly finished," we do not really mean this; they are not ended, but merely laid aside. This is illustrated in the extreme reluctance of the artist to regard any version of his work as final, in the theoretician's continued extension and correction of his doctrines, and in the harried hesitation of the armed forces to accept a model, sign a contract, and begin production. Put in an extreme form, one might say that our experiential dealings with things are a series of false truces and rude anticlimaxes.

Secondly, in this experiential pursuit of things, each of these approaches reinforces and is reinforced by the other two. The images, ideas, and emotions through which we deal with things mutually illuminate one another and con-

tribute to their common growth. By themselves, images would be isolated, ideas would be irrelevant, and emotions would be inappropriate. But these never occur by themselves. Experience is a process in the course of which these moments are gradually refined and corrected by their reciprocal contribution to one another, and at the same time their integration and fusion become steadily closer. Images, ideas, and emotions are not parts or ingredients out of which experience is composed. They are recurring phases in the development of experience, different tacks that experience takes as it sails before or across the wind toward its object.

As experiences are never final, so are they never complete. As we knit together the accumulation of their history, as we try to bring things under the simultaneous focus of psychic components and to fuse our images, ideas, and emotions into a single whole, pieces that at one time fitted no longer do. Experience unravels, and there are always loose ends lying about. We never quite eliminate the blurrings of experience, we remain unreconciled to the rejections it entails, and the complexities of things seem to yield only to contradictions. Artists save their variant readings, sketches, and studies; the Supreme Court settles cases by the use of principles that are ambiguous, anachronistic, and irreconcilable; and scientists deal with things by employing alternative ideas that contradict one another, as when light is regarded sometimes as a wave and sometimes as a particle. Experience is infinitely self-correcting, but it never deposits corrected proof.

Thirdly, and finally, our experiential dealings are normally guided by a dominant interest in either the particularity, the import, or the connectedness of the thing before us. *Any one* of these aspects may seize and compel our attention, but *some one* of them usually does. Which of them this is to be depends on circumstances and ourselves. Everything of which we become aware must be regarded from all of these

perspectives, and the point of concentration can be at any one of them. It is not the case that some things can only be thought about, some only felt, and some only apprehended. Anything in the world can be dealt with in a manner that is primarily aesthetic; and likewise anything in the world can be dealt with in manners that are primarily cognitive and affective.

Of course, things do exhibit what might be called "specific psychic potentialities": any given thing is probably more apt to be treated in one of these ways than in others, and this propensity will differ among several given things. The stomach-ache that we have been considering solicits attention chiefly to its import: our concern with it is most apt to be affective, and to center around what it may portend for us. But this limitation is not categorical. If we are doctors or medical researchers, our interest in the ache easily becomes cognitive; we keep a careful record of its appearance and its course, we encourage its various symptoms in order to trace them systematically, and we even experiment with ourselves in order to refine our theories. Artists, on the other hand, have frequently taken their own illnesses and sufferings as things to be apprehended; they have set out to capture the particularity of the agonies they pass through. Proust's fascination with his asthma and De Quincey's with his opium addiction are only extreme cases of an aesthetic tendence that we all manifest when we look back upon — and talk about — our ailments and our operations.

Every situation that we encounter invites us to explore all of its facets, even though some one of these urges us most peremptorily. Experience responds by being specialized in its focus and intent, but generalized in its development and organization. As we become aware of something, this elicits our interest in a definite way; as we pursue this interest, we expose facets of the thing that both appeal to and nourish another interest; and so on until the encounter is broken off.

Each step in this process reveals unexpected and uncharted vistas in what we first thought was already well known, so that the challenge of experience perpetually outweighs its accomplishment.

Since experience is never final or complete, it can never be wholly satisfactory. Each stage in our affective, cognitive, and aesthetic acquaintance with things points on to a further stage; in its present summing up of what the past has prepared, it exposes more for the future to exploit. The dilemma of experience is simply this: the further it proceeds, the more material it has to synthesize; and each fresh synthesis changes its material, by reorientation, rejection, and reorganization. The will-o'-the-wisp that haunts all experience, and lures it on, is that of absolute union with its object, in which we sense intuitively the ineffable quality of things, at the same time that we grasp discursively the web of relations that holds among them, and realize instinctively their meaning for human feelings and human purposes. But however much experience gorges itself upon things, it finds that its outlook upon them can never be more than partial, that it must compress and select, and that its concentration is alway transient. The more intensively we cultivate our experience, the more relentlessly we feel the paradoxical pressure to both rest content with what we have mastered of things and to push further along the paths that this opens to us. For every clear-cut disclosure that experience yields, it drops a dozen hints. And we are confronted with a dilemma: shall we pause to explore and enjoy exhaustively the lode that lies open to us, or shall we press on while the trail is hot?

This is abundantly familiar to us in daily life, in all of its basic dimensions. When we are in love, we want to linger in the delicious freshness, wonder, and tenderness of our discovery of one another; and yet we also want to press on to further intimacy. The expectancy of love is both fascinating

and tormenting in itself, and both impetuous and reluctant to reach its consummation. When we are reading a story — or looking from the window of a train — we are torn between entrancement with what is before us, remembrance of what has been, and impatience for what is coming. And when we are studying a new subject, we are intrigued by each insight that we gain, but are even more anxious to attain the larger view that looms before us. Emotions, images, and ideas precipitate out of the crucible of experience, affording us a stark and sudden glimpse of the world, as though a moving reel had stopped. These moments are like the lighted tableaus that loom as we glide through the Tunnel of Love at the amusement park. But before we can grasp — much less report — the vision that is disclosed, our emotions, images, and ideas sweep us away on the tide of their suggestions and cross references. Keats's "Grecian Urn," that "foster-child of silence and slow time," is a memorial to this quality of experience. The "fair youth" whose "mad pursuit" of his beloved is ever frustrated of its object is consoled in these terms:

> Bold Lover, never, never canst thou kiss,
> Though winning near the goal — yet, do not grieve;
> She cannot fade, though thou hast not thy bliss,
> For ever wilt thou love, and she be fair!

Like the lover on this ghostly frieze, experience can gain a partial victory only by surrendering all hope of a total conquest.

Every artist, scientist, and technologist lives almost continually in this volatile atmosphere of delight and frustration. All men who immerse themselves in experience, and deliberately try to press this closer to the contours of things, are at once rewarded and tantalized, appeased and challenged, by the new meanings that life generates from the carcasses of what we thought we knew. T. S. Eliot has spoken for all

such, and not only for the poet, in a passage from his *Four Quartets*:[1]

> . . . one has only learnt to get the
> better of words
> For the thing one no longer has to say,
> or the way in which
> One is no longer disposed to say it. . .

Experience, in its effort to become articulate, must narrow and maintain its focus if it is to achieve clarity; but in doing this it closes its horizons and shuts its eyes to change, and so deteriorates toward imprecision. Against this ultimate dilemma, experience has no choice but to seek for a constant variety of perspective within the continuing unity of a stable framework. This it does, and we must follow it in its desperate course.

II

3. This phenomenological account must now be carried a step further. I have been insisting that experience is itself a synthesis of psychic factors, and that it gives us a complex yet unified interpretation of the world. But experience is clearly neither homogeneous nor amorphous. It is a continual flux that contains tremendous variety and admits of infinite shades of difference. And yet it exhibits a definite structure and organization. Our attitudes and concerns in the face of the environment have a different character at different times. We spontaneously and readily recognize recurrent features and patterns in experience; on this basis we group together numerous distinct experiences as being similar among themselves and different from other experiences that fall into other groups; and we distinguish various specialized sorts of activity, and so various special types of arti-

[1] From *Four Quartets* by T. S. Eliot, copyright, 1943, by T. S. Eliot. Reprinted by permission of Harcourt, Brace and Company, Inc. The passage cited is from the concluding section of "East Coker," at p. 16.

fact: though "experience" is a continuum, "experiences" obviously fall into kinds or classes.

If we are to understand the aesthetic life, and art, which is its culmination, we must get a precise picture of this "pattern of experiences" that is manifest within the "continuum of experience." The necessary first step in this direction is to clarify the distinction, which has been implicit throughout my discussion, between "experience" and "an experience." Looked at from one point of view, experience is a constantly changing kaleidoscope — a succession of incidents, each of which endures only momentarily, with no connection between them. Looked at from another point of view, experience is an unbroken reel; it flows on without interruption, and any division of it into parts, moments, or episodes is artificial. Looked at from either of these points of view, the distinction between "experience" and "experiences" is unjustified. Yet this distinction is imperative, for two quite different but equally sufficient reasons: common sense makes it compulsively; and without it we cannot possibly understand the refinements and specializations that are so obvious in our employment of experience.[2]

Even though we cannot accurately define the term "an experience," its ostensive meaning is perfectly clear: when in retrospect we use such phrases as "*what* an experience," "that *was* an experience," or "have you ever experienced anything like *that?*" we are indicating especially conspicuous cases of a familiar phenomenon. An experience is a conscious occasion that stands out and is marked off from the whole panorama of experience. It has a certain unity, the most

[2] John Dewey, perhaps more than anyone, has emphasized the aesthetic importance of the distinction between "an experience" and "experience." Cf. especially the discussions in *Experience and Nature* (Chicago: Open Court Publishing Co., 1925), chap. IX; and in *Art as Experience* (New York: G. P. Putnam's Sons, 1934), chaps. III and IV. I disagree with Dewey's interpretation of this matter (the question is treated below in Chap. VI) but his analyses are pertinent and rewarding.

prominent feature of which is usually the object that presently occupies it: a stomach-ache, a garden in bloom, a broken shoelace, or an experiment in progress. But the unity that constitutes an experience may come from a goal or purpose that is envisaged rather than actual, and objects then take on significance as they further or impede our progress toward this goal. An experience, once it has attained this unity, may acquire a structure and a mood that mark it so strongly as such that it can change its course and even its object without losing its identity.

Various conscious occasions, each of which we recognize as an experience, will differ widely in duration, intensity, cohesion, and completeness. Some last but a few moments, involve us only slightly, are unified only casually, and evaporate quickly in the heat of more pressing concerns without having attained any real completion. Others may occupy us for months, haunting us sporadically, lurking continually at the confines of attention and frequently forcing themselves to its center; they involve us deeply and widely, requiring that many elements be merged into a single pattern and toward a single purpose; and they demand a disposition, rather than a mere dispersal or evasion. A political campaign would be an experience of the latter kind, and it would contain many experiences of the former kind, such as an encounter with an especially unpleasant heckler. Of course, our demarcation of these occasions that are experiences is imprecise and careless, but it is not for all that arbitrary. An experience is a segment of the panorama of experience that compels our recognition of its unity and distinctness. Experience is not a series of experiences: it is a continuum, largely undemarcated, that crystallizes into experiences on those occasions when our transactions with objects and circumstances in the environment become sufficiently purposive, organized, and intense. It is the pattern that experience forms in crystallizing that I am now anxious to explicate.

When we lay bare this pattern, we find that it exhibits a twofold organization. We discriminate and classify our experiences in two general ways, or along two axes — we make distinctions of kind, or quality, and we make distinctions of degree, or quantity. The experiential classes of the first sort I shall call *types*, or *modes*, of experience; those of the second sort, *levels*, or *stages*, of experience.

4. The occurrence of experience in types, and the number and character of these types, depend upon the relative prominence of psychic components. An experience becomes of a certain type because one of these components is dominant, and so gives to the experience a definite structure and direction. The determining factor here is not the faculties involved, such as sense, feeling, will, reason, appetite, and so on, for all of these are always involved, though certainly with different intensities. It is rather the interest that controls the operation of these faculties, the use to which they are put, the end that is sought. One component becomes dominant, seeks a specific sort of transaction with the thing encountered, and expresses itself in consciousness as a governing interest. Consequent upon this, attention is focused in one direction, response moves toward a definite adjustment, and experience takes on a specific structure and character. We originally discover these types of experience in the immediate quality of awareness; the recognition of recurring textures and patterns in the flux of experience — the felt difference of various ways of experiencing — is a spontaneous and compulsive datum of consciousness. If asked what we are doing, we reply quite glibly and confidently: observing, enjoying, thinking, appreciating, evaluating, planning, or just daydreaming. But the existence of these types, and the organization that holds among them, are grounded in the structure of the adaptive situation, defined by the conditions of life, and determined by the operation of psychic components.

There are, therefore, three basic modes of experience, each of which is governed by the dominance of one of these components. The present descriptions of these will be no more than abridgements of the analyses given in the last chapter and anticipations of the fuller discussions to come.

In *aesthetic experience*, some particular thing occupies the center of attention. The actual occasion suffuses awareness with its own immediate content and quality, compelling attention to itself, and we are spontaneously enthralled by what is before us. As this surge begins to be spent, we answer its appeal by deliberately concentrating upon the particularity that it presents. We make a purposive — though never wholly successful — effort to disrupt the kinaesthetic, perceptual, emotional, and intellectual habits in terms of which we usually interpret things, in order that we may be alert to what they say of themselves. Our interest is directed toward a close and sensitive scrutiny of the concrete character of the thing we are experiencing.

In *cognitive experience*, it is the order and connection holding among things that occupies the center of attention. Our immediate encounter with the thing before us compels awareness of the similarities, contiguities, relations, and sequences that it shares with other things. If this spontaneous reference of the actual occasion to an established framework is not sufficiently clear, we make a deliberate effort to bring it under general concepts and to see it as a member of various spatial, temporal, and causal patterns. Our interest is directed toward assigning the thing we are experiencing to its proper place in a logical system.

In *affective experience*, the self occupies the center of attention. Our immediate awareness of the thing before us is compelled by the sense of our involvement with it and its import for us. If this spontaneous concern for our own affairs is left puzzled by the impact of the present occasion, we make a deliberate effort to measure the demands and the possibili-

ties that this exposes to us. Our interest is directed toward estimating the availability of the thing we are experiencing to our purposes, so that we can commit ourselves successfully.

These are the basic and principal modes in which we experience things. For instance, our most typical and significant experiences of a symphony are by appreciating it as a unique structure of sound, rhythm, and meaning; by understanding the principles of composition and orchestration that the composer has employed, as well as the influence of his cultural background and his personal temperament; and by feeling either an intense and specific emotion or a gentle reverie that his music has aroused.

It would, however, be absurd to hold that there are only these three modes of experience, or that every experience conforms exactly to one or the other of these modal patterns. The process of experiencing — the continuum of experience — exhibits an infinite variety of structure and texture, shading off by imperceptible degrees from one of these types to the others. Much of the panorama of experience is vague, amorphous, transient, and dull, so that its quality escapes detection; there are great stretches of "experience" that do not crystallize into "experiences." And even where experiences are sharply delineated as such, attention may be so balanced a compound of aesthetic, cognitive, and affective moments, or may shift so rapidly among these perspectives, that no single component establishes its dominance and the experience never becomes of a type. Hence many experiences defy classification; and many subtypes, which result from various special blendings of psychic components, can be discerned. Some of these mixed modes, as they might be called, notably the kinds of experience that we call sentimentalizing, recognizing, daydreaming, and romanticizing, are important to the consideration of aesthetic experience and art and will be discussed later.

Nevertheless, the three types described above are the major modes of experience. They represent the essential kinds of response that life demands. They are the basic refinements through which experience becomes more subtle and sensitive, and they support the specialized transactions that we have with the environment. These types are recurrent phases in the unified adventure of coming to grips with things. They exhibit experience in its most purposeful, tenacious, and successful occurrences; and they issue in the principal artifacts through which man creates culture.

As psychic components define the three main perspectives from which we view the world, so these corresponding types of experience contain the principal reports that we have of the real objective order. This division of experience into aesthetic, cognitive, and affective modes constitutes the true ordering of our acquaintance with the world. These are the dimensions within which we frame the real in becoming aware of it, and the avenues along which we press toward a closer grasp of it. All of experience is a synthesis of these moments. The point to be insisted upon is that these types of experience, each of which is three-dimensional, represent the same objective order viewed from three different but coordinate perspectives. They are equally valid as reports of this order, and equally relevant to life within its confines.

5. We can turn now to the second basic way in which we distinguish experiences: that according to quantity or degree. Experience exhibits different stages of intensity, organization, and purposiveness — these are what I call levels of experience. As with types, we originally discover these levels of experience in the immediate quality of awareness. We recognize that we are not always equally involved in the encounters that we have with things: attention varies in its concentration, interest may be sharp or dull, the direction of response may be vague or vivid. We here differentiate moments

of experience, phenomenologically, in terms of the extent to which effort, intention, deliberation, and commitment are conspicuous within them.

But again as with types, the occurrence of these levels of experience is grounded in the adaptive situation and the conditions of life. Man finds himself in a complex and dynamic environment. His problem is to adapt to this with readiness and efficiency. The onward press of life requires that he dispose of the things he encounters as quickly and easily as possible. It is for this reason that man develops such a large body of habits, and relies so heavily upon these in his transactions with things. The continuity of the environment makes habit possible, and the pressure of the environment makes it useful. But the world exhibits differences as well as uniformity, variation as well as regularity. Man must be alert to these, must be prepared to conform to them, and so must maintain a proper flexibility before life. He frequently encounters situations that are strange or momentous or difficult; when he does, an extra measure of attention and effort is called for on his part. And when this occurs, experience moves up to a higher level of intensity and purposefulness. Experiences happen on different levels because the situations they deal with differ in their significance and intricacy. Things change in the demands they make upon us, and we change in the concern we feel for things. Man, in the attempt to economize his efforts at the same time that he refines his behavior, discovers that in different situations this balance must be struck differently. This realization is reflected — with greater or less accuracy — in the urgency of the concern we take in things, and so in the extent to which we act deliberately to clarify things, bring them into a full focus, and prepare an adequate response.

Distinct levels of experience cannot be theoretically defined with anything like the sharpness of types, nor can they be phenomenologically identified with the same ease and cer-

tainty. Along this axis, even more than along the other, experience appears as a continuum. So the significant levels of experience can best be clarified, in a preliminary manner, by referring to concrete cases of their occurrence within the various types of experience that I have already described.

Thus, in the cognitive dimension, we distinguish between the simple and superficial recognition of an object that is immediately attained by bringing it under a class concept or a causal pattern; the more elaborate process of thinking about an originally puzzling object and explaining it by bringing to bear upon it an already prepared body of ideas; and the still more critical and extended operation that consists in the development of a new system of ideas that can elucidate what was before obdurately obscure and unaccountable. Similarly, we distinguish between aesthetic appreciation as the facile, even though complex, experience that we have before a familiar or easy work of art; aesthetic expression as the labored and practiced clarification of an apprehension that is at first confused, tentative, and elusive; and artistic creation as a sustained effort to articulate and objectify an insight so as to promote its continuing reoccurrence and refinement. Finally, we distinguish between a frequent and transparent emotion that immediately elicits an appropriate adjustment to the thing that has aroused it; the impact of intense but inchoate feeling that drives us in contradictory directions and requires an effort of intelligence and will before it can be resolved; and the prolonged and conscientious deliberation that searches profoundly into the motives of the self, projects itself distantly in space and time, envisages possibilities and eventualities, considers means and ends, weighs these against rules and principles, and finally establishes a program of action to reach a selected goal.

These three gross levels of experience — which I shall identify respectively as *reception*, *activity*, and *construction* — are readily discriminated. At the level of reception we deal

with things largely by bringing to bear upon them our established habits and patterns of experience; we accept what consciousness presents, we fit this readily into the perceptual, intellectual, emotional, and kinaesthetic habits that we have accumulated, and we take what it has to offer and comply with its demands. Experience here proceeds without any psychic disruption, and without the need for any elaborate augmentation or renovation of the resources that the psyche presently commands. We experience receptively a well-known symphony, a lucid account of the political situation, or an impediment that postpones the closing of a business deal. Experience at this level may be quite complex, prolonged, and intense; it remains receptive so long as we do not envisage any need to intervene upon and change the situation that is taking place, nor to reorient ourselves with regard to it.

Yet experience at the level of reception is *not* passive. We never submit ourselves supinely to the world, waiting for this to write upon us as it will, as though our minds were blank wax tablets. In experience and behavior we usually meet things more than halfway. We contribute largely out of ourselves to the responses that we make. The docility that would mirror things as they are is not a natural state, but is strenuously acquired. In calling this lowest level of experience "reception," I do not mean that we attend inertly to what our senses bring us; we cannot do this, for all experience is active, interested, and directed. Experience here is receptive in the simple sense that it ingests what is brought to it without great effort, and by relying upon the equipment — natural and acquired — that is already at its disposal.

The transition from reception to activity is gradual in principle, and usually in practice, though it may be sudden and violent. Activity is experience that has now become more explicit and purposeful; it acknowledges difficulty, and seeks to modify the adaptive situation in a way to secure a more satisfactory adjustment. To this end, we act to change the

thing we are dealing with, or to extend our psychic resources. We study the score of the symphony, or seek out a better performance; we read books on politics, and participate in civic affairs; we summon arguments to persuade our prospective client, or look for another who will be more tractable.

The transformation of activity into construction is equally gradual and incapable of being localized at a point. In our transactions with the world, we encounter things and situations that defy our efforts to come to grips with them: they escape the reach of even quite purposeful activity because this does not command the resources to reduce things to its terms. The import of things is recalcitrant to our emotions and intentions; the particularity of things slips through the interstices of images and expressions that are too vague and too highly generalized; the connectedness of things evades our body of ideas, which is too arbitrary and inflexible to follow it. And so we are driven to an extension and refinement of our affective, aesthetic, and cognitive implements. We create a work of art — which may be another musical composition, but may likewise be a poem or a painting — that will more fully express the particularity that this work of art inadequately renders to us. We undertake a fresh analysis of the factors responsible for the political crisis, or even develop a new theory of politics. We set out to cultivate the techniques of salesmanship, or perhaps to reconsider and transform the whole scheme of values and practices that we have hitherto accepted. In all such cases, we move without break onto the level of construction — we create artifacts — in order to consummate our acquaintance with things.

As has been said, the levels here distinguished are not absolute regions of experience. But they are empirically obvious, they are valuable as analytical devices for ordering the welter of experience, and they are highly significant for an understanding of the aesthetic life and art. As we move up this continuum from reception through activity to the construction of

artifacts, we bring ourselves more fully to bear upon the things we are concerned with, our interests and resources come more purposefully into play, and experience reflects a more refined and organized encounter with things. Here again, experience clearly reveals that it is a continuing process of coming to grips with the things in the world; that these transactions are urged on both by natural necessity and human purposiveness; and that experiences occur on one level or another depending upon the urgency with which things solicit our attention, the intricacy with which they confront us, and the alertness and sensitivity that we bring to them.

III

6. It will be well to document briefly the fact, already insisted upon, that experience always contains aesthetic, affective, and cognitive moments, and that its development depends upon a synthesis of the special but limited insights that these afford. This has been sufficiently illustrated for the level of reception in the earlier account of the course of a stomach-ache.

The case is the same on the levels of activity and construction. The mutual support that artists, theorists, and technologists lend to one another — to borrow back repeatedly with large increments of meaning — can be seen in man's progressive mastery of any large-scale problem. A familiar case is offered by the moral life. Novelists, dramatists, poets, painters, and musicians have vividly presented to us the actual moral conflicts that we encounter, the concrete values resident within these, the motives and purposes through which they are resolved, the ideals we can aim at and the results we can produce. Philosophers, theologians, psychologists, and sociologists have explained to us the conditions that influence moral choice and character, the systems of values by reference to which we should guide our actions, and the futures we can best prepare for ourselves. Preachers, psychiatrists, penologists, and reform-

ers have moved in their various ways to improve the quality of our lives, as these affect both ourselves and others. Each step forward in one of these directions has been dependent upon, and has in turn provided for, steps in each of the others.

The artifacts that issue from experience in its most creative occurrences exhibit this same entanglement of perspectives and concerns. Gunnar Myrdal's *The American Dilemma*, Lillian Smith's *Strange Fruit*, and the pamphlets and news releases of the NAACP furnish a conspicuous but not unusual case in point. Each of these is concerned with the problem of the Negro as a minority race in a predominantly white society; each deals with this problem with one primary aim in mind — they are devoted, respectively, to explanation, presentation, and control — but each is, very obviously, impregnated with the purposes, methods, and achievements of all of these points of view. Every case of human creativity embodies all of these interests and serves as a vehicle for all of these values. There are no "pure" occasions in experience, on whatever level. What I have described are abstract types. In approaching these, experience becomes more concentrated, but it does not become one-dimensional. It narrows its focus, for the sake of the depth and sharpness it can obtain; but it does not sacrifice, in any of its modes, the material it has accumulated in its others.

7. A similar interpenetration holds among the levels of experience. In the vast majority of cases, an experience that transpires chiefly on one level involves — whether explicitly or implicitly — moments at both other levels; any actual dealing with things in experience calls into play, more or less fully and deliberately, the whole depth and range of the psyche. Experiential occasions are not isolated from one another: they are episodes in the life of a unified person. What occurs on such occasions borrows from what has been deposited in the psyche as the result of past transactions; these deposits are

stored in the various forms — differently emphasized by different specialists — of memory, habit, disposition, nerve traces, and reinforced cortical paths. And each occasion makes its own contribution to this deposit, increasing and changing the store of what is available to the future. Experience is a vehicle through which man both realizes and creates himself. The use that man makes of experience on any occasion sums up, whether casually or purposively, the residue that he inherits from the past and the ends that he envisages for the future, and brings all of this to bear upon the situation he actually confronts.

This interpenetration has several consequences that loom prominently in the life of the mind, and hence are important to an understanding of the aesthetic life. It means, in the first place, that our most casual encounters with things already contain incipiently within themselves further and more cultivated encounters. In experience, we not only meet things, but also prepare to deal with them. All experience both reflects a present encounter and presages a future transaction. Even a slight and adventitious meeting with things at the level of reception predicates a certain conclusion, or fulfillment; and so it advocates certain operations at the levels of activity and construction. Of course, we frequently neglect to carry out these operations: we envisage the difficulties that await us, or we are distracted by other things and concerns, and so we spurn the lure. Most of our engagements with things are broken off in this way, far short of a climax and even before the issue is really joined. But even in these cases, we have an intimation of what could be done — of the beauty that could be more fully apprehended and expressed in art, of ideas that could better illuminate facts, of values that could be realized. And we often have a sense of guilt because we do not do what could be done.

Secondly, this involvement means that the most purposive and cultivated experiences, on the levels of activity and con-

struction, have emerged as the necessary fulfillment of en-
counters at a lower level. So such experiences properly
represent a gradual and cumulative process of acquaintance
with things, which is given impetus and direction by the
demands of life. And from this it follows that the artifacts —
the works of art, theory, and technology — that issue from
such high-level experiences are not the products of an idle
and arbitrary human whim, but are the completions of trans-
actions that have their source in vital encounters between
man and the world. In pushing experience to the level of
construction — in creating and using artifacts — man in-
variably moves far away from the situations and encounters
that initiated the experiential process. In doing this, it is
natural that man should somewhat lose sight of the things he
was originally dealing with, the transactions he was seeking
to consummate, the purposes he had in mind. And so he tends
to regard his artifacts as ends-in-themselves.

This tendency is powerfully reinforced by the fact that
experience, in progressing to the level of construction, gen-
erates and employs a rich body of materials and a varied set
of techniques. Stone, clay, and metal; pigment and cloth;
crude sound and untutored language; man's spontaneous
facial gestures and bodily movements — these and other ma-
terials are gradually transformed into the subtle and ordered
media of sculpture, painting, and architecture, of music and
literature, of drama and the dance. Similarly, man discovers
or constructs the procedures of logical inference and experi-
mentation, of tool-making and manufacturing. As these
develop, man becomes fascinated with them for their own
sakes. He tends to forget the vital conditions and demands
that first gave rise to them, the transactions they were in-
tended to complete, the purposes they should fulfill. And he
sets out to exploit the internal possibilities of these media and
techniques, without regard to their external sources and uses.

I do not mean to decry this sophistication; these processes

and artifacts have great and varied value. But it is desirable to emphasize the point that even the most refined employments of experience on the level of construction have their source and meaning in man's encounters with the world, and have it as their purpose to carry these encounters to fulfillment. When man too much forgets this, his activities and artifacts become decadent: they cease to be replenished from the springs of life, and so consume themselves in the quest for internal development, consistency, and precision. In each case, this means that the activity in question acknowledges no principles or purposes save those that it sets itself: it denies all extrinsic values, and fastens gluttonously upon those that are intrinsic. The extreme — but all too frequent — outcomes of this process of internalization are the tour de force, the closed deductive system, and the useless gadget.

This involvement among the levels of experience has a third consequence that requires to be noticed. Because of this interpenetration, experiences of the least purposive and organized sort nevertheless reflect prior experience at a higher level. When experience yields an immediate and facile, yet satisfactory, reception of things, this is because such encounters have had the way prepared for them by learning, habit, and skills that have been cultivated at higher levels. Our aesthetic, cognitive, and affective transactions with things are enriched and facilitated not only by our own exertions, but also — and even more so — by the guidance of men who have made an intensive and sustained scrutiny of things from these various perspectives. This fact is all but self-evident, and there would be no need to remark it except that it is frequently denied or unacknowledged in the aesthetic context. It is never expected of every man that he should be his own theorist or technologist: that he should develop independently his own systems of physics, chemistry, biology, and cosmology, or that he should serve as his own doctor, lawyer, engineer, and minister. In both of these broad areas,

we are strong advocates of specialization and we gladly submit ourselves to the hands of the expert.

In the area of our aesthetic dealings with the world, we do this, when at all, with far less care and discrimination. We accept without a qualm the permeation of our culture by a flood of cheap sentimentalism, wish-fulfillment, pseudo-art, and semipornography; while charlatans flourish with at least as much success as artists, and even thrive on exposure. If we remain indifferent to the aesthetic education of our culture — if we do not care under what distorted and unrealistic guises particularity is presented to us — we cannot be surprised at the aberrant values men place upon things, the false expectations of life that they entertain, and the crushing disillusionments that they encounter. These errors and failures are inevitably laid up for them when their encounters with actual particulars have been prepared by a pseudo-art that peoples their familiarity and their anticipations with things that never were and never could be. The aesthetic lives of most men — their apprehensions of particularity — are passed largely at the level of reception: they make the acquaintance of things without any intense expressive or creative effort to grasp their intrinsic character. But what they so receive — how they come to regard the particular things of which the world is made up and what they anticipate from these — is largely determined by the reports and accounts and presentations of things that are embodied in the art forms to which they are constantly exposed.

The most pervasive of these art forms are currently the cinema and comic books, radio and television, popular fiction and music, and advertising. I am calling these "art forms" on the ground that they do pretend to expose the particularity — the actual character — of the things and situations that men encounter daily, and they are so accepted by their audience. These are the media that perform for modern man the artistic function — that are responsible for his aesthetic education.

They do this because, alas, they represent the "higher" levels of "artistic" endeavor from which the normal man's aesthetic acquaintance is stocked. And they will continue to do this until we purge them and provide a more adequate substitute. For man requires that things be presented to him, with the same urgency with which he requires that they be explained and controlled. This may be done by art or mummery, by science or divination, by skilled techniques or black magic: that is, it may be done well or ill. But it must be done. For the common experiential dealings of men with things are inevitably colored by the interpretations with which their culture furnishes their consciousness.

Aesthetic appreciation is one major guise under which man makes the acquaintance of things. Artistic creation is one of the refined employments of experience through which he presses this first acquaintance closer to the contours of things. Art is one of the issues of experience in which one man embodies his vision of the world, and so enriches and refines the vision of other men. This aesthetic process takes place in close conjunction with cognitive and affective processes, which issue in theory and technology. These three modes, each comprising three levels, are the landmarks that define the structure and course of the whole panorama of experience. They constitute the directions and the stages by which we pass in carrying to completion our transactions with things. Adequate experience, in which we realize the best possibilities of the world and ourselves, is not a head-on collision with things, but a gradual encirclement of them. We triangulate the things we are concerned with, and close in upon them cumulatively, until they have yielded all of themselves that our dimensions can contain.

Chapter IV

THE AESTHETIC PROCESS
I: FROM IMPULSE TO
EXPRESSION

I

1. The attempt to give a systematic account of the aesthetic process is complicated by the two characteristics of experience — of the life of the mind — that were discussed in the latter part of the preceding chapter. The first of these arises from the fact that the aesthetic life is intimately entangled with our cognitive and affective undertakings, and cannot be discussed intelligently in isolation from them. The second arises from the fact of the mutual interdependence and intermingling of the several stages or levels of the aesthetic process itself. Though both will occupy us, we will for the present be especially concerned with this second complication.

The aesthetic impulse initiates art, and art consummates the impulse. But the passage between these two is not direct and immediate. Rather, art is an outcome that has been prepared through a gradual process. Appreciation, expression, and creation are the principal stages in this process, representing successive levels of its refinement and objectification: they are already incipient in the most primitive and amorphous occurrences of experience, and they become explicit as the modes of operation through which the aesthetic impulse actualizes itself and attains its object. This impulse first manifests itself as an awareness of particularity, which is responsible for the texture in consciousness that we call aesthetic

quality; on this level it is closely merged with other impulses, it operates spontaneously rather than intentionally, it usually occurs as an undifferentiated element in the fused whole of awareness, and it qualifies many experiences that we do not designate as specifically aesthetic. When this pervasive aesthetic factor dominates consciousness — when our interest in the actual character of things subordinates without conflict our interest in their connectedness and import — experience crystallizes into moments of appreciation, when the world is given to us clothed in beauty; in such moments the aesthetic impulse attains release without effort or impediment. But there are numerous occasions when this impulse encounters obstacles, from the world as well as from the psyche: it finds the particularity of things to be both momentous and recalcitrant, and it finds its outlet impeded by the urgings of other concerns. Faced with this double challenge, it enunciates its purpose explicitly, and becomes expressive activity; particularity now engrosses us, and our pursuit of it is highly self-conscious and intentional. Partly in support of this pursuit and partly as an issue of it, the aesthetic impulse creates and takes lodgment in concrete artifacts, which conserve its past achievements and give it foothold for the future. The results of this creativity are works of art. They are tentative and partial terminations, rather than complete and final products. But they embody a refined and concentrated employment of experience, and it is through them that the aesthetic impulse comes to a climax and attains its richest measure of fulfillment.

These episodes in the aesthetic life, which common sense distinguishes so readily, are intermingled in all of their occurrences. The process within which they emerge is dialectical in nature: its earliest moments demand its latest to enlighten and fulfill them, and its latest moments require its earliest to sustain and direct them. What the aesthetic impulse has all along been driving toward is only fully exposed when it finds its completion in works of art. Conversely, the substance

of works of art is given to them by this impulse from its encounters with things. It is from his transactions with the world and his participation in life's affairs that the artist ultimately derives his material — what is variously called his subject matter, his problems, his themes, his meanings, or his substance. When this material has received artistic treatment, has been expressed and embodied and conveyed, it emerges as the content of the artist's works. The significance and the value of these works are measured by their success in dealing with this originally alien material.

2. This, in barest outline, is the biography of the aesthetic life. Unfortunately, like most biographical sketches, it is too straightforward to be true. It falsifies because it treats the episodes it recounts as though they were temporally separate and internally self-sufficient. To speak as I have just spoken — and to take yourself literally — is to suppose that life prepares itself on one stage, moves on to another, regroups its forces and plans its next assault, then conquers yet another stage, and so on to its completion. This is not the case. A living process must be complete from its inception. A human fetus, without possessing what we can discern as the necessary organs, still must and does carry on the processes that are vital to existence; then, as organs are differentiated and developed, these processes become more refined and successful. Similarly, men thought — and continue to think — logically before knowing even the rudiments of formal logic, they applied geometrical notions in laying out their fields long before Euclid wrote his *Elements*, and they worshipped for hundreds of centuries before theologians discovered the One God.

Every function of the living creature is synthetic in character: it does not grow by the addition of parts and steps, and it does not perform as a summation of stages. From the start, it is able to complete the cycle of its rhythm, from stimulus

to satisfaction; if it could not do this, it would be useless. All vital processes, from the moment that need calls them into being, find available the organs to support them, the operations to release them, and the objects to sustain them. The primitive performance of these processes — be they physiological or psychological, physical or mental — is often crude, uneven, and approximative: it achieves only rough results, it is inefficient in its employment of energy, and it is only grossly appropriate to the ends it serves. This is true of digestion and perception, of movement and language, of the manipulation of hand and brain. But these primitive performances are none the less complete. With sureness if not finesse, reliably if not subtly, in a way that is persistent if not sensitive, they carry their impulse onward to fulfillment. Once inaugurated and in operation, it is then time for their development. New organs are instituted or old ones adapted to special uses, stages that were incipient become explicit, techniques are initiated and trained, fresh ways are found to exploit the environment, and the process moves forward toward continually greater efficiency and refinement. All human functions, from the moment of their inauguration, are complete in the sense that they move from beginning to end, from impulse to release, from need to satisfaction. From here on, their development is synthetic rather than analytic: it is by the expansion of processes that are already present, not by the addition of new ones; by the specialization of organs, not their creation *ex nihilo*; by the division of labor, not the invention of tasks; by the discovery of more available means, not the multiplication of goals.

This pattern can be seen repeated everywhere — in the processes of reproduction and in those of thought, in toolmaking and in government, in art and in agriculture, in religion and in sports. The ancient king and his privy counselors become the elaborate machinery of Federal government; the idols and sacrifices of primitive man become the symbolic

ritual of the High Mass; the amoeba's raw sensitivity to light and darkness, heat and cold, becomes the rich and structured sensory fields of man; and Abner Doubleday's roughly drawn diamond and simple rules generate, in the fullness of time, the panoply of a modern World Series.

As human consciousness discovers cases of this process, and of the purposes these tend toward, its immediate impulse is to intervene in them. The intention is to implement these processes and facilitate their completion. And man, by taking thought, by considering means and ends, by manipulating available materials, and by integrating these processes and their goals, often does improve the quality of life. But the result is also frequently the opposite. Whenever such natural processes are artificially interrupted, great and various dangers arise. The phases of the process are needlessly multiplied, until it becomes cumbersome and accumulates an inertia that may arrest it; the red tape of any bureaucracy, public or private, illustrates this. At the same time and in the same measure, these phases and the persons who administer them lose touch with one another, with a resulting compartmentalization that is now typical of universities, industries, and even such intimate professions as medicine and the ministry. Means are elevated to the status of ends, as has happened in our absorption with the methods of education, the techniques of painting, and the vocabulary of musical composition, until we have largely lost sight of the materials these deal with and the purposes they serve. And the operations and organizations that arose as adjuncts of some vital process become vehicles of a sterile and inverted obsession, whether this take the shape of artistic virtuosity, religious ritualism, legal formalism, or the concentration of corporate wealth. In these and similar cases man's intervention has distorted or disrupted the development of the processes he has thought to advance. For this intervention is frequently too narrow in its purposiveness, too impatient in its action, and too analytical in the procedures

it employs. Man's conscious quest after some values blinds him to others. In his passion to attain his goals he tries to bring about suddenly and by fiat what can only happen slowly and by small accretions. And his ability to conceive the elements and phases of a process separately leads him to treat them in isolation from one another, so that his efforts conflict and cancel out. In all of these ways, artifice does violence to nature. For natural processes are inclusive and integral in their operation, they achieve their effect grossly before trying to refine it, and the steps through which they pass are subordinated to the end that is their outcome. In every instance of healthy development, the natural pattern of growth is the same: it is gradual and synthetic, proceeding by differentiation, cumulation, and reciprocity.

In the case of the aesthetic process, this means that the three principal levels or stages that can be discerned within it — appreciation, expression, and creation — are all present from the beginning. When man is first struck by the particularity of things, and takes pains to elucidate this to himself, he is already creating art. The aesthetic impulse, which is a drive to capture the intrinsic character of things, can only be satisfied by a work of art, which is an articulate statement of what was at first inchoate. Of course, both the impulse and the act that satisfies it are crude and undiscriminating in their early occurrence. Man — both racially and individually — starts off with too much to do and too limited an equipment at his disposal to be very critical in his demands. He has a wide world to explore, he has little accumulated familiarity with it, and the pressures of time and circumstance bear heavily upon him. So his exploration of the particularity, the connectedness, and the import of things is hurried and impatient; having discerned these aspects of the world, he is anxious and restless to acquire the means to come to grips with them. Hence, the art, theory, and technology of primitivism and of childhood are not notable for their sophistica-

tion or finesse. In his racial and individual youth, man acts in each of these dimensions alike with a directness of purpose and an untroubled confidence that his elders can never recapture. He has little awareness of those subtleties and inconsistencies in the world he is dealing with that are later to become so vexatious. The art of primitivism and childhood faithfully reflects this attitude. It is characterized by colors that are so rich as to seem gaudy to a mature taste; by great boldness and simplicity of design; and by a frank distortion in favor of those aspects and features of things that are seen to be conspicuous and felt to be important. Of course, such art has its corresponding weaknesses: its view of things is apt to be naive and shallow; its lack of critical sense limits its capacity for refinement and variety; and it tends to be rigid, and so inhospitable to novelty. The theoretical and technological efforts of primitives and children exhibit analogous characteristics. Each has a demand to fill, an impulse to appease, and it has neither the time nor the training to be overnice in the way it does this. For this reason, the mature and the civilized man are inclined to be amused and indulgent in their attitude toward the aesthetic, intellectual, and practical efforts of children and primitives. They look at these efforts and their products with a mixture of scorn and tolerance, and dismiss them as the babblings of infancy, confident that they probably have no purpose and that they certainly could not serve it with any success.

In this they are mistaken. In a genetic and functional sense, these efforts, and the artifacts that issue from them, qualify fully as art, theory, and technology; or, as is more apt to be the case, as a largely undifferentiated mixture of these three. For man's earliest conscious discovery of things — again both racially and individually — seizes them at once as being what they are, as intimately involved with one another, and as bearers of human portent. He does not discriminate at all clearly between these aspects of things; and his efforts to deal

with them mirror this entanglement. The objects that he makes are composites of these insights and interests. Under close examination, the products of childhood and primitivism — their myths and stories, their ceremonies and superstitions, their pictures and incantations, their games and rituals — turn out to be highly equivocal. What at first seemed to be art suddenly appears to be theory and then as quickly turns into technology. And when we ask the child or the primitive to specify what he had in mind, he first fails to understand us and then thinks we are talking nonsense. Things are there, being themselves, sustaining relations with one another, and exerting pressure upon us. And to try to deal with one of these aspects in isolation from the others is foolish because falsely abstract and artificial. In an important sense, the child and the primitive have reason on their side.

II

3. Once man has made discriminations in his experience, and hence in things themselves, and has recognized particularity as a character of things that challenges his grasp, then he is fully launched upon the aesthetic quest. This occurrence of aesthetic quality — this discovery of beauty — demands to be made explicit and complete. And so it leads on, compellingly and without perceptible transition, to expression, to creative activity, and to art. The aesthetic process is not a serial development that grows by the successive addition of separate steps. It is not the case that appreciation before already prepared and present beauty — which could only be natural beauty — must progress to a certain high stage before man could envisage the possibility of purposely cultivating his aesthetic sense in order to sustain and enhance his vision of particularity. Nor is it the case that expression must become highly refined and articulate before it occurs to man to objectify and embody this vision, so as to conserve it for himself and share it with others. Quite to the contrary, ex-

pression and creation are already implicit in appreciation, and the quality of appreciation can be raised only by expressive and creative efforts. These three proceed together, not one after the other; they march hand in hand, not single file; they are bound together, like mountain climbers to their rope, and each can advance only in concord with the others. The earliest work of art was quite certainly nothing more than a shout and a gesture. It must have taken its author altogether by surprise, and left him still uncomprehending. Yet this unexpected and incomplete act was just as certainly compact with the whole aesthetic cycle. It consecrated an intense aesthetic encounter; and by its embodiment of this, however tentatively and fugitively, it preserved an insight that would illuminate future encounters.

The thesis here advocated is apt to encounter two deeply-rooted objections. One of these is the persistent prejudice that a work of art must be a highly finished product that exists in material form and is expressly intended for exhibition. On this view, art is always consciously contrived, it is perfected with pain and care, it is externalized in a concrete medium, and it bids for permanence. Anything that does not satisfy these conditions is not art — it is the blind groping of an untutored impulse.

Fortunately, this prejudice has been thoroughly discredited — if not yet uprooted — by the doctrine of art as expression. We should be grateful to such men as Veron, Tolstoy, Hirn, Croce, Collingwood, Dewey, and others [1] for their labors

[1] The doctrine of expression has been so pervasive in modern aesthetics that it is perhaps superfluous, and even invidious, to mention specific works that have contributed to its development. But the following might be cited as among the classic texts, either because of their historical influence or their doctrinal significance: Eugene Veron, *Aesthetics* (1878), trans. W. H. Armstrong (London: Chapman and Hall; Philadelphia: J. B. Lippincott and Co., 1879); Leo Tolstoy, *What is Art?* (1896), trans. Aylmer Maude (Boston: Small, Maynard and Co., 1924); Yrjo Hirn, *The Origins of Art* (London and New York: Macmillan and Co., 1900); Benedetto Croce, *Aesthetic* (1901), trans. Douglas Ainslie (London: Macmillan and Co. Ltd., 1909); R. G. Collingwood, *Speculum Mentis* (London and New York: Oxford

in establishing the status of art as a spontaneous outpouring of the human spirit and an essential phase in the mind's development. These men, and others holding the same broad view, have differed in their interpretations of the precise character and function of art; but all have agreed that art is any expression of some special sort of emotion, or quality, or content that man finds in experience. There is a very great deal of art, in this sense, that is crude, unfinished, and transient; it has these imperfections because the impulse behind it is itself inchoate, hurried, and unsure. But these works are art because they issue from and carry onward man's struggle to strengthen and clarify an insight that has impressed him. It is only through expression that the quality of this insight can be improved; and as this is improved, the impulse behind it will be illuminated and finer art will issue from it. Thus, we must include as art many activities and artifacts that we do not respect and would not wish to preserve. And this need not too much bother us, for we can then draw distinctions of degree where before we made judgments of kind. Analogously, the statement of Thales that "all things are water" is clearly a case of theory, though we find it naive and inadequate. Historians of thought have long recognized that this idea, despite its crudity, was immensely important for man's intellectual development; once enunciated, it furnished an impetus and a direction that soon carried thought to the atomic doctrine of Democritus. This "theory" of Thales radically changed man's outlook on the connectedness of things: it clarified his cognitive acquaintance with the world, and so generated further theoretical efforts that gave this acquaintance additional clarity, which then made possible a more acute theory, and so on in narrowing circles that finally closed upon their prey.

University Press, 1924); R. G. Collingwood, *The Principles of Art* (London and New York: Oxford University Press, 1938); John Dewey, *Art as Experience* (New York: G. P. Putnam's Sons, 1934).

It is a commonplace that such is the course of progress in theory and technology. If we have not yet sufficiently recognized that the aesthetic process is likewise circular and cumulative, that is because we tend to confine our attention to the high tides of artistic endeavor — to Beethoven, Michelangelo, Shakespeare, and their peers — and to regard individual works of art as isolated and self-caused. The more modern emphasis upon schools of art, upon the gradual development of styles and techniques, and upon the varied influences that artists undergo, is correcting this attitude. In conjunction with the dominance that has been gained by the doctrine of expression, this should soon win familiar acceptance for the truth that any fresh aesthetic venture — whether individual or cultural — must at once produce art if it is to sustain itself; that this art will inevitably be rude and tentative; and that such works of art are the necessary means to the growth and refinement of the aesthetic insight that moves through them.

This is the normal course of development for an individual talent and style as well as for artistic movements and periods. Even the most precocious artists, and those who seem the most sure of their course, usually go through a quite well-defined period of searching and experimenting. It often takes them some time to discover the material they want to deal with, and even longer to get a proper grasp of this; likewise, the treatment and techniques that this insight requires are apt to be a slow growth. The case is the same in the larger cultural development of artistic forms and styles. Gothic architecture, the Elizabethan drama, the sonata form, Impressionism, and the modern novel are familiar instances of the phenomenon of long and obscure periods of preparation followed by what appear, to a retrospective and forgetful eye, to be sudden and unstudied successes. There is much of the youthful work of both individuals and schools that is virtually unknown save to scholars and collectors.

In anticipation of a later analysis, the matter can be put

thus: works that we would not, on the basis of our descriptive and critical principles, class as works of art, and which may even possess very little artistic value, still serve the artistic function. From the point of view of their form and content — that is, as embodiments of a vision — they are not art because our insight and our taste have moved beyond them. Genetically and functionally they are art, because they issue from and advance man's attempt to express and present a particularity that has impressed him, and so they prepare the way for a later and a finer grasp. Their very success as aesthetic vehicles has made them obsolete as works of art.

This discussion has now led directly into the second objection referred to above. This springs from an attitude that assigns to appreciation (or aesthetic experience) a place of absolute priority in the aesthetic process; and that regards both expressive activity and artistic creation as distinct and later stages of this process, stages that are closed rigidly against all but men of special talents that have been assiduously cultivated. Put very simply and explicitly, this view holds that all men have aesthetic experiences, which are made available to them through natural beauty and, especially, by art; but that very, very few men have either the urge or the capacity to engage in expressive and creative activities. So long as attention is confined to those occasions when we purposely seek out appreciation through the fine arts — when we visit the theater, the concert hall, the museum, or the library — this view is empirically plausible: our contacts with such exhibited art emphasize the separateness of the audience, the artist, and the work of art, each of which seems to come and go quite independently. Certainly very few men spend years of their lives before an easel, a drafting board, a piano, or a desk; and even fewer exhibit in public. But everyone can attend exhibitions and performances, and derive some appreciation from them. So it is an obvious conclusion that the aesthetic life is compartmentalized.

However, when we broaden our regard and take into consideration the humbler and less studied aesthetic occurrences that are interspersed through our daily lives, the plausibility of this view is seen to be specious. For only a slight self-scrutiny will disclose that we all of us frequently move on, in a completely spontaneous and unrehearsed fashion, from aesthetic experience to expressive activity and to artistic creation. This is manifest in the singing, dancing, poem-writing, storytelling, and sketching that most of us indulge in at one time or another. All of these are forms of artistic outlet through which we bring an aesthetic impulse closer to fulfillment. Occasions of this kind are familiar in the lives of everyone, and the pattern of their development is easily discerned.

They commence when we become acutely aware of the present moment, and of what this moment contains. This content may be something in our surroundings or something within ourselves: it may be a landscape, a face, an event reported in the newspaper; or it may be a memory, an emotion, an imagined incident, a wish, or a mere heightening of our general feeling-tone. We may be driving through the country, sitting by the fire, taking a shower, or walking to the office; we may be elated or depressed, busy or at leisure, tired or refreshed, intense or distracted. Under the widest variety of external circumstance and subjective mood, some particular thing emerges in consciousness and fastens our attention upon itself — that is, it arouses an aesthetic interest. Our awareness is suffused by the quality of the present moment, and we are enthralled by what this moment discovers to us. In probably the majority of cases, we make no special efforts to retain this moment, or to press closer our acquaintance with what it gives us; we accept it gratefully, we regret its incompleteness and its premature departure, and we carry with us a gentle nostalgia as our attention moves on to other things and other concerns.

But in a sufficient number of cases, we do not let the matter drop so lightly; or, to state the case perhaps closer to the way it actually feels, the particular thing that has gripped us will not release us so readily and easily. The thing that has engulfed our attention — the look of fear on a face glimpsed in a crowd, the lovers holding hands glumly in a doctor's waiting room, a mood of exultation or despair that sweeps over us, a recollection or a longing that stabs us sharply, a vista from a sea cliff or the odors in a meadow — this thing will not retreat. It is too compelling for us to turn from it; and it is too incomplete, too vague and tentative, for us to be satisfied with it. So there is nothing for it but to remain with this particular and to try and make our vision of it more precise and articulate: that is, to try to bring it to expression.

In this attempt — which is perfectly natural and not necessarily volitional — we pass quite easily from the experiential level of reception to that of activity and even construction. This passage may occur in either of two ways, both very familiar in daily life. It may happen in a completely unconscious and unstudied manner, in which case we find ourselves giving overt expression to what we had not even been aware of experiencing, or undergoing. Our bursts of spontaneous song and dance, our sudden ejaculation of a few cadenced phrases, our exaggerated facial and bodily gestures, our vehement and subvocal elaboration of a story to explain and justify something we have done or plan to do — these are examples that come at once to mind. What is happening in these cases is that some particular thing, remembered from the past or encountered in the present, bursts so intensely and unexpectedly upon consciousness, its appearance is so unprepared and incomplete and out of context, that we cannot receive it as it is and accept it into experience, but must at once clarify it and give vent to it. When we pace the floor and recite a long story, replete with gestures, to excuse ourselves to an imaginary critic; when we dance a

few steps in the downstairs hallway while waiting for our young lady to prepare herself for the ball; when we stare into the dying embers of a fire and create in imagination a whole sequence of events that is to give substance to a thwarted ambition — in all of these, and many similar, cases we indulge spontaneously in expressive activity because it is only in this way that we can comfortably accept into experience the particular thing that has forced its entrance. Once this has intruded, and fastened attention upon itself, it is, so to speak, a choice between expression and repression.[2] But in the sort of case I have been speaking of, we make the choice before facing the decision.

The other way in which we frequently and familiarly move onto the level of expression is conscious and deliberate. We commence our dealings with some particular thing at the level of reception. We watch the sea beating on the coast during a storm; friends thrust upon us the conflicts of their personalities and the domestic crises that ensue; falling in love, we are entranced by the person of our beloved and tantalized by the ineptness of our courtship; we read a novel, or listen to a symphony, or look at a painting. In all of these cases, the particular thing that we encounter is given to us with some inherent structure and completeness, and we meet it with some preparation and familiarity. We are able to apprehend the object with a sufficiency of both interest and satisfaction, and aesthetic appreciation ensues. But there is often a good deal in the content of such experience that remains elusive and unintegrated. There are details that we either cannot grasp clearly as such or cannot see as a coherent part of the whole; there are incidents that seem isolated; there are mean-

[2] The errors and evils that ensue when we refuse to recognize or accept what we experience have been acutely analyzed by Collingwood; he refers to this occurrence as "the corruption of consciousness." See *Principles of Art*, pp. 217–220 and 282–285. Various aspects of this important problem are discussed below in Chap. IX, Sec. ii, Chap. X, and Chap. XII, Secs. i and iii.

ings that hover in the background but will not emerge; there is a quality or mood or significance that we suspect but cannot indict. In order to capture what evades us, to get from this encounter what it promises but does not yield, we deliberately set out to cultivate our aesthetic acquaintance with the particular thing that has aroused such experience.

The effort of expression is here undertaken in a much more serious and studied way than in cases of the first sort I discussed above. And, quite interestingly, we are not now so apt to externalize this expression: that is, not unless we are trained and practiced artists. We do not so readily sing, or dance, or gesture, or tell a tale; at least, we do not do this so obviously and overtly, though we often do it in a suppressed and internal manner, as when we beat time, hum, make incipient facial and muscular gestures, or flash a series of words or pictures before imagination. I think there are two principal reasons for this apparently contradictory fact that as expression becomes more purposeful it also tends, at least at first, to be less hurried and external in its release.

In the first place, the thing that we are trying to bring to expression already has a high degree of particularity and structure, so that it can support and nourish our attention; it is given to us with sufficient completeness that we do not have to construct it immediately for ourselves. In such cases, the natural object or the work of art has a substance and stability that we can concentrate upon and deal with expressively as we try to bring it to fuller realization. We do not need to embody what we wring from experience, to set it over against ourselves and record it as it emerges, because this already has a concrete object from which it has been derived and to which it can continually be referred. Where expression is more casual and spontaneous it is also more compulsive in its urge for externalization, for without this it has nothing to sustain it and tends to dissipate quickly.

In the second place, when we are consciously moved and

urged by an object, we feel the burden of expression more seriously. In such cases we are explicitly aware of the decision we face and the choice we make. Having found our first aesthetic acquaintance with some particular thing to be challenging as well as rewarding, stimulating as well as satisfying, we set out to press this encounter closer home. We commit ourselves to the task of clarifying our experience of particularity, of transforming a tentative and transient glimpse of things into a definite and stable insight; we intend to exorcise the haunting, evasive, and provocative quality that enthralls us to this experience by rendering and fixing its object with precision. In attempting this, we run the risk of destroying our appreciation without realizing our expression. The recognition of this risk lends caution to our efforts and humility to our designs. We feel grateful for even the limited vision that experience has vouchsafed us, we sense the fragility of this and are anxious lest we shatter it, and so we feel responsible for at least maintaining the insight given us against our own obtuseness and impetuosity.

Furthermore, I think that in such cases we are even aware, though less acutely, of a responsibility that we assume toward things. It is not merely our experience of things, the impression they make upon us, that we are seeking to express and so bring to fulfillment. It is the character of things themselves, the intrinsic being that they possess, their actual quality and structure, their persistence in following their own course, that we are pretending to lay bare. We all usually recognize, at least dimly, the obligation that this puts us under: since we are concerned not merely with the appearance of things — which after all is only our own affair — but also with their reality, we are pledged to render them with fidelity. No one can watch an artist at work, or hear him speak of his struggles, without feeling the force with which this sense of objective responsibility to things weighs upon him. The artist peers at the particularity he is dealing with, scrutinizing it

voraciously, staring at it as though immobilized, darting his glance around and within it, threatening it, cajoling it, beseeching it; he puts down what he finds, in words, in line and color, in notes, in stone or clay; moved by impatience and despair, he looks and revises, revises and looks. Then he shakes his head, in sadness and frustration, and says: "No, that's not it; I don't have it yet." The "it" is the particularity that he finds to be out there, luring and eluding him; and his integrity as an artist is largely measured by the mixed sense of guilt and grace that colors his dealings with this particularity.

Even those of us who are not practiced artists feel this obligation to the things whose aesthetic acquaintance we seek to cultivate. We seem to recognize that in rejecting as unsatisfactory our first immediate apprehension and in trying, through expressive activity, to make our appreciation of the particularity of things more faithful and profound, we have assumed a responsibility that we cannot shirk; it is as though we had entered into a contract with things to give "full faith and credit" to their self-enunciation. Our actions reflect this. Whether we are dealing with a natural object or a work of art, we go to great pains to make sure that we are bringing to bear upon it all of the pertinent resources that we can command, and that we are alert and responsive to all that it has to say for itself. We return again and again to the object of our aesthetic concern — to the landscape, the human involvement, the novel, or the painting — we approach it from different points of view, we scrutinize it in detail and contemplate it in detachment, we study any available critical, historical, and technical accounts that may serve to bring it more fully before us.

Consequently, when the quest for expression is undertaken with less compulsion and more reluctance it is usually carried out in a manner that is far more careful and correct. When we act on the spur of the moment, whether aesthet-

ically, cognitively, or affectively, it is very much a matter of any port in a storm: our sudden song or dance or story is full twin to the wild hunch and to blind trial and error. When necessity does not urge us on so impetuously, our expressions — like our hypotheses and our purposes — benefit from the study we devote to them. When our expressive activity is of this kind, it is self-critical, studiously planned and structured, and sensitive to the content it is trying to bring to realization. In such expression we continuously correct ourselves: we stop and consider our gestures and movements, we go back and change the tempo or the rhythm of our song, we delete and modify the words of the story we are telling ourselves. We do all of this, just as we take analogous care with our hypotheses and purposes, in order to make our expressions more finished in themselves and more adequate to the things they deal with. Expression is here already merging into creation. We must arrest it at this point, however artificially, in order to examine more closely both its own nature and the manner in which it leads on to creation.

Chapter V

THE AESTHETIC PROCESS
II: EXPRESSION AND
CREATION

I

1. There are two major ambiguities that are apt to obscure the nature of aesthetic expression. Both have to do with the question of the relative completeness and self-sufficiency of expression as a psychic act. One of these ambiguities centers around the problem of the origin of expression, the other around that of its destination. There are two questions that it is perfectly natural to ask about expression. First, does it have a source, and deal with some material, that is prior to and outside of itself; or is it internally initiated and autonomous? Second, does it require a further act and an embodiment that go beyond it; or is it internally finished and self-sufficing? These questions can be put more briefly and pointedly in this way: what is it that is expressed in expression? is there a significant difference between an expression and a work of art?

To the first of these questions we can give an answer that is at least straightforward, even if not universally acceptable. A good deal of the obscurity that surrounds this issue has been an accident of the historical background of the doctrine of expression. This doctrine arose in conscious opposition to the traditional theory of imitation, and with the avowed purpose of correcting what it regarded as the fatal error of that long-established view. This error, it was held, resided in

the belief that it was of the essence of art to discover and imitate some order of reality that lay beyond it. From its inception, therefore, expressionism was determined to avoid an interpretation of art and aesthetic activity that defined these by reference to any antecedent object with which they dealt.[1] As a result of this determination, expression was explained in exclusively psychological terms: the artist, it was said, expressed himself, and his feelings or impressions or insights. Expression was conceived as an activity through which the person engaged in it took the originally chaotic and volatile flux of his experience and rendered this articulate. What the artist expresses is what he finds within himself that is both vivid and confused, both intense and incomplete; to express this is to bring it clearly into consciousness; what the artist achieves through expression is the awareness of what he really feels and means.[2]

There is no cause to quarrel with this doctrine as far as it goes. But there is reason to point out that as it stands it is incomplete, because it tends to regard expression as a subjective act that occurs within an objective vacuum. This is a distortion of the actual case. The feelings and meanings for which we grapple do not arise spontaneously or arbitrarily. They are aroused within us from our encounters with things outside us. Emotions and impressions and insights all have objects: they issue from and carry attention to a larger situation of which they are themselves a part. It is perfectly true that the artist, in and through expression, clarifies his experience. But it is equally true that this experience is of something; it refers beyond both itself and the psyche to the occasion in which these are participants.

The resolution here proposed for this issue is determined

[1] This historical aspect of the matter is discussed more fully below in Chap. VI, Sec. ii.
[2] The classic statement of this doctrine is of course Croce's *Aesthetic*. The most searching and conscientious analysis is probably that of Collingwood in *The Principles of Art*; see esp. chaps. VI–VIII and X–XII.

by the doctrine that has already been developed. What we express is our apprehension of particularity. This may be any particular at all: any situation or occasion within or without ourselves. But it is the particular that it is antecedent to our aesthetic apprehension of it. This apprehension, therefore, has a double status: it is *our* apprehension, and as such it is a function of our psychic resources; but it is also an apprehension *of* some particular thing, and as such it is a function of the actual character of this thing.[3] These two strands can never be disentangled; it is impossible for us to set our experience of things — whether in its aesthetic, cognitive, or affective modes — over against things themselves, for we can only reach things through experience. In one sense, it makes no difference whether we say that an artist expresses his own feelings and impressions, or that he expresses the quality of the world and of life; for his feelings and impressions are of the quality of the world and of life, and this quality can be reached only through someone's feelings and impressions. In another sense, it makes a great difference which of these we say, for it determines our interpretation of the role and responsibility of the artist. If we hold that the artist expresses himself, then he is encouraged to indulge his feelings and impressions with little discrimination or discipline, and with only the obligation to confess sincerely what he undergoes. If we hold that the artist expresses the quality of life and the world, then he is responsible to this: it becomes his task to train his sensitivity in order that he may discover and disclose, as nearly as possible, the concrete determinateness of things.

The distinction here at issue is elusive. But it is also crucial. So at the risk of monotony further clarification can be attempted by stating it in a slightly different way. The artist's expression is, to put it so, his manner of speaking to us. But

[3] It seems probable that different artists incline, by temperament or training, to regard the material they express primarily in one or the other of these ways. This is further discussed in Chap. XI, Sec. ii.

what is he saying, in general? This could be either of two things. He might be saying: "This is how *I feel* about such-and-such (a tree, or space, or rejected love, or anything else)." Or he might be saying: "This is what such-and-such presents to a sensitive and conscientious *human feeling.*" Though not mutually exclusive, these statements are significantly different. I think that the latter is the correct interpretation of expression.

This means, to be quite explicit, that the present doctrine is a variant — a reformulation — of the theory of imitation. Art has a subject matter; this is the concrete and fully determinate character of actual occasions. We seize this only roughly and fleetingly, but still effectively, in all of our experiential encounters. At times it stands out more sharply and compellingly as an apprehension. It is this apprehended material, which commands but does not satisfy attention, that we seek to express. Our intention in expressing this is to discern it more richly and exactly.[4]

There is a subsidiary question that arises here. Is this subject matter composed of particulars or universals? The answer has been suggested in an earlier discussion:[5] it is composed of both. We derive the subject matter that we express from our encounters with the world. These encounters are with particular things and occasions, each of which is uniquely itself. But there are resemblances and regularities that run among these, just as there are structures and forces that they manifest. We are familiar with these experienced similarities, and we are interested in them and in the features that characterize their reoccurrences. So they also are present as elements of

[4] The most fully elaborated statement of the general position that art has a subject matter is probably that of Theodore M. Greene in his *The Arts and the Art of Criticism* (Princeton: Princeton University Press, 1940). His analysis of this subject matter, with reference to the several arts, is thorough and acute.

[5] Chap. II, Sec. ii. This question arises again and is treated more fully below, in Chap. VII, Sec. iii.

our acquaintance with things. We are not only bound to an individual woman by a unique sentiment and relationship; we are also "in love." We not only face life on our own strictly personal terms; we also share an "existential situation" with our "contemporaries." All of our experienced encounters are shot through with both particularity and universality. Since these encounters initiate expression and furnish its subject matter, both of these strands are always present in it.

In the immediate apprehension of his subject matter with which the artist starts, either particularity or universality may be the more prominent element. His attention may be struck by an actual occasion which emphatically proclaims its concrete uniqueness, and the relevance of which for other occasions only emerges later: say, this storm at sea, this love affair, this suicide of a broken man, this faith disappointed. Or his attention may be struck by a recurring situation or state of affairs or problem, which exists for him at first only as a general type of occasion: say, the race question, the situation of the child of divorced parents, the problem of the heightening of the destructive element in man by his participation in war, or the phenomenon of the political demagogue. In the former case, the actual occasion both enunciates its uniqueness and asserts itself as the epitome of the similar particulars that it suggests; and the artist is spared much pain, though he runs the risk of exaggerating uniqueness to the point of eccentricity. In the latter case, the artist must undertake the hard task of particularizing the general occasion that interests him. He must localize and embody his theme or subject in a concrete instance: in definite characters or objects or occurrences, and in a precise design. In both cases, the subject matter with which the artist deals is at once particular and universal — it is this actual occasion and the quality of all such occasions.[6]

[6] Henry James, that most deliberately and articulately self-conscious of writers, was obviously fascinated by this duality in the material with which art deals and by the challenge that it poses to the artist. He refers to it over

CARL A. RUD'SILL LIBRARY
LENOIR RHYNE COLLEGE

This is to say that a work of art is not necessarily, or probably even usually, an "imitation" of a single particular thing or actual occasion. The artist does not normally express and present only what he has gathered from his encounter with this sole object or situation. He also expresses and presents his matured grasp — his prolonged and repeated experiences — of numerous similar things or occasions. In *Daisy Miller*, *The Portrait of a Lady*, and *The Wings of the Dove*, Henry James is drawing three extremely distinctive young women; he is also depicting the general situation of the "simple" American girl in the more sophisticated society of Europe; that he is purposely dealing with this double content, he makes clear beyond doubt. And while it would be absurd to press the incident, it is still interesting to note the ease with which Beethoven's Symphony Opus 55 was detached from its dedication to Napoleon and called the "Eroica." This entanglement of strands of both particularity and universality of subject matter is inevitable, for we cannot grasp one without the other.

Subject matter as first apprehended is a confused mixture of these two strands. The lineaments of the particular case are so blurred that they are ambiguous or even quite inarticulate as to the universals at whose juncture they stand. A simple spot of color changes, as we try to fasten it in perception, from this shade to that to yet another. A man's actions seem to spring now from one motive and then from a different, to have first this quality and then another, and to tend in several directions at once. When we scan our feelings and impressions, they unwind like a reel of film run by a maniac, and our recognitions outdate so rapidly that they are only recollections that confuse the present scene. Concurrently, the

and over again in discussing his work. See especially the prefaces to *The Awkward Age* and *The Wings of the Dove*. In the first page or so of the latter preface he identifies this universal element by the successive labels: "motive," "situation," "idea," "theme," "subject," "case," "play the part," "be the type."

universals that we bring to bear upon the particular case are at once too vague and too arbitrary to help. Yellow is not right, nor is blue, nor is green. The hero of one cause is traitor to another, frankness blurs into rudeness, and security may rise to freedom or sink to slavery. Sinners make their beds and should lie in them, but they are more to be pitied than blamed, and let him who is without sin cast the first stone, yet it is our duty to fight evil where we find it.

In the course of expression and creation, both the particular case and the universal meanings that cluster around it are made to declare themselves; and by being rubbed against one another, each is brought to a higher polish. This fusion of particularity and universality is the content of the work of art: through the expressive and creative acts we attain to a clear vision both of what we are talking about and of what there is to be said about this. This content, being unique in what it declares and inseparable from its embodiment, cannot be abridged or paraphrased.

2. This discussion has led imperceptibly into the second ambiguity mentioned earlier, concerning the destination of expression. Is expression self-sufficient, or does it demand a further act, that of creation, to complete it? The question at issue here can be put more pointedly in this way. Is an expression fully achieved as a psychic content — an occurrence in experience — or does it require material embodiment in what is familiarly called a work of art?

These questions cannot be dealt with in so straightforward a manner, because they are to some extent linguistic. As with the former issue, at least some of the obscurity surrounding this one springs from historical circumstances. Almost all of modern aesthetic thought has reacted strongly against what it regards as the idolatry of the work of art as a material object. It has insisted that works of art are not objects that somehow enshrine artistic meaning and value — beauty, in an older

vocabulary — and make this available to all who approach them. It has held that the "real" work of art is an occurrence in experience, first in the expressive and creative acts of artists and secondly in the appreciative responses of audiences. The material artifacts that common sense calls works of art are merely the inert mediators between these two sets of occurrences. The work of art is a happening rather than an object.

There is much that is true in this emphasis, but it is apt to go too far. In the first place, it tends to minimize unduly the aesthetic significance of the media of the several arts. Sound and stone and paint and words and human performers are substantial things. It is the universal testimony of artists that they can express only by embodying their apprehensions in such solid structures. The physical work of art is not an after-thought, produced only by manual skill in order to objectify what was already subjectively complete; it is integral and essential to the act of expression. Since this point has been urged by many critics, and the concept of expression has long since been modified to take account of it, it need not be pursued.

There is a second aspect of this issue that is both more important and more difficult to clarify. This concerns the relationship between expression and creation. In one sense, this distinction is artificial. The difference here is one of degree, not of kind. Expression is creative. In the terms of the earlier analysis of the levels of experience, the distinction between expression and creation lies not in any different purposes that animate them, but in the different intensities of purposiveness with which they are carried on. Between expression and creation there is no radical change of intention, direction, or method. But there is a radical change in the seriousness with which we engage ourselves in the aesthetic quest and in the importance that we attach to its outcome.

If we look for one quality to mark this transition, it is perhaps most accurately located in the sense of responsibility

and dedication that strongly characterizes creation and is largely absent from expression. This sense reaches in two directions: toward the subject matter that is being dealt with, and toward those who will be touched by the content that art conveys. I think that the serious creative artist consciously carries the burden of these responsibilities, just as do his counterparts in the fields of theory and technology. He recognizes that he is creating a work of art that pretends to disclose the actual particularity of things in the world and of life's occasions. He also recognizes that his art will influence the way in which other men will apprehend these things and occasions, and participate in them. To assume these responsibilities with a spirit of dedication and integrity is to engage in creation.

This distinction is admittedly unattractive, because it is not conceptually sharp. But we can nevertheless feel this difference within ourselves and detect it in works of art. When expression becomes studied and deliberate, it is already incipiently creative and is assuming the burdens of creativity (it was just at this point that we interrupted our account at the close of the previous chapter). In its purer form, expression is far more carefree and heedless: it delights in its own exercise, it is intrigued with its achievements, and it largely sustains itself by its sheer mastery of the medium it employs. In expression we tend to be engrossed in what presently engages us. The material we are bringing to expression, and the skills we use in expressing this, absorb us. We are relatively inattentive to the content that we express — the interpretation that we put upon things — and quite oblivious to any influence this might exert. We may be more conscious of the joy that expression affords us, or of the challenge it poses, but in either event our attention is closely confined to the immediate occupation. Expression is exuberant and arrogant, impatient of criticism and impenitent of its mistakes.

We easily recognize the transformation in attitude and

treatment that marks the level of creativity. Perhaps the out-
standing trait of works that issue from creative acts is their
deep seriousness: they insist upon their subject matter, and
they assert the significance of their content as an interpreta-
tion of this. With such art, we are chiefly aware of the mean-
ings it conveys and of the relevance of these meanings for our
reading of life and the world. The medium is apt to appear to
us, at least at first, as either a transparent vehicle of the con-
tent it embodies, or as an intrusion that disturbs our grasp of
this content. No matter what delight we may receive from the
sensuous and formal aspects of such art, or what admiration
we may have for the technical skill and versatility it displays,
these are secondary considerations. The great creative artists
obviously share this attitude: they make it quite clear that they
regard their medium as a necessary but recalcitrant intruder
between themselves and the vision they are seeking to realize
and convey. They treat this medium correspondingly, wrench-
ing its styles and canons, putting it to unwonted uses, and
introducing novel principles of design and structure. In his
creative works the artist makes evident to us his awareness
of the grandeur and the importance of what he is under-
taking, as well as of its challenge and its risks, and his sense of
his inadequacy for the task. Creation is at once presumptuous
and humble.[7]

This pause to examine the internal characteristics of expres-
sion has been necessary because of the central place that the

[7] This distinction between expression and creation finds sharp illustration
in the differences of tone and treatment that characterize the works of a
youthful and a mature artistic talent. A striking case is the drastic and seem-
ingly unprepared change in Schubert's music about 1820, marked especially
by the Quartetsatz in C minor. The contrast between Beethoven's early and
late piano sonatas and string quartets is of course famous. Another interest-
ing illustration of this difference is the criticism, frequently voiced against
artists, that they have betrayed the charm and virtuosity of their early
works and are producing art that is only dull and vainly pretentious be-
cause they have overreached their powers. This suggests that there are
many artists who are unable to make the transition from expression to
creation, as those terms are here used.

concept holds in contemporary aesthetic theory. But throughout this discussion I have been anxious to insist that expression has an origin and a completion that lie beyond itself, that its external relations are of its essence, and that it is an occurrence in an integrated process. In a word, expression is the name of a transition rather than a state. We must now return explicitly to this aspect of the matter.

II

3. As we achieve an expression, this refers not only to itself but also both backward and forward within the aesthetic process. Probably the first and most conspicuous consequence of an even partially successful expression is to strengthen and clarify the subject matter from which it issued. When, and to the extent that, we express this as content, we immediately attain a more stable and secure grasp of it. Expression reflects back upon and enriches apprehension: it enables us to find more rightly what is actually present in the symphony, the seascape, the human face or situation, the mood or emotion that has been urgent but inchoate within us.

At the same time, expression carries us irrevocably forward toward at least latent creation. What we express acquires an effective existence of its own: it is there, it can be beheld continuously or successively, it exposes new vistas and makes suggestions for its further improvement. This is so whether we express a content internally or externally, whether we hold it in memory or embody it in a material medium. An expression, in summing up and organizing a past aesthetic encounter, both gives us something definite to work on in the present and indicates the as yet unachieved material that the future should explore.

This forward movement that issues from expression carries in two directions: to its own further development as a quasi-independent entity, and to a further clarification of the insight, or apprehension, of which it is a partial fulfillment.

As we attain an expressed content, this becomes a thing of value to us in and for itself. We become keenly interested in the characters that emerge in our story, in the plot that is sweeping them on, in the denouement that awaits them; or in the rhyme scheme, the metrical pattern, and the interplay of words and sounds in our poem or song; or in the plastic qualities and values of the colors, lines, and masses in our imagined or embodied sketch. Our attention is here centered upon the internal properties and structure of the expression we have attained, largely independently of the original aesthetic experience that gave rise to it and that it is meant to carry to fulfillment. To the extent that we are familiar and expert in the media of the arts, this interest in the intrinsic character of an expressed content is apt to become more intense, and it frequently becomes obsessive. This disruption is a constant threat to the creative process, and we shall be concerned with it later.

But at the same time that the expressive act becomes enmeshed in itself and its vehicle, it also drives on toward a yet closer acquaintance and more adequate embodiment of the particular thing that first aroused it. Unless the aesthetic process is suppressed or subverted before its full term, its natural outcome is in creative activity. Once we have been impressed by an apprehension of particularity, and have felt the urging of things to meet them on their own terms, there is present a drive to carry this to completion by expression and creation. Experience at the level of reception is never really satisfactory, because it does not bring us close to things in any of their prime dimensions. Hence, such experience condemns itself as insufficient, and urges us on to correct and amplify it. Of course, we are very largely deaf to this plea; we are often so hurried and distracted by the press of events that we hardly hear it, and when we do, inertia and impatience often keep us from heeding it. But even when we ignore this urging, we are usually conscious of its presence;

it makes itself felt as a vague discontent with the quality of life, a dull regret that this cannot be richer, and an evanescent resolve to improve its future condition. And on frequent occasions, which are numerically considerable even if proportionately small, we obey this urging. We then set out deliberately to cultivate experience: we seek to arrive at expressions, hypotheses, and purposes that will do justice to the facets that things expose to us. And from this it is an easy and natural transition to the level of creativity; we at least commence — though we all too rarely finish — what we intend to be works or art, theories, and technological devices.

Creativity in all of these fields is the natural outcome of a natural impulse. Since every situation in life is unique, and since the equipment we bring with us from the past is never wholly adequate, there is a constant pressure to engage in creative activity. Essentially, creation is simply the attempt to realize the full possibilities of our encounters with things. It is the sustained and purposeful effort to wring from life the last drop that it has to offer; and, what is equally important, to put what is so realized in a form such that it can facilitate and enrich the encounters of others, and so enable them to derive yet more from life. Artistically, this means that we would completely grasp and expose the actual intrinsic character of the things we deal with; theoretically, that we would lay bare all of the connections that hold among these things; technologically, that we would exploit whatever things offer that is good for man, and inhibit whatever is bad. This is a dream that will never be fulfilled. But it is this dream that pervades all of experience, consciously or unconsciously, and lures it on.

Creativity, far from being a strange and rare gift, is the natural and proper outcome of all experience. We tend to think of creation as a forced wrenching from experience of what this is not equipped or prepared to yield — as a lashing of experience to heights of lucidity and intensity that it is

not meant to attain. There is truth in this view, because experience has so much to deal with, and under such pressure from necessity, that it can hardly afford to be so painstaking. And this view is strengthened by the ferocious difficulties and oppositions that the creative effort has to overcome, the concentration it requires, and the sacrifices it entails. But it is equally true, though it has the ring of perversity, that we are forcefully disrupting experience when we stop it short of creation. Every encounter with things points on to its realization through creativity; it is we, as integral psyches pursuing a complex of vital purposes, who resist this urging and interrupt experience before it attains this consummation.

I think the truth of this view, that the aesthetic process is thoroughly dialectical and that expression and creation are both incipient in appreciation, is borne out by the character of those occasions that I have previously called "experiences." Whenever our encounters with things are at all intense and meaningful, they have also a definite quality of restlessness: they promise more than they have so far yielded, they continually open up fresh vistas, and they burden us with a sense of obligation to carry their acquaintance further. In such experience, the three moments of appreciation, expression, and creation are all contained; the presence of each, and the interaction of all, can easily be discerned. On these occasions, when we are really moved by art or nature, we want to retain and perfect our experience, and also to share it with others. We both strengthen our own attention and demand the attention of others by calling out and pointing at the thing that has aroused us; we read a passage aloud to anyone whom we can persuade to listen; we push our guest into a chair and fill the phonograph with records; we sketch the scene that enthralled us, or tell the story of the incident that gripped us. As we do this, we become interested in this externalization and embodiment of our experience, and devote ourselves to its development: that is, we express, and become concerned

with the intrinsic character of this expression. In doing this, we almost necessarily and involuntarily engage in creation. We find that we must set down what we have discovered of particularity, before this flees beyond recall or accumulates beyond control. There are probably few of us who do not have cached somewhere at the back of a desk drawer hasty sketches and designs, scribbled bits of verse, tentative outlines of the plot and characters for a play or novel, or plans for a future home. These are the creative climaxes of past aesthetic episodes. I think that, if we will make the effort of recall, we can see that they at least served the purpose of clarifying the experiences from which they issued; and there is always the possibility that we will return to them — in earnest to the future and not merely in idle reminiscence — and will be incited by them to a fresh aesthetic endeavor that will carry them nearer to completion.

The compresence of appreciation, expression, and creation in the aesthetic process stands out most clearly in the experience of the performer. Anyone who has acted is familiar with the manner in which attention shifts among these levels, continually enriching each with what it takes from the others. You find yourself responding appreciatively to the poetry, the characters, and the dramatic movement of the play itself; you find yourself absorbed in your own performance as an actor, in the stage techniques you employ so easily and effectively, in the details of gesture and emphasis by which you project your characterization; and you find yourself watching with the utmost care the play-as-a-spectacle that you and your fellow actors are progressively creating, noting its effect upon the audience, correcting any distortions or false notes that may creep in, and anticipating its further development.[8]

[8] Henry James — who was certainly a close student if not a successful practitioner of the theater — gives pointed expression to this fact in a passage from *The Tragic Muse*. Peter Sherringham is seeing Miriam Rooth (the Tragic Muse) perform for the first time since she has seized mature control of her hitherto undisciplined talent; on this occasion he is "vividly

The performer in any medium, so far as I can judge from reports, finds himself similarly entangled. Each moment of this process ideally illuminates the others. A clear and accurate preliminary reading of script or score is the necessary basis of the performer's craft; in elaborating and executing his performance he brings to light much meaning that was at first obscure or isolated; in the light of his audiences' responses, he knits his performance more tightly together, and obtains a closer and finer grasp of his text and of the treatment it requires. So these moments, when they interplay properly, become individually more lucid and collectively more coherent. But each moment also threatens to engulf the others and disrupt the process. If you are too swept away by the play, you cannot effectively act or project it; if you become too engrossed in your performance, you fall out of your part — the word is significant — and betray your author, your cast, and your audience; if you are too obsessed with the effect you are having, you lose touch with the springs that give meaning to your creativity, and soon find yourself improvising with no end in mind save entertainment. On the occasions when these three moments are fully integrated with one another and fused into a single whole, then there is brought to us a great performance.

With these clues in hand, I think that this same entanglement can be discerned in the structure and course of all vivid

visited by a perception that ended by becoming frequent with him — that of the perfect presence of mind, unconfused, unhurried by emotion, that any artistic performance requires and that all, whatever the instrument, require in exactly the same degree: the application, in other words, clear and calculated, crystal-firm as it were, of the idea conceived in the glow of experience, of suffering, of joy. Sherringham afterwards often talked of this with Miriam, who however was not able to present him with a neat theory of the subject. She had no knowledge that it was publicly discussed; she was just practically on the side of those who hold that at the moment of production the artist cannot have his wits too much about him. When Peter told her that there were people who maintained that in such a crisis he must lose himself in the flurry she stared with surprise and then broke out: 'Ah, the idiots!' " (The text is that of the first edition.)

aesthetic occasions. Of course, different such occasions vary quite widely as concerns their primary location on one or the other of these levels. In some of them, our mood is largely receptive and appreciative: nature or art gives us, immediately and easily, a satisfactory image of particularity which holds us and delights us, but does not especially stimulate us to probe more deeply into this imaged content or to amplify it. On other occasions, our response is more active and expressive: the images that we obtain of things, while sharp and compelling, are not sufficiently clear, coherent, and stable; an effort is required from us to track down and organize the material given by nature or the artist, and so to grasp the thing they present. There are, finally, some aesthetic episodes that are largely creative; our encounters with things are haunted by the paradoxical quality of being vivid and revealing, but at the same time unprepared, incomplete, and transient. We are entranced by this sudden vision, but even more we are intrigued by the obscurity that it momentarily illuminated; the memory of the vision remains, sustaining and guiding our aesthetic effort, but the recovery of the particular that it briefly and tentatively gave us is chiefly the task of creation.

These distinctions among aesthetic occasions are perhaps most easily indicated by reference to the ways in which we characterize different works of art. There is, in the first place, the kind of art of which we tend to say that it is "attractive," "charming," or "lovely." We usually find that art of this sort is immediately satisfying but soon exhausted: it delights us with its sensuous qualities, it quickens us with the sharp and unexpected light it throws on things, and it rouses our admiration for the facility and aptness of its conception; but it does not stir us deeply, call greatly upon our resources, or much tempt us to return to it. The acquaintance with such art is gratifying, casual, and temporary; when we judge it from a more exalted mood we are apt to dismiss it, rather

unjustly, as facile, shallow, and — most damning word — pretty. There is another sort of art that we usually describe by such adjectives as "stimulating," "suggestive," "striking," and "provocative." Art that is thus characterized seems at first to offer less and demand more; its impact is cumulative rather than sudden; it elicits from us a greater effort but leaves us more latitude; our acquaintance with such art is frequently terminated with the conviction that we have derived much from it, but also with anxiety that we have not made of it just what we should. A third kind of art that is easily recognized is that which we refer to as "profound," "challenging," "moving," "powerful," and "permanent." This is the sort of art that stirs us forcefully but obscurely when we first encounter it; it discloses itself to us only gradually and laboriously; it seems to concentrate within itself a meaning that is universal and fundamental in its significance, and to touch the deepest springs of our own being; we feel that its impact upon us is permanent and far-reaching, that it has changed us as persons because it has radically altered the ways in which we view things. It is before art of this kind that we have insistent recourse to such heroic words as Truth, Reality, and the revealing wisdom of genius. These come to us as the only terms in which we can adequately describe our experience before such art.

These categories of aesthetic experience and art are, of course, neither absolute nor exclusive. Every encounter with art reverberates, however slightly, throughout this realm. The simplest quatrain or lyric intimates a hidden richness in the particular that it seems to present so summarily; it hints that what has been said so aptly and appealingly, and with such an air of finality, is after all only one small way of looking at one small aspect of things. Conversely, the most massive and complex works of art contain episodes that seem to be complete in themselves and that yield a spontaneous joy. The effort of trying to follow the artist along his tortuous course

is momentarily relieved by a burst of light that illuminates the scene and rewards our search. These are simply extreme cases of what is present, and so more or less apparent, in all aesthetic occasions: our encounters with the particularity of things — with the content of art — delight us with what they immediately discover, but at the same time they enthrall us to explore this more thoroughly.

III

4. The dialectical character of the aesthetic process is exhibited with equal force at the level of creativity. This means that artistic creation, which is the culmination of this process, is continuously dependent upon appreciation and expression: it must return at frequent intervals to these lower and more immediate levels of aesthetic experience, to gather fresh material, to check its present bearings, and to plot its future course. The artist must perpetually renew his acquaintance with the particularity of things; he must retreat from the special vision he is following, and the narrow salients he has established, in order to maintain touch with the broad stream of life and with the gross stuff of life, which are his ultimate sources of supply. The work of art, throughout the course of its development, must be criticized and corrected by reference to the insight and intention that first generated it. In sum, creativity is not a stage which, once attained, is thenceforward self-sustaining. Rather, its roots are in the subsoil of appreciation, and it can flourish only on what it derives from them.

In the final analysis, all creativity has a pragmatic basis: it is initiated and continued in order to improve the quality of man's transactions with the environment, to extend and refine his grasp of things, and to permit him to come to grips with the world more effectively. Within the framework of this general effort, the specific function of artistic creation

is to articulate man's vague apprehensions of the particularity of things, and to embody and present these with great clarity and persuasion. Creativity can fulfill this function only if it keeps itself in close and constant touch with the particulars it is concerned with. The same point might here be urged about art that has frequently been urged about philosophy — and, in fact, about all intense and specialized efforts —that it is their inescapable tendency to become quite remote from the things they deal with, that this is even necessary to their successful prosecution, but that it must nevertheless be remembered that their ultimate obligation is to the materials and problems of common sense, which originally gave rise to them. Creation, whether artistic, theoretic, or technological, should never be the making of objects that are their own excuse for being. This concern with the intrinsic character of what is being done and made creeps into all human activity: even apart from the demands of circumstances, man complicates everything he touches, from government to the rules of whist, because complication makes things more interesting. This concern is legitimate and valuable if not allowed to carry too far. But it becomes unhealthy if it distracts attention from the extrinsic function of what man does and makes. The recognition of this fact is enshrined in man's periodic revolutions against the accumulated complexity of his culture and toward a simplification of life. This is seen alike in recent revisions of the judicial system, in the forms of modern architecture and the vocabulary of modern poetry, in contemporary design in various fields, and in the partial removal of chrome from our automobiles. The classic statement of this claim that common sense has upon creation, at least as it concerns art, still remains Wordsworth's Preface to the *Lyrical Ballads.* Internal elaboration is, within limits, both a necessity and an ornament of man's activities and artifacts; it enhances their effectiveness as well as their interestingness. But if creative activity dissipates too much of its energy in this direction it

evades its prime responsibility, which, as a refined employ-
ment of experience, is to serve as an instrument of life.

Since the aesthetic process, like all vital processes, is dia-
lectical and synthetic in character, the course of its develop-
ment follows a pattern that is cyclical, not linear. The sep-
arate occurrences of this process do not move steadily for-
ward in a constant direction, passing only once through the
series of stages from appreciation to expression to creation in
order to reach their completion. On the contrary, these occur-
rences continually turn back upon themselves. They may pass
through all of their stages, return to their beginning, and re-
peat this journey several times; or they may interrupt their
forward march at any point, seek their source again, and then
resume their course. Speaking more concretely, this means
that the artist does *not* first exhaust the aesthetic possibilities
of the thing he is dealing with — he does *not* drain away from
this and store in experience all that he can appreciate; he
does *not* then refine and express this definitively; and he does
not, finally, embody this content completely in a work of art,
and so have done with the matter once and for all. These
stages of the aesthetic process are carried forward simultane-
ously, and the artist shifts constantly from one to another
of them.

Creation, as the culmination of this process, is most exactly
conceived as vibrating between two poles, or as facing in two
directions. It looks backward toward its source, seeking to
attain a clearer apprehension of the particularity it is dealing
with. At the same time, it looks forward toward its product,
seeking through this to make its vision more articulate and per-
manent. These two phases can be described as internalization
and externalization, or as insight and embodiment, or as con-
templation and concretion. The important point is that these
are phases in a cycle that is cohesive and recurrent. Each of
these phases, then, is necessary to the other and to the cycle
as a whole: the artist can retain and clarify his insight only to

the extent that he embodies it; and he can realize his vision concretely only to the extent that he can maintain a rich and vivid insight. Further, since the cycle of creation is recurrent, these phases repeat themselves; each depends on and demands the other, and as creation goes on they succeed one another in an endless procession, one appearing and making its contribution while the other retires to prepare for its next entrance. Finally, since these statements sum up to an account that is much too divisive, it must be stressed that this cycle is integral, and that these two phases operate always together. The creative cycle — and so the whole aesthetic process — comes to a climax when these phases are fused into a single entity: this is the vision of the artist become concrete, and given to us through his work of art as an embodied insight.

The traditional view of the artist — and the view that is still the more widely and popularly accepted — emphasizes the external phase of this cycle, which materializes the work of art in tangible shape; it regards the artist as primarily a man who has great skill in handling his material, whether this be paint or stone or words. The more strictly modern view — which is due chiefly to the expressionists — emphasizes the internal phase of this cycle, which projects the work of art as a mental content; it regards the artist as primarily a man of great sensitivity in discerning the perceptual and emotional impress that things make upon him. Each of these views is a partial truth.

The whole truth of the matter is that these two phases are alternating and reciprocal moments of the same cycle. If we look at the matter in objective terms (as was the earlier habit of thought) the artist's attention, as he moves through this cycle, shifts continually between the particular thing he is concerned with and the work of art that "imitates" this. If we look at the matter in subjective terms (as thought is now accustomed to do) the artist's attention shifts between the raw material of his sensations and emotions, and the "expres-

sion" to which he is trying to bring these. The difference in these interpretations is little more than linguistic. Under both of them alike, artistic creation deals with certain material that is given to it by the impress of the external world upon human sensitivity; and artistic creation seeks to bring this material to a shape and form that present it with the utmost explicitness, precision, and stability. There is no limit to the interplay between these phases; so artistic creation is never a process that is ended in the sense of being complete and final. Each return that the artist makes to the source of his inspiration — his subject, or theme, or argument, in the old-fashioned but still revealing words — exposes fresh aspects that require to be taken into account, expressed, and embodied; and each partial embodiment of his vision constitutes a vantage point from which he gains a different and a deeper insight. There is no absolute or predefined conclusion to this process. What finally issues from it as a work of art is less a finished product than a provisional termination.

This dependence of creation upon its source in immediate aesthetic experience finds its most frequent tribute in the familiar advice to artists that they must immerse themselves in the world that they intend to depict. Embryo poets are told to feel as intensely and as variously as they can — and they construe this to mean that they break their hearts for love as often as possible; painters are continually in migration to what they hope will be more stimulating scenes; architects feel the need to take the Grand Tour; while novelists and playwrights are advised to study the forces and issues that are at work in their contemporary environment. All of this advice manifests an awareness that what the artists needs above all else is an alert and vivid sense of the actual character of the things he is concerned with. To a great extent, this must come from within the artist himself: the measure of his talent is largely defined by the enthusiasm and acumen with which he greets particular things. But it is still the case that this aesthetic

sense can be awakened or renewed by an acquaintance with things that are striking in themselves and hitherto unfamiliar. The truly great artist finds the challenge of particularity within himself, and is able to transform the most prosaic and ordinary things into vivid entities. But lesser talents need stimulation from the strange, the exotic, and the remote. And they are wise to seek it.

Perhaps the most revealing evidence on this issue is the manner in which artists frequently seek their point of departure — their original aesthetic stimulus — in the work of other artists. Where the sense of particularity has been dulled and weakened, or where it was never too strong and sensitive, the obvious recourse is to nourish it upon things which have already been highly particularized: that is, upon things which art has already transformed into entities. A person may well have and retain an artistic intention, and a high degree of craftsmanship or technical skill, while he does not have an original vision that is adequate to sustain these. It is then natural that the artist should borrow from others the insights upon which to exercise his talents. The best known instances of this reliance upon a secondary artistic source are in music: the most obvious cases are the many compositions that are entitled "Variations on a theme from X"; but many overtures, songs, operas, and hymns illustrate the same principle. Though I cannot here pause over the point, it is significant that this should occur so prominently in music, which is the most abstract and self-contained of the arts, and the one with the most highly organized medium. This suggests that the expressive resources of music — especially instrumental music — are so different in kind from the material they deal with, and have been carried to such a high pitch of internal development, that it is the frequent fate of musicians to have magnificent control of the techniques of artistic embodiment but to have little commerce with the wellsprings of artistic insight. Hence the eager search for a ready-made content, an already particu-

larized subject, that can stimulate and sustain their talent. But this situation is by no means unique to the musician. Painters have frequent recourse to fictitious scenes and characters as entities to be now realized in a new medium; poets write lyrics that are inspired by music; the ballet, the theater, and the novel borrow continually from one another. And artists in all media, in their search for material, owe a huge debt to the products of those more anonymous art-forms that we know as legend, folklore, and hero-worship.

This reference to the deliberate search for creative stimulation must be balanced by the recognition of an opposite tendency that is just as real. Artists often flee from any contact that might quicken their aesthetic sense, and from any acquaintance with the diverse ways in which other artists are handling a common material, whether subject matter or medium. Given the dialectical character of the aesthetic process, and an artist who is differently circumstanced, this behavior is equally logical and natural. When an artist has a vivid and fertile sense of particularity, which supplies him with more than abundant material to be expressed and embodied, any further quickening of this can only be a distraction. And when an artist is intent upon embodying his special vision of things, the insights of other artists are a complicating and confusing intrusion. It is a frequent complaint both by and against artists that their appreciation of other art than their own is so often limited and impatient. I think that this is largely inevitable. An artist is a person who by temperament and training is prone to push every aesthetic encounter at once to the level of creation. For such a one, creation is an appetite, and particularity is the grist that its mill requires. An artist whose aesthetic sense is alert and prolific is already satiated with the particularity that he discovers, and that presented by other artists is a food he neither wants nor needs. On the other hand, an artist whose aesthetic sense has been weakened and jaded is so voracious of particularity

that he must at once seize it as a means of embodiment, and cannot pause to appreciate it. And artists of both types have their attention continually diverted from the aesthetic content of art to a cognitive analysis of the means by which this aesthetic effect has been achieved.

5. The aesthetic life has its own proper metabolism. Or, to vary the figure slightly, it proceeds by a recurrent diastole and systole. Every moving encounter with particularity anticipates and urges its consummation through a creative act. The natural course of aesthetic experience is one of expansion: a first acquaintance with things-as-particulars, being necessarily incomplete and shallow, impels us toward the larger and more intimate familiarity of expression and creation. Concurrently, every vivid embodiment of particularity invokes and summarizes the career that has brought it forth out of appreciation. The ordained method of artistic creation is one of contraction: the effort to present things-as-entities, entailing as it does a rigorous selection and compression, refers us continually backward to the insights from which it issued and the successive fusions these have undergone.

In appreciation, as a conscious occasion, we feel as though we were trying to dilate our organs of aesthetic vision, to make these docile and faithful, sensitive and discriminating, to what impinges on them. The diastole of the aesthetic process, from appreciation toward creation, is a movement in which we open ourselves to things, as a whale opens its cavernous mouth while moving through a school of fish, in order to receive them as capaciously as possible. When this phase of the cycle is interrupted, when appreciation is frustrated, the sensation is one of being dragged away from things, or of things withdrawing from us, while there is still much to be gained by further intercourse. The felt quality of the creative effort, on the other hand, is one of contraction. The particularity of things is so rich and intricate, and the course by

which we make their acquaintance is so devious and gradual, that we are continually in danger of losing or forgetting our original insights in the pursuit of later ones. The great challenge to creativity is to accrete and synthesize what it grasps of things; the great threat it lies under is that of distilling its material so repeatedly that the brew becomes too heady; or, conversely, of straining this material so thoroughly that it becomes too thin. The systole of the aesthetic process, from creation to appreciation, is a movement in which we close upon what we have discovered of the particularity of things, and seek to condense from this just that which constitutes their determinateness and uniqueness. Anyone who works creatively in art — and the case is the same in theory and technology — soon realizes that he must spend a large part of his time and effort in going over work already done, recreating the content and direction of this, regrouping his forces and intentions, and finally taking a few hesitant steps forward.

The healthy development of the aesthetic process is dependent upon maintaining the proper rhythm of diastole and systole. Any break in this cycle disrupts the process. If the sudden insights that we gain in appreciation are not fastened and synthesized by being embodied, they are at best inchoate and fugitive. Aesthetic experience is incomplete, and sinks back into the blurred landscape of consciousness from which it momentarily emerged, unless it can fix itself in a definite and structured image. The doing of this is beyond the ability of most of us, save occasionally, and the value of art lies in the fact that it gives us objects from which we can derive the images that complete our aesthetic experiences. Without art, the aesthetic life is shallow and vacillating; until finally the urge that lies behind it becomes so diffuse that it atrophies.

Unless the creative effort is continually quickened by the breath of appreciation, and renewed by contact with things, it becomes empty and inert. This is such a frequent and tragic fate of artistic movements that it is important to trace briefly

the manner of its occurrence and the consequences that it entails.

The various arts, in the course of their development, accumulate a large and highly organized body of internal resources. Media and techniques multiply and are refined; styles are established; certain themes and subjects become fashionable; modes of interpreting and treating particulars are widely accepted; canons and rules of formal structure are systematized; and a common understanding grows up between artists and audiences. This totality of materials, processes, ideas, and attitudes — what is frequently called a tradition — constitutes what can most accurately be described as an artistic cosmos: it has a landscape, a population, and an ecology of its own; it tends to be a highly closed region, jealous of intercourse across its borders; and it *seems to be* self-sustaining and self-replenishing. It is this latter, and deceptive, characteristic that I am here concerned with. There is always present a tendency for artists and audiences to confine themselves rather closely within some such artistic cosmos, to isolate this from outside influences, and to try to live on the resources it affords them. This is as unsalutary in art as in nature. A geographical and ecological region, however rich and self-contained it may appear, is at least dependent on the sun and the ambient atmosphere to replenish its materials and its energies. Likewise an artistic cosmos needs to have its conventions and traditions, its styles and techniques, its forms and values, refreshed by close and continuous intercourse with the welter of particularity that the world contains.

Now artists, when they find their primitive aesthetic sense becoming obtuse and lethargic — when they lose their passion and devotion for the actual character of things — find their most obvious line of retreat into an artistic cosmos. Having nothing to excite them to creation, they seek refuge in the routines of fabrication that such a cosmos gives them. Having nothing to say, they engage themselves in the elabora-

tion of what has already been said. The results that issue from this sanctuary bear the most eloquent and persuasive testimony to the dependence of creativity upon appreciation. The art that is produced under such auspices is doomed to preciosity and sterility. It grows steadily more elaborate in structure and design, and more studied in the use of its materials; it becomes subtle and equivocal in what it has to say, and it says this with such delicacy that it seems almost to be apologizing for saying anything at all; it abounds in elusive and esoteric references, clothed in a vocabulary and a rhetoric that are private to its own cosmos. At the same time, and through the same course of circumstances, such art withdraws progressively from what is taking place around it; its attitude toward man and his affairs, toward the world and its vicissitudes, passes beyond even the concern of pessimism and becomes one of indifference and disdain. It begets no fresh insights, and it projects no systematic vision, because it holds that there is nothing to be seen. The measure of its sterility is the fact that it sends man back to the world with no quickening of sense and emotion, with no broadening of sympathy, with no heightened delight in what is to be found there. Such art is usually described as decadent. But if we are to use words at all literally, much the better term would be senile; for this art has lost both the interest and the ability to deal with actual things, it is concerned only with itself, and it is prepared to renounce the world if by doing so it can preserve its own existence for even a little longer. An aged and infirm man follows a strict regimen, draws up a succession of wills, and seeks various absolutions. In a similar vein, the last acts of a sterile art are to make its forms more rigorous, to endoctrinate its disciples more fanatically, and, finally and most hopelessly, to issue manifestoes.

Chapter *VI*

THE PARADOXES OF
AESTHETICS

I

1. The most revealing clue to the character of the aesthetic life is given by the contradictions that have always been current concerning it. In all the numerous accounts of the aesthetic attitude, of aesthetic quality, of appreciation, of the sense of beauty, of the creative process, of art, the same conflicts and antitheses recur, cast in varying terms but always easily recognizable. As soon as we reflect upon our experience of art and beauty, however superficially, we find ourselves confronted by a series of contradictory characteristics; and the more closely we press home our examination, the more compulsive do these irreconcilable disclosures become, and so the more violent the tension between them. The aesthetic life reveals itself as a bundle of paradoxes, which any account that is at all honest must acknowledge, and which it is the hard task of theory to resolve.

The most conspicuous and the most celebrated of these paradoxes arises out of the seemingly contradictory facts that aesthetic experience is at once disinterested and intense. There is no characteristic of the aesthetic attitude that has been so often noted and so strongly emphasized as that of its disinterestedness. The various guises in which this concept has appeared constitute virtually a roll call of aesthetic doctrines: detachment, catharsis or purgation, isolation, objectification, emotion remembered in tranquility, psychic distance, self-surrender, passivity, pure perception, will-less knowing, re-

posefulness, equilibrium, synesthesis, impersonalness, contemplativeness, empathy, pleasure objectified, disinterested pleasure, receptivity — these and many others all echo the same meaning. These concepts and the doctrines they summarize reflect different intellectual presuppositions — different general climates of thought — but they all embody the same empirical recognition: that the dominant and pervasive quality of the aesthetic life is its absorption in the present moment and its insulation against the usual interests and demands of life.

When our attitude toward things is aesthetic, when we are appreciating art or natural beauty, we do seem to be compellingly lifted out of ourselves and carried away from our familiar contexts. Our normal cares and concerns slip from us, and we become engrossed in what is actually before us. Time seems to stand still, space evaporates, and the present here and now suffuses consciousness. The feel of such experience, especially in its intenser moments, is that the self and the world are submerged in what is immediately happening, and that the whole of existence is compressed into the object confronting us. We seem to resign the direction of experience, surrendering it to the thing we are experiencing, and to be transported to another realm. The dominant trait of our aesthetic moments is their detachment from the usual concerns of life, their internal serenity and sufficiency, and their close communion with the objects they give us.

But aesthetic experience has another character, almost if not quite as prominent, which seems directly contradictory of its disinterestedness and detachment. Such experience tends to be intense, exciting, fervent, and violent. The aesthetic object elicits great energy and concentration from us, and our experience of it involves us deeply. All of what are called our various faculties — our senses and emotions, our memories and ideas, our hopes and purposes — are highly stimulated by our aesthetic encounters with things. We seem to live more intensely, to realize the world and ourselves more vividly, to

participate in things and events more closely. We are passionately aroused and keenly interested, we become violently partisan in our devotion to or rejection of aesthetic objects, and we feel ourselves intimately associated with and committed to these objects. In sum, if the aesthetic life is disinterested, tranquil, and passive, it is also intense, turbulent, and passionate.

This paradox of disinterested involvement, or passionate detachment, is the most prominent of the seeming contradictions that the aesthetic life asserts about itself. But it is by no means the only one, nor does it occupy any privileged position of importance and influence. If such priority is to be assigned, it belongs more properly to the paradox that is constituted by the twin assertions that art is unrealistic and yet reveals reality. As art presents things, and as we make their acquaintance in appreciation, they frequently wear a guise that is quite different from that in which we ordinarily discover them. Art distorts and disarranges things; it changes their proportions, inverts their sequences of occurrence, selects and emphasizes some aspects while neglecting or ignoring others, separates things that are normally together and juxtaposes others that are usually remote. In all of this, art seems to have no concern for what common sense calls reality, and deals, as we say, in fiction rather than in fact. But as opposed to this, we often feel that art yields us a revelation of things as they really are, and this point has been insisted upon by most aesthetic doctrines. These tell us that art, in apparently turning its back upon reality, is in fact shattering the disguises — or tearing aside the veil, or piercing the husk, or breaking down the barriers — that usually stand between mind and its object, and so is giving us our only glimpse of the essence or true being of things.

A variant terminology that is often used to describe this same paradox is that of the antinomy of creation and discovery, which occurs especially in our conception of the

personality and function of the artist. On the one hand, we regard and praise the artist as a "creator," as one who absolutely confers existence upon the objects that he makes. We feel and speak of the artist's works as springing entirely from his own mind and imagination, quite undetermined (though perhaps stimulated) by the touch of antecedently real things. But we also regard and praise the artist as a "discoverer," as one who makes his way to things, or aspects of things, that have been there all along but have hitherto been undiscerned. We refer to the artist's works as disclosing to us what he has found out about an order of being that is real in its own right and quite independently of the artist's intervention.[1] In short, the artist asserts of himself that his "creations" make manifest his "discoveries"; and art asserts of itself that it distorts "appearances" in order to reveal an "inner reality."

A further aesthetic paradox, closely related to the preceding, is the double claim that art is both an escape from life and a more intense participation in life. Our moments of appreciation do seem, in the time-honored phrases, to carry us above the turmoil and the pettiness of life as we are accustomed to it. It is as though we moved in a larger and clearer environment, where all confusion and obscurity had been removed and where vision and comprehension had full scope without impediment. When this quality of the aesthetic life is strongly emphasized, we get such doctrines as those of release, play, sublimation, pure art, the ivory tower, and art for art's sake. These concepts are the obvious outcome of theories which take with great seriousness a factor that is real and pervasive in aesthetic experience: namely, its feeling of self-containment and self-sufficiency, and of being set apart from the ordinary course of experience.

But the aesthetic life exhibits another quality that is just as

[1] This theme is very fruitfully explored in several of the essays in Eliseo Vivas's recent volume, *Creation and Discovery* (New York: The Noonday Press, 1955).

real and ubiquitous as this, and quite contrary to it: our moments of appreciation seem to bear directly upon the affairs and concerns of life, and to project us into the heart of these. Through aesthetic experience we become intimately involved with things, we participate actively in their interests and adventures, and so we see them as they see themselves. This point is most frequently put by saying that art deepens our sympathy for the things and situations — for the human persons and problems — it presents. It puts us more nearly in the place of the objects and personalities it depicts, and has us confront the world from their position rather than from our own. So it is held that through our appreciation of art we achieve a special sort of sympathetic understanding: we overcome the partiality of our prejudices and preconceptions, we live through situations from the inside instead of judging them from the outside, and so we are prepared to accept things on their own terms instead of rejecting them for not conforming with our demands. If our aesthetic encounters seem to carry us away from life during their actual occurrence, they also seem to return us to life with a finer and more profound sense of its problems and its possibilities.

The final aesthetic paradox that needs to be considered is in an important sense a summary of those already discussed; it describes the feelings that we have toward art as the result of these contradictions that we seem to find in appreciation. This paradox consists of the double conviction that art is at once useless and fraught with significance, purposeless and yet important. I think it can be argued that the position assigned to art and the aesthetic life in Western culture, from Plato onwards, is essentially defined by the tension between these two attitudes. On the one hand, it is felt that artistic creativity is one of man's highest and most precious gifts, that works of art have great value and deserve our deepest respect, and that the refinement of aesthetic taste is at once the task and the fruit of an advanced civilization. We take art very

seriously, we shower honors and even adulation upon artists, and we regard aesthetic education and sensibility as indispensable attainments of a cultivated person. Though there have been periods when art was neglected, and sects that have denied its significance and even castigated it as a vain pursuit, the far more usual attitude has been one of humility and awe.

But this is only one side of the situation. For though art has been adored, it has not been really accepted; if it is an object of adulation, it is also treated as an anomaly. At the same time that we sense the significance of the aesthetic life, we are forced to the uncomfortable recognition that we cannot say at all wherein this resides. We feel that the artist is important, but we do not know what contribution he makes. We feel that appreciation should be cultivated, but we do not know why. Though we pay every compliment to those who are intimately concerned with aesthetic affairs — as artist, critic, curator, or teacher — we still feel a definite sense of estrangement from them. The source of this confused attitude is our failure to grasp with any precision what role art fills, what function it serves, what it contributes to human well-being. We are unable to conceive art as a coherent part of the human enterprise, and the aesthetic life as a vital part of the human career. These seem, though pleasant and refined, to be useless and aimless. So however significant we sense art to be, we are still suspicious of it as an adornment of leisure that threatens to encroach too closely upon our essential tasks and interests; however we respect the artist, we still regard him as an alien; and however we may praise aesthetic appreciation, we still think of it as insulated from and irrelevant to our real concerns.

II

2. We must now follow up more closely the suggestion made in the preceding section that the most fundamental of these aesthetic paradoxes is that which concerns the relation-

ship of art to reality. Works of art seem, on immediate ac-
quaintance, to make a compelling reference beyond them-
selves, to embody a content that they have gathered elsewhere,
and to be in some sense symbols of the antecedently real.
Yet works of art make it equally clear that they are not copies
of what is already and otherwise known, that the meanings
with which they are burdened can be conveyed only by
themselves and in their own way, and that the content they
assert of reality is often at variance with our familiar notions
of what is real.

This paradox is basic for aesthetic theory for the simple and
sufficient reason that it raises basic issues: namely, those of
ontology. The problem that it poses is that of the ontological
status of the object of art. Art declares that it embodies sig-
nificant meanings about real things; in aesthetic experience we
appear to grasp an object that otherwise eludes us. Thought
feels compelled to accept this claim on empirical grounds,
but then cannot give a satisfactory theoretical explanation of
it. The paradox of art as both unrealistic and revelatory thus
arises not from any internal inconsistency in the aesthetic life,
but rather from the inability of aesthetic theory to account
for a characteristic that this life quite unequivocally asserts
for itself. That is, it arises because theory cannot identify an
order or aspect of reality that art alone discloses. This para-
dox — and the others with it — ceases to be such if we are
willing to make, and able to justify, the claim that the object
of art has a definite ontological status.

It is precisely this claim that modern aesthetics widely dis-
misses as meaningless or irrelevant. It has for sometime now
been characteristic of those who deal intimately with art to
be uncertain and uncomfortable about the relation of art to
reality. Artists, critics, and theorists alike temporize when
faced with the questions of the truth-value of works of art
and the knowledge-content of aesthetic experience. Since the
major portion of man's life is closely geared to the ideas of

truth and reality, this has inevitably brought it about that art has been separated from the common concerns of life, with tragic consequences to all parties. The paradoxes that we have been discussing are the reverberations of this separation in the domain of theory. If art is to be rescued from this position of isolation, thereby dissolving these paradoxes, it is important to realize more clearly the course through which it got there in the first place.

3. To understand the development of modern aesthetic doctrines, it is necessary to return to the theory of Arthur Schopenhauer, who, it can reasonably be claimed, was the last thinker to take art with deep and consistent seriousness. Schopenhauer held that art makes a significant and unique contribution to human culture because it discovers, and imitates, and discloses to us an order of being to which we would otherwise be blind. But besides asserting the dignity of art — an assertion that is hardly unusual — Schopenhauer accounts for this by a precise identification of this order of being that is the peculiar object of art, and by a careful analysis of the manner in which the artist reaches and presents it. The power of art is here explained by reference to an explicit and systematic ontology.

This theory is based upon the traditional dualistic metaphysics, with its central distinction between the realms of Being and Becoming, the ideal and the actual, Platonic Ideas and physical particulars, reality and appearance, the permanent and the transitory. Ultimate reality — that which Plato called the ὄντως ὄν and Kant the *ding an sich* — is identified as Will. This Will objectifies itself through several orders, or grades, of being. The manifestation of Will that is most familiar to us is that of the innumerable individual objects that we conceive through the categories of space and time, quantity, causality, and the other modes of the principle of sufficient reason. These objects are constituted as such solely

by the structure of our intellects; our knowledge of them is immanent and abstract, interested only in discerning the relations among them, their impact upon us, and the ways in which we can control them.

Will also objectifies itself in the form of Platonic Ideas, which are the "determined species" of all natural bodies and the "general forces which reveal themselves according to natural law." [1] These Ideas constitute a superior order of reality, spiritual and immutable, having both temporal and metaphysical priority over the world of physical objects, which is derivative from them. Since Ideas have these characteristics, they cannot be known through the logical operations that mind employs in knowing finite things; and they cannot be "used" by man to serve his ends or satisfy his appetites. Ideas impose themselves upon inferior grades of being, including all that is finite and physical.

Schopenhauer holds that the normal and usual habitat of man, the focus of his concern, is the world of physical particulars; man is held there by his individual will, which requires these things as instruments to its purposes. Consequently, our attention and interest are predominantly devoted to understanding and manipulating the physical environment, with all of our energies bent upon the satisfaction of the self. However, it is possible for man to overcome this bondage to his individual will, and to shift his attention from physical particulars to Platonic Ideas. We realize this escape from appearance to reality, from Becoming to Being, in aesthetic experience. The passage in which Schopenhauer describes this transition is so acute, and has been so influential, that it deserves a full quotation:

If, raised by the power of the mind, a man relinquishes the common way of looking at things, gives up tracing, under the

[1] Arthur Schopenhauer, *The World as Will and Idea*, trans. R. B. Haldane and J. Kemp (London: Kegan Paul, Trench, Trubner, 1896); book III, para. 30, at p. 219.

guidance of the forms of the principle of sufficient reason, their relations to each other, the final goal of which is always a relation to his own will; if he thus ceases to consider the where, the when, the why, and the whither of things, and looks simply and solely at the *what*; if, further, he does not allow abstract thought, the concepts of the reason, to take possession of his consciousness, but, instead of all this, gives the whole power of his mind to perception, sinks himself entirely in this, and lets his whole consciousness be filled with the quiet contemplation of the natural object actually present, whether a landscape, a tree, a mountain, a building, or whatever it may be; inasmuch as he *loses* himself in this object (to use a pregnant German idiom), i.e., forgets even his individuality, his will, and only continues to exist as the pure subject, the clear mirror of the object, so that it is as if the object alone were there, without any one to perceive it, and he can no longer separate the perceiver from the perception, but both have become one, because the whole consciousness is filled and occupied with one single sensuous picture; if thus the object has to such an extent passed out of all relation to something outside it, and the subject out of all relation to the will, then that which is so known is no longer the particular thing as such; but it is the *Idea*, the eternal form, the immediate objectivity of the will at this grade; and, therefore, he who is sunk in this perception is no longer individual, for in such perception the individual has lost himself; but he is pure, will-less, painless, timeless *subject of knowledge*.[2]

This transition is radical. We here repudiate the mixed cognitive and emotive bias that usually dominates experience and defines our concern, we escape from the limitations of the self and the world, and we know things in terms of their essential being. So Schopenhauer must complete his theory by indicating the vehicle through which this transition is wrought. This vehicle is "Art, the work of genius." Art "repeats or reproduces the eternal Ideas grasped through pure contemplation, the essential and abiding in all the phenomena of the world; and according to what the material is in which it reproduces, it is sculpture or painting, poetry or music. Its one source is

[2] Schopenhauer, para. 34, at p. 231.

the knowledge of Ideas; its one aim is the communication of this knowledge." [3]

The doctrine that Schopenhauer develops on this foundation is perhaps the most sensitive and complete account of the aesthetic life that has ever been rendered. There is no need to enter into the details of this account, but its relevance to the paradoxes discussed above must be indicated. This theory resolves these paradoxes, and reconciles the apparent contradictions of art and appreciation, in a brilliant manner. The aesthetic experiences that art makes possible are detached and disinterested because they are encounters with objects — Platonic Ideas — that have no import for the self and cannot be bent to the service of the individual will. But such experiences are intense and meaningful because they bring us into touch with the ultimately real, the source of all else that is. Again, the objects that art presents to us in appreciation seem unreal as measured against the concepts and standards that reason has derived from its partial and prejudiced consideration of physical particulars; but this artistic presentation is a revelation of an order that is far more real. Similarly, art is an escape from the endless and meaningless routine of life that is governed by subjection to the will, with satiation following hard upon desire and with frustration as the only alternative; but art raises us to a plane where we participate in life from the standpoint of the force that underlies it, and so we are able to envisage the vicissitudes of life as episodes in a larger and more meaningful pattern. Finally, our aesthetic moments are useless and even purposeless so far as furthering the interests and contributing to the satisfactions of the individual self; but these moments are the most significant in life, as it is in and through them that we overcome the limitations of selfhood and associate ourselves with the unchanging source of all life and existence.

This theory, which is so sensitive and consistent, has only

[3] Schopenhauer, para. 36, at p. 239.

one serious weakness. But that one, unfortunately, is fatal: the ontology on which it is based is thoroughly uncongenial to the modern temper and has been widely rejected. Even granting the descriptive adequacy and the explanatory power of Schopenhauer's interpretation of art, this theory still has to be denied because its metaphysical and epistemological principles are largely unacceptable to contemporary thought. Our regnant philosophies have been positivistic in their outlook: they tend to equate being with physical existence, defined in spatio-temporal terms, and they tend to regard the methods and results of scientific inquiry as exhausting the significant meaning of things. Consequently, the modes of being that Schopenhauer identified as the objects of art — the entities that art discloses — are excluded from any status in reality. The whole theory then falls to the ground in the manner, as Hippolyte Taine described it, of "un vaste ballon gonflé." [4] The subsequent history of aesthetics consists to a large extent of the search for a body of ideas that will be at once acceptable to the new modes of thought and adequate to the persistent facts.

This climax and denouement are of course much more dramatic in retrospect than they were felt to be by those who engineered them. These men knew that something had to be done, but they had no idea that the operation would be as radical as it later proved. Schopenhauer's fundamental aesthetic category was the concept of imitation: art is accepted as being self-evidently an imitation, and the problem that theory inherits is to explain what art imitates and how it does this. In Schopenhauer's hands, imitation is a creative act: in artistic activity the mind reaches out to what it had not appre-

[4] In a review of the French edition of *The World as Will and Idea* that appeared in the *Journal des Débats* for March 4, 1874. The article is reprinted in H. Taine, *Derniers Essais de Critique et d'Histoire*, 36th ed. (Paris: Hachette, 1923). I have discussed in detail this question of the historical and theoretical origins of expressionism in an article "Hippolyte Taine and the Background of Modern Aesthetics," *The Modern Schoolman* 20 (March 1943).

hended before and could not apprehend in any other manner. The artist must first discover in the realm of Being what he then embodies (realizes) in the realm of Becoming: he makes Ideas actual. In aesthetic experience — through works of art — men do not rehearse a familiar lesson but scan an utterly new text. Culture is enriched by art, not merely edified or amused.

The theories that immediately succeed Schopenhauer still speak his language and think in his terms. Taine and the new "scientific aestheticians" retain imitation as their basic category, and refer to the artist as stripping away the appearances of things and revealing their essences. But the logic of their position soon overtakes them. On their own terms, such talk is mere babbling. If Existence exhausts Reality, and science is adequate to describe Existence, then there is no mode of being which is the proper object of art. Imitation is hereby reduced to a servile copying of the obvious and superficial characteristics of things, and the word soon drops from the vocabulary of aesthetics.

But the theory does not share the fate of the word. Indeed, it seems, in the final analysis, that only some form of the doctrine of imitation is capable of affording a satisfactory explanation of art. For as soon as we make our aesthetic coherent with our ontology, the relation of the work of art to its object becomes, in however refined and sophisticated a sense, an "imitative" relation. When the critics and the theorists have exercised their finest subtleties, and have thereby all but destroyed the significance of art, they return to some naive or esoteric variant of imitation to recover the body of their subject.

This is a measure of desperation for the new schools, however, and is resorted to only surreptitiously and when all other alternatives have proved inadequate. The serious weight of inquiry is directed instead to the search for a new aesthetic category — a new frame of reference — in terms of which to

describe and explain the phenomena of art. Three such categories have dominated modern aesthetics.

4. If art can no longer be rooted in reality, probably the most obvious place to root it is in the artist. Thus arises the theory of expression. This path is taken early: Taine stumbles into it without quite knowing where he is; Tolstoy and Veron follow it purposefully; Croce and Collingwood pursue it to its logical conclusion. Expressionism has made notable contributions to aesthetics. But it remains a truncated theory because it is unable to give a consistent and satisfactory answer to the question of what it is that is expressed in art. If this is merely the artist's personal emotions, it is hard to see how art can claim much significance. If it is the same aspect of the same order of reality as that dealt with by science, it is hard to conceive art as other than a temporary stand-in while we await more exact knowledge. If it is something that already exists in the mind in some other form, it is hard to envisage art as more than translation and embellishment. If it is some special realm to which art alone has access, it requires more precise identification and substantiation than is afforded by such current doctrines as that art discovers "values" or "ideals" or "surface qualities" or "spiritual reality." Expressionism, when pressed, exhibits an unwillingness to hold to any of these positions, but retreats circularly from one of them to another.

As this calculated ambiguity of expressionism becomes manifest, the search for a basic aesthetic category begins afresh. One place to look for this is within the texture of experience: art is defined by reference to the response that it elicits, and the character of art is to be elucidated by a scrutiny of the nature of this response and of its place in the economy of the psyche. There has been a horde of such psychologistic theories, most of which derive in one way or another from the various writings of I. A. Richards, and they agree on only

one point of substance: that aesthetic experience is noncognitive. These theories may be primarily hedonistic, emotive, sensual, contextualistic, therapeutic, or linguistic. Art is variously defined in terms of pleasure, play, release and sublimation, pure perception, the formation of attitudes, or as a symbol that is its own denotatum or designatum. But whatever the positive interpretations that these doctrines propose, they agree on the negative tenet that art does not embody any meaningful and significant content. Though art is held to serve a multitude of purposes, it is never admitted to have an antecedent object.

When these efforts to explain art by reference to processes in either the artist or the appreciator have proved unsatisfactory, there is only one obvious path that remains open: this is quite simply to root art in itself. This is the path that is taken by formalism. The work of art is held to be an independent and self-contained entity: constructed only in accordance with the principles of its medium and of its own internal nature; having no reference beyond itself; and constituting its own texture of values. The effort to explain art in terms of form, like the parallel effort of expressionism, has placed all aestheticians in its debt. Its advocates have done much to clarify the principles of design in the various arts; they have given us some of our most penetrating criticism; and, most importantly, they have fought to preserve the work of art against the erosion of textual, biographical, sociological, and psychological interpretation. But they eventually find themselves threatened with futility because they have isolated art from all extra-aesthetic sources. If art is declared to be pure form, or absolute construct, the problem of its apparent significance can be settled only by the alternatives of nihilism and mysticism; and the first seems as untrue as the latter is unfruitful.

To the extent that these three suggestions for a basic aesthetic category prove unacceptable, and if thought is still reluctant to define art in terms of its object, there is only one

recourse left. This is to deny that the aesthetic life is marked off by any quality or function or outcome that is peculiar to it. This is the position adopted by John Dewey, and it has been quite influential. The point of departure of this movement is the conviction that expressionistic, psychologistic, and formalistic doctrines have all tended to interpret art in terms that are too restrictive and exclusive, and to relegate it to an only incidental or esoteric role in life. As against such a view, the thesis upon which Dewey and his followers insist is that aesthetic experience and art represent a natural development of general human impulses, a culmination of traits and tendencies that are pervasive in all of man's activities. All experience has an aesthetic texture just to the extent that it is coherent and satisfactory as experience. All human doing and making exhibit an artistic motive and quality just to the extent that they are engaged in and enjoyed for their immediate exercise and outcome.

In *Experience and Nature*, where he is dealing only incidentally with aesthetic questions, Dewey states his position thus: ". . . delightfully enhanced perception or esthetic appreciation is of the same nature as enjoyment of any object that is consummatory. It is the outcome of a skilled and intelligent art of dealing with natural things for the sake of intensifying, purifying, prolonging and deepening the satisfactions which they spontaneously afford." [5] In *Art as Experience*, some ten years later, he develops the same position more fully, and sums it up in these terms: "I have tried to show . . . that the esthetic is no intruder in experience from without, whether by way of idle luxury or transcendent ideality, but that it is the clarified and intensified development of traits that belong to every normally complete experience. This fact I take to be the only secure basis upon which esthetic theory can build." The definitions of appreciation and art

[5] John Dewey, *Experience and Nature* (Chicago: Open Court Publishing Co., 1925), p. 389.

follow from this. "That which distinguishes an experience as esthetic is conversion of resistance and tension, of excitations that in themselves are temptations to diversions, into a movement toward an inclusive and fulfilling close." "Art denotes a process of doing or making. . . Man whittles, carves, sings, dances, gestures, molds, draws and paints. The doing or making is artistic when the perceived result is of such a nature that *its* qualities *as perceived* have controlled the question of production." [6]

This doctrine has great intrinsic merits. And historically it has been of value in counteracting the influence of all those schools that define art by reference to some limited faculty or domain. But I think the movement goes too far in its protest. In its quite proper anxiety to bring the aesthetic life back within the orbit of man's vital concerns, it obscures the distinctive character and function of aesthetic activity, and submerges this in the undifferentiated continuum of the human career. That is, the advocates of this position identify appreciation and art in sheerly quantitative terms, as an intensification of any moment of awareness and any course of activity whatsoever. The aesthetic life denies this purported description and explanation of itself, because it asserts that it has a distinctive character and makes a unique contribution.

This brief account is admittedly perhaps closer to ideal history than to real chronicle. What has been occurring in modern aesthetics is a great deal richer and more complex than is brought out by this purposely foreshortened narrative. But it might be claimed that this account fairly indicates the intellectual revolution that gave rise to contemporary schools of aesthetics, depicts the pattern of their development, and points up the unsolved problem that lies at their roots.

This problem is, of course, that of identifying the aesthetic

[6] John Dewey, *Art as Experience* (New York: G. P. Putnam's Sons, 1934), pp. 46, 56, 47–48. Italics in original.

object. That is, it is necessary to describe the order or aspect of reality that stands as the antecedent subject matter of the artist, that is realized through expression and creation and presented as the content of art, and that we grasp as the aesthetic object in appreciation. This can be labeled indifferently the object of art, emphasizing the artist's search and discovery of it; or the aesthetic object, emphasizing its embodiment in the work of art and its disclosure to us in aesthetic experience. The paradoxes of the aesthetic life are resolved immediately we can specify this object in a manner that satisfies three conditions: it must be real and meaningful in itself, it must be relevant to human concerns, and it must be adequately disclosed only by art and in aesthetic experience.

Chapter *VII*

THE AESTHETIC OBJECT

I

1. The theoretical basis on which it is here proposed to identify the aesthetic object, and to resolve these paradoxes, has been developed in detail. In the application of these general ideas to this specific but central problem, there are two points, both previously stressed, that will need to be kept constantly in mind. Otherwise the account now to be given might appear as an abrupt *volte face*.

In the first place, it must be reëmphasized that there are no pure occurrences in experience. Every conscious occasion reflects the action of all three of man's psychic components. Those experiences that are even the most intensely aesthetic still contain cognitive and affective aspects. The things that on such occasions we grasp primarily in terms of their particularity still bring with them overtones of their connectedness and import.

In the second place, it must be reëmphasized that art, though it deals with particularity, nevertheless has a universal reference. Actual things are similar, though never identical, and recognition is a pervasive function of mind. We therefore transfer the content and meaning of works of art to the familiar denizens of the everyday world.

The implications of these propositions need only be made explicit to afford a simple account of the aesthetic object. The things that we discern in aesthetic experience, and that are more richly disclosed through art, are precisely the same as those that we encounter in all experience, of whatever mode or level this may be; they are what have previously

been described and exemplified as constituting the catalogue of actual things or occasions. The aesthetic object is such an actual thing envisaged as absolutely concrete and determinate. Aesthetic objects do not comprise a separate class, having independent being; they are not a special order of reality. It is not the case that there are three distinct realms of being, one composed of facts, another of values, and another of entities. There is one order of being, infinitely various and complex, composed of actual things or occasions. The connectedness, the import, and the particularity of things are dimensions, not realms, of being; every actual thing participates in all three dimensions.

The material with which art deals — its subject matter or point of departure or referent — is identical with that of common experience, and so with that of theory and technology: it is the realm of actual things. Art transforms these things into aesthetic objects by concentrating its regard upon them as being unique and just themselves. But this concentration is never complete, and does not altogether exclude from awareness the connectedness and the import of things; these latter aspects, which are just as real, as significant, and as pervasive as particularity, recede toward the periphery of attention, but they do not disappear from view. What we have offered to us as the aesthetic object — as the content of art — is an intensified vision of the concreteness and determinateness of some actual occasion. But because no experience is pure, and because art has a universal reference, when things appear as aesthetic objects they are not purged of their entanglement with other things and with ourselves. As transformed into an aesthetic object, the thing asserts its particularity and uniqueness; as the subject that undergoes this transformation, the thing asserts its composite character. These assertions go hand in hand, and give rise to the paradoxes of aesthetics.

The resolution of these paradoxes resides in this dual role that is played by the aesthetic object, and in the consequent

duality that is laid upon aesthetic experience. When our attitude is primarily aesthetic, attention is centered upon some concrete particular, and any reference beyond this, to other particulars, to the self and its purposes, to ideas and concepts, is greatly inhibited. The aesthetic object is detached from the environment of other things, as well as from the human neighborhood, and the relations that ideas and emotions trace outward from it are severed. But even in the course of experiences that are intensely aesthetic, this attitude does not maintain its dominance continually and without competition: it is challenged by our natural concerns for the import and the connectedness of things. The aesthetic object is retransformed and replaced in the dimensions of the self and the world: we consider the meaning it reflects upon these, and our apprehension of it is modified by this deepened awareness. So throughout the aesthetic life there is a perpetual tension and vacillation between these two tendencies, one seeking to grasp things on their own terms, the other seeking to absorb things into our total interests. These two moments, which will obviously have a content and quality that are quite different, alternate with and interpenetrate one another throughout the course of each occasion that still remains a single, unified, and continuing aesthetic experience. It is their compresence in the aesthetic life that gives rise to the paradoxes that loom so large within it. This summary statement of the character and status of the aesthetic object can now be expanded as it is applied to the resolution of these paradoxes.

II

2. The common substance of conscious life is a closely knit fabric of particularity, import, and connectedness. We fracture the things we encounter into images, emotions, and ideas; and simultaneously we weld these diverse views into a single coherent picture. As we grasp things and ensconce them in experience, we note their individuality or uniqueness

or "thisness"; we feel their immediate impact and sense their more remote repercussions upon ourselves; and we refer them to an already accumulated and prepared body of ideas, which establishes their pertinent relations with other things. Our usual dealings with the world are dispersed at about the same intensity through these three dimensions. Attention plays back and forth across them, fusing what it takes from each into a composite interpretation, and so building up at once our "normal" conceptions of things and our "normal" attitudes toward them.

But attention may on any occasion be concentrated on one of these dimensions. The usual routine of life is then interrupted in order to be intensified, and experience takes on a special quality. It is when our regard is focused on particularity, and things are viewed as aesthetic objects, that experience wears the peculiarly aesthetic traits of disinterestedness, detachment, and distance. The reason for this is simply that in so viewing things we at once weaken the attention that we pay to the import of things for ourselves and their connectedness among themselves. We consequently drain away from experience much of the quality that accrues to it from our sense of these latter aspects of things, while we heighten the quality that accrues to it from our realization of their uniqueness.

The first result of this is to make our regard for the concreteness and determinateness of things a great deal more acute and sensitive than it usually is. We alert ourselves, and take pains to grasp the aesthetic object with all of the depth and discrimination that lie in our power. We take heed of nuances of character and structure that we would ordinarily overlook altogether or dismiss as inconsequential. The aesthetic object that is taking form and substance in experience enthralls us, we are anxious lest we miss even the slightest of its aspects, and we bring all of our faculties to bear upon the effort to obtain a clear and complete vision of it.

Consequent upon our absorption in its particularity, the

aesthetic object is detached from its usual contexts and many of its customary associations are disrupted. It is removed from its lodgment in the framework of our ideas and purposes, and so it loses a large part of its relevance for our normal interests and concerns. The more intensely we experience a thing as unique and determinate in its own right, the less apt are we to experience it as similar to other things and as portentous for ourselves. It is so much itself that it sheds the general meanings and significances that we habitually find in things. The aesthetic object impresses itself upon us on its own terms instead of being taken and forced into the settled patterns of our modes of thought and feeling. The result of all this is to give to aesthetic experience, in one of its moments, the aura of disinterestedness, detachment, distance, passivity, and purgation that is so famous.

But this is only half of the story. As we have seen, the total aesthetic experience also exhibits the qualities of involvement and turbulence. Since the aesthetic life consists of encounters with the same things that we meet in all of experience, which are only transformed but not destroyed as such in becoming aesthetic objects, and since we participate in these encounters with our total selves, it is only natural that this should be the case. The specifically aesthetic concern for the uniqueness and determinateness of things is preponderant and controlling; but it always shares attention to some extent with our concerns for the location of things in a public environment and for their presence in our private lives. And in the course of even intensely aesthetic experience these latter concerns will from time to time become dominant and interrupt appreciation. The mind plays upon the thing before it with all of its resources, both natural and acquired: with the faculties that it brings into the world, and the experience, in the form of ideas, emotions, habits, memories, and purposes, that it has accumulated in its passage through the world. So we never really lose sight of the presence of things in the dimensions

of the self and the environment. This double awareness is always present, even though in the background, lending depth and body to aesthetic experience, filling it out, and giving to it much of the vague but heavy portent that is so characteristic a feature of it. As we see more clearly the particularity of things, we prepare a sharper realization of their impingement upon us and of their place in the total scheme of things. This realization may come to full maturity only later, when our attitude ceases to be aesthetic, becomes instead either cognitive or affective, and we set out intentionally to absorb what we have learned of the actuality of things into the patterns of our ideas and purposes. But we usually deal with things in all of these dimensions simultaneously, however our regard may be concentrated upon one of them. Even when our experience is dominantly aesthetic, we are apt to be tracing out the fresh indications of connectedness and import that are opened to us by our invigorated sense of particularity. So it is to be expected that such experiences should be intense, should involve us passionately, and should draw us to an intimate participation in the things and events that they depict.

3. From a strictly phenomenological point of view, the paradox of disinterested involvement is the most important of the aesthetic paradoxes because it is the most prominent: it describes the quality that is most pervasive and characteristic in aesthetic experience. But from a dialectical point of view, the paradoxes that center around the relation of art to reality and to life — and especially the former — are more important because of the ontological questions that they raise.

It has already been argued that all of these paradoxes have the same essential structure: they arise because the aesthetic life always contains two moments, or phases. In our appreciation of art and beauty we seem at first to act as strictly aesthetic agents, and to make the acquaintance of things solely on their own terms. But as this acquaintance ripens it involves

us as complete human beings, our interest becomes more balanced and inclusive, and we draw things within the matrix of our accumulated experience and our total concerns. At one moment the aesthetic object is just itself, isolated from all other objects and from ourselves; at another moment we become aware that behind the aesthetic object there stands a full-bodied three-dimensional thing, which then takes its place in the world of things and in our own lives.[1] In the language that has been defined earlier, now the aesthetic object is only an entity, now it is also a fact and a value. Art always leads this double life in our encounters with it.

I would now further suggest that the more specific paradoxical qualities of aesthetic experience (which seem to be derivative but are actually constitutive) arise because of the different points of view from which we regard art when, in the second moment of our acquaintance with it, we destroy its isolation and absorb it into the fabric of our lives. The aesthetic object has both a primary and a secondary status. Its primary status, which it occupies when our regard for it is dominantly aesthetic, remains constant, and is that of an entity. Its secondary status, which it occupies when our regard is more wholly human, is complex and variable.

During the intensely aesthetic moment of appreciation, art appears to be utterly unconnected with reality or life. The aesthetic object is remote and self-contained, seeming to need no support from actual things and to shed no light upon them. But our attitude soon changes, becoming broader and

[1] It should be noted that this "thing that stands behind the aesthetic object" is not necessarily, or even frequently, a single concrete particular. The "imitation" of art is much more than portraiture or depiction of the individual. The reference that we find in the aesthetic object is more usually a universal meaning, of the kind proper to art, which sheds light on many particulars. As it was put earlier in the discussion of expression (Chap. V, Sec. i), this meaning is the precipitate of many prolonged and matured experiences on the part of the artist; similarly, it illuminates our acquaintance with a whole range of actual things or occasions. This point is developed more fully in the final section of the present chapter.

more cohesive. To the extent that this secondary regard becomes cognitive, we retransform the aesthetic object into a fact. Or, to be more exact, we treat this object — the content of the work of art — as factually meaningful. We refer this content quite confidently and spontaneously to the regions of our familiarity, and this has the effect of bringing these regions more vividly before us, of extending and refining our acquaintance with them. We realize that art conveys meanings which bear upon the character of actual things, and which are relevant to the real world.

But we also realize that art is unrealistic in the sense that it often does violence to our settled conceptions of things: it flaunts our established modes of perception, it disrupts our ordered interpretations, and it challenges our values. The artist distorts and disarranges, selects and emphasizes, separates and juxtaposes things in ways that make them seem quite foreign to us. Yet all the while art is doing this, it insists, in our experience of it, that it is carrying us closer to the heart of things, and is showing them to us more nearly as they really are. Art deals with the things of the common world, familiar to us in ordinary experience; it wrenches our accustomed ways of viewing and interpreting these things, ways that have been slowly and carefully developed, that are widely held in common, and that are acknowledged to be effective guides in our dealings with things. And art claims that this "unrealistic view of reality" that it presents is a sound and valid revelation. How can this be?

This can be, and is, for the simple reason that art, in focusing our attention upon particularity, gives us a view of things that contains at once both much more and much less than we are accustomed to in our ordinary casual experience. Our usual encounters with things are a rather close fusion of aesthetic, cognitive, and affective moments. We make the acquaintance of things by continually shifting our regard from one of these perspectives to another, paying heed now to the

actual thing before us, now to its location in the world of things, and now to its impact on us; and at the same time we fuse these moments into a single cohesive whole. In our ordinary experiencing of things, we sacrifice some of their particularity, some of their connectedness, and some of their import — and usually a great deal of these — for the sake of getting what seems to be the important part of each within the focus of experience and in satisfactory proportion with one another. That is, we normally sacrifice intensity and fineness of vision in order that this may be more facile and inclusive. This is even more true of our accumulated and established conceptions of things: of what can best be called our habits of experience. These habits consist of stereotypes, class-concepts, settled beliefs, abstract and general ideas, prejudices, preferences and other such elements which are the gradual precipitation of past experience and which largely determine what we expect to experience, and so do experience, on recognizable occasions in the future. These habits of experience are a blended selection of what we have come to regard as the more conspicuous and significant aspects of the particularity, the connectedness, and the import of things. Partly as the result of our own repeated encounters with similar things and situations, and partly as the result of social inheritance and training, we accept as especially important certain of the actual characteristics of things, certain of the relations that hold between them, and certain of their human consequences. That is, we acquire convictions as to what things are as entities, as facts, and as values. These convictions, of course, are never completely settled and inflexible: they vary somewhat from person to person, and they hold in suspension various elements that are precipitated out in different ways on different occasions. Water is not the same thing to men who are thirsty, or dirty, or drowning; nor to people who have been brought up near the ocean, in the mountains, or on a river bank. But

men's habits of experience are to a high degree common and constant, and especially so within a cultural group.

For my present argument, the point to be emphasized is that these habits are the dominant factor in determining and defining what men regard as real. Reality, or the realness of things, is that selection of their particularity, their import, and their connectedness that men have come to accept and expect. When we view things aesthetically, and especially as the trained and specialized vision of the artist grasps and presents things, we get both more and less of them than these habits contain.

In the first place, our attention is concentrated on the particularity of things, with a relative neglect of their import and connectedness. The artist forces us, or we happen of ourselves, to become so enthralled to the actual character of things that we overlook their relations with other things and with ourselves. At the very least, this disrupts our habits of experience, wrenches us from our preconceptions, and presents things to us on terms that are novel and strange. A river becomes something to be merely looked at as being what it is, with a rich character of its own, and not also something to be understood by reference to the surrounding topography and to be used as a means of transportation or water-supply. An illicit love affair is something to watch developing before us, with its accidental beginning, its casual episodes and intense crises, its gradual disintegration into boredom or quarreling, its repercussions upon the various parties involved by it. It is only incidentally something to be explained in terms of childhood neglect, a nagging wife, a busy husband, a scheming secretary, or a search for even spurious glamor to relieve the dullness of children and cooking; and it is only incidentally something for which blame is to be assigned, and of which the consequences are to be assessed. Because of this emphasis upon one dimension of things, and this neglect of their other dimensions, the aes-

thetic object defies our habits of experience and assumes the aura of unreality; it is not an object such as we are accustomed to, and so we tend to regard it as a thing which does not "really" exist.

If this emphasis and neglect are carried to any great extreme, we are apt to go beyond the mere negative charge of "unrealness" and accuse the artist of being irrational or immoral. Common sense feels that it is wrong of artists to deal with things in terms that do violence to our cognitive and affective habits. The artist is charged with perverting the nature of things, with exposing what is better left hidden, with destroying man's simple faith and confounding him with false subtleties; and, what is worse, he is charged with condoning and even sympathizing with actions that should be condemned. Murderers, adulterers, thieves, and villains generally should be punished, not revealed to us as creatures like ourselves who are driven by circumstance, accident, and compelling purpose to do what for them is a concrete act, not an item under a rubric. This view has even been carried to the point where the censors of popular entertainment will not permit a "bad" person to come to a "good" end, or a "wrong" action to be "rewarded." This reflects the normal — and in some respects even the healthy — common-sense insistence that a thing is its connectedness and its import, as well as being itself, and that these must always be taken into account in any treatment of the thing. The artist insists that a thing is above all its particular self, and that we are not justified in restricting and torturing it into the shape demanded by our habits. Art often strikes us as unreal because in our usual dealings with things we are so intent upon their relations and consequences that we do not grasp with any richness or acumen their individual contours. A man who kills himself is a suicide; he is driven to this action by bankruptcy or ill-health or general despair and hopelessness; and the consequence of his act is the impoverishment of his family. The course through which Quentin Compson, in Faulkner's *The*

Sound and the Fury, came to his end in the River Charles is so far outside the range of these clichés and biases that it must put a great strain upon our sense of reality. And even so "realistic" a play as Arthur Miller's *Death of a Salesman* forces us to expand and reanimate our dulled habits in order to include it within the reality they define. To the common-sense accusation that he distorts reality, the artist replies in kind. And one measure of his art is his success in leading men to enlarge their habitual views and interpretations of things, their rational stereotypes and their moral prejudices, so as to accommodate the particularity that he has presented.

But this focusing of attention upon particular things as such, with its consequent neglect of their connectedness and import, is not the only feature of art that lends it an air of unreality. For, in the second place, artists are very highly selective even in their treatment of particularity. The poet and novelist and dramatist, the painter and sculptor and architect, the composer and the choreographer, grasp and present only a segment of the actual character of things. The particularity that is made available to us in our encounters with things is manifold. The envisagement of things at which we have gradually arrived, and which we have then enshrined in our habits, is like a thin layer stripped from the surface of these encounters: it represents a great many of the facets that things expose to us, but it represents none of these with any great depth or refinement. These habits of experience which furnish our familiarity are hasty and shallow composites of the richly various particularity that is there to be experienced. These habits compose our picture of reality. Which is to say that, from the point of view of common sense, the real is largely synonymous with the familiar.

What the artist does, almost of necessity, is to concentrate his gaze upon only some of these facets of things. And he explores these chosen facets with a persistence and acumen that are altogether foreign to common sense. He insists with great vigor upon those aspects of particularity that interest him; and

in advancing these he is quite ruthless in his disregard of other aspects, which he alters or even suppresses when they threaten to obtrude upon and interfere with his pursuit of his goal. The frequent response of common sense to this artistic treatment of particulars is to accuse the artist of distortion, carelessness, willful untruth, perversity, and lack of balance. This richness of the character of things, and this narrowing and intensification of the artistic vision, can be verified with casual ease from any of the arts. The varying ways in which Van Gogh, Cézanne, Turner, Claude Lorrain, Henri Rousseau, Watteau, Manet, Kandinsky, and Braque paint a landscape is an obvious illustration. Each has selected some aspect of this, and has been obsessed to bring it vividly before attention: each is saying, "see, this is what a landscape is; look at this, and don't bother about all the other features; they are only incidental." The difference between them lies only in their identifications of the essential and the fortuitous. Again, we have novelists depicting the quality of the human adventure in such diverse terms as those of Jane Austen, Dickens, Trollope, Faulkner, Dostoyevsky, Proust, and James Joyce. We have composers who feel man's emotional involvements with the world in such different ways as Beethoven, Mozart, Brahms, Debussy, Wagner, César Franck, and Schoenberg. Even with respect to areas of experience where we would the most expect a wide and fixed agreement about the particularity of things, we find artistic disagreements of an extreme sort. Religious and domestic architecture illustrate this point. We would anticipate a common view of what constitutes devotion, of the proper attitude with which we should approach God, and of the sort of edifice that best expresses and stimulates this. And we would certainly expect a firmly settled view of what a home should be. But we find neither of these. Religious architecture, even in any one sect, varies enormously: it may stress magnificence or simplicity, opulence or sternness, majestic awe or humble communion, soaring hope or passive renunciation. While a home

may be designed with primary emphasis on convenience or impressiveness, its physical site or its owner's personality, its materials or the furniture it contains, family life or expansive entertainment.

What common sense through habit accepts as real things have all of these characteristics, and none of them strongly. A landscape has solidity, a geometrical pattern, color, atmosphere, surface quality, light and shadow, and other traits. A home is a place to relax, to entertain, to exhibit one's possessions, to sleep and eat, to look at, and to express one's personality. We feel close to God and remote from Him, we seek His justice and His mercy, we love Him and fear Him, we are humble and proud before Him, we are sad and joyous in our thoughts of Him. The real things that have become our familiars are shallow composites of many characteristics, and these frequently clash. When the artist fastens upon some one or few of these, and pursues them relentlessly, the logic of his experience will often lead him to neglect or deny other characteristics that are equally parts of the reals that we accept. So common sense says that art is unrealistic, and on its own terms it is right.

But common sense also says that art reveals reality. If there is no special private realm to which art gives man access, this can only mean that art ultimately yields a richer and finer view of just those real things that it seems at first to distort and betray. When we say that art is unrealistic we mean, essentially, that it gives us much less of the *totality* of things than our habits of experience have accumulated and accustomed us to. When we now say that art reveals reality we mean, essentially, that it gives us much more of the *particularity* of things than our habits of experience retain and make available to us. By narrowing and concentrating our regard for things, the artist leads us to discover aspects of them that we have hitherto overlooked, or have long forgotten, or have rejected as unimportant, or have simply relegated to the amorphous back-

ground of awareness for no good reason save that they do not especially appeal to us.

The insight into particularity that the artist gives us, however outrageous it appears at first glance, proves on further acquaintance to be relevant and illuminating. We are brought to the vivid realization that actual things and events do have those characteristics that the artist is insisting upon. Memory is stimulated, and we relive past encounters with such intensity and acuteness that we now discover to have been present and important in them, elements that we had never noticed at the time. Our attention is alerted and directed in such a way that there emerge sharply from this actual encounter features that before we have only vaguely suspected. Our interest is given an orientation and focus such that we approach future encounters with a definite anticipation which enables us to seize from them much that would otherwise have gone unrealized.

The paucity and fragmentariness of our ordinary experience of things are notorious. The accusation has been made over and over again that we see instead of looking, that we hear instead of listening, that we know instead of understanding, that we believe instead of learning, that we react instead of feeling, that we judge instead of sympathizing, that we take exercise instead of enjoying the play of nerve and muscle. Bergson has summed up this charge in his usual happy way in saying that we do not really attend to things, but merely seek to recognize them: "Enfin, pour tout dire, nous ne voyons pas les choses mêmes; nous nous bornons, le plus souvent, à lire des étiquettes collées sur elles."[2]

Art fills in the gaps and repairs the fractures that yawn so largely in our ordinary experience of particular things. The artist sharpens the contours of things, and brings us to a fuller and more acute discovery of what they offer to experience. By his treatment of the various elements and aspects of things,

[2] Henri Bergson, *Le Rire*, 82nd ed. (Paris: Presses Universitaires de France, 1947), p. 117.

he gives these a prominence that we have to notice. And it is a short passage from this artistic apprehension to the realization that these same elements and aspects are real and important in actual things. When we recognize this, we cease to speak of art as unrealistic, and begin to refer to it as a revelation of reality. By this we simply mean that art presents the particularity of things in a way that enables us to see this with far greater clarity and acumen than is otherwise possible. Art thus extends and refines the range of our familiarity. What art reveals to us when it presents things as entities, and what at first seems so remote and unrealistic, we later confirm as inherent in the actual things that we encounter daily.

4. The paradox arising from art's double claim that it is both an escape from life and a more intense participation in life is analogous in origin and structure to the one that we just considered. So long as our regard is strictly aesthetic, we do not think of the work of art as impinging at all upon our lives or as having any relation to our usual concerns. We are so immersed in the particularity before us that we have at most only a dim sense of any existence or meaning beyond this. It is in reflecting upon this aesthetic moment that we say of art that it carries us out of ourselves, that it takes our minds off things, that it releases us from the frustrations that life imposes and the suppressions that it demands, that it gives us a vicarious victory over difficulties that we cannot otherwise surmount. The aesthetic object, presented as an entity, sweeps us into its orbit, takes us out of our usual self-absorption, and so our experience of it appears as an escape from life.

But this moment passes, and our attitude grows more inclusive. To the extent that this secondary regard becomes affective, we retransform the aesthetic object into a value. Or, more exactly, we treat this object as an actual thing that we were encountering, or might encounter, in the world. If the thing presented in the work of art is a physical object or scene,

we become intensely aware of the human import of this thing. The aesthetic object ceases to be only an entity: we realize that it has meaning for our vital concerns, we regard it as a thing having some kind and degree of value for us, and we are led to consider the various ways in which it might abet or impede our purposes. A bowl of fruit is sustenance; a landscape is a place for amorous dalliance or quiet solitude; a street scene is the neighborhood of our youth; the garden described in a poem is that in which we plighted our love, or wept at its rejection. If the thing presented in the work of art is a person, or a human situation or episode, we realize that we might be this person, that we might be entangled in this situation or involved in this episode. We accept as though at least they might be real the people that we meet in novels, plays, operas, ballets, paintings, sculpture, poems, and songs: we suffer and rejoice with them, we share their hopes and disappointments, we follow their adventures closely, we undergo their failures and successes. Similarly, we are emotionally stirred by music and painting and architecture; these evoke memories, excite anticipations, and lead us to envisage scenes and situations in which we take a part that is none the less active for being imaginative. We project ourselves into the personalities that we meet in art, and we participate in their careers. And where art does not give us an explicit person or situation — as is largely the case in music, architecture, and the dance — but only an emotion or a mood, we use this as a nucleus around which to weave our dreams, peopling and arranging these as our feelings dictate. So art, which at one moment of our acquaintance with it lifts us out of life, at another moment immerses us in life.

But this is by no means the end of the matter. If it were, the impact of art would be only of the sort that we call sentimental or romantic: we would merely use art as a peg upon which to hang our dreams, a door to Neverland, a drug of wish-fulfillment. This does happen far too often in our en-

counters with art, and especially with pseudo-art of popular entertainment, and the matter will be discussed later. But the impact of real art in our serious encounters with it is far different, far more significant and profound and gripping, than this. When art returns us to the context of life, it does not set us free to follow our own fancy, and it does not confront us with objects and situations to which we respond as we would to the familiar incidents of everyday life. Rather, art leads us to envisage human beings and human encounters in a new light, to adopt an attitude that is more tolerant and sympathetic toward them, and to reconsider the judgments and evaluations that we are accustomed to pass upon the characters and actions of men.

Art is able to accomplish this because even when the aesthetic object assumes the status of a value, it still retains many of the characteristics that are proper to it as an entity. We now realize that art depicts objects and persons, situations and episodes, that could perfectly well exist and occur in the "real" world; so our concern for their human consequences is aroused. But this concern does not seek or find the release that it would if our attitude and experience were purely affective; we do not merely estimate the import of these things for us, and then respond in a way to dominate them for our own purposes. Because the thing that we are experiencing is an aesthetic object, and has the status of an entity, it focuses our attention upon itself as an actual particular: it asserts its own unique character, it proclaims the significance that it has for itself, and it insists on its right to pursue its own course toward its own ends. It refuses to accommodate itself to our evaluations, to submit passively to our judgments upon it, to acknowledge that it could or should be other than it is. The things and persons and actions that are presented in art induce us to suspend our usual prejudices and values, and to accept them on their own terms.

It is frequently held that art has this power because we know

that what it depicts is not real. I think this misses the mark widely. Of course we do recognize, at least in retrospect, that art is fictitious. But this awareness certainly does not loom largely, even if it is present at all, in actual aesthetic experience. It is a familiar saying that the characters in our favorite books are more real and vivid to us than most of the people that we meet and deal with daily. The same is true of the moods and emotions evoked by the music we love, of the scenes in the paintings we hang in our homes, of the situations that unfold in the plays that we go to again and again. Anyone who has seen Laurette Taylor in *The Glass Menagerie*, or has heard the Budapest Quartet play Beethoven's Opus 131, or has followed the careers of Plantagenet Palliser and Lady Glencora in Trollope's Parliamentary novels, or has looked at a Van Gogh landscape, can never possibly be led to accept the notion that the power of art depends upon our recognizing that it is unreal.

Quite to the contrary, the power of art depends upon our accepting the particular thing that it presents as intensely real and significant. We are so intent upon the aesthetic object that, even though we are well aware of the bearing this has upon actual things and actual life situations, our usual response to these latter is inhibited and altered. We are so absorbed in the objects and characters and episodes presented in art that our sense of their human import is tempered and controlled by our realization of their intrinsic significance. Normally, when our attitude is affective, we recognize and classify things by reference to abstract concepts, judge them against abstract values, and consign them to abstract destinies. That is, we are dominated by a mixture of selfish interest and reforming zeal. We want to exploit natural resources, abolish war, convert the heathen, punish criminals, and improve the position of the oppressed. But when this attitude occurs before art — when it is pervaded and directed by a larger aesthetic concern — we are made intensely aware of the intricate character of things,

of the forces that act upon them and the motives they obey, and we recognize the justification they have for the courses they follow. The summary appraisal and treatment to which we subject actual things is suspended, and we enter into these things as presented as aesthetic objects, and see and feel and live from their point of view. In *War and Peace* we sense the inevitability and yet the casualness of war, we see it apparently engulfing human interests and yet really touching these only superficially, we feel it going on its course quite undisturbed by man's efforts to direct it. A painting of a steel mill or a denuded forest or a suburban development forces us to realize what we do to our natural and human surroundings in the pursuit of limited economic ends. Nora, of *A Doll's House*, is not merely a wife who needs psychiatric and legal help, nor is she merely a symbol of suppressed and coddled womanhood; she is a person of rich and conflicting feelings, desires, and interests. The things and persons that we meet in art, the adventures we encounter, the emotions we undergo, are so vivid and complete that we follow them on their own terms, and accept them at their own estimations, instead of measuring them against our feelings and purposes, and judging them by our standards. The aesthetic object dominates its reference to actual things and situations; because of this, it returns us to life with a finer sense of the nuances and complexities that await us in the world of reality, with a broader perspective, and with a deeper tolerance.

Ivan, in *The Brothers Karamazov*, begins his conversation with Alyosha, which culminates in the magnificent story of the Grand Inquisitor, with this "confession":

I could never understand how one could love one's neighbors. It's just one's neighbors, to my mind, that one can't love, though one might love those at a distance. . . For any one to love a man, he must be hidden, for as soon as he shows his face, love is gone . . . The question is, whether that's due to men's bad qualities or whether it's inherent in their nature. To my thinking, Christ-

like love for men is a miracle impossible on earth. He was God. But we are not gods. Suppose I, for instance, suffer intensely. Another can never know how much I suffer, because he is another and not I. And what's more, a man is rarely ready to admit another's suffering (as though it were a distinction). . . And so he deprives me instantly of his favour, and not at all from badness of heart. Beggars, especially genteel beggars, ought never to show themselves, but to ask for charity through the newspapers. One can love one's neighbor in the abstract, or even at a distance, but at close quarters it's almost impossible.[3]

In our usual dealings with things, the more intimately we are involved with them the more difficult it is for us to regard them at all as they regard themselves. Proximity affords us by far the best opportunity to make the close acquaintance of things and persons, of situations and actions; but actual proximity usually means that this acquaintance is distorted and cut short by the pressure of our vital concerns. Art, because it gives us aesthetic objects, enables us to project ourselves into things, to prolong our acquaintance with them, and to participate in situations from their point of view as well as from our own. We escape from the egocentric predicament, and live through events on several planes, or in several roles, simultaneously. Our sympathy for things and persons is hereby greatly increased, our evaluations become more tolerant, our judgments more nearly impartial. If we are to understand and love even those who are our neighbors, we must be able to envisage our mutual affairs and encounters in their terms as well as in our own. Aesthetic acquaintance makes this possible. It is for this reason that it has the paradoxical quality of being at once an escape from life and a more intimate and profound participation in life. When we think of the narrow, petty, and devious ways into which the actual business of living frequently forces us, then we realize that art is really an escape to life.

[3] Fyodor Dostoyevsky, *The Brothers Karamazov*, trans. Constance Garnett (New York: Modern Library, 1929), pp. 281–282.

III

5. The paradoxes hitherto discussed are all inherent in the structure of the aesthetic life, and issue from the fact that this life comprises as integral features of itself two moments that are quite distinct in orientation and quality. The final paradox, that art is important but purposeless, stands on a different footing. It arises when, having first accepted at their face value the claims that the aesthetic life makes for itself, we then seek to interpret and pass judgment upon these claims from some point of view that is extraneous to the aesthetic life. Art asserts that it is relevant to our grasp of the world and significant for the conduct of life. But art does not, in and of itself, either elucidate or substantiate this plea.[4]

Since art does not itself disclose the purpose that grounds its importance, we attempt to do this for it. And the obvious way for us to do it is to base ourselves upon our currently more familiar cognitive and affective habits of interpretation, and in these terms to understand and evaluate what has been occurring in our experiences of art. Having accepted the importance of art on the basis of a complete immersion in the aesthetic life, we now seek to analyze this importance by with-

[4] No more, for that matter, do theory and technology. Both the abstract notions of science and the intricate machines and techniques of the engineering disciplines have in the past been highly suspect and are still the object of frequent ridicule. Any extreme departure from common sense proves itself only gradually, and always by remaking common sense in its image. The cast of common sense is now a gross replica of the pure and applied sciences; these are thereby so firmly established in our esteem that we forget that there have been periods when man's image of himself and his surroundings was expressed in other terms — political or religious or military or philosophical — and when the view of the world set forth by theory and technology was regarded as a wild extravagance. Common sense even now exhibits toward these specialists a strong undercurrent of scepticism tinged with scorn, which usually expresses itself as a gentle mockery but often enough breaks into biting satire. The cartoons of Rube Goldberg, and that masterpiece of Charlie Chaplin's, "Modern Times," make a shambles of the exaggerations and inefficiencies of the "practical" sciences, while much contemporary humor follows — though rather at a

drawing altogether from the aesthetic attitude and absorbing art into the framework of our rational and practical purposes. In a word, we set out to reduce the aesthetic to nonaesthetic terms.

Of course we fail in this attempt. Art does make a contribution to our cognitive and affective undertakings, because it furthers our grasp of the connectedness and the import of things. But art does this only indirectly, or by reflection, as it were; its primary contribution is made directly to the human enterprise, which it illuminates uniquely by presenting to man the particularity of things. The apprehension of things as concrete and determinate is not a mere means to a better understanding of the relations in which they stand to one another or of the uses to which we can put them. To suppose this is to suppose that man is only interested in anticipating the future in order to insure that the eventual past shall have been what he wanted it to be. One could as reasonably argue that theory and technology are worthwhile only to the extent that they facilitate our grasp of things as entities, so that we may live in a specious present. All such arguments are invalid because they postulate an order of subordination among undertakings that are truly coordinate. Looked at in this way, from some other local point of view, the only role to which art can aspire is that of either a luxury or a handmaiden. Regarding this quite rightly as a rejection, the artist and the connoisseur avenge themselves by asserting that art has a private calling, an esoteric gift and destiny, and by creating art forms which seek by their recondite nature to substantiate this claim. On these terms, art cannot possibly be understood: it can only be the subject of fatuous abuse from one party and of empty praise from the other. When the uncouth and the philistine ask of art, "What is it good for?" the dilettante and the aesthete can only re-

distance — the beautifully blazed trail of Aristophanes and Molière in poking fun at the conceptual and linguistic absurdities with which "pure" science obscures the obvious and disguises the commonplace.

spond, "Nothing." The answer is as unsatisfactory as the question is uncomprehending.

The true purpose of art is to present things as entities, not to aid in the explanation of them as facts or the control of them as values. This purpose is important in its own right because it discloses a real aspect of things and satisfies an essential condition of life. In the measure that art loses its independence, and is made subservient to rational or practical interpretations, it deteriorates, and the vision it affords us of life and the world is tarnished.

6. It is this same insistence upon analyzing art in nonartistic terms that is responsible for many of the difficulties that have been raised concerning the character and status of the aesthetic object. This problem has already occupied us somewhat, but it can perhaps be seen more clearly in the light of this last discussion.

The question that is at issue here can be put in several ways. What is the ontological status of the aesthetic object? What reference beyond itself, if any, does art make? What sort of symbol is the work of art — if it is a symbol at all — and what sort of meaning does it convey?

There are five principal answers that can be given to this question, each of which proliferates into a good many varieties. We might hold that art discloses an order of being that is uniquely its object, accessible only to it. This was the position of Schopenhauer; and it is still advanced quite often, though usually under the cloak of mysticism, whether apologetic or arrogant, to cover the appearance of irrationality that modern modes of thought give it. We might hold that art conveys the impressions and feelings of the artist — that its object is simply the artist's vision of himself; this is the answer of expressionism. We might hold, with the psychologistic schools, that art has no antecedent object, but only the purpose of exciting certain feelings and attitudes in its audience; this is to say that the

aesthetic object is a sheer fiction, fabricated only with an eye to the effect it will have. We might hold that the work of art is a construct, a design realized in an ordered medium, having no reference beyond itself; this is the answer of formalism. We might hold that art deals with and discloses one aspect of a single but many-faceted order of reality, other aspects of which are dealt with and conveyed in other ways.

These answers, admittedly, are not sufficiently subtle to do justice to the doctrines they only grossly represent. From the point of view of descriptive adequacy and explanatory power, the first and the last of these interpretations enjoy a distinct advantage over the other three: since they give a precise identification of the aesthetic object, and root art in an antecedent reality, they can clarify and account for the aesthetic data that the others can only accept as inexplicable or explain away. From the strictly aesthetic point of view, there is nothing to choose between these two avowedly realistic interpretations; but the last seems to have the balance of metaphysical evidence on its side, and it is certainly more congenial to modern thought.

If this argument is sound, it would seem puzzling that this last, or "aspect of reality," interpretation has not been more deliberately elaborated and defended. The reason for this, as already suggested, is the pervasive tendency to measure the claims of art against standards that are so defined as necessarily to reject these claims. When we assert that art discloses reality, of which we are agreed that there is but one order, there arises the prejudice that this reality is already exhaustively described in quite other terms and by quite other methods than those of art. If we suppose that there is some master discipline that enjoys a monopoly of significant discourse — of "meaningful and verifiable propositions" — about the real, then all other seeming modes of discourse are put in an invidious position. The main claimant to this title is now science; though it is important to note that this claim is pressed rather by the distant devotees of the scientific method than by its active practitioners.

The advocates of the view that art makes meaningful statements about the real appear hereby to be faced with a cruel dilemma. It seems ridiculous to assert that art discourses of the same reality as science. But it seems even more ridiculous to assert that science does not discourse of reality (this gambit is often tried by those who hold that science is only arbitrary, or conventional, or pragmatic, but it can lead at best only to stalemate).

The solution to this dilemma is simple and obvious. To achieve it we have only to ask the question: what *is* the reality of which science discourses? There are two possible answers. The first, which is the one usually stipulated or assumed, identifies this reality as particles and forces having only spatio-temporal properties, as these are described by the physico-mathematical concepts of the exact sciences. On this answer, the claims of art fall to the ground: for this is obviously not the reality that is given as the content of art, and if it is the only reality that is recognized, then art does not talk about reality at all.

But there is another perfectly good answer to this question. This consists in identifying the reality of which science discourses as the richly qualitied, fully determinate, and heavily portentous objects that we encounter in ordinary experience. These are the actual things or occasions that constitute the single embracing order of reality. It is to this reality that art, science, and all other meaningful modes of discourse refer. They deal with different aspects of this reality, by different methods, with different purposes in view. Reality is not composed of minute particles, carrying various electrical charges, standing in certain relations, and undergoing change in accord with mathematical formulae. These elements are not "reals": they are facts. They are not the subject matter — the antecedent reality — with which science deals: they are the outcome of scientific treatment of this subject matter. To obtain an adequate view of this subject matter we must supplement

this factual rendering of it with the coordinate accounts that render it as entities and as values.

The aesthetic object is as much a symbol of the antecedently real as are the scientific (theoretic) object and the technological (instrumental and moral) object. These objects are in no sense ontological rivals: they are not mutually exclusive, nor are they even in conflict with one another. They cannot be, because they represent the same actual things and occasions viewed from three different perspectives, and the being of these things and occasions is equally that of facts, of values, and of entities. The reality disclosed by art is neither superior nor inferior to that disclosed by science; they are disclosures of different aspects of the same reality, and what both are superior to is the confused common-sense view of this reality in which alike they have their point of departure.[5]

The chief point at which this interpretation might be challenged is with respect to the power of universal reference that it attributes to art; for this is widely held to be the unique prerogative of science, to which art cannot pretend and should not aspire. The confusion that surrounds this issue arises from the notion that there is only one sort of universal. The scientific universal refers to the common properties, relations, and sequences of things, independent of their actual embodiment or occurrence; its typical expression is in the form of a hypothetical "if A, then B." In current philosophical language, the function of such a universal is to enable us to anticipate experience. Its outlook is strictly prospective: it tells us what to expect in the future under certain defined conditions, in order that we may prepare ourselves and forestall events. The universal of science spares us the necessity of attending closely to things and occasions because it makes available to us, in abstraction and prediction, what it regards as important that we should

[5] This matter is examined somewhat more fully below, in Chap. XII, Sec. iii.

know about them and, especially, about the order of their occurrence.

The universal reference of art is obviously of a very different sort than this. In fact, the difference is so marked that art is often denied to have either the intention or the power of such reference; and the question of art as seeming to deal at once with the individual (or particular) and the universal virtually constitutes a separate, though subsidiary, aesthetic paradox. To resolve this difficulty it need only be borne in mind that not only do actual things occur in accord with general patterns and sequences, but that when they occur they exhibit similar characteristics and structures. The artistic universal refers to the concrete and determinate resemblances that pervade actual occasions without for all that obliterating their uniqueness. Such a universal says, in effect: "This is *A*, and a good deal of what is comprised in such a unique thisness will be present on another occasion, such as *B*." The function of such a universal is to enable us to meet experience with alertness and discrimination. Its outlook is, if one might coin a term, "inspective": it points our attention to the concrete character of actual things in their immediate occurrence. The aesthetic object impresses itself so strongly upon us that the mere hint of resemblance on some future occasion makes vivid again what it has discerned to us on the present occasion.

The explanation of this phenomenon, and of the apparent paradox to which it gives rise, is to be found as always in the fact that the aesthetic life contains two moments. During one of these, we accept the aesthetic object as a unique particular; during the other, we make the aesthetic object a part of the body of experience, and it assumes a universal reference because of the content and the direction that it gives to our regard of other particulars. The function of the universal of science is to anticipate experience. The function of the universal of art is to enhance the sensitivity and richness with which we participate in experience.

The difference in intention, method, and result of these two sorts of universals — the difference between what the theoretical argument demonstrates and the aesthetic object presents — can best be brought out by a concrete example. Spinoza, in the Third Part of the *Ethic*, sets out to "treat by a geometrical method the vices and follies of man," and to "consider human actions and appetites just as if I were considering lines, planes, and bodies." His justification for this procedure is that nature's "laws and rules, according to which all things are and are changed from form to form, are everywhere and always the same; so that there must also be one and the same method of understanding the nature of all things whatsoever, that is to say, by the universal laws and rules of nature." In Proposition XXXV of this same Part, Spinoza deals with the nature of hatred, envy, jealousy, and suspicion. He treats this question as follows:

> Prop. XXXV. — *If I imagine that an object beloved by me is united to another person by the same, or by a closer bond of friendship than that by which I myself alone held the object, I shall be affected with hatred towards the beloved object itself, and shall envy that other person.*
>
> *Demonst.* — The greater the love with which a person imagines a beloved object to be affected towards him, the greater will be his self-exaltation (Prop. 34, pt. 2), that is to say (Schol. Prop. 30, pt. 3), the more will he rejoice. Therefore (Prop. 28, pt. 3) he will endeavour as much as he can to imagine the beloved object united to him as closely as possible, and this effort or desire is strengthened if he imagines that another person desires for himself the same object (Prop. 31, pt. 3). But this effort or desire is supposed to be checked by the image of the beloved object itself attended by the image of the person whom it connects with itself. Therefore (Schol. Prop. II, pt. 3) the lover on this account will be affected with sorrow attended with the idea of the beloved object as its cause together with the image of another person; that is to say (Schol. Prop. 13, pt. 3), he will be affected with hatred towards the beloved object and at the same

time towards this other person (Corol. Prop. 15, pt. 3),
whom he will envy (Prop. 23, pt. 3) as being delighted
with it. — Q.E.D.

Schol. — This hatred towards a beloved object when
joined with envy is called Jealousy, which is therefore
nothing but a vacillation of the mind springing from the
love and hatred both felt together, and attended with the
idea of another person whom we envy. Moreover, this
hatred towards the beloved object will be greater in
proportion to the joy with which the jealous man has
been usually affected from the mutual affection between
him and his beloved, and also in proportion to the affect
with which he had been affected towards the person who
is imagined to unite to himself the beloved object. For
if he has hated him, he will for that very reason hate
the beloved object (Prop. 24, pt. 3), because he imagines
it to affect with joy that which he hates, and also (Corol.
Prop. 15, pt. 3) because he is compelled to connect the
image of the beloved object with the image of him whom
he hates. . .[6]

In W. H. Auden's *For the Time Being: A Christian Oratorio*,
there is a passage in which some of these same matters are
explored. The section is entitled "The Temptation of St. Jo-
seph," and the subject is treated in this dramatic form:

Joseph
My shoes were shined, my pants were
 cleaned and pressed,
And I was hurrying to meet
 My own true Love:
But a great crowd grew and grew
Till I could not push my way through,
 Because
A star had fallen down the street;
 When they saw who I was,
The police tried to do their best.

[6] Spinoza, *Ethic*, trans. W. Hale White, rev. Amelia Hutchison Stirling (London: Oxford University Press, 1930), pp. 135–136.

Chorus (off)

Joseph, you have heard
What Mary says occurred;
Yes, it may be so.
Is it likely? No.

Joseph

The bar was gay, the lighting well-designed,
And I was sitting down to wait
 My own true Love:
A voice I'd heard before, I think,
Cried: "This is on the House. I drink
 To him
Who does not know it is too late";
 When I asked for the time,
Everyone was very kind.

Chorus (off)

Mary may be pure,
But, Joseph, are you sure?
How is one to tell?
Suppose, for instance . . . Well . . .

Joseph

Through cracks, up ladders, into waters deep,
I squeezed, I climbed, I swam to save
 My own true Love:
Under a dead apple tree
I saw an ass; when it saw me
 It brayed;
A hermit sat in the mouth of a cave;
 When I asked him the way,
He pretended to be asleep.

Chorus (off)

Maybe, maybe not.
But, Joseph, you know what
Your world, of course, will say
About you anyway.

Joseph

Where are you, Father, where?
Caught in the jealous trap
Of an empty house I hear
As I sit alone in the dark
Everything, everything,
The drip of the bathroom tap,
The creak of the sofa spring,
The wind in the air-shaft, all
Making the same remark
Stupidly, stupidly,
Over and over again.
Father, what have I done?
Answer me, Father, how
Can I answer the tactless wall
Or the pompous furniture now?
Answer them. . .

Gabriel

No, you must.

Joseph

How then am I to know,
Father, that you are just?
Give me one reason.

Gabriel

No.

Joseph

All I ask is one
Important and elegant proof
That what my Love had done
Was really at your will
And that your will is Love.

Gabriel

No, you must believe;
Be silent, and sit still.[7]

[7] Quoted from *The Collected Poetry of W. H. Auden* (New York: Random House, 1945), pp. 421–424.

Spinoza is concerned with the principles that determine the occurrence of jealousy, Auden with the character that jealousy wears when it occurs. But the two treatments stand on a footing as regards the universality of their reference. The ability to anticipate experience, be it ever so accurately, is vain and empty without the gift of participating sensitively in one's own experience and sympathizing with the experiences of others.

Chapter VIII

THE STRUCTURE AND CONTENT OF AESTHETIC EXPERIENCE

I

1. We turn now to the nature of aesthetic experience, the process through which we grasp the aesthetic object. In this inquiry, there are two chief points to be considered. One of these concerns the structure of aesthetic experience, the operations that it involves, the pattern of its development. The other concerns the content of this experience, the items that appear in it, the material with which it fills awareness. Structure and content are of course intimately intermingled in fact; but they will have to be investigated somewhat separately and then, more meaningfully, wrought into the unity that they actually constitute.

From the preceding discussion of the paradoxes of aesthetics, there emerged the paramount fact that our aesthetic encounters always contain two moments. It was pointed out earlier (Chapter V, Section iii) that the aesthetic process is dialectical in character and has a rhythm composed of two alternating phases, a diastole and a systole. The terms of these two pairs of concepts are closely related, and by bringing them together we can reach a comprehensive view of the structure of aesthetic experience.

The moment when attention is focused on particularity and absorbed by the aesthetic object corresponds with and occurs during the phase when the aesthetic process is expansive and

sensitive, receptive to any insights that art and the world offer. The moment when attention is more wholly human and seeks to absorb the aesthetic object corresponds with and occurs during the phase of contraction, when the aesthetic process closes upon and comes to grips with the material it has just gathered, with the purpose of transforming its isolated insights into a coherent vision. Let us call the first of these the moment, or phase, of *aesthetic discovery*; the second, that of *aesthetic assimilation*. It is the interplay of these two moments that determines the structure of aesthetic experience and the pattern of its occurrence.

The whole of experience is a series of transactions through which the mind seeks to extend, refine, and coordinate its acquaintance with the world. If the mind is to succeed in this enterprise, it must be continually alert for materials — for insights and information and meanings — that were hitherto unknown to it; and it must just as continually absorb this new material into its fabric, so that it can be retained and used in the future. This matter can be put most pointedly by saying that experience is both *an activity* and *an accumulation*. It reaches out into the contemporary world for what is novel and unfamiliar; and at the same time it hoards what it has garnered, working this into the habits that constitute its scheme of things. In all of its undertakings, the mind must both act and accumulate; this is equally necessary in its aesthetic, its cognitive, and its affective pursuits.

During the moment of aesthetic discovery we are brought face to face with the particularity of some actual occasion. Many of our habits of perception, thought, and feeling are suspended or disrupted. The intrusion of these established frames of reference is inhibited, partly by the impact of the aesthetic object and partly by our own intention. Our faculties of sense and intelligence become intensely alert; and the operation of these faculties is largely governed by their own general capacity (both natural and acquired) and by the con-

tent of the aesthetic object to which they are attending. The bonds of the past are dissolved in the heat of the present encounter. We open our sensitivity to the quality and structure and meaning of the aesthetic object; and we probe this with discrimination and persistence. We lose sight of the import and connectedness of the thing that stands behind the aesthetic object; this object often concentrates our regard so closely upon itself that we are unaware of any reference beyond it to an antecedent reality. Experience seizes what is necessarily new because unique, and is informed with what the present occasion discovers to it.

During the moment of aesthetic assimilation we bring this discovery of particularity face to face with our accumulated modes and habits of experience. The aesthetic object that has just been given to us is so rich and intricate in its own character, and so isolated from all contexts, that we cannot comprehend and retain it as such. So we now set out to secure an adjustment between the new insight that has been gained and the frames of reference that are the deposit of the past. The aesthetic object is filled out with meaning borrowed from previous encounters with reality, and it spills over into the dimensions of the self and the world. Experience diffuses its discovery through its catalogues and categories of reality, and these are enriched.

2. The only point in this account that may require to be emphasized is that these moments of discovery and assimilation belong to and occur within aesthetic experience as such. The moment of assimilation does not constitute a rupture of the aesthetic process; it is not a movement to another mode of experience in which we deal with things cognitively or affectively. It is true that during this phase the aesthetic object ceases to be regarded only as an entity which is self-contained and self-sufficient: it expands and merges with the actual thing from which it was originally distilled, it is collated with our

accumulated experience of such things, and it stirs our total concerns as men. But the aesthetic object is not herewith destroyed: it does not become an anonymous item to be entered under the proper heading in our general list of things, and it does not become a thing having import for us. It remains itself, unique and determinate. But now it not only asserts itself; it also proclaims that it is a disclosure of the character of actual occasions, and that what it discloses must be taken into account by our ideas and emotions. The light that the aesthetic object sheds upon things as entities reflects upon our conception of the factualness and the value of things.

The occurrence of this moment of assimilation can be empirically verified in most aesthetic occasions. In art that is at all representational or realistic — in the broadest common-sense meaning of those terms — this effect is prominent. When we read a sonnet of Donne or Shakespeare, or a novel by Hemingway or Franz Kafka; when we look at a painting by El Greco or Rembrandt; when we listen to the music of Beethoven or Stravinsky; when we watch a drama of Marlowe or Odets; when we walk into the Sainte Chapelle or the Palace at Versailles — in all such cases there is a compelling and quite specific reference from the work of art to our accumulated experience. The aesthetic object speaks to us of things and situations, of moods and purposes, that are already our familiars, we recognize its relevance, and so we accept its meaning as significant for our view of life and the world. Even in art which appears to be the most formal and abstract — such as pure or absolute music, nonobjective painting, and constructionist sculpture — this same effect is present: the reference of such art is less local and specific (and especially it is more difficult to identify this reference verbally) but it is none the less definite and intense. No one can live at all intimately with the work of such modern artists as Kandinsky and Mondrian and Henry Moore without coming to perceive and feel space in a changed manner; and there are radical differences in the

atmosphere of subjective mood and objective outlook that is conveyed by Debussy, Boccherini, and Brahms. In our appreciation of art this assimilation of the aesthetic object is an integral phase of aesthetic experience as such: the aesthetic object is assimilated in the simple and effective sense that it is illuminated by our past experience and in turn illuminates our future experience.

The fact that the aesthetic object, in being assimilated, does not cease to be itself can also be empirically verified. For we easily discern the difference between the occasions on which the aesthetic object dominates experience, and determines quite precisely what is assimilated, from those other occasions on which we replace the aesthetic object (if there is one present) by some other object that is already available in our experience or is supplied by our fancy, and then clothe this pseudo-aesthetic object with whatever properties are dictated by wish or impulse.[1] Shakespeare's *King Richard III*, when it is assimilated, sharpens our sense of what the goad of ambition is like and what price we must often pay to satisfy it. The verse of Edgar Guest or Ella Wheeler Wilcox is not assimilated at all, in the proper sense of that term; it merely stimulates our dormant dreams of success and invites us to enjoy vicariously whatever we take to be its sweets. The same comparison holds between the paintings of Edward Hopper and the pictures of Maxfield Parrish, the short stories of Eudora Welty and Clarence Buddington Kelland, the musical idioms of Duke Ellington and Guy Lombardo; such examples could be multiplied endlessly. In those cases where there is no true aesthetic object, or where we destroy and supplant this, there is no assimilation of fresh material, but only autoexcitation. The true aesthetic object, in entering the body of experience, modifies and refines it.

One further remark on this question is presently necessary.

[1] This summary treatment of the complex problem of pseudo-art and degenerate forms of aesthetic experience is supplemented with a detailed analysis in Chap. IX, Sec. ii.

Even where there is real appreciation of real art, and proper assimilation of the aesthetic object, the matter need not end here. We can and sometimes do proceed to leave altogether the aesthetic mode of experience, adopt another attitude, and employ the deposit of such experience for other purposes. For the aesthetic object leaves a residue behind it, even when it has entirely departed.[2] It not only renovates our categories; it may largely furnish them. We can generalize what we have gathered from the particularity given us, and can put this to cognitive and affective uses. We can apply the meaning we have taken from *Richard III* to understand or detect a potential tyrant, or even to discourage one. We slip lines or phrases of poems into our love letters, in order to counterfeit a sentiment that we lack the ability or the patience to express for ourselves. We refer to a man as a Don Quixote or a Don Juan, we divide women into the Helens and the Penelopes, we speak of Trojan-horse tactics and Herculean tasks. In such cases we dissolve the aesthetic object, which both loses and gains in this process: it loses much of its uniqueness and determinateness, and ceases to be as such; it gains in the extent of its reference and in the meanings it borrows from elsewhere in experience, and becomes an exemplification.

This concept of the exemplification can be pointed up by contrast with the earlier treatment[3] of the universal reference of art. The aesthetic object functions as a universal when it retains its status as such — when it persists in experience with approximately its original concrete content — and illuminates our direct acquaintance with actual things. It serves as an exemplification when it loses enough of its determinateness (its precise identity) to be indifferent to many individual differences and to insist only on certain relatively gross similarities.

[2] "Entirely departed" from our awareness of it as an aesthetic object, that is. The aesthetic object as embodied in the work of art — as the content of this work — is of course still "there" and available to us for renewed acquaintance.

[3] Chap. II, Sec. ii; Chap. VII, Secs. ii and iii.

The process is quite like that by which metaphors become "dead." The distinction between the aesthetic object as universal and as exemplification is one of degree, and its application to actual cases is often uncertain. The first time that another tactical device was described as "a Trojan horse," the phrase must have struck a vivid spark of meaning; the figure has now been so eroded that it in its turn has to have meaning restored to it by being described as "the first Fifth Column."

From the strictly artistic point of view, this transformation of the aesthetic object into an exemplification — into a mere device for the somewhat picturesque identification of things — is a desecration; from the more largely human point of view, it is the inevitable (and in at least some respects the happy) fate of the aesthetic life to be fused with the total human enterprise, and for its objects to be garnered and threshed and eventually baked into the cake of commonsense. It is only necessary that the aesthetic life should meanwhile continue on its own way, gleaning new objects to supply this process.

The aesthetic life itself and as a whole, with its constant rhythm of discovery and assimilation, can best be compared, in a figure of speech, to a series of forays that the mind makes into strange territory, and from which it returns home in order both to contribute its capture to its accumulated stores and to replenish itself from these. The mind's base of supply in these adventures is the body of experience that it has gathered and coordinated in the past. This close-knit web of images, emotions, and ideas is the substance upon which mind chiefly relies in its transactions with things. But we are from time to time haunted by the suspicion that this settled framework is incapable of accepting the acquaintance that things are trying to press upon us. That is, a tentative glimpse of the unfamiliar challenges our categories of familiarity.

It is this encounter with a particularity that we feel we are for the first time meeting on its own terms that constitutes the essence of the moment of aesthetic discovery. We seem to be

released from our normal habits and concerns, and from the limitations of a local point of view, so that we see things with a wonderful clarity and completeness. This discovery intrigues us; we want to prolong it, to push it further, to exploit it to the utmost; we are reluctant to surrender the intimate view it gives us and to return to the more familiar and prosaic ranges of experience. So do explorers over the physical world feel a continual urge to go further, to stay longer, to see more — and finally to settle down and live with the natives.

In our aesthetic journeys, such expatriation is impossible. There are two reasons for this. One of these is the point that has just been discussed, that our concerns as total human beings soon assert themselves: life cannot be sustained merely on the vision of the particularity of things, however revealing and entrancing this may be. There is a charming story by Marcel Aymé, called "La Bonne Peinture," which tells of an artist whose paintings were so deeply felt and so truly conceived that they afforded physical and spiritual nourishment of the widest variety to those who looked upon them. Food and drink and shelter became unnecessary, love bloomed in every heart, man's fiercest appetites and fondest dreams were satisfied, and France settled down to enjoy the millenium. This is, alas, a fairy tale. Real life demands for its sustenance not only entities, but also facts and values. The aesthetic object that we have discovered impinges upon us as men, we realize the general human significance of what it discloses, and so we feel impelled to weave these strands of meaning into the fabric of experience.

In the second place, the insight that the aesthetic discovery yields cannot be sustained unless it is embodied in terms that are within the reach of our familiarity. What we grasp in the first intense moment of aesthetic acquaintance seems to be both ineffable and self-evident. We feel that we could not possibly express or embody what we have discovered, and that fortunately we do not need to because it proclaims itself so clearly. In the course of only a little time this latter conviction

turns out to be illusory; our insight begins to waver and fade, and to demand more illumination than it sheds. So then we set out, in the face of the former conviction, to do what we first thought impossible: that is, to put this insight into a permanent and accessible form. This can only be done by transposing it into terms that are already generally familiar: that is, by assimilating it into the tissues of our images, ideas, and emotions. We frequently make a distinction between "sensing" or "feeling" or "glimpsing" or "apprehending" a work of art on the one hand; and "grasping" or "understanding" or "realizing" or "comprehending" it on the other. The first of these sets of terms indicates, I think, an aesthetic discovery that has not been successfully assimilated: the work has a definite impact and content for us, but we cannot somehow say just what this is, we cannot make it precise and stable. The second set of terms indicates that the work has been assimilated: it has ceased to be only itself and has become part of a universe of meanings. The particular is brought under and illuminates the universal; the concrete refers to and enriches the abstract; what is presented in the work of art is recognized, and so appeals to similarities in our past experience. The aesthetic object is enrolled on our catalogues, it enters into our vision of the world and of life, and so it becomes a part of the body of experience with which we shall greet the future. What is assimilated is not identical with what is discovered. The content of our aesthetic discoveries cannot be assimilated as such: some of this is lost, being too unique and isolated to be absorbed and retained; all of it is modified, and much is added to it, by our habits and preconceptions. What we keep as the meaning of a poem or a painting or a piece of music is not what we received in the fierce shock of aesthetic discovery. But it is enough to enrich life very greatly. And we can always increase this deposit of aesthetic meaning by repeating our initial discovery and each time absorbing more of what it contains.

So what seemed at first to be an ineffable and self-evident

content is gradually uttered and made manifest in concrete form: it is embodied in words, in sound, in stone, in line and color, or in some other medium. The insight through which we first grasp the aesthetic object can be fastened and retained, and can become a coherent vision to be communicated to others, only to the extent that it is so embodied. It is in this sense that concrete objects, such as poems and paintings and symphonies, are works of art. These are not, of course, the actual apprehension and realization of the aesthetic object. But they are the guise in which the content of this aesthetic discovery is, so far as may be possible, prepared for assimilation into the fabric of experience and so enabled to make a meaningful and permanent contribution to life.

The aesthetic voyager, unlike the physical explorer, cannot take up a settled abode in the world he has discovered. For this is not really a world at all, but only a point of view. There is no separate aesthetic realm, complete and sufficient unto itself. There is merely a special perspective from which we look at the world that usually surrounds us and at the life we usually live, and so see these in a way that is otherwise impossible. Art transports us to this perspective, but it cannot maintain us there. We can only make incomplete and episodic journeys, seizing quickly what insights we can and then returning home, where what we have discovered can be embodied and assimilated. It is during the moment of discovery that we gather the nourishment of the aesthetic life, but it is during the moment of assimilation that we put this in such form that the aesthetic life can be sustained by it.[4]

II

3. We can now take up the question of the content of aesthetic experience. Of what elements is such experience composed, and what sorts of material does it contain? The answer,

[4] Several qualifications of this analysis are required in order to correct the too rigid and static distinctions that it makes, and to bring it into closer

in a word, is this: *a series of images* standing out against a background that is formed by *the accumulated body of experience.*

The concept of the image that was previously defined (in Chapter II, Section ii) must now be elaborated. An image is determined as such by its manner of occupying our attention, and not by the material that it brings to us. The content of images is infinitely various, and that aspect of the question will be dealt with shortly. But the essence of the image as a psychic element lies in the way we attend to it and the manner in which we operate upon it. Looked at in these terms, the distinguishing characteristic of images resides in the fact that they are highly self-contained, isolated, and episodic. Images seem as though they were given to us virtually complete in their content and structure, and to require nothing from us save our attention to them. They do not refer elsewhere to borrow meaning that is already prepared and available, and they inhibit any tendency on our part to make such systematic and independent references. Rather, images closely control the experiences of which they are the focus, determining with great precision the materials with which these are filled and the courses that they follow.

Of course, the distinction between the psychic elements that I have previously described as images, ideas, and emotions is only relative. Every content that we hold before the mind partakes of the features of each of these, and is an amalgam of them. So the elements that fill our awareness are a mixture of material that is imaged, thought, and felt. But as one or the other of mind's basic perspectives becomes dominant, the actual thing that we are encountering is translated to us in the primary form of image, idea, or emotion. And the distinction between these is none the less significant for being a matter of degree.

accord with the actual course of the aesthetic life. These are given below, in Chap. IX, Sec. i.

Ideas and emotions point unreservedly to their location in our established frames of reference. We at once bring to bear upon them the full weight of our accumulated experience, in so far as this appears to us to be relevant: that is, we refer these ideas and emotions to the matrix of our accepted theories and settled purposes. An idea is all but meaningless save in the context of its proper system of ideas. Such ideas as time, inertia, death, stress and strain, Original Sin, property, the state derive much of their content from the organized bodies of doctrine within which they are defined. The case is analogous with emotions. An emotion demands a self that stands behind it, and an end that it has in view. Such emotions as impatience, frustration, fear, anxiety, guilt, covetousness, patriotism derive much of their content from the situation of the person undergoing them and the purposes that animate him. Our experience of things in the guise of ideas and emotions depends upon conscious and controlled reference to an explicit and systematic context.

Images stand on quite another footing. Things as translated into images point emphatically to themselves, insisting upon their determinateness and distinctiveness. An image is a psychic content that appears to be internally complete and self-sufficient; it seems to carry within itself its own unique load of meaning, which not only requires no supplementation from our accumulated experience but resists any attempt to import such extraneous meaning into it. Images focus attention very closely upon themselves, and fill attention very precisely with just what they have to say. Finally, images appear to be largely independent and isolated, not only with respect to any systematic context of meanings, but also with respect to one another. Every image seems to convey an insight that is absolutely true in its own right and absolutely irrelevant to any other insight. In their immediate occurrence, images impress us as being at once eternal and episodic.

An example might illuminate this account, which has so far

been purposely impressionistic. We can take the second quatrain of Shakespeare's familiar Sonnet XXX ("When to the sessions of sweet silent thought"):

> ... Then can I drown an eye, unus'd to flow,
> For precious friends hid in death's dateless night,
> And weep afresh love's long since cancell'd woe,
> And moan the expense of many a vanished sight. ...

If we first come to this sonnet as mature and cultivated, but not professionally "close," readers, the effect of these lines is to startle and fascinate us with a series of brilliant but disjointed images. Each of these striking figures (the eye we "drown," death's "dateless night," love's "cancell'd woe," the "expense" of the past) gives us a vivid and explicit image; each of these images, in turn, seems to convey an atom of meaning that is unique and complete, to afford an insight that is private to it and that requires no support from other insights. And these separate images leave the sense of succeeding one another with little transition from one to the other and with little cumulative effect, as though their insights found no permanent lodgment in a larger scheme, but simply continued to shine each with its own light.

This same effect is characteristic of, and can be verified by, our first acquaintance with works of art in other media. When we notice a painting, and approach to look at it more closely, it is usually because some single item or segment within it has captured our attention: our interest is seized by this one image — which may be relatively small or large, simple or complex, and is almost sure to vary considerably from one viewer to another — and for the moment whatever else is on the canvas is nothing but background. Then, as we continue to look at the painting, other figures or elements emerge from it, and our attention tends to dash from point to point within the canvas, delighted by a succession of images. It is only much later, in the course of a closer and more purposeful acquaintance, that

these isolated images merge into larger images, their individual character is modified, and we begin to get a sense of an over-all pattern that contains these images as details. The factor that is responsible for the constitution of these images as such — that makes us notice and demarcate them — can be any one of several: it may be their representational content, their formal clarity and completeness, the sensuous appeal of their color and line, or their emotive suggestions; and it is always apt to be a blend of these. But one point stands out sharply: when we first look at a painting, we do not see either single brush strokes or a single unifying design; these are the issue, respectively, of a labored analysis or synthesis. What we see is a series of separate images, which are largely isolated and self-contained in their impact upon us, and which seem to be fragments sharing a neighborhood rather than parts of a whole.

This effect is probably even more marked in such arts as music and drama, where the work takes place in time, with the elements disappearing immediately upon their occurrence save as they are held in memory. Unless we are very expert, our first few hearings of a symphony or a quartet are notoriously fragmentary: we are brought alert by a lovely melody or a clearly enunciated theme; a persistent rhythm or a startling instrumental intrusion catches our attention; we notice an isolated figure or motif, and then recognize this later in a variation. At the performance of a play it is episodic scenes and incidents — frequently even a small piece of stage business, a humorous or dramatic bit of dialogue, an epigrammatic line, the striking portrayal of a minor character, or some feature of the set — that we first detect and fasten upon. These segments of the music and the drama seem to come to us as distinct and autonomous elements: they are the images that constitute what the art-work originally gives us and we grasp. We do not, save with rare exceptions, hear single notes or words, nor see single gestures; and we certainly do not either intuit or understand the total structure and content of the work. What we do is to appre-

hend images, each carrying a definite load of meaning and interest, and each largely independent of the others in our immediate awareness.[5]

This account, based on the self-pronouncement of images, is too extreme, and must now be corrected. The appearance that images wear of being self-sufficient and isolated is an exaggeration of their true status. For when we look more closely we can discern two relatively prominent and organized contexts that are actually involved in the occurrence of images, lending them a rich if inconspicuous support. In the first place, images always occur against the background of our accumulated experience; it is to this that they appeal for the particles of common meaning that they fuse into such seemingly unique and unprepared insights. Unless they could refer to these funds of familiarity, images would be unintelligible. The image, which seemed to be self-sufficient, turns out to be composed of material derived from our antecedent experience. In the second place, images always (with perhaps rare exceptions) occur as members of sets or series, and these sets of images are themselves internally organized. The explicit and coherent web in which images are contained is the expressed content of the work of art; the unity that issues from the insights that these images yield is the aesthetic object. Much of both the precision and the richness of individual images is made possible by the fact that they are loaded and pointed by their artistic context. Images can be sudden and terse because the way has been prepared for them; they can be ambiguous without being vague because of connections that have already been established. The image, which seemed to be isolated, usually ends by being merged in a larger image.

Yet despite these qualifications it must still be recognized

[5] The surest and simplest corroboration of all this, since I am here speaking chiefly of the impact of art upon us, is to eavesdrop at the excited talk that goes on in the foyers of theaters and recital halls during intermissions and after the performance is over.

that the apparent isolation and self-sufficiency of the image are not altogether illusory: if these are only appearances, they still lie close to reality. For images do exhibit an unusual measure of individual completeness and determinateness, a striking power of eliciting from our funded experience only selected and limited items, and a large independence of the total body of this experience. Much more of the meaning that is conveyed by images is carried and controlled by them than is the case with either ideas or emotions. The explanation of this is twofold.

For one thing, the complex images that are embodied in works of art have a prominent and well-articulated internal structure. Their form, or design, is strong and definite. This makes it easy for us to grasp images as unified wholes, to mark them off from other psychic elements, and to hold them before attention. Again, because of this integration, images do not leave loose ends lying about to distract attention or to allow it to fade and wander; their tight design prevents us from seizing upon any element within them and following this outside the image to some unintended and irrelevant meaning. Finally, because the image is so definitely structured, it leads us compellingly from point to point within it, guiding us through its various parts along a settled course and at a settled tempo. The order and the measure of our attention to the contents of the image (or series of images) are rigorously governed by the formal structure of this image.

The second part of this explanation is the power of images to control the references that they make to the accumulated body of experience. The image does not refer us to a pre-existent and explicit system of meanings, and then leave us to make what further references this system suggests or requires. Images cannot avoid referring to such organized contexts. But the image has the faculty of taking from these contexts only highly selected fragments, which it then removes from their habitual setting and incorporates into itself. One

source of this power is design. The other, equally important, resides in the fact that images appeal to different systems of meanings (different portions of the body of experience) which are not usually associated: they thus prevent the escape of attention to any preëstablished context; instead, they capture from these various systems just the segments that they want, and then compose these hitherto strange elements into a unique and highly determinate structure.

This analysis can be illustrated again by the quatrain quoted above from Shakespeare. These few lines contain a good many images, which combine through several stages into larger images, which finally form the aesthetic object conveyed by the sonnet. Now, it is obvious that these images draw much support from the whole sonnet within which they occur, and from our own accumulated experience: the sonnet quickly announces its subject matter and establishes its mood, and these appeal to our familiarity. But it is also obvious that the expressed content of these images is a great deal more precise and self-contained than the general concepts (melancholy, reminiscence, regret, surcease, and so on) to which they refer us; and the aesthetic object that these images together compose is a great deal more complete and determinate than the themes that paraphrase it ("let the dead past bury its dead," "present joy is worth past sorrow," "the world's well lost for love," et cetera). Finally, the reasons for this are equally obvious. For one thing, these images are packed into a tight design that never lets attention wander, that leads us on from one meaning to another, and that collects the reverberations of these meanings and binds them into a compact whole. Secondly, each of these images controls the reference it makes, and so determines the meaning it collects, because at the same time that it appeals to our familiarity it shatters the molds in which this is cast. When the eye is given to us as drowned, death as dateless, and woe as cancelled, we can readily supply the atoms of familiar meaning that these images call

for; but the images themselves, by placing these meanings in strange contexts and compressing them into a close design, compose the unique and determinate meaning that is the aesthetic object. The content that is conveyed by an individual image — and this is even more true of the total work of art — does not antedate it: images transform the meanings they incorporate, as they are in turn transformed by the aesthetic object that incorporates them.[6]

4. This discussion leads directly into the question of the content of images. What is the range of the materials and the meanings that images contain and pour into aesthetic experience as its content? What is it that is conveyed to us and occupies our awareness in aesthetic experience?

Analogues of this question, raising the same general issue, have already arisen in several other contexts.[7] The answer remains the same: anything and everything. The possible content of images is whatever can be demarcated in consciousness; aesthetic experience is defined not by what it fastens upon, for this is limitless, but by the way in which it attends to this and deals with it. Even a cursory examination of our aesthetic experiences soon impresses us with the wealth and variety of

[6] This entire discussion, here cast largely in the context of literature, applies of course with equal force to all of the arts. In the plastic arts, in music, in drama and the dance, we find the same essential effects achieved by the same general methods. Every work of art, even the slightest and simplest, comprises several images; these cast meaning upon one another, and borrow meaning from the whole that they compose; the aesthetic object that issues from the synthesis of these images is far more dense and precise than the corresponding objects constituted by ideas and emotions; finally, every artist depends upon the two basic techniques of clarity of internal structure and control of external reference.

This account of the image will be elaborated in the final section of Chap. X, when the way has been better prepared for it, with the emphasis there placed on the functional aspect of the question: that is, on the principal ways in which artists construct and employ images in order to compose a work of art and convey to us an aesthetic object.

[7] Regarding the catalogue of particular things, Chap. II, Sec. ii; regarding the nature of expression and what is expressed, Chap. V, Sec. i; regarding the aesthetic object, Chap. VII, Sec. iii.

the materials that they encompass, transmute, and give to us in the form of images and aesthetic objects. So an exhaustive listing of these is out of the question: all that can be done is to sketch a broad, and quite traditional, classification. In doing this, it must be emphasized that the materials here analyzed do not occur separately: they interpenetrate one another, and are together composed into the aesthetic object.

Perhaps the most obvious of these materials are what can be roughly identified as *sensuous and emotional elements*. A delightful employment of our senses is a prominent feature of virtually all aesthetic experience. The colors and lines of a painting, the sound and rhythm of words, the quality of tones and of melodies in music, the gestures and postures and movements of the dance, the tactile qualities of stone or wood — these occupy a large part of our attention, and are the source of a large part of our enjoyment, in art. More vague and amorphous than these, but just as significant, is the arousal of massive and profound organic feelings, which we often cannot recognize or identify but which nevertheless pervade the aesthetic object: feelings of depression or elation, of excitement or lethargy, of tension or release, of the hazard of circumstances or of inevitable doom, of hope or despair, of struggle or renunciation, of frustration or of life opening before us. Closely similar to this effect is the appeal to our kinesthetic senses: we are conscious, as an integral part of the aesthetic image, of a slowing or hastening of the tempo of life, of being raised aloft or pressed to earth, and we perform incipiently the most intricate muscular movements, thus eliciting a wealth of sensuous and organic feeling which is quite precise in itself though it withers at the touch of language.

A second major class of such material is that made up of *formal properties*. The discovery and enjoyment of form or structure is just as prominent in aesthetic experience as are its sensuous and emotional elements. The design of a painting, the meter and rhythm and rhyme scheme of a poem, the

development and repetition of themes in music, the plot of a story or drama, the structure of a building — all of these are elements that we readily grasp and enjoy. The form that an artist realizes in a medium — and that comes to us as the structure of sensuous material — moves us deeply and variously; it has immediate physiological and psychological effects, which are at least partly independent of the sensuous material in which it appears. Movement, balance, proportion, tension and resolution, climax and denouement, reiteration and variation, massiveness and delicacy, simplicity and subtlety — these and a horde of other words reflect the direct action of form in the constitution of aesthetic experience. In addition to these intrinsic meanings and values, form (as we have previously seen) supplies the structure around which the other elements of the image are organized. The formal properties of art are both rewarding in themselves and a necessary support of its other properties.

The third important type of material is composed of *symbolic meanings*. This is the most elusive part of the content of aesthetic experience, and the effort to explain it will require us to draw some rather arbitrary distinctions. Let us, then, define the work of art in strictly formalistic terms, as a design realized through and in some medium: the work of art is made up of words, or sound, or pigment, or stone, arranged with a certain structure. The work of art, so defined — and I am quite aware that it is a very incomplete definition — is the culmination of the artist's creative process; it is the embodiment of his vision, of the aesthetic object that he has attained. Further, it is the point of origin of our aesthetic experience; it is the physical locus from which we derive the images that compose for us the aesthetic object. Now the aesthetic object, as envisaged by both the artist and ourselves, is something quite other than a structure of matter and form; it contains a great deal more than only the sensuous-emotional and formal materials just identified. The artist's vision is largely

based upon the particular thing he is dealing with and seek-ing to present; and it contains deposits drawn from the whole wealth of his accumulated experience of the world and of life. The same is true of the aesthetic object that is our counterpart of the artist's vision. This is to say, in traditional terms, that art is both an imitation and an expression. But as a simple amal-gam of form and matter, it could be neither of these. It could be only itself, a construct which could at the most "please in being seen." If the work of art is to be what it obviously is, an embodiment of the artist's vision which conveys the aes-thetic object to us, its matter and form must be conceived to carry a heavy weight of reference to the world and to man's accumulated experience. This is what I am calling its *symbolic meanings*.

We can now transpose this discussion into the context of aesthetic experience, and see how it bears on the analysis of the aesthetic image. The content of images — what we are aware of and attend to as the aesthetic object — is much wider than the sensuous elements and the formal properties already noted. When we read a poem or look at a painting or listen to music, the images that we achieve contain a vast amount of material that is neither sensuous nor formal, and that is drawn from beyond the poem or painting or music as an isolated physical object. General and abstract ideas are conveyed to us; memories are elicted; very precise and intricate emotions are aroused: ideals are called before our minds; our hopes and intentions are appealed to; our attention is centered upon such complex and organized particular things as a landscape, a love affair, a casual street scene, an involved human career, the tragic and comic aspects of man's struggles. A very great deal of this content is present in images through the medium of what I have called symbolic meanings. A symbolic meaning is a reference that reaches out and draws into the image ma-terial that is already resident in the world or in our accumulated experience. The sensuous elements and formal properties

of images function as symbols, and endow the image with this additional content, by leading our attention to things that are extraneous to the medium and the design strictly as such.

Of course, this material is not lifted from its natural setting and incorporated in art without undergoing a change. In being transposed it is also transformed. The artist does not simply copy what he finds around him, or pour out what he feels within him. Through symbolic meanings art lays its hands upon the vague and fugitive things that compose the world and occupy life, and transforms these into aesthetic objects. Art is much more than a plagiarism of the world and of life.

This is not the place to enter into an exhaustive analysis of the artistic symbol. But it is necessary to point out that there are several different levels of symbolism, and that these are variously employed in art. At least three such levels can easily be distinguished. There is, first, what might be called a physiological — or perhaps better, a psycho-physical — mode of symbolism. The sensuous and formal characteristics of art have an immediate and intrinsic symbolic reference: they bring with them, as an integral part of themselves, certain organic and emotional and even ideational suggestions. Color and line, tone and rhythm and melody, the sound and arrangement of words, the texture and pattern of materials, the movements and attitudes and gestures of the body — all of these stir us in many ways that are none the less powerful for being little understood. These data of sense are embedded in the fabric of the world, and they vibrate through experience in an obscure but pervasive manner. The color red, in different shades, seems to bring with it an intense, but also a complex and variable, sense of danger, excitement, temptation, majesty, and struggle.[8]

[8] There is a large literature on this subject, with work bearing on it having been done by specialists in many fields. There is a very thorough and penetrating treatment in Charles Hartshorne, *The Philosophy and Psychology of Sensation* (Chicago: University of Chicago Press, 1934), esp. chap. VIII, secs. 38–39, and pp. 146–151.

There is, secondly, the level of arbitrary symbolism. Many of the material and formal elements that art employs have definite meanings assigned to them by agreement and convention. Words have connotations and denotations that are carefully defined; the plastic arts not only represent physical objects and situations directly, but also make a large use of iconography; much of the pantomine (the gestures, postures, movements, and facial and bodily expressions) that figures in acting and the dance has a well-settled meaning; and even in music, where symbols of this type seem to play the smallest role, the composer frequently employs themes and motifs that have precise designations. The fact is that any recognizable sense datum can be used as a conventional sign. The color red, in different contexts, indicates a brothel, a stop sign, or a storm warning.

A third level of symbolic operation is that of tradition or association. This is intermediate between the other two, and shares some of the characteristics of each of them. The elements and objects that are presented in art have many meanings that have been acquired in the course of time, and that have become habitual without ever having been arbitrarily established. The total impact of words, colors, sounds and melodies, forms, et cetera, goes far beyond the symbolic values that are intrinsic in them or have been assigned to them. These meanings are the gradual accretion of social and individual experience: some of them are traditional, and will convey the same content to all who are of a common culture; others will depend upon local accident, and may be shared by only a few people or may be private to one person. The color red makes most of us now think of Communism and Russia and Senator McCarthy's Fifth Column, while to three different individuals the color red — and especially some certain shade of red — may recall the dress worn by a childhood sweetheart at a school dance, a barn where one played in the summer, or a favorite baseball team.

These modes of symbolic function are not independent of one another. Probably most traditional and associational meanings have their original but now indecipherable source at the physiological and psychological level. And as the examples cited above suggest, even arbitrary symbols may not be as wholly "arbitrary" as at first appears: though their designations are assigned by convention, they are often derived from their psycho-physical meanings. Virtually all of the sensuous and formal materials that are present in images carry with them at least some of each of these kinds of symbolic meaning. The media of the various arts differ a great deal in their inherent tendency to operate at one or the other of these symbolic levels: as they come to artists, they are already differently burdened with symbolic meanings. But the artist has a good deal of residual freedom and power in his manipulation of symbolic references: they are his resource and his challenge.

There is one further problem bearing upon the question of aesthetic materials and meanings that requires a brief comment. This concerns the possible primacy of some of these with respect to others. Is it, or is it not, the case that some of these materials and meanings are prior to others; that some belong properly to the substance of art, while others are extraneous and derivative; that some of what we "get" from the work of art is immediately given, while some is only inferred? This question has occupied a prominent place in contemporary discussion, and there has been a strong tendency to limit very stringently the "real" or "inherent" or "intrinsic" content of art. It is often held that art directly presents to us only what I have referred to as sensuous and formal material, and that all other meanings that we seem to "find" in art are in fact only represented to us and inferred by us.

The interpretation that I have proposed repudiates this view. The accounts given of expression, of the image, and of the aesthetic object, all insist that the whole body of meaning conveyed by art is equally immediate and direct. If we

are to admit and explain in theory the meaning or content
that in experience we discover in art, then we must ac-
knowledge that symbolism (of all the three sorts identified
above) is just as basic and intrinsic a factor as any other.[9]
Distinctions within the work of art between the immediate
and the inferred, the presentational and the representational,
what is directly given and what this "stands for," are in-
vidious and unjustified. Of course we have to experience ("in-
terpret," if one will) the work of art in order to reach the
aesthetic object; and of course there is always the danger that
in this effort we will inject into the aesthetic object what the
work of art does not contain or intend. But this difficulty is
not avoided by stripping art to any bare — or esoteric —
meaning. It can be avoided only if the artist does his work
properly, and if our experience of his work follows the
proper course.

[9] Arnold Isenberg has given a brief, thoroughly reasonable, and very
acute discussion of this whole question in an article, "Perception, Meaning,
and the Subject-Matter of Art," *Journal of Philosophy*, 41: 561–575 (1944).
The article is reprinted in Vivas and Krieger, *The Problems of Aesthetics*
(New York: Rinehart and Co., 1953), pp. 211–225.

Chapter IX

THE AESTHETIC AND THE
PSEUDO-AESTHETIC

I

1. Aesthetic experience as a conscious occasion may be dominated, at its inception, by either a sense of discovery or an effort of assimilation. When we first look at a painting or read a poem or listen to a piece of music, the images that this presents may be so vividly and compellingly delineated that they at once capture and satisfy our attention. Their structure is sharply and cleanly articulated, their thread of meaning is at once apparent and is easily picked up and followed, and we are led into and through the work of art without any apparent need to assimilate this. Such occasions are dominated by images, which seem to be projected from a source outside of us onto a screen before the mind's eye, with no conscious support from the accumulated body of experience. These images spontaneously compose themselves into an aesthetic object, which is discovered to us with great clarity and completeness; this immediately illuminates some area of our familiarity; this reflects further meaning back upon the aesthetic object and the particularity that it presents; and the fabric of experience stretches quickly and easily to make room for this new insight.

But it also often happens that the painting or poem or piece of music that we encounter is so vague and tenebrous that it challenges attention rather than capturing it. What structure we can grasp at all is loosely enunciated, and what meaning emerges seems always on the verge of collapsing into in-

articulateness. In such cases as this there is very little initial discovery of the aesthetic object. In extreme cases there may even be none: as we put it, we simply cannot grasp what the artist is about, or driving at, or trying to say; and the only reason we prolong the experience and stay with the work of art is that we have cause to believe — from the reports of others, from our own past acquaintance with the artist's work, or from a vague promise that the present work contains — that there is something to be found, and that this something will justify our quest. The gap between the work of art and our own familiarity — between what the artist is saying and what we are prepared to comprehend — is so great that the spark of insight cannot leap it. Since the work of art can do nothing more for itself than continue to be, we must somehow assimilate it into the body of our experience, find something within ourselves that will render it more intelligible to us, and so give it a context that will illuminate it and bring it out.

Occasions such as this are dominated by a purposeful appeal to the accumulated body of experience. We sharpen our faculties and search our familiarity for assistance in grasping the particularity that we suppose the artist to be presenting us. But our habits of experience cannot readily be brought to bear upon this vague insight, and they destroy it to a greater extent than they clarify it; what little assimilation takes place only distorts what we have discovered and provides no basis for further discoveries. The aesthetic object seems to be so strange and fragile that it shatters as soon as we try to force it into the mold of our accepted ways of perception, thought, and feeling; so the images that we glimpse remain fragmentary and isolated, finding no lodgment in our established frames of reference. Something like this quite certainly occurs with the vast majority of people when they first encounter Joyce's *Ulysses*, or the poetry of Dylan Thomas, or a cubist painting by Braque, or Schoenberg's atonal music.

Aesthetic experience as an organic occasion contains both

of these moments from its inception. Even when our discovery of the aesthetic object is the most facile and immediate — when art seems to suffuse us with its sensuous qualities, to hold us in the grip of its formal structures, and to pour its symbolic meaning in upon us — we are conscious of contributing to the transaction. Art may not, when it is so vivid and compelling, confront us with any challenge. But art always voices an appeal, at least to be attended to and accepted. We respond to this appeal by using our senses with greater alertness and discrimination, by bringing into play whatever is appropriate from our accumulated experience, and by seeking to anticipate what the work of art is going to disclose, so that we can receive this more easily and correctly. Assimilation is always going on, even when the discovery of art seems the most complete and self-sufficient. Furthermore, as we assimilate more thoroughly the images that come to us so spontaneously, we frequently find that they are incompletely explored and have materials to yield that we did not at first suspect; the aesthetic object that they compose becomes, in the course of closer acquaintance, progressively more subtle and even, perhaps, elusive.

Conversely, even when we have to make the most intense effort to interpret the meager and disjointed clues that the work of art gives us, and to distill some coherent meaning out of them, we have in mind some conception of at least the sort of particularity the artist is dealing with and the general drift of his intention. The opening verses of a poem convey to us something of its subject and mood and treatment; our first glimpse of the design of a painting yields us some notion of a unified whole, leads us into this at some point, and gives us some directions for our future journey through it; the opening bars of a piece of music set an emotional tone and point our expectations. This original discovery, or insight, may be little better than conjecture on our part, a guess that we hazard almost at random and in the full awareness that we are suppos-

ing it rather than being compelled to recognize it. This aesthetic hypothesis — to give it a name that is too explicit and purposeful to be really descriptive — is tentative and provisional; we propose it to ourselves, and follow it out, for want of something better to try, but we are quite prepared to surrender it and try again. Some such discovery, or hypothesis, of the aesthetic object must emerge and take form very early in the experience; if not, our acquaintance with the work of art degenerates into a jumble of isolated and interrupted impressions that is like nothing so much as the snatches of conversation that assail one at a cocktail party. In such cases we soon break off the acquaintance, and go back to its commencement to try to resume it on a firmer footing: we return to the beginning of the poem and start reading it again; we shake our heads and turn away, and approach the painting afresh; and if we cannot leave the concert hall, we simply think about something else until this piece of music is finished — which it was for us long ago — and another one starts. There must be at least a provisional discovery of a possible aesthetic object, or there is no nucleus around which experience can cohere. Finally, it should be noted that encounters of this kind often culminate in a vision which is firmly integrated internally and which makes a secure place for itself by rearranging our accumulation of experience: as we bring ourselves to bear upon these obscure and fragmentary images, and finally attain the aesthetic object, this process so enlarges and refines our perspectives that whole new vistas of particularity are opened to us.

The majority of aesthetic experiences fall between these extremes. The moments of discovery and assimilation are present at the start, however incomplete and tentative either may be and however various the balance in which they are held. The activities that constitute these moments are carried on in close conjunction, sometimes simultaneously and sometimes successively. The rhythm at which these moments

move allows of wide differences: there may be steady alternation and growth; or there may be frequent interruptions and changes of direction, as what is discovered defies assimilation and what is assimilated distorts and frustrates discovery. Also, the outcome of this process varies greatly: the aesthetic object that we finally attain and accept may be quite complete in itself but still somehow isolated, as though its meaning could be acknowledged but not integrated, like an odd companion whose company we cherish but whom we would never dream of introducing into our regular circle of friends; or this object may be so thoroughly absorbed that it virtually loses its original status; far more frequently, the outcome of mature acquaintance with a work of art is intermediate between these results. But beneath these differences, the general course of aesthetic experience is clearly discernible: as the moments of discovery and assimilation strengthen and clarify one another, they coalesce, with the result that a series of images becomes an aesthetic object, and this object reflects light upon reality.

2. Since it is of such importance that discovery and assimilation should commence together and proceed apace, it is to be expected that there would be purposeful efforts to insure that this effect is achieved. There are in fact such efforts, coming from three directions.

In the first place, the artist takes pains to arrange that his work will immediately yield distinct images, which will also at least intimate the complete aesthetic object and at the same time alert our familiarity to grasp this.[1] The artist wants to attract our attention, to give this something upon which it can easily fasten, and to offer us some rough preliminary grasp of the total structure and content of his work. One means to this

[1] This is subject to the serious qualification that the artist does not want us to rush through his work too quickly or easily, or too much at our own behest; so he often takes steps to puzzle and delay our perusal. This point is elaborated below in Chap. X, Sec. iii.

end is the employment of materials that are sensuously and emotionally attractive, and are already fraught with symbolic significance. The other and more important of these devices is that of form or design. The artist seeks to acquaint us, as quickly as possible, with the chief constituents of his work and with the relations in which they stand to one another. He seeks to point our expectations toward a certain course and conclusion, so that we will be prepared for the elaborations that he intends to produce. And he seeks to refer our attention to certain carefully selected and fragmented areas of familiar meaning, to establish novel associations among these, and to prevent his references from being submerged in any established system of meanings.

The artist accomplishes all of this largely by the formal structure that he gives to his work. Each of the arts, besides relying upon certain general principles of design, adopts whatever special devices its medium affords. The skillful employment of form permits us to grasp the aesthetic object in both its unity and its variety, to seize its various aspects in their proper sequence and significance, and to anticipate what is to come later in its development. By his mastery of design, the artist gives us vivid and coherent images which facilitate our discovery of the aesthetic object; at the same time he sets this in a definite position against the background of our accumulated experience, so that we will bring to bear upon it just those segments of meaning that are relevant to its assimilation.

The second of these efforts to prepare the way for aesthetic experience is perhaps less noticed: this is the contribution that we ourselves make. It is very rarely that our encounters with art are unexpected: we usually know that we are about to confront a work that has much to offer us, and we dispose ourselves to meet this under the most favorable conditions. This preparation takes two forms. We try to banish other concerns from our minds, and to achieve that odd mixture of

concentration and relaxation that is called the aesthetic attitude and that is so characteristic of our mood as we wait for the lights of the theater or concert hall to dim, as we enter a museum, or as we make ourselves comfortable with a book. Besides this — which might be called preparation for the aesthetic encounter — we also prepare for the specific work of art. We·study the appropriate critical notices, historical and biographical reviews, program notes, exhibition catalogues; we go over the script of the play we are to see or the score we are to hear; we seek to familiarize ourselves with the special techniques of the performer. The same sort of rehearsal precedes many of our encounters even with natural beauty: we often prepare ourselves before going in search of this, aware that it is there to be found with its own determinate character.[2] To this statement of obvious fact it need only be added that such aesthetic preparation has its dangers as well as its advantages: it easily degenerates into the affectation of the aesthete; and unless we are both perspicacious and well-informed, our efforts may fill attention with the wrong material and give it a mistaken direction.

[2] There is a piece of Arizona folklore that amusingly illustrates what is apt to happen without this aesthetic preparation. The tale concerns a Texas cowboy who, after the manner of his kind, wandered farther and farther westward until he found himself working at a ranch in the high country near the Grand Canyon. (For those who are unfamiliar with the region, it should be made clear that the Grand Canyon takes even tourists by surprise. There is nothing in the landscape that anticipates it, no slightest declivity leading up or down to it. It is simply there all at once, an enormous rift, barren and jumbled, in an otherwise perfectly flat and thickly forested plateau.) None of the local hands happened to mention, much less describe, the Canyon, assuming that all the world was as familiar with it as they were. So our Texas stray, out rounding up some cattle, stumbled on it all unexpected. Some other cowboys were nearby, and reported what occurred. The Texan stood stock still for a minute, wrapped in awe and amazement at the huge Canyon yawning and sprawling literally at his feet. Then he flung himself on the ground and seized a tree, as though afraid that he would fall, or be sucked, into the chasm. Then he looked all about—up in the sky, down in the Canyon, on the ground near him—searching for the cause of this unheard-of hole. Finally, pulling himself to his feet and staring hard at the Colorado River a mile below him, he found his conclusion and expressed it: "My Gawd, something happened here."

It is with respect to just this problem that there enters the third figure who helps to prepare the way for aesthetic experience. This is the critic. As we have seen, appreciation requires both the discovery and the assimilation of the aesthetic object: it involves both images and the body of experience. In preparing and consummating these encounters, the artist is largely — though not wholly — confined to facilitating our discovery of images and the object they compose. He can do a great deal in this respect; but he can do much less to promote assimilation. This latter operation demands that we have the background into which to absorb the work of art, that we be able to meet it on familiar terms, that our habits of experience be adequate to deal with it, and that we be capable of supplying from within ourselves whatever is relevant to the work and that it cannot supply for itself. The work of art itself, of course, furnishes us many clues that aid us to assimilate it. But these tend to come too late to be really effective, especially if it is a work that unfolds in time, cannot be halted and repeated, and can only be encountered once, or at most a few times. A concert, a ballet, a play, or even a special exhibition, illustrates this difficulty perfectly. If these are at all subtle and complex, much of what they contain is gone beyond recovery just when we come to suspect its existence and have prepared ourselves to comprehend it. We can ready ourselves to assimilate art; that is, we can prepare for the aesthetic encounter in general. But to ready ourselves for a specific work of art is beyond most of us, unless we can encounter it frequently and absorb it at leisure.

The real function of the critic is to obviate this difficulty. It is not the task of the critic to give us a digest of the work of art, or his impressions of it, or a translation into simpler and more obvious terms. An effort in any of these directions defeats his purpose rather than furthering it, for art cannot be abbreviated or epitomized or translated. What the critic can and should do is to prepare us so that our encounters with art

will be richer, more profound and refined, and more readily consummated. He does this by directing our attention toward the pertinent aspects of the work of art he is dealing with, by evoking the regions of experience that are necessary to comprehend this, by supplying what background we can probably not supply for ourselves, and by enabling us to anticipate the steps through which the work is going to lead us. The critic is a middleman between artist and public. As such, he should regard it as only a minor and incidental part of his task to place a value on the goods he handles: the evaluation of works of art is at best a trivial business, and is usually pernicious and distracting; it diverts attention from *this* work of art, which needs all of our concentration, either to other works or to some abstract standards and patterns that supposedly determine artistic merit. That is, it substitutes a cognitive for an aesthetic attitude.

The critic finds his vital function in preparing men to meet actual works of art with sense and intelligence properly attuned. If this task is not well done, both artists and the public suffer. For it is beyond the powers and the patience of most men to discover and assimilate unaided the aesthetic objects that are implicit in art. To grasp the full impact of a work of art is an intensely personal achievement: the critic should not emulate the pelican, for there is no health in a predigested aesthetic diet. But the critic finds a legitimate and valuable function in facilitating our initial apprehension of the aesthetic object, and in orienting our attention so that we can the more readily absorb this into the body of experience.

II

3. In art, far more than in theory and technology, it is true that there is no royal road to learning. We can, within limits, understand and profit from the results achieved by the theorist and the technologist without measuring their evidence, comprehending their methods, and proving their argu-

ments: we can grasp and apply the theorems of geometry or the principles of genetics without knowing how they were arrived at or what they really mean; and we can drive an automobile without the slightest acquaintance with the construction of an internal combustion engine. But to appreciate art we must discover and assimilate for ourselves the aesthetic object that is offered to us. The artist does a great deal to prepare, facilitate, and guide this adventure. Still, it is we who must conduct it. It is the task of the artist to make as sure as possible that we trace the course of his discovery, though more rapidly and incompletely, and with many abbreviations. It is our task to follow him closely. For it is only by repeating his journey that we can arrive at his destination.

In doing this we bring into play all of our resources: we employ our faculties of sense and mind, as well as our powers of concentration; and we call upon the accumulation of our past experience, bringing this to bear upon the work of art in order to render it familiar and then to illuminate and amplify it. To the extent that these resources are deficient, our realization of the aesthetic object is impeded and distorted: if eye and ear and touch are insensitive and undiscriminating, if thought and imagination are lacking in strength and subtlety, our discovery is impoverished; and if our experience has been limited and superficial, so that we cannot follow the clues the artist gives us or supply the references he demands, our assimilation is hesitant and erratic. Even the most competent criticism can only aid us in the employment of the resources that we have: it cannot bestow these upon us.

The aesthetic object thus contains, besides the elements that it derives quite directly from the work of art, a great deal of material that is already present in mind and memory and is drawn into it by way of its intrinsic factors, especially its symbolic meanings. As we read a poem or look at a painting or listen to music, the sensuous and emotional appeal that these make, the formal organization that they exhibit, and the sym-

bolic meanings that they convey merge into a single whole. When the work of art is successful, and our response to it is correct, the aesthetic object gathers all of these diverse contents into itself, and fuses them into a real unity.

Unfortunately, this is not the whole of the story. The artist can never completely control the references that his work must make to our accumulated experience. These references, which are indispensable, introduce a variable and unknown factor, with the result that our discovery and assimilation of the aesthetic object are always partly at the mercy of idiosyncrasies of character and accidents of biography. Whatever the pains the artist may take, we continually introduce into his work some content that is not pertinent; and we continually pursue his references away from the aesthetic object that he has in mind, losing ourselves in reminiscences of the past or fantasies about the future that are equally irrelevant to this object.

All too often a nonaesthetic element thus comes to dominate occasions that are supposedly aesthetic in character, with the result that a really valuable type of experience is replaced by a weakened or adulterated one. It is frequently complained that artists debase or mar their work by injecting into it features that have a wide and easy human appeal, but that are not aesthetically appropriate. And it is even more frequently complained that audiences distort and defeat the artist's intention by paying to his work only a loose and casual regard, neglecting much that this contains and supplementing it with much that is foreign to it. In short, the aesthetic attitude, at both the creative and appreciative levels, is always subject to the intrusion of other interests and attitudes that threaten it with disintegration. How and why does this occur?

The answer can be given quite simply. It was emphasized earlier that it is of the essence of aesthetic experience that throughout its development the aesthetic object retains its status as such, so that it controls not only what we discover but also what we assimilate. It was also mentioned that it is

possible for the aesthetic object to be destroyed and replaced with some other object. This may occur at any stage of aesthetic experience, and it may take any of several forms. It is when this possibility eventuates, and dependent upon the manner of its occurrence, that we get various sorts of pseudo-art and degenerate aesthetic experience. The attitude that is necessary to create and appreciate art is disrupted when we substitute for the aesthetic object, which is the proper focus of attention, some other object that is extraneous to this, however closely associated with it in our minds. Art deals with things in their particularity (and by reverberation in their universality), and presents them as entities. The value of art — and of the aesthetic life — resides precisely in the fact that it enables us to realize the actual character of things with enhanced richness, intensity, and refinement. Consequently, to supplant particularity with something else is to deny the nature of art and to destroy its function.

Yet we are continually tempted to do this. To grasp what the artist offers us demands great concentration, requires the disruption of our habits of experience, and challenges our hard-won catalogues of familiarity. The task imposed on the artist, who must wrench particularity from the established frameworks in which it is embedded and disguised, is even more arduous. As a refuge from this effort, there lies open before us the easily accessible world of familiar objects and meanings, of acknowledged values, of inviting daydreams, of unrestrained emotional and imaginative wish-fulfillment. It is so simple and pleasant to embellish a vaguely recollected past; it is so flatteringly self-righteous to subscribe to moral principles and social values that ask only for our acquiescence and require no action to support them; it is such a relief to escape into a world that has no conditions to meet save that of accommodating our emotions and desires; and it is so easy a victory to project careers that need neither time nor effort to be achieved.

So it is not surprising that we deny the challenge with which

art confronts us, surrender the quest for aesthetic insight, and relax in some other mode of experience that is more easily attained and more immediately pleasing. The general way in which we do this is to renounce the search for the aesthetic object, and to replace this with some other object that is more readily available and satisfying. The work of art is taken not as an embodiment of the artist's vision of particularity, and so not as a presentation of the actual character of things, but rather as a point of departure for our own idle reminiscence, rumination, and fantasy. The aesthetic objects that are embodied in art are the results of a rigorous scrutiny of the quality and contents of lived occasions: through them artists offer us their insights into the furnishings of the world, and into the rewards and vicissitudes, the possibilities and the limitations, with which the world confronts us. But we often renounce these aesthetic objects, and treat art as a simple incentive to an undisciplined dream of life and the world as we would like them to be. Art, which in function and intention is under a strict obligation to express the actual character of things, is debased into a detonator of subjective chain reactions that express nothing but the whims and predilections of those who indulge in them.

In general terms, then, aesthetic experience degenerates when we look through the work of art, which presents a unique particular, and find instead something quite other than this. So the spurious modes of aesthetic experience can be specified by indicating the different types of objects that we are most prone to substitute for the aesthetic object. There are three such improper ways of responding to art, and of creating pseudo-art, that are especially prevalent. I shall identify these as *sentimentality*, *edification*, and *fantasy*.

The aesthetic response becomes sentimental when we substitute for the aesthetic object *a similar familiar object, which we then clothe out of our memories and emotions*. The thing or person, the scene or situation, the encounter or adventure

that the work of art presents is used only as a reminder of what is already near and dear to us. We recognize the "subject matter" or "theme" of the work: Motherhood, The Fireside, Lovers Walking in the Dusk, A Fond Parting, Consolation after Defeat, Man with His Dog, Baby, Childhood's Dreams, A Peaceful Old Age, and so on; we also find and abstract from the work a certain mood or emotional atmosphere, usually a pleasant one, such as comfort, peacefulness, tranquility, confident exuberance, rest, ardor, exultation, or gentle happiness. We then replace the general subject matter with a specific remembered or projected instance of it, taken from our own experience; and we surround this with the pleasant mood that the work has established. In sentimental experience we look through the work of art to something recollected or imagined in the context of our own lives; and we regard this from a position of detachment and security, so that even when the scene or incident is inherently sad it is viewed as a prelude to better things and is bathed in an atmosphere of calm contentment. We neglect the aesthetic object, and the actual character of things that it discloses, and use art as a device to fulfill our wishes, support our dreams, and bolster our regrets. It is in such retrograde experience, and only in such, that parting — as well as death, defeat, suffering, and renunciation — becomes a "sweet sorrow."

The aesthetic response becomes edificatory when we substitute for the aesthetic object *some general rule or principle that it instances to us.* The work of art suggests to us some moral rule, some practical maxim, some abstract concept, some useful homily, some lesson of experience, some proverb or aphorism, some piece of sage advice or simple folklore. Further, the work seems to establish very clearly and forcefully the wisdom of obeying such dictates, and the folly of defying them. We find that it comforts our self-esteem, and reinforces our doubts, to have our beliefs so persuasively inculcated; and we also find that it affords us a useful stick with which to

prod our less docile brethren. Art here serves as the rose-colored glasses through which we justify our opinions, recompense our sacrifices, and fortify our hopes; it also serves as the sugar coating by which we get others to swallow the pills of wisdom that they might otherwise reject. When we use art for edification we look through the work of art, neglecting its concrete uniqueness, and fasten upon the "lesson" that we find illustrated therein. The aesthetic object, which is intended to refine and extend our acquaintance with particulars, becomes a mere instance and exemplification of some general rule with which we are already perfectly familiar. Such retrograde experience, instead of opening new vistas, only confirms us in our settled modes of interpretation. Undoubtedly, every tale has a moral. But every moral requires countless tales to exhibit its nuances, to insist on its exceptions, and to keep it contemporary. When we abuse art to edify ourselves and others, we neglect the novel tale and seize only the hackneyed moral.

The aesthetic response becomes phantasmagorial when we substitute for the aesthetic object *some other object which is suggested in general outline by the work of art but constituted in detail by our own wishes.* We find in art some clue, however meager and remote, to a world that we have longed for but have never found, and have not even known where it should be searched. The aesthetic object now ceases altogether to direct our attention to the actual character of things, or to what experience has accumulated and epitomized concerning this character. Instead, it serves merely as a stimulant and support to our own daydreams: it is a device through which we find release and vicarious fulfillment for our suppressed or frustrated wishes. Art — or more usually pseudo-art — may offer a virtually complete edifice for this dream life, where all we need do is identify ourselves with the chosen personage in the work; this is the case with much romantic literature and painting. Or art may supply only the sensuous

and emotional cues, leaving it to us to fill these out as we will; this is most familiar in the case of music.

Sentimentality, edification, and fantasy are not sharply separated and mutually exclusive modes of experience; they can be described as pure abstract types, but in their actual occurrence they are always intermingled. Furthermore, even the most intense and refined aesthetic experience contains some residues of each of these modes of response. Just because art does appeal to our accumulated experience, and does refer our attention to the character of the world and the concerns of life, it is inevitable that these extraneous elements should force their way into our aesthetic lives. It is the proper task of the artist to create works that embody his vision of particularity; and it is our proper task as appreciators to attend to his works in a way that will illuminate and strengthen our weaker insights. But the contents of life and the world are such that they often nullify our efforts, disappoint our expectations, deny our simplest requirements, refute our surest predictions, and escape our most certain ideas. This is the way of things, and it is well that art should insist upon it and that we should abide it. But it is quite natural that we should also seek escape from this pressure of present particulars by glorifying the past and future, by confessing our hope and faith, and by indulging our legitimate but unpermitted wishes. When sentimentality, edification, and fantasy loom too large in our aesthetic response to things — and especially when they dominate it — experience becomes dull and deceptive. But some intrusion of these elements must be expected and tolerated. Even the finest artist injects some of them into even his finest work. And the most cultivated audience as surely adds its quota.

The pervasive human appetite for sentimentality, edification, and fantasy has important repercussions on art, and on the aesthetic life in general. In the first place, and most obviously, it has motivated the production of a great deal of

what I have called pseudo-art. These are works that embody no intention or effort to see and feel things more finely and clearly, that contain no fresh insights, that do nothing to animate and sharpen our experience of particular things. Instead of contributing to our vision of things and our sense of life, they feed upon our hopes and fears, play the sycophant to our preconceptions and preferences, and smother us under banalities. Pseudo-art ignores the conditions of reality, both as to its limitations and its possibilities, and depicts the world after the pattern of our most supine and extravagant wishes. A depressingly large amount of so-called "popular art" falls within this classification: it contains most of what appears in the motion pictures, in "slick" magazines, on radio and television, in advertising claims and endorsements, and in other media of large circulation. The success story, the happy ending, the female form devoid of fat or bone or muscle, the cliché, the inspirational book, the drama of hardship-borne-with-a-smile, and many similar products manifest this trend. There is abundant room in the world for honest entertainment, which has the declared purpose of simply taking us out of ourselves and getting our minds off our troubles: we would be much poorer and sadder without George S. Kaufman, the Marx Brothers, S. J. Perelman, Al Capp, Rex Stout, Sid Caesar, Cole Porter, and many others who have the magic faculty of creating a substantial fairyland.[3] But pseudo-art is not honest. Its makers delude themselves and their audiences into believing that the real world can and should conform to their descriptions. Such pseudo-art does nothing but foster our retreat from life, confirm us in our prejudices, and indulge our taste for vicarious success.

[3] It is to be noted that much of the best of such work, which seems at first to deal only in make-believe and to have no purpose save our enchantment, turns out on closer acquaintance to be an indirect but most effective commentary on life and the world. When this delayed-action fuse goes off, fairyland becomes persuasively real, and the mad antics of genial fools hold the mirror of ridicule before our faces.

In the second place, and a great deal more importantly, this appetite for the sentimental, the edifying, and the phantasmagorial has an indirect but very deleterious effect upon true art. Artists, intent upon their proper task of seizing and presenting the particularity of things, discover that their efforts are often undermined by the insistent human tendency to subvert art to these inferior uses. Men look through art and search for objects and episodes over which they can sentimentalize; they distill from art some moralistic nugget that they can hug to their bosoms and stuff down the throats of their fellows; and they draw upon art as a base of supply for their journeys into dreamland. Artists, being sensitive and serious about their work, are unwilling to tolerate even a reasonable minimum of such treatment; and they become both incensed and concerned about its prevalence and the lengths to which it is carried. So they set out quite purposefully to inhibit this tendency: they develop art forms, and they create works of art, that will defeat man's inclination to find in art merely a source of sentimentality, edification, and fantasy. I think that this has been one of the strong motivations — though by no means the only or the chief one — leading to abstract and non-objective art. Artists have determined to create works in which there is nothing obvious to be recognized, and so nothing to sentimentalize over. This is also one of the factors that have led artists and critics to insist that art is amoral: that it does not evaluate or judge or make recommendations, but merely presents what it finds in the world. Artists, enraged by man's perpetual moralizing, have gone further than this, and have created works that mock our pretentions and challenge our values. I think it would be difficult to overestimate the influence, subterranean but pervasive, that the human inclination to these aesthetic perversions has had upon artistic creativity. Artists have been harried from pillar to post in their effort to obviate these misinterpretations: they have sought refuge in the simple and in the esoteric, in extreme

realism and extreme distortion, in formalism and functionalism, in craftsmanship and in dada. In short, artists have been so outraged by these abuses to which their work is subjected, and so determined to escape them, that they have been led away from their true function of presenting the actual character of particular things.

In the third place — and this is important only as a footnote to the history of ideas — these aberrant modes of aesthetic behavior have often been accepted as valid, and made the basis for theories of art. Thus, art has been explained and justified as an escape, a wish-fulfillment, a form of play, a tool of didacticism, a formal structure, and a device for ordering and releasing our emotions. I think that these theories are doomed to inadequacy because they are based upon aspects and functions of art that are at best derivative and inferior, and are largely illicit. This raises the question of the true nature and function of art.

Chapter X

THE FUNCTION OF ART

I

1. It has been an integral part of my thesis that aesthetic experience is a necessary and spontaneous mode of our acquaintance with things; and that artistic expression and creation are the natural outcome of the aesthetic impulse. Until we have achieved a coherent vision, our insights are cursory and scattered, we sense meanings that are portentous but imponderable, and our hold on particularity is neither refined nor stable. We feel this inadequacy, and are driven to repair it. So every aesthetic encounter with things points to its completion through expressive and creative activity.

In view of this double insistence, an equally insistent question obtrudes itself: why is art necessary? If a regard for particularity is both natural and indispensable, then it might seem that every man should be able to supply out of his own resources the creative acts that would satisfy the aesthetic impulse. This is clearly not the case. Rather, the needs of the many are consummated by the work of a few: art does for man what he cannot, on the whole, do effectively for himself. But the questions still loom through the facts: Why is the aesthetic impulse dependent on art for its fulfillment? Why do we require assistance to achieve the aesthetic vision that our nature demands? Why is not every man his own artist?

The major obstacle that confronts the aesthetic intention is the pervasive human tendency to rush through its experienced encounters with things and to dispose of them as quickly as possible. Experience is essentially an instrument of life, not an invitation to leisure. Its function is to yield us an adequate

acquaintance with things and with ourselves, and then to consummate this acquaintance through action. Our dealings with experienced situations are a queer mixture of impetuosity and inertia: we are anxious to come to grips with things quickly and efficiently, to effect their disposal in the most obvious and least demanding fashion, and to free ourselves for other encounters; so we are reluctant to pause over the present moment, to retard it and relive it, to drain it of all the details and nuances that it holds. We slur over the particularity of experienced occasions, forcing them into the molds of generalities and discharging them by habitual forms of action. The rich and varied content of experience continually stimulates a curiosity that it is too hurried and preoccupied to satisfy. To the searching gaze that creativity demands, experience offers at once a perpetual invitation and a persistent rebuff. It is precisely this duality that constitutes the haunting and paradoxical quality of experience. The aesthetic impulse to dally with experience and exhaust what it offers is impeded by the human impulse to take from experience only what seems to be immediately needed and to move on to the future.

Care must be taken not to exaggerate this tension between the common course of experience and its aesthetic employment. Modern critics have often interpreted this as though it were an irreconcilable opposition. They speak of the artist as one who must wrench himself utterly from the normal concerns of life, turn his back upon his surroundings, and, through his art, deal with a world that is entirely of his own contrivance. Furthermore, they speak as though this were a difficulty that only the artist encounters: they seem to think that experience is naturally oriented toward logical and practical pursuits, that it is spontaneously concerned with the self and the world but not with particular things, and that it readily lends itself to the purposes of the theorist and the technologist. According to this widely-held opinion, experience rushes toward the consummation of its cognitive and affective im-

pulses, but holds back steadily from its aesthetic fulfillment as from an alien fate that would destroy it.

None of this is the case. It is natural and necessary that man should be interested in the actual character of lived occasions, the actual content of his encounters with the world. Every such occasion is unique, as regards both the object or situation encountered and the impulses and intentions that it arouses in us. If experience is to serve the purposes of life, it must have a regard for the particularity of things and situations and encounters; it must honor the uniqueness of these and be sensitive to what they assert of themselves. Man spontaneously takes both an aesthetic delight in what consciousness brings to him of the outer and the inner worlds, and an aesthetic interest in extending this acquaintance. So experience is not actively hostile to the aesthetic intention to linger over our encounters and involvements with things, to improve the present moment, and to grasp objects and occurrences on their own terms.

Experience does, however, offer considerable passive resistance to this aesthetic quest for particularity. This comes chiefly from the forces of impatience, economy, familiarity, and habit.

Experience is impatient of the delay that the aesthetic impulse, seeking its own fulfillment, would impose upon it. Our regard is continually directed away from the present here and now, anxious to anticipate its consequences, prepare a future course, and force a desired conclusion. Clouds presage a storm, roads lead to destinations, jealousy seeks an outlet in action, landscapes have histories and utilizations, and courtship is a prelude to marriage. We sense the dangers of aesthetic delay and enjoyment at the same time that we feel their allure: while we are intent upon the clouds that bank and charge across the sky, upon the scenes that unfold along the road, upon the turgid and violent play of our emotions, upon exhausting the catalogue of our beloved's charms —

even while we are engaged with these things the shifting kaleidoscope of the world has removed them, replacing them with other things which, being unanticipated and unprepared-for, threaten to overwhelm us. Time presses its demands upon us, the manifold concerns of life clamor for our attention, and we hesitate to prolong any actual occasion beyond the minimum that it obviously requires. So impatience is a lesson that we learn early and never wholly overcome.

Experience economizes its attention and effort by gradually deciding what aspects and characteristics of things are important, and then refusing to heed any others. These chosen features coalesce into a general idea, or class-concept, under which many similar but not identical particulars can be subsumed. The spontaneous reception we now accord to things is that of recognition: as we encounter objects and events and situations, we type them, and the type tells us all that we feel we need to know about them. We can dispose of life's occasions most readily by bringing them under such ideas, which permit immediate recognition and prediction. So we become reluctant to push our acquaintance with things beyond this point.

The accumulation and organization of experience give us a large familiarity with the world and with ourselves. We grow accustomed to the objects and situations we encounter, to our own emotions and purposes and problems, to the attitudes and judgments of other men. These things lose their power to startle or even to interest us. We feel that they have no secrets from us, and so no charm for us, and we pay them only a cursory attention. Use inures us to them. Familiarity is less an intended product — a designed instrument — of experience than a side-effect of its history. But it is none the less a powerful factor in diluting the regard we give to things. For though familiarity may not breed contempt, it certainly fosters indifference.

Habit is at once the product of these forces and the catalyst

that hastens their formation. Impatience seeks an outlet that is rapid and regular; economy demands a mechanism that operates with a minimum of original information and supplemental control; familiarity, being blind to individual differences, forges an instrument that is not overnice in its disdiscriminations and that reacts identically to situations that are only roughly similar. These traits constitute a working definition of habit. The more important sorts of habit are perceptual, emotional, kinesthetic, conceptual, and verbal (or, more broadly, symbolic). Habit is a pervasive background that conditions the contents and the pattern of all experience. Habit has itself a complex origin: it is at least a precipitate of instinct, training, biography, and reflection. Our habitual modes of viewing and interpreting the world are partly inherent in our structure and situation as men; they are partly the result of our individual and social condition; they are partly the repository of what we have intended and done. Habit is the web of the past, both near and remote, reaching out to prepare the future. The cumulative effect of habit is to hurry us through our encounters with the world, to eclipse the unique features of lived occasions, and to reduce experience to the repetition of a limited number of stereotyped patterns. Habit obscures particularity and erodes the contours of life.

2. It would be feckless to lament the existence and the enormous power of these forces of impatience, economy, familiarity, and habit. Even if they are regretted they cannot be denied. They are necessary implements of experience in its dealings with the plethora of objects and situations with which the world confronts us, and with the manifold decisions that life requires. The channeling of perception and feeling and thought, and the general notions and standardized techniques that precipitate out of them, are conveniences without which man would be helpless before the environment. But because of the constant operation of these forces, the

aesthetic impulse, if left to its own devices, is usually over-
whelmed early in its course, and absorbed into the general
flux of experience. This is not at all to say that the aesthetic
component is nullified or destroyed; as we have abundantly
seen, this component is a necessary factor in the life of the
mind and a permanent ingredient of experience. But it does
not often appear as a prominent element in our encounters with
things. And it is far less often that it is able to dominate ex-
perience, to maintain attention at one perspective, and to drive
the mind toward an intense and refined grasp of particularity.

These remarks apply with equal force to the cognitive and
affective impulses: all of these components of the psyche are
in the same situation. The paradoxical combination of im-
pulsiveness and inertia that is so pervasive a characteristic
of experience manifests itself in three closely related ways. In
the first place, experience tends to maintain a rather even
balance among aesthetic, cognitive, and affective moments.
It spontaneously locates things within these three dimensions,
and resists any impulse that would sacrifice some of them to
others. Secondly, experience tends to unfold at the lowest
level of intensity that is consonant with the demands upon it.
Unless it is seriously challenged by circumstances, it is in-
clined to accommodate itself to the present encounter by
drawing upon the reserves of its past acquaintance with the
particularity, the connectedness, and the import of things.
Thirdly, experience manifests a vast ruthlessness toward the
things it deals with. It is unwilling to linger over its present
content, and is continually looking for new objects to occupy
it.

As a summation of these characteristics, experience exhibits
an inertia that is highly similar to that ascribed by classical
mechanics to physical objects. It tends to move relentlessly
forward in a steady path unless disturbed by the exigencies
of circumstances. And these disturbances — which are of
course continual — it seeks to absorb with the least delay

and deviation in its course. Every encounter of man with the world introduces a new element into experience, and so throws it somewhat off balance. Experience is thus the perpetual victim of conflicting tendencies. Its natural interest in each fresh encounter, and its concern to deal with this appropriately, incline it to a careful and prolonged examination of the things it confronts. But the forces of impatience, economy, familiarity, and habit incline it to dispose of these things as simply and quickly as possible. The latter tendency usually dominates life and controls our transactions with the world.

Experience thus constantly thwarts its own inclination to linger over its encounters and to refine its acquaintance with things. And it resists, at the same time that it welcomes, the intention of all those who would induce it to this closer scrutiny. The special efforts of the artist, the theorist, and the technologist confront the same attitude of indifference and complacence: man clings as stubornly to his accustomed ways with his ideas and emotions as with his images; he is as conservative in his theories and practices as in his vision; his catalogues of facts and values are as rigid as his apprehension of what things are like as entities. Those who would change our ways of explaining and controlling things have just as much trouble as those who urge us to reconsider their particularity. It is not only artists like Shelley and Keats, the Impressionists and Frank Lloyd Wright, Beethoven and Stravinsky who have been abused and neglected for daring to interfere with our aesthetic habits. Theorists and technologists, from Copernicus and Columbus to Darwin and Jenner, from Harvey to Freud to Henry Ford and General Mitchell, have encountered the same obtuse and hostile unconcern when they have tried to change our habits of thought and action. There is a strong questing spirit in the human psyche, and to the artistic implications of this I shall soon turn. But the general tenor of experience is largely defined by inertia.

Because of this, the texture of experience tends to be dull

and flat. It is not often that life issues a real challenge to our faculties, or that the world requires the close scrutiny of attention. So we are usually satisfied to obtain a vague and superficial sense of the present moment, to recognize familiarities within this, and to respond by habit. The massive inertia of experience pulverizes the things and situations it encounters, spewing aside much of the meaning they contain and reducing them to terms that can be easily handled. The world touches us lightly, our past supplies the answer, and we move monotonously on toward the future.

This stolid disregard of things is an unfortunate but prominent feature of experience. Perhaps it has become increasingly so under the conditions of modern civilization: the mechanization of men's activities, mass production and dissemination, the pressure to conform, the narrow role and limited routine that are the fate of most men, the emulation of mediocrity — all of these and other similar factors have perhaps increased the flatness of experience by limiting its range and variety.

That this is necessarily the case is far from proved (and the greatly increased leisure that these factors afford may be used to argue against it). But that, unsurprisingly, has not prevented it being assumed. So it is now a widely held tenet that the generality of men have neither the urge nor the capacity to attain to a deep and vivid experience of the world. It is beyond the ability — and even the desire — of the "normal" man to sharpen his vision of the particularity of things, his comprehension of their connectedness, or his sense of their import. It is the privilege and responsibility of the "elite" to achieve a refined acquaintance with the world, and so to extend their powers of explanation and control. The many have only the duty of benefiting passively and indirectly from the larger mastery of things that this makes possible. The enhanced insight, understanding, and participation in life that follow from rich and sensitive experience are hereby

held, as a matter of principle, to be beyond the grasp of most men. And it is only a step from this to a state of affairs where these values are, as a matter of fact, put beyond their reach.

On this view of the quality and employment of general human experience, it inevitably follows that the higher stages of experience — the levels that I have called activity and construction — are removed from the normal human orbit. As regards theory and technology, man is to have no traffic with them save through the mediation of "experts," utilizing blindly the results and the products that these make available. We are to accept, without understanding them, the diluted and popularized versions of the new ways in which theorists — be they physicists, psychologists, theologians, or sociologists — envisage the world. And we are to employ, without knowing how they work or why we need them, the tools and techniques that applied science puts into our hands.

But as we have seen, there is no such indirect utilization of art. Our dealings with art are intensely personal, and require direct participation. This might seem to imply that it is the fate of art to gradually disappear. As man's use of experience in confronting the world and conducting the affairs of life becomes more passive and servile, and as science monopolizes the task of explaining the world and directing our pursuits, art becomes at best useless, and more often a dangerous distraction, and if it does not efface itself its disappearance should be effected. This view has been advanced more than once. Peacock, in "The Four Ages of Poetry," reached the conclusion that "A poet in our times is a semi-barbarian in a civilized community. . . In whatever degree poetry is cultivated, it must necessarily be to the neglect of some branch of useful study: and it is a lamentable thing to see minds, capable of better things, running to seed in the specious indolence of these empty aimless mockeries of intellectual exertion." [1] A

[1] In *Collected Works of Thomas Love Peacock* (London: Richard Bentley and Son, 1875), III, 335–336.

good many people have either welcomed this conviction or acquiesced in it.

But on the whole a milder and more lenient view has prevailed. And this view, in its defense of the artist, has fastened on precisely that point that Peacock, and those who think with him, urged as the most serious charge against art: that it is "empty" and "aimless" and "indolent," a "plaything" and distraction that men cry for only that they may be "charmed asleep." If a refined and sensitive employment of experience is held to be beyond the capacity of most men, then it must be expected that the quality of general human experience will be shallow and monotonous. This is obviously undesirable. So art is assigned the function of amusing men in their moments of leisure, and of introducing color and variety into the otherwise drab course of their conscious lives.

I am not saying that this interpretation of human nature and of art has often been openly expounded. After all, it requires a good deal of hardihood to tell the majority of one's fellow men that they are no better than Aristotle's slaves: that they lack the power of an active intellect, and are limited to a passive reason that can only accept the simple tales and instructions that its betters prepare for it. But I do think that this view has been influential, even though unacknowledged, and that its effects are conspicuous in our culture. It is perhaps the only aesthetic opinion that is shared by the moguls of commercial entertainment and the denizens of the Ivory Tower. Flowing from sources that enjoy such prestige, it has pervaded our times.

Where this attitude prevails, art comes to be regarded as primarily a diversion and a relaxation. Art is cut off from its roots in life — it is denied any vital part in the human enterprise — and is relegated to the task of brightening those moments when men withdraw from their serious concerns and can recreate themselves. The artist is expected only to enliven experience, to titillate our jaded senses, and to ornament an

otherwise dull routine. Under this usage, the art that is desired and encouraged is of two main types, both of which are perversions of the true function of art. There is, in the first place, a vast demand for work that can easily divert and amuse the popular taste without requiring any effort or cultivation. Such pseudo-art, which is chiefly devoted to sentimentality, edification, and fantasy, abounds in all of those media that make a mass appeal. It insults its audience by supposing that only the obvious, the mawkish, and the spectacular can attract their attention and be assimilated into their experience, and so dispel the monotony of their lives. There is, in the second place, a far smaller but very intense demand for work that can flatter the vanity and snobbishness of those who like to think of themselves as the sophisticated avantgarde. As I have put it in an earlier chapter, this is the kind of art that seeks to retire to a private cosmos and to live on its own resources: it strains after subtle and esoteric effects, it concerns itself chiefly with its media and techniques, and it becomes highly self-conscious and almost exclusively formalistic. In short, this view of the capacities of human nature, and of the possible and proper employments of experience, has a doubly vicious effect on the aesthetic life: it divides mankind into the "mass" and the "dilettanti"; and it debases art into entertainment and preciosity.

II

3. This opinion of man is as untrue as it is unfortunate. The facts, I think, demand a far more generous interpretation of the human potential. Especially is it the case that men are not willing to acquiesce supinely before life; rather, they want to participate actively in it. Men have a positive taste for apprehending, understanding, and controlling the things and situations they encounter: they seek out the particularity, the connectedness, and the import of things, driven by a

natural appetite to refine and strengthen their grasp of these dimensions.

One of the first and most compulsive lessons that life forces upon us is that of the distinction between appearance and reality: things are not always what they seem to be, our rules of thumb keep encountering exceptions, our opinions and predictions are disappointed by accidents, and our customary techniques are frustrated by recalcitrant cases. All of this leads man to scrutinize things closely, and to intervene purposively in his transactions with the world. The sole agent of this scrutiny and intervention is experience, considered both as an activity and as an accumulation. The world thrusts upon us a plethora of distinct and disparate things: physical objects and events, persons with their special characteristics and emotions and purposes, human situations and relationships, social facts and ideals. Perhaps the most elemental and significant fact about these things is that each of them is both typical and unique. Various ones of these things have much in common, they are similar in their obvious and seemingly important traits, so we group them together, regard them as sharing the same nature, and treat them alike. Thus we arrive at the elaborate catalogue of class-concepts and the intricate set of habitual responses that figure so prominently in our dealings with the world. But each of these things is also absolutely unique. Each of them has privacies and peculiarities that are utterly its own, and so can never be exhausted by concepts and habits.

It is this latter aspect of things that lends aesthetic experience its significance. We cannot find our way about in the world if we rely merely on general notions and standardized procedures. These are great conveniences, through the very multiplicity of the references that they make: each of them embraces a multitude of similar things and dictates a multitude of similar actions. But these "similars" are not identical. And herein lies the danger of such generalized ideas and tech-

niques: the individual escapes through the interstices that abstraction always leaves. The abstract refers us to shadows rather than substances. These shadows are immensely valuable as portents of coming events, but they still leave us to deal face to face with the unique events that do in fact arrive. For this, our ideas and practices must be closely patterned to particularity: that is, they must be continually refreshed through vivid contact with the actual richness of things.

It is through aesthetic experience that we gain this. On these occasions the inertia of experience is overcome, and the too usual experiential procedure of recognition, classification, and dismissal is interrupted. Then we are enabled — or compelled — to meet things on their own terms rather than on our own, and to listen to all that they have to say for themselves instead of hearing only what we find convenient. We may be attracted or repulsed, charmed or disquieted, elated or saddened, by the thing that presents itself. But at all events we are enraptured. We are making the personal acquaintance of some feature of the environment that before was only an entry on a filing-card. In these moments we are brought back to the concrete body of the world, and our experience of particular things becomes rich and intense.

The actual things of the world — what we call collectively "nature" or "reality" — can present themselves in this light: they do so to all of us at least occasionally, and to artists frequently. These are times when we have been absorbed by some actual thing around us: the grace of a landscape, the recesses of a human personality and the intensity of its passions, the quality of a face and figure, the intricacies of a human relationship. And it would easily be possible to increase both the frequency and the acuteness of men's aesthetic realization of nature and life. This would only require that our senses be sharpened, our attention be alerted and directed, our perception of form and balance and rhythm be trained, our taste be refined, and our attitude toward the aesthetic possi-

bilities of the world be made more receptive. Cultivation along these lines would be easy and healthy. But even if all this were done, the fact remains that natural objects encounter the constant opposition of impatience, economy, familiarity, and habit when they seek to present themselves as particulars. Or, speaking more literally, we encounter this opposition when we seek out the private acquaintance of things. So it is necessary that art present things to us if we are to grasp them as entities.

It is the function of art to seize upon man's natural aesthetic appetite and to lead it to an adequate fulfillment. This appetite is urgent and impulsive. Men desperately want — in the double sense of both needing and desiring — vivid and stimulating awareness of the things around them: they are hungry for experiences that will pull them out of the routine responses that life demands and habit inculcates, and will engross them in the character and the adventures of something else. This interest, as we feel it in consciousness, is a complex of curiosity, sympathy, discontent, a craving for distraction, and other elements. And it is an impulse that is vital and forceful in the human spirit — the impulse to discover what people and things and events are really like. The infant is intrigued by the flame of the candle and the rhythm of his rocking; the child by the insides of a watch, fire engines, mud oozing between his toes, and the flight of birds; the youth by a girl's face, a hero, a sailboat fighting the wind, or an injustice that cries for correction; the adult by almost anything that can present itself as unique and vivid. Men for the most part cannot usually satisfy this want out of their own resources; they cannot often or on the whole have satisfactory aesthetic experience before nature. For the reasons discussed above, they require that particulars be presented to them artificially fashioned to hold and fill their attention. So men seek avidly for music, pictures, stories, and other works that will give them such particulars. When we go to the cinema or the theater, to

the art gallery or the concert hall, to illustrated magazines
or the television set, we are voicing the same demand as our
remote ancestors did when they gathered to listen to stories,
to dance and sing, or to look at pictures on the walls of caves
— we want, as did they, to have the particular things and
events of our environment brought into a sharp and compel-
ling focus.

4. It is the fact that this aesthetic demand is both intense
and undiscriminating that makes the presence of art so neces-
sary, and the quality of art so important. Men are going to find
an outlet for their interest in particularity; the appetite is too
voracious to be denied. But man's natural aesthetic taste is
usually neither subtle nor sophisticated, and in its search for
objects to give it sustenance it is prone to follow the path of
least resistance. So if intrinsically good art, which presents
particulars honestly and sensitively, is not readily available
and understandable to them, pseudo-art will thrive. And this
encourages the degenerate modes of experience that were dis-
cussed in the previous chapter.

For men are inevitably influenced by the individual charac-
ter and quality of those things to which they attend closely.
This is true whether these be things of the "real" world of
nature or of the "fictional" world of art; it would be absurd
to maintain that the experience of art, or of pseudo-art, goes on
in a psychic vacuum and leaves no trace upon memory and
imagination, upon mind and emotion. The case is quite the
contrary. The music, the pictures, the stories, the poems that
absorb our attention usually treat of things and events and
situations that have an immediate reference to similar things
that are already familiar to us in the real world. What we
gather about these "artificial" things that are presented to us
in art is then transferred to the "real" things that we encounter
in the world. The make-believe world of fiction is as much
a part of our psychological environment as the real world of

fact. Our consciousness is stocked and sharpened in both, and moves easily back and forth between them. We certainly distinguish these two realms readily enough; but we do not and can not segregate them. The aesthetic object is assimilated, and deposits its meaning in the accumulation of experience.

It is in this way that the art that is vivid and meaningful to us influences the quality of our lives. We take what it tells us about people and things, and we refer this to the actual particulars that confront us in the environment. And we do this whether the art in question is intrinsically good or bad. In the one case as in the other, art contributes importantly to the conceptions and attitudes that we form concerning our physical, human, and social surroundings.

Until it has been cultivated, man's taste for particularity is at once urgent and undiscerning. So it is apt to seek satisfaction through the easy and the obvious. The wish-fulfillment of sentimentality, the complacency of edification, and the escape of fantasy, stand as a constant temptation and threat to man's healthy aesthetic development. They are more immediately available and more spontaneously rewarding than real art, which engages our efforts instead of distracting us, and which presents what is true rather than what is palatable. Even men who have great inherent artistic talent, and who later employ this with tact and refinement, exhibit this originally voracious and undiscriminating aesthetic taste. They devour whatever they encounter in the media that touch their sensitivity: the embryo poet or novelist reads everything he can lay his hands on, the would-be dramatist haunts the theater without noticing the boards, the nascent painter or sculptor appropriates every style and technique and intention that comes to his notice. This restless and uncritical responsiveness is one of the young artist's greatest assets. But it is also a danger to him, and much potential talent has been perverted or destroyed by the early influence of deceptive or inadequate art. Hence the recognized importance of the prop-

er aesthetic education of those who manifest artistic ability — not only must their skill be trained, but their taste must be cultivated: that is, it must be guided toward and nourished upon good art, and not allowed to blunt and dissipate itself with the crudities and extravagancies of bad art.

Men for the most part are both more susceptible and less vulnerable to the effects of pseudo-art. They are less vulnerable, in the sense that the harm they suffer from it is not so extreme or important: as they have less to gain or contribute aesthetically, so they have less to lose or contaminate. Also, since their lives exhibit a closer balance of aesthetic, cognitive, and affective factors, they do not embrace particularity with the abandon of the artistically sensitive, nor dedicate themselves to it with their enthusiasm, so they are not apt to be led tragically astray by aesthetic misapprehension of the actual character of things. Since they are not quickly touched or deeply moved by any dimension of things, they are not prone to the blind idolatry of any particular. Men of the average run are subject to sudden and violent gusts of idolatry, passion and dogmatism, as some encounter with the world breaks through the barrier of inertia and threatens some vital concern. But they are almost immune to the virus of a continuing and concentrated engrossment with either the particularity, the import, or the connectedness of things; the world appears to them as grossly substantial and roughly amorphous, and things rarely emerge from it as either entities, values, or facts.

Most men, however, are more susceptible to pseudo-art than are the specially gifted, even though they are far less apt to be mortally crippled by its effects. This heightened susceptibility springs from the two facts that their apprehension of actual things is vague and desultory, while their hunger for particularity is impulsive and undiscriminating. Because of this, their aesthetic taste seeks the simplest and most immediate satisfactions that fall in its way: it readily follows the

lure of what is superficially attractive and quickly rewarding;
it has few positive standards of its own but accepts those it
finds around it; and so it is easily misled by specious success
and grandiloquent claims. Men welcome any presentation —
in story or painting or drama or music — that stirs their senses
and appetites, that embodies their dreams and wishes, that con-
firms their opinions and judgments, that promises what they
long for, that banishes the obscurities and difficulties that the
world possesses for them, that retouches the past and gilds
the future. In short, they welcome art that brings actual things
within their reach and presents them in a pleasing light.

This tendency toward the easy and the obvious is by no
means peculiar to the aesthetic dimension of life: exactly the
same characteristic holds true of our cognitive and affective
tastes. Pseudo-science and pseudo-technology are just as preva-
lent and pernicious in the modern scene as is pseudo-art. There
is an enormous market for glib and simplified accounts of any
phenomenon that interests man, whether this be the origin
of the world, the structure of human character, the organiza-
tion of world peace, mysticism, secret treaties, or man's hidden
psychic powers. And it is impossible to determine — but aw-
ful to contemplate — how much delusion has been fostered
by books on the "meaning" of culture, evolution, God, Com-
munism, education, vitamins, immortality, and sex. A similarly
eager and almost plaintive welcome is given to products and
techniques that promise to further the desires and banish the
ills of man: quack medical cures, eccentric religions, fanatic
political creeds, social utopias, and useless gadgets of all kinds
find a wide reception. While if one can manage to combine
both a theoretical and a practical appeal, as in the "inspira-
tional literature" that offers peace or contentment or maturity
of soul or mind or ego, there are apparently no limits to the
way in which people can be gulled.

The truth of the matter is that in all of these dimensions
of life alike, man's reach exceeds his grasp. Men have a spon-

taneous and avid interest in the particularity, the connected-
ness, and the import of things; they are not content with the
vague and flaccid acquaintance that is afforded them by their
normal experiential encounters with things. But they cannot
sufficiently improve this acquaintance by their own powers;
they have neither the ability nor the persistence to maintain
themselves on the higher levels of experience that I have
described as activity and creativity. So they are largely de-
pendent on the work of others to disclose to them the entities,
facts, and values that the world will yield to a sensitive and
stubborn employment of experience. The absence of such
works is not going to quench their natural appetite to appre-
hend, understand, and dominate things. Man's taste, whether
aesthetic, cognitive, or affective, is as credulous and uncritical
as it is eager and impetuous. So this taste is easily deceived
by works whose pretentions to present, explain, and control
things are shallow and false.

I have already had occasion, when describing the de-
generate modes of experience that at once solicit and are
fostered by pseudo-art, to detail the deplorable consequences
that follow upon the prevalence of such art. These can all
be comprehended under one indictment: pseudo-art erases the
particularity of things, and replaces this with generalities,
stereotypes, and partial truths. It does not depict the actual
character of things, but rather the character that we would
like them to have or that we have been led to believe they
ought to have. It teaches us to expect of particulars what it is
impossible for these to deliver; and so it generates attitudes
that deceive us, expectations that must be disappointed, and
aspirations that are as empty as they are futile. By mislead-
ing us as to the nature of both what is actual and what is pos-
sible, it falsifies our motives at the same time that it under-
mines our purposes. Most especially, pseudo-art vastly simpli-
fies the world and life; it leads us to see things as this or that,
as one or the other, as black or white. In short, pseudo-art en-

courages and feeds upon just those tendencies in experience that real art is intended to combat: namely, impatience, economy, familiarity, and habit.

III

5. The human tendency to deal with particulars in terms of generalities and to ascribe to unique things all of the characteristics that we associate with a type, is exhibited with ironic force in a passage of Dostoyevsky's novel, *The Possessed*. The convict Fedka, in complaining to Stavrogin of that consummately devious and unsuccessful scoundrel, Pyotr Stepanovitch Verhovensky, makes this diagnosis of his character:

"Pyotr Stepanovitch is an astronomer, and has learned all God's planets, but even he may be criticized. I stand before you, sir, as before God, because I have heard so much about you. Pyotr Stepanovitch is one thing, but you, sir, maybe, are something else. When he's said of a man he's a scoundrel, he knows nothing more about him except that he's a scoundrel. Or if he's said he's a fool, then that man has no calling with him except that of fool. But a man may be a fool Tuesday and Wednesday, and on Thursday wiser than he. Here now he knows about me that I'm awfully sick to get a passport, for there's no getting on in Russia without papers — so he thinks that he's snared my soul. I tell you, sir, life's a very easy business for Pyotr Stepanovitch, for he fancies a man to be this or that, and goes on as though he really was." [2]

A brief but haunting episode in Albert Camus's *L'Etranger* brings out a somewhat different aspect of this same tendency: the obstinacy with which men fasten on a single facet of a human relationship or situation — and this often a minor and isolated facet — and then judge those concerned entirely on this narrow ground. Meursault, the "hero," is on trial for the

[2] Fyodor Dostoyevsky, *The Possessed*, trans. Constance Garnett (New York: Modern Library, 1936), p. 263.

shooting of a man during an encounter that was hopelessly vague and confused and accidental. Just prior to this, Meursault has been involved in a series of largely unrelated incidents: his mother has died in an asylum, and he has buried her; he has gone to the beach, met a girl, named Marie, with whom he used to work in the same office, and has taken her to a cinema; he has been intimate with her, once or twice and in a desultory manner; he has done some foolish, but not vicious, things to help a friend out of a difficulty; in a word, he has been behaving in a rather dazed and inconsequential manner. The prosecuting attorney weaves these isolated and unconsidered incidents into a tight pattern of premeditated crime springing from a depraved character, with every action and relationship brought under a rubric and condemned as such. Meursault's reaction to this account, as he listens to it in court, is that it is beautifully clear but quite false; and he sums up its distortions in these words:

"Il [the prosecutor] a résumé les faits à partir de la mort de maman. Il a rappelé mon insensibilité, l'ignorance où j'étais de l'âge de maman, ma bain du lendemain, avec une femme, le cinéma, Fernandel et enfin la rentrée avec Marie. J'ai mis du temps à le comprendre, à ce moment, parce qu'il disait 'sa maîtresse' et pour moi, elle était Marie. . . . J'ai trouvé que sa façon de voir les événements ne manquait pas de clarté. Ce qu'il disait était plausible. . . Mais je ne comprenais pas bien comment les qualités d'un homme ordinaire pouvaient devenir des charges écrasantes contre un coupable."[3]

This same point, with a slightly different emphasis, is beautifully brought out in a scene from Trollope's *Is He Popenjoy?* The former Mary Lovelace, now Lady George Germain, is a gay and high-spirited girl whose goodness and purity are unspoiled by either the consciousness that she has these qualities or the fear that she might lose them. She loves society,

[3] Albert Camus, *L'Etranger* (Paris: Copyright Librairie Gallimard, 1942), pp. 140–142. (All rights reserved.)

and laughter, and dancing, and all the pleasant trivia of life, with a child's ingenuous faith that no evil can be thought where none is. Her husband is a good and tender man, but a slave to the conventional judgments of his class and blindly convinced of the axiom that all smoke comes from the same fire. He calls his wife to task on the unchallengeable but perverted ground that her conduct might be misconstrued. After several stormy and futile arguments, in which she stands on the absolute purity of her character and he on the fact that it can nevertheless give rise to false scandal, she seeks counsel of her father, the Dean of Brotherton. His comfort and advice to her are summed up in one pathetically trenchant remark: "Perhaps one of the last things which a man learns is to understand innocence when he sees it." [4]

Dostoyevsky, Camus, and Trollope, who certainly represent very different human outlooks and who speak here through an illiterate convict, a simple clerk, and a subtle dignitary of the Church, are in complete accord on the fundamental outrage that men commit when they impose their static preconceptions upon the flux and variety of life. There could not be a more touching complaint against man's callous disregard of the totality and the details of things. Nor could there be a more persuasive statement of the need for art — of the human shortcomings that it is art's task to correct, and of the sensitiveness and receptivity that it is art's function to cultivate.

The involvements of men with one another, and with the world, are intricate and subtle, and are so rich in nuances as to be always confused and often contradictory. When these involvements are lived through with sensitivity of feeling and imagination, and so are realized from within, they bring us into touch with individual persons and things that we respect as such and whose characters we know that we cannot ex-

[4] Anthony Trollope, *Is He Popenjoy?* World's Classics ed. (London: Oxford University Press, 1946), p. 276.

haust in any summary verdict. It is the great gift of art that it enables us to see things in this intimate way, and to participate in the actions of men as they are prepared and carried out. When art does not perform this task, or when we refuse to heed its lesson, our sense of these involvements grows flat and rigid. We slur over what is specific in human actions and relationships, and deny what is spontaneous and unconsidered; instead, we insist on categorical motives and purposes, and on static relations that are independent of the individual persons and things they relate. The outrage that men feel against these remote judgments finds its perfect echo in Meursault's perplexed and plaintive remonstrance — "pour moi, elle était Marie."

6. It is the chief function of art to overcome these tragic consequences of man's voracious but untutored aesthetic taste. The tendencies that pseudo-art merely confirms, real art trains and transforms.

To achieve this cultivation, art must prolong, deepen, and refresh our aesthetic scrutiny of things. The most elemental and essential accomplishment of art is to retard the tempo of experience. Our usual encounters with actual things, urged on as they are by impatience and economy, are hurried and casual; our regard is fastened less on their present content than on their future outcome. Lust posits possession and consummation, hate impels us to destruction, embarrassment induces us to shrink and hide, and fear calls for escape. The first and most necessary task of art is to slow down this pell-mell rush of experience, to disrupt this pursuit of the future, and to promenade us through the present here and now. That is, the artist must postpone our resolution of the situation he is presenting, and must hold us instead to a continuing absorption in its actual content and structure. The gaps that normally yawn so large in experience must be filled in, the nuances that are overlooked must be brought to light, and the

elements that we otherwise reject as practically trivial or logically irrelevant must be recovered.

A second accomplishment of art is to repeat the episodes that compose an experience, and to vary the sequence of their occurrence. As our habitual encounters with things — our usual passage through the events of life — tend to be hurried, so do they tend to be direct and linear. We meet objects and situations, examine them as far as seems requisite, form a conclusion, and dispose of them. Of course, this process is not strictly irreversible, and it quite often encounters impediments: we are uncertain, we vacillate, we are frustrated in our choices, and we face conflicts that we cannot bring ourselves to resolve. But such arrests of experience are not fruitful of a closer and fuller acquaintance with its object; we return over and over again to the same point, we repeat the same cycle, we reach the same impasse. Such occasions are like a backwash that life has left behind it, and the longer we remain in them the less able are we to draw any sustenance from them.

The repetition that art introduces into experience is of quite another sort. Here we are led through an experienced situation several times, and each time in a new way: our encounters with the aesthetic object begin at different points, they follow different routes, and they expose different vistas. Art juxtaposes elements that are usually separated in experience, it accumulates meanings and concentrates them at a single point, and it disarranges the orders that habit has established. The thing we encounter through art takes on added substance, and our acquaintance with each aspect of it is illuminated by what we have grasped of its other aspects. As we see one part of it more clearly, this extends our view of other parts, and so on in a reciprocal manner that has no limits beyond the capacity of attention and memory. It is largely for this reason that good art rewards us more richly with each encounter — art has a cumulative effect that continues indefinitely. Each

added morsel of meaning reflects throughout the work; every element or episode echoes back all the others, and their reverberations extend and ramify in a continuing progression. A fine work of art has no denouement, and even no climax. When we reach its apparent end we are not finished with it, but are referred again to its apparent beginning.

The third major accomplishment of art is to exhibit the aesthetic object to us from different perspectives. Our usual experience of things is firmly set within a single established frame of reference: we receive things into a systematic body of ideas, which assigns them to a definite place, confers upon them certain characteristics, and orders them with respect to other things. Now, it is of the essence of art to refer the thing it is talking about to contexts other than that one which constitutes its normal and familiar abode. That is, art places us, with respect to the aesthetic object, in a series of novel perspectives. We are thus led to discover in it facets and aspects to which our accustomed modes of thought blind us. We realize that it has similarities and relations with things from which we had hitherto thought it to be altogether separated. The order of importance of its various characteristics undergoes drastic change, so that what seemed to be essential becomes adventitious, and what was incidental is fraught with significance.

7. If we recall here the earlier analysis of the aesthetic image (Chapter VIII, Section ii), and bring it to bear upon this discussion of the functions that art must serve, both subjects can be illuminated. The examination of the character of images and of the role that they play in aesthetic experience led to three conclusions. First, that images, as contrasted with ideas and emotions, are highly self-contained, isolated, and episodic. Second, that because of these traits, images have an unusual measure of completeness and determinateness, a unique power of eliciting from our funded experience only

selected and limited items, and a large independence of the total body of experience. Third, that images derive this special status and power from two important characteristics: the tightness and clarity of their internal structure, and the close control that they exercise over their external references.

The present inquiry into the function of art analyzed this into the three essential and necessary accomplishments of retarding, repeating, and reorienting our established experiential patterns. That is, the work of art must be composed in such a manner that it is able to reach into our accumulation of experience and our habits of experiencing, disarranging and redirecting these so that they can discover and assimilate the aesthetic object. The artist cannot ignore this fabric, which is woven of our shared humanity and of the common world we face. What he has to say must be acceptable to this, and find lodgment within it. Yet no more can he sacrifice the novelty and individuality of his insight. So if the artist is to speak intelligibly, the content that he wishes to convey must be generalized enough for us to grasp it, and our attention must be directed with great precision to just those areas where this content is to be found. In a word, it is required of the artist that he express himself in terms that will at once reach and challenge our experience.

The central problem of artistic composition is to preserve the particularity that is presented while still bringing this within the grasp of our familiarity. The uniqueness of the aesthetic object must be maintained at the same time that it is enunciated in a language that it shares with other things and that is already known to us. To envisage and talk about any actual thing or occasion is necessarily to make appeals beyond this thing: it is to describe it in a general vocabulary and build it up out of elements that have a recognized structure and meaning; it is to speak of the similarities and contrasts of this thing with others, and of the relations that hold between it and them; it is to break this thing down into its parts, and to

view it as itself a part of larger wholes. There is simply no other way in which the artist can deal with what concerns him, and express the vision he attains. The unique and determinate content of the work of art must be composed out of common elements.

To the uninitiated, it is apt to appear that this problem of distilling particularity out of terms that all have a general reference and a previous familiarity is peculiar to the literary arts. Words are so obviously abstract and generalized and systematically defined that we see at once that the poet or novelist must face a difficult task in bending them to his special purpose. The problem is not so apparent in the other arts: a painting, a piece of sculpture, and a musical composition are such concrete and distinct entities that we easily fall into the way of thinking that we — and everyone else — must accept them as such and on their own terms. But the case is exactly the same here as with literature. The colors, lines, masses, and representational forms of the painter are also familiar cues, already generalized and labeled for recognition; so are the tones, rhythms, and melodies of composers, the space and mass and figures of the sculptor and architect, the gestures and motions and expressions of the actor and dancer.

Every art employs a medium that is already constituted and understood as a language, though these media certainly exhibit significant differences of degree in this respect. Still, all of these languages tend to become so monolithic that they allow no room to novelty and uniqueness; actual things and occasions are engulfed by them, leaving no trace behind. If the artist, in whatever medium he works, is to rescue things from this limbo of anonymity, he must remove them from the grasp of common and general elements, of systematic meanings, of contexts that regard particulars as indifferent. That is, he has to find a way to make the particular thing he is concerned with stand out above the term he uses in talking about it.

Images afford him this way. The devices that artists use to embody their meanings in the form of images are too many and complex, and too specialized for each medium, to be examined here in any detail. That is a task that requires the skill of a practiced critic, and that can be made meaningful only by a close analysis of works of art in the presence of those works. A few references to the more important techniques employed in constructing images, and to the manner in which these images then serve the artist's purposes, must suffice. It will be simplest to base these remarks in the context of poetry, and then to extend them to the other arts, elaborating them from whatever clues are thus suggested.

We can start with the now common notion that metaphor is the substance of poetry, the primal stuff out of which the poet builds his images.[5] Metaphor is, in essence, a very simple device: it is, quite literally, a figure of speech by which a sense or meaning that is usually associated with one sort of thing (object or situation or occasion) is "brought over" and attached to another sort of thing. This transference and comparison are accomplished in various ways. Sometimes — as in the strict connotation of metaphor — it is done by append-

[5] The recognition of the importance of metaphor is probably as old as speculation on the nature of poetry. It has figured prominently in such speculation at least since the time of Coleridge. And it has been the focal point of theory and criticism for the past generation. So there is an enormous contemporary literature on the subject; and the following are cited merely as samples — each very fine of its kind — of the different sorts of inquiry that have been conducted into the nature of metaphor and the uses to which it is put: Cleanth Brooks's lucid and acute analyses of poets and poems in terms of their varying metaphorical techniques, in *The Well Wrought Urn* (New York: Reynal and Hitchcock, 1947) among others; Rudolf Arnheim's paper, "Psychological Notes on the Poetical Process," in the cooperative volume, *Poets at Work* (New York: Harcourt, Brace, and Co., 1948), examining the psychological basis of the power of metaphor; and the treatment of metaphor as a joint linguistic and metaphysical problem in W. M. Urban's *Language and Reality* (London: Allen and Unwin; New York: Macmillan and Co., 1951). These diverse lines of inquiry have not, unfortunately, been brought into sufficiently close conjunction, with the result that our understanding of metaphor remains dispersed rather than systematic.

ing adjectives or other qualifiers to nouns. Sometimes this is expanded into a simile, an analogy, or an allegory. Sometimes — as in a trope — a word is used in a sense other than its usual and defined one, or is applied in a novel context. Sometimes — as in metonymy or synechdoche — one word is substituted for another that it somehow suggests (and the precise manner of this "somehow" is theoretically unlimited). But in all of these guises the essential nature of metaphor remains unchanged; it is a "bringing over" of meaning from one context to another with which it is not systematically or familiarly associated.

This simple device derives its extraordinary power of imagery from the fact that it enables the poet to keep attention focused upon the particular thing he is concerned with (his "subject" or his "object," his "theme" or his "instance," whatever terminology one prefers) over a prolonged period of time, and though he is all the while referring beyond this thing to other things. As we have seen, this necessity to clothe his aesthetic object in borrowed garments presses inexorably upon the poet; he cannot conjure his meaning out of nothing, but must express it by talking in terms that already have systematic connotations and generalized denotations. The straightforward vocabulary of ordinary discourse is quite unfit for his purpose, however, being too well settled and organized: it blurs the uniqueness of the poet's visioned content, crushing the particularity of this under the weight of its own accumulated meanings.

So the poet is forced to deal in indirection, and metaphor makes this possible for him. By the use of metaphor, the poet can talk about the particular thing that is his subject by a series of appeals to a number of other particulars that have no established connections among themselves. He can illuminate his subject by referring to only partial and carefully selected aspects of the things to which he compares it. He is not restricted to any logical set of relations or meanings, but can

make allusions that are purposely strange and paradoxical. The metaphorical references that the poet collects are ambiguous rather than clearly defined, disjointed rather than systematic, isolated and episodic rather than coherent and cumulative. Because it confers these powers, metaphor enables the poet to prevent the contexts to which he refers from obtruding upon his subject except to the extent and in the manner that they are wanted. His subject dominates its metaphorical references, and stays aloof from the web of abstractions in which it would otherwise be caught.

This general account can be conveniently elaborated by brief consideration of the three necessary accomplishments of art. Metaphor retards the tempo of our encounters with things because it interrupts the straightforward course of experience, pulling it aside to look at its object from several successive and unrelated perspectives instead of disposing of it directly and once for all. From the point of view of logic and practice, every metaphorical reference constitutes a diversion and delay: it is a red herring drawn across the spoor of attention. From the point of view of poetry, this has the advantage of making us live through experience more slowly and deliberately; and this in turn enhances our opportunities to grasp the full flavor of the object or situation we are experiencing, as each metaphor brings us back for another look. A classic example of this employment of metaphor is Gaunt's celebrated panegyric of England in *Richard II*. The situation and sentiment are of the simplest; they could be paraphrased conceptually as an appeal to save one's country from exploitation by tyrants bent only on self-aggrandizement. Shakespeare's poetry transforms this as though by magic, bringing England alive for us with qualities hitherto unsuspected, making us feel its debasement as a personal affront and its rescue as a personal responsibility. The source of this magic is a series of metaphors, piled one on top of another in a manner that is almost wanton. England is no longer merely "our coun-

try": it is now an "Eden," a "fortress," a "precious stone," a "moated castle," a "womb and nurse," a "tenement and pelting farm." Metaphor has enriched our acquaintance by prolonging its occurrence, by stopping it at crucial points, and by exhibiting aspects of its object that are usually passed over unnoticed.

The employment of metaphor to repeat an experienced occasion, and to transpose the order of its episodes, is a natural sequel to the retard that it introduces into experience. When metaphors are not merely strung together, but are organized as elements of an inclusive pattern, each succeeding one contributes something unanticipated, thus shedding light on all its predecessors while also transforming the expressed content in which they merge. The incorporation of these fresh insights induces a continuing reëxamination of the aesthetic object they convey. The end of a fine poem leads us compellingly back to its beginning, making us anxious to relive, with the benefit of this larger understanding, the experience it presents.[6]

Finally, metaphor lends itself very effectively to the poet's intention to exhibit the aesthetic object from different perspectives. When several metaphors bring over meanings from contexts that are normally far apart, and join these meanings together, our modes of interpretation are shattered. By refer-

[6] Probably the simplest of all the metaphorical devices by which artists induce us to repeat an experience and see it in an unusual light is that of irony. Here the outcome of our first acquaintance with the work of art is just the reverse of what we had all along anticipated: the aesthetic object confutes our expectations. So we feel impelled to peruse the work again, in order to discover those traits in the aesthetic object that we had missed, and missing which had led us astray. Irony is so effective precisely because it is economical: it alerts our sensitivity to make certain discoveries, but does not spare us this effort. For these same reasons, irony is a dangerous device: it tempts the artist to the cheap triumph of the "surprise ending" or the "punch line"; and it easily degenerates into a sardonic mockery of common sense. Finally, it should be emphasized that irony is by no means restricted to literature; it is widely employed in painting, drama, and the dance, and it is far from unknown even in music and architecture.

ring to its subject from various and carefully contrived points, the poem prevents any one system of references from covering this subject with its own shadow. Instead, the expressed content of the poem, which inevitably can take on form and substance only gradually, is able to assert its uniqueness and independence from the beginning, just because its fragments pull it toward different frames of reference and so create in the mind a tension which cannot accept any one of these as final. Then, as this content finds further expression and becomes more fully determinate, these tensions are not resolved by having their several frameworks logically reconciled, but are kept in a dynamic — and often very precarious — balance centered on that altogether new entity, the aesthetic object which is the achieved meaning of the poem. The poet, so to speak, uses metaphor to build up his aesthetic object bit by bit out of seemingly scattered pieces taken from different and widely separated contexts.

Because it has these characteristics, metaphor is a powerful aid to the poet in assuring for his work clarity of internal structure and precision of external reference. That is, it enables the poet to convey his meaning in the guise of images. This necessity confronts artists in whatever medium; and the devices employed in the other arts all serve these same purposes. They are, it might be said, functional equivalents or analogues of metaphor.

The most basic of these, and one that is so obvious we are apt to overlook its importance, is what can be called in general the technique of display or "framing." Every artist tries to insure that when we first encounter his art work, and before we have even started to examine it, we will already experience it as isolated and self contained. He seeks to show it off to the best advantage, to lift it out of its surroundings, and so to enclose our attention within its confines. Paintings are framed and lighted with care; sculpture is placed on pedestals and posed against velvet; books are skillfully designed to

eliminate distraction and ease our reading of them; architects take pains with the vistas that expose their buildings; the beginning of a musical recital is a ritual of stillness and solitude; the apron and proscenium separate the stage from the world, and the set creates for the drama its own private environment. In every art we find this concern to assert for its works a status of external independence and internal completeness, and thus to encourage us to regard them as patterns composed of images.

When we look within the art work itself, and analyze its intrinsic features, probably the closest analogue of the single metaphor is the familiar device of distortion, which occurs throughout the arts and in a wide variety of guises. We usually associate distortion with the plastic arts, and there chiefly with the treatment of representational material. Both of these limitations are mistaken. We think of the painter distorting the proportions and relations of his subject, so that we are led to regard this from a novel perspective and to find in it features and aspects to which we are normally blind. This is a frequent and important employment of distortion, but by no means the only one; and to emphasize it too much is to neglect other equally significant uses of this device. All of the arts employ distortion, and they apply it to formal as well as representational elements. It is exhibited by the actor and dancer in their use of exaggerated and superficially inappropriate gestures or movements; it occurs widely in music, as through the introduction of unaccustomed intervals and progressions; it plays a prominent part in the literary arts, most obviously in the guise of exaggeration and understatement, and far more subtly in the disruption of meanings that a skillful style imposes upon its readers or hearers through its use of rhythm, meter, alliteration, and other techniques. Distortion is coextensive with art, for it is the most natural of all ways to open fresh vistas on particularity.

Devices for retarding experience and repeating the episodes

of which it is composed are prominent in all of the arts. The simplest of these is the use of reiterative patterns in the plastic arts and architecture. A similar but more complex technique is that of theme and variation, which is most familiar in music but conspicuous throughout art: the composer, by subtle transformations of key, tempo, harmony, rhythm, or choirs, leads us several times through essentially the same experience, exposing various aspects of it. The building of suspense and tension serves a similar purpose: a melodic or harmonic progression seems to indicate an obvious and immediate resolution; but instead of this we are given an elaborate development of the original musical material, which enriches experience while it sharpens anticipation (a dramatic example of this technique occurs in the long opening passage of Beethoven's Quartet Opus 59, Number 3). The unfolding of a plot, with its discoveries, delays, crises, and denouements, plays an analogous role in the novel and drama. This device is by no means restricted to music and literature, but is pervasive even in the so-called "static" arts of painting, sculpture, and architecture. Indeed, artists in these media complain that the attainment of this vital effect of delay and development is one of the hardest challenges that they face; and many of the features that they introduce into their works — multiplicity of picture planes, variations of light, competing foci of interest, et cetera — are deliberately used to surmount this difficulty.[7]

[7] Typical of this recognition are numerous remarks made by Kandinsky in his volume of reminiscences, *Rückblicke 1901–1913* (Sturm Verlag, 1913). *Regard sur le passé*, trans. Gabrielle Buffet-Picabia (Paris: Galerie René Drouin, 1946). Commenting on the profound impression made on him by Rembrandt, Kandinsky epitomizes this by saying that these paintings had Duration (*Durée*), that they had to be penetrated and explored part by part, and that they thus incorporated an element that appears to be incompatible with painting, namely Time (*le Temps*). In analyzing the means by which this effect was obtained, Kandinsky remarks especially the use of "clair-obscur," the introduction of secondary planes, and the juxtaposition of colors. In speaking of his own work, Kandinsky says that he was perpetually obsessed with the problem of making the spectators "walk around in" (*se promènent dans*) his paintings.

Much of the art of the actor and the dancer depends upon an identical technique. The actor prolongs and elaborates his "business," taking the almost interminable stage time of two or three minutes to light a cigarette or look up a telephone number, thus enabling us to fully realize the emotional potential of the situation he is enacting. This is done even more forcefully by the dancer engaged in his intricate bodily soliloquy. He repeats himself, develops his theme, emphasizes his meanings, and makes visible to us the course run by his passions. The outcome of all of these devices is to retard the tempo of experience, with the result that we now attend to episodes from which attention would ordinarily be diverted, either casually or purposefully.

Each of these literary or artistic techniques serves in its special way the general end of disrupting habit and recovering particularity. The artist uses them separately and selectively to create a series of images, each of which is endowed with a certain measure of completeness and independence. He also uses them in conjunction, combining these images — these artistic elements — in a manner to lead our attention along various courses and toward different conclusions whose reconciliation is long delayed. It is from this creation of tensions that are only gradually resolved that art derives much of its depth and richness. By skillfully composing his images, the artist so contrives his work as to force experience into paths that are divergent and even contradictory. The result of this is to block our tendency to impose our molds upon the work: just when we have established one set of meanings — one interpretation — and are prepared to absorb whatever comes next into this, we come upon features that challenge or escape it. So our expectations are denied, our interpretation is called in question, and we must accommodate ourselves to the concrete content of the work.

Both the occurrence of this effect and the manner in which it is obtained are perhaps most obvious in painting. The repre-

sentational forms in a painting stimulate one chain of visual, kinesthetic, emotional, and intellectual responses; the line and movement of the design cut across this, disrupt it, and set up a competing train of meaning; the balancing of color and mass establishes a third course of attention; and the situation can be further complicated by the use of such additional devices as light and shadow, texture, and iconography. A similar effect is achieved in the quite different medium of music when the composer employs a variety of themes, melodies, rhythms, harmonies, and choirs, either simultaneously or consecutively. Kinesthetic and emotional episodes that are normally experienced integrally can thus be broken up into segments, and these segments can be brought together in various conjunctions. The writer uses all of the devices discussed above — metaphor, plot, meter, rhythm, rhyme, and even punctuation — for these same purposes. The novelist, playwright, and dramatic poet also have available the powerful tool of characterization: the mere fact that there are several characters present, and in some degree of conflict, entails that we will view their common situation from different points of view. When these individual characters and their encounters are finely drawn, we get an altogether new sense of the meanings and values that life contains and that we usually destroy or compromise so blithely.

Since the artist's controlling intention is to present particularity as such, he is naturally suspicious of the generalizations that lie in any established and organized system of meanings. The artist knows that he cannot do without these; they constitute the accumulated body of experience in terms of which our further experiencing must take place. But he also knows that he must shatter their monolithic structure if he is to insert within them the novel content of his insights. It is for this reason that he seizes so avidly on the various metaphorical techniques through the use of which he is able to juxtapose contexts that are usually remote, to lodge his object

simultaneously in several different environments, and to shuttle us rapidly from one mood or point of view to another. He values these because they serve him to present his meanings in the guise of images, which interrupt our orderly perusal of familiar things and confront us with the startling uniqueness of aesthetic objects. This is the necessary method of art, and it should be evident that it carries within itself the seed that may lead to its own destruction; for this method inevitably threatens to disrupt not only our experiential habits but even the general conditions of intelligible experience. But there is no way in which this risk can be eliminated. The artist's problem is to rise above it by composing a coherent aesthetic object out of the more precise but less systematic readings that he embodies as images in his work of art.

Particularity cannot be abbreviated and issued in a syllabus. It must be approached and apprehended directly. Any attempted synopsis of things leaves behind their individual character, and recapitulates only what they have in common with one another.

It is for this reason that art must be fashioned in such a way as to prolong, deepen, and refresh our personal experience. The artist cannot epitomize the achievements of his experience and transfer them to us in the neatly packaged form of a digest. He must instead enable us to retrace his steps, place us in the same perspectives that he has occupied, and lead us to the same encounters with things. It is the function of logic to convince us of what is demonstrably certain, and of rhetoric to persuade us of what is probable. It is the function of art to show us what is. The work of art is neither a demonstration nor an argument. It is a composition, skillfully contrived to summon our resources of sense and feeling and thought, and to maneuver these to the point where they can best apprehend the aesthetic object.

Chapter XI

THE VARIETIES OF ART

1. I want to deal in this chapter with what is probably the greatest obstacle — and the most prolific source of confusion and misunderstanding — that confronts the philosophy of art: this is the extreme diversity of the field that it seeks to explain and order. Any random selection of objects that have been widely accepted as works of art exhibits an almost wild profusion of variety and difference. A casual glance at such a collection is apt to arouse the suspicion that many of these objects have nothing whatsoever in common with the others, that inquiry is dealing with several distinct types of things rather than only one, and that nothing but a linguistic habit and the whims of museum directors are responsible for these being grouped together. But a closer and more prolonged scrutiny discovers gradations and relations among what at first appeared to be unconnected groups, differences of kind dissolve into differences of degree, and this fosters the conviction that all art is essentially one, so that a single formula can describe this whole vast and varied field.

In approaching this problem, it will first be well to obtain a closer and more concrete view of the diversity of art; for this is the factual material that inquiry must always keep before itself, and that theory must eventually explain. The diversity that I have particularly in mind is not that constituted by the several "arts," such as painting, poetry, music, and so forth; nor is it that constituted by the several styles cultivated in these arts, such as classical, romantic, naturalistic, and so forth. Though both of these types of diversity are significant, they are not critical; the first manifests the same

force operating through different media, the second manifests its adoption of different points of view and its employment of different techniques. So while both reveal interesting vistas, they do not pose crucial difficulties. The diversities that I am thinking of are more fundamental and — at least apparently — less systematic, more glaring in their occurrence and more tense with seeming contradictions.

This challenging evidence of artistic diversity can be roughly divided into two groups. In the first place, in our identifications of things as works of art we seem to recognize among them differences of what can only be vaguely called purity or importance or dignity. Thus, we speak quite easily of fine art, decorative art, *objets d'art*, the crafts, applied art, commercial and industrial design. When we seek the meaning that underlies these distinctions, it appears to be this: there are certain works that issue from an intense and concentrated operation of artistic intention and ability; these are works of fine art. There are other occasions on which artistic ability and intention are active at a lower level of intensity, or on which they act in close conjunction with some other intentions and abilities; these issue in works that we regard as art only in a qualified sense. Of course, these distinctions are by no means clear-cut and rigid; the grades of art designated above merge and overlap, and there would be violent disputes concerning both their boundaries and their contents. But it is clear that we do mean to establish a distinction between works that are art in the strict and proper sense, and other works that are art only in some special and derivative sense.

There is, in the second place, a wide diversity within the field of strictly fine art. Much of such art obviously deals with some subject matter, makes a reference beyond itself, and has a content — this is what is traditionally called imitative or representational or realistic art; but much fine art disclaims any such basis or intention, and insists that it is merely itself, a

work of structured matter, with no content or reference other than its own sensuous and formal qualities — this is what is now called pure or abstract or formal art. Some art is aloof and disinterested, while other art is a vehicle for the expression of its author's intense emotional commitment and partisanship. Many works of art seem to regard the matters they deal with in a spirit of mixed tolerance, sympathy, and detachment, and are content to say "This is what man and the world are like"; but many works convey a passionate message, and obviously mean to change man and the world. These distinctions are again neither clear-cut nor rigid: much art is complex and ambiguous, admitting of more than one interpretation. But it is beyond question that the one term "fine art" is being used, quite consciously and purposefully, to include works that are avowedly very different in their intention, their structure, and their impact. These are real and significant diversities in art, which need to be explained.

2. The skeleton of the explanation here proposed can be set forth in three propositions. *First*, artistic activity is a vital and indispensable phase of mind, serving its own special function of presenting things as particulars: that is, of rendering clearly and vividly the actual character of things. *Second*, artistic activity often occurs in close conjunction with the other principal phases of mind, the theoretic and the technological, contributing to and borrowing from them, and merging itself with them in the creation of products that derive from a mixture of interests and serve a mixed purpose. *Third*, artistic activity always contains a tendency to become absorbed in itself, to cut loose from the vital function that initiated it, and to be primarily concerned with its own internal problems and with the values it can create out of its own resources and procedures.

Each of these propositions always holds true, not only of art, but equally of theory and technology. They indicate the.

diverse paths along which the life of the mind proceeds. The point can be succinctly put by saying that art, theory, and technology are each constantly under a triple pressure: to fulfill its own specific task and function; to subordinate its effort to the general human enterprise; and to refine and perfect its own materials and methods. These three principles of *specific performance, general contribution,* and *special refinement* always operate. But they operate with different relative force on different occasions. Presuming an artist to be aroused by a glimpse of particularity, and to set out to clarify this and fasten it down, then any one of three general outcomes may ensue (with infinite variations of detail). His attention and concern may remain primarily aesthetic, focused upon the intrinsic character of the thing he is dealing with, and intent upon grasping and embodying this. His cognitive or affective interest — or both — may also be forcefully aroused, so that his strictly artistic intention is joined with a concern to explain or control the thing he confronts, to expound it systematically or to exploit its practical uses. Finally, his attention may shift from the thing that aroused him to the steps he is taking to deal with this, with the result that his interest focuses upon the materials and techniques he employs, and upon the object he is making, with little regard for anything beyond this.

Issuing from and embodying these tendencies, there are three major types of artistic value, which I shall designate respectively as *presentative, functional,* and *formal.* Presentative value accrues in a work of art when the artist focuses his effort upon making vivid and articulate the character of the particular thing that has aroused him. Functional value accrues when the artist is animated by a powerful but subsidiary concern to explain or control things, as well as to present them — to instruct or persuade men, as well as to clarify their vision. Formal value accrues when the artist, fascinated by the immediate sensuous qualities of the material he works

with — words, or sounds, or color, or stone — and by the patterns or structures into which this material can be worked, devotes himself to exploiting the possibilities of his medium.

Every work of art, with possible rare exceptions, embodies each of these types of artistic value. As a product of mind, art consecrates the pressures and concerns of mind as a whole. But different works of art embody these values in widely various ways and proportions: in much art it is difficult, if not impossible, to say which of these values predominates, with the familiar result that different persons will respond to the same work in different ways, and will give different interpretations of it. But in a great deal of art one of these values emerges as clearly dominant, so that the whole field of art can in turn be divided into the three major types of *presentative art*, *functional art*, and *formal art*.

II

Presentative Art

3. This is art in its most strict and basic mode, aiming to disclose to man the particularity of things. It is art of this type that I have had especially in view while describing the general character of art as one phase in the life of the mind. It includes approximately all those sorts of art that have traditionally been called "imitative," "representational," and "expressive." In all such art the elements of subject matter and content loom prominently. This is art which has been created under the stimulus of an intense encounter with the world, and which seeks to render this encounter more precise and articulate than it was upon its first occurrence. Within the type of presentative art would fall, I think, the major portion of traditional literature, drama, poetry, painting, and sculpture; certainly such music as songs, opera, and what is generally called programme music (I shall discuss "absolute" or

"pure" music later); much of the dance; and at least some architecture.

It is through presentative art that the aesthetic impulse finds its most spontaneous and appropriate release; or, to state the same point with a slightly different emphasis, man's interest in the particularity of things, which is both naive and compulsive, creates such art as the vehicle of its own refinement and satisfaction. Art is immediately and impellingly presentative — this is its essential mode of being — because it has its inception in our natural concern for the actual character of things that we encounter in life and for the content and meaning of these encounters.

It was pointed out earlier [1] that particularity is whatever can be demarcated in consciousness, and that anything upon which mind can fix its attention is an actual occasion. Consequently, the catalogue of things that presentative art deals with is coextensive with the contents of experience, and very little can or need be done toward reducing it to an ordered pattern. Artists seek to grasp and present whatever interests them. This may be some physical object, such as a seascape, a meadow, or a bowl of fruit. And it may be any one of numerous characteristics that human sensitivity discovers in such objects: their surface qualities, their structure, the repose or tension they exhibit, the moods that haunt them; the very different ways in which Renoir, Picasso, Titian, Rubens, Rembrandt, Delacroix, and Raphael paint a nude exemplify the vast experiential possibilities that such things contain. This may be some emotion, attitude, or aspiration of man, perhaps trivial and ephemeral, perhaps profound and enduring: a song of Schubert or a lyric of Herrick may capture in one sure cast the transient feeling aroused by a woman's walk or a child at play; while a symphony or an epic may grope tortuously for the torments of anxiety and faith that color a whole life. This may be any of the manifold situations that man

[1] Chap. I, Sec. iii; Chap. II, Sec. ii.

confronts, with the motives they bring into play, the problems they pose, the alternatives they offer, and the consequences they entrain: a short story of Chekhov or a genre painting will disclose a casual episode, while *Moby Dick* and *Antigone* present the long-prepared climaxes of a human career. This may be the temper and tone of the artist's contemporaries, with the ideals they piously enshrine, the values they actually pursue, the habits they follow, and the destinies they expect: Jane Austen's *Mansfield Park* and W. H. Auden's "For the Time Being" are such brilliant, though very different, commentaries on the pretentions and realities of the societies they depict. These are merely indications, and to attempt to go beyond them to an exhaustive listing, or even a compact index, of aesthetic particulars would be an endless undertaking. Every occasion in experience replenishes this realm, for every such occasion is unique and the artist may seize upon any of them.

The field of presentative art exhibits within itself a bewildering variety. Different artists, all intent upon realizing the character of the things that they encounter in the world and discover in experience, pursue these by different methods, seize different aspects of them, and present them in different guises. The novels of Joyce, Dickens, Trollope, and Dostoyevsky are alike presentative art, but they are very different in character; the same is true of the paintings of Turner, Van Gogh, Cézanne, and Vermeer; and again of the poetry of Blake, Shelley, Robert Frost, and T. S. Eliot. Quite evidently the quality and emphasis of artistic insights vary, and artists consummate these insights with visions that vary in their content and structure. Confronted with these diversities, it is natural to wonder if there are discernible causes that are responsible for them, and if they can be arranged within some systematic pattern. Since every artist — and even every work of art — embodies a unique experience and vision, it is extremely dangerous to generalize about them. But artists share a

common humanity and deal with a common world, so similarities of interest and intention are to be expected. And the various categories that have been used to type and classify art, even though it be insisted that they are only convenient makeshifts, still suggest that artists and works of art can be grouped together: this is presupposed by all such descriptive terms as realistic, naturalistic, impressionistic, classical, romantic, idealistic, expressionistic, and many others in common employment. So it is desirable to look for the systematic pattern that underlies these intimations of order.

4. To comprehend the true ordering of presentative art, it is necessary to visualize a schema that is based on two axes and spreads through two dimensions. One of these I shall call the *Imitative-Expressive* axis, the other the *Conventionalized-Individualized* axis. The axis that runs between the end terms of imitation and expression differentiates between artists on the basis of whether their primary artistic bias is toward the outer world or the inner world; it measures the different tendencies in artists to view things as significant in their own right, or as having significance bestowed upon them by their repercussions in human consciousness.

There are some artists who are chiefly concerned with the objective character of particular things, persons, situations, and events; their attitude is detached, uncommitted as to what might occur and untouched and unsurprised by what does; they seek to depersonalize their regard of things, to give to their sensitivity a hardness of polish that reflects the world faithfully and without the intrusion of their private reactions. Such artists set out to be observers of and commentators on life's panorama. Their consciousness is directed outward, and they intend to invade the privacy of things. This is the pole of imitative art.

There are other artists whose chief concern is with the reverberations that particular things arouse in human ex-

perience. Their attitude is that of impassioned participants in all that happens in the world, and they feel themselves to be intimately and vitally involved in all of life's encounters. Every object is an actor, and every event an episode, in their personal careers; responses matter more to them than stimuli, and they seek to make their sensibilities both delicate and violent. For such artists, the true substance of things lies in the meanings and values that men find in them: the emotions that things arouse, the reveries they evoke, the dreams and plans they stimulate, the form and color and passion with which they feed man's inner loneliness — it is here that the significance of things lies. These artists aim to project themselves into things — or perhaps better, to absorp things into themselves. The consciousness of such artists is directed toward subjectivity, and they intend to become intensely and subtly receptive to every impingement of the world. This is the pole of expressive art.

Neither of these poles is ever reached; they are the vanishing points of artistic tendencies. Experience is an encounter between man and the world, and neither of these elements can ever be distilled off. Imitative art reflects the personality of the artist as well as the world, and expressive art consecrates not only the emotions of artists but also the occasions that have aroused them. But these tendencies are none the less real and important, and the efforts of artists to isolate these elements greatly enrich and clarify our visions of the world. Such artists as Cézanne and Vermeer, Jane Austen and Robert Frost, seem almost to render things as they are without any human intrusion; while such artists as Thomas Wolfe and James Joyce, El Greco and Van Gogh, almost persuade us that things are what they do to us.

The axis that runs between the poles of conventionalization and individualization differentiates between artists on the basis of whether their primary artistic intention is to deal with the public world that they share with their contempo-

raries by reason of an established tradition, or to search out aspects of the world that are ignored or neglected by their contemporaries. This axis measures the different tendencies in artists to make themselves spokesmen for the refined vision and conscience of mankind, or to achieve a highly personal rendering of things.

There are some artists who accept much of their outlook and orientation from their society; they live artistically within a framework that is defined by the manners, interests, attitudes, values, and stereotypes of their culture; they reflect the concerns and beliefs of those around them; they deal with a world that is already public in the sense that there is wide common agreement about its structure, contents, and significance. The work of such artists is directed toward exploring this world with great subtlety and persistence, thus enabling their contemporaries to see it more vividly. These artists may deal with this world in either an imitative or an expressive manner: they may focus attention on what their society finds in the world, or on how it reacts to the world. In both cases they extend and refine man's acquaintance with a world that is already generally familiar to him. This is the pole of conventionalized art.

There are other artists who seek to break the interpretations and perspectives, the credos and habits, of their contemporaries: to them, these are mere dogma and prejudice, limiting and distorting their view of the world. These artists want to approach things as nearly as possible in a state of innocence: to attend only to what things assert of themselves, and to feel only what things compel them to. They aim to shatter all established habits of perception and emotion and thought, to strip away the accumulated meanings that convention has imposed upon things, and so to make themselves more receptive to the real character and impact of things. The world that such artists discover is at first intensely private, because unfamiliar; but if they succeed in sharing their discovery,

then it is added to the public domain and greatly enriches this. As in the case of conventional artists, the work of these men may be either imitative or expressive in manner: their naked sensitivity may be exposed to either the objective contents or the subjective impact of the world. In both cases they extend the horizon of man's vision, and make available fresh deposits of particularity that the future will gradually render familiar. This is the pole of individualized art.

These poles are again vanishing points that are never reached. The vision achieved by a mature artist has its source in his individual insight; but this has inevitably been cultivated by his society. The artist can rely primarily upon his insight, using the interpretations and perspectives of his culture merely as a point of departure for his forays against the uncharted world; or he can attach himself closely to the framework erected by his culture, using his insight to render this in finer detail, to bring it into sharper focus, and to embrace it more comprehensively. The most intense personal insight can be made intelligible only by reference to a conventional outlook; and this outlook can be sustained and kept contemporary only by insights that do more than merely reiterate it. Such artists as Blake and Dostoyevsky, as Beethoven and Picasso, seem to open vistas that are utterly new and unsuspected; they distort and disrupt our familiarities in order to make way for their personal vision. On the other hand, such artists as Trollope and Henry James, as Watteau and Vermeer, render familiar things with a freshness and fidelity they have not worn before, and make us wonder at our previous blindness to what has all along been before us; they accept their heritage, preserving it against the erosions of habit and carelessness.

The field of presentative art is ordered in quadrants around these two axes. The most explicit and economical way to convey this pattern is through a diagram, and I have done that in the accompanying figure. But this device has the danger of suggesting that the distinctions among these quadrants are

Imitative

Discloses the world of our familiar acquaintance in fine detail and with great comprehensiveness.

In extreme cases tends toward historical or sociological reporting. Degenerates into edification.

Jane Austen	Vermeer
Trollope	Tintoretto
Robert Frost	Watteau
Henry James	

Realism
Naturalism
Classicism

Reflects the response of a more or less generalized human sensitivity to the pressures of life.

In extreme cases tends toward exaggeration of the goods and ills of human nature and the human situation. Degenerates into sentimentality.

Turner	Dickens
Michaelangelo	Sophocles
Byron	Faulkner
Tschaikowsky	Hardy

Expressionists
Art and the spirit
of the time.

Expressive

Impressionism
Cubists
Surrealists

Cézanne	Proust
Gauguin	Franz Kafka
Picasso	Dylan Thomas
Paul Klee	

Discovers to us, in the private vision of the artist, aspects of the world that are novel and unsuspected.

In extreme cases tends toward caricature, portraiture, or irony. Degenerates into mysticism.

Romanticism
Art as release

Van Gogh	Thomas Wolfe
El Greco	James Joyce
William Blake	Euripides
Beethoven	

Reflects the personal impact of life and the world upon the individual artist.

In extreme cases tends toward emotional autobiography and celebration of the self. Degenerates into fantasy.

The Field of Presentative Art

sharper and more abrupt than is actually the case. So the concrete indications I have given in this figure should be taken as intended to illustrate my argument, not to classify dogmatically the works and schools that are mentioned. Art that is individualized and expressive — such as that of Thomas Wolfe and Van Gogh — sees the world in terms of its private impact on the artist. Art that is conventionalized and expressive — such as that of Faulkner and Turner — sees the world in terms of its impact on a certain type of human sensitivity, which may be widely generalized or highly specialized and restricted. Art that is individualized and imitative — such as that of Cézanne and Proust — fastens on aspects of things that are hidden from normal awareness or disguised by established interpretations. Art that is conventionalized and imitative — such as that of Vermeer and Turgenev — extends our accustomed ways of acquaintance with things with great acumen and delicacy, and brings the familiar facets of things to a high polish.

A final illumination can be shed on these quadrants, and several strands of thought can at the same time be brought together, by a brief consideration of the artistic failures, or anticlimaxes, that occur when these tendencies are pushed too far. For this purpose, it will be necessary to bear in mind the earlier analyses of the aesthetic object and of the different types of pseudo-art and degenerate aesthetic experience. Against this background, it can be shown that each of the four major forms of artistic treatment discussed above runs the danger of collapsing into the nonaesthetic in its own specific way.

A manner of treatment that is at once expressive and conventionalized stresses the general human significance of common objects and situations: it therefore opens the door, for both the artist and the audience, to replace the aesthetic object with a similar familiar object which we clothe with the emotions and values that custom has hallowed. This defines

the sentimental attitude. And sentimentality is indeed the great weakness to which art of this sort is susceptible. Such artists as Dickens, Tschaikowsky, and Turner illustrate this clearly.

A manner of treatment that is at once expressive and individualized stresses the personal impact of life and the world: it therefore is apt to incite us to replace the aesthetic object with something suggested by our own preference, and so to indulge in projection, wish-fulfillment, and vicarious enjoyment. This is the definition of fantasy. On the side of the artist, this may produce an attitude in which everything that he undergoes is regarded as tremendously important just because he undergoes it; he loses his sense of proportion, relinquishes the struggle to render his insights lucid and stable, and simply celebrates the tumult and violence of his feelings. On the part of the audience, this leads to the aesthetic object being treated as a mere stimulant.

A manner of treatment that is at once imitative and conventionalized stresses the familiar contents of the world; it therefore invites us to replace the aesthetic object with a hackneyed and sententious interpretation of whatever common thing this object is easily taken as representing to us. We are encouraged to recognize some recurring feature of the natural or social environment, and then to dwell on the emotional, moral, and religious meanings that convention has associated with this. Such art readily becomes a mere confirmation of our established categories and a justification for our settled views: that is, it does nothing but reinforce our stereotypes and prejudices. This is the definition of edification: the aesthetic object is corrupted into an exemplification, and the work of art becomes a piece of special pleading.

This exhausts the types of pseudo-art and degenerate aesthetic experience that were identified earlier. But we can now see that that list, being too little systematic and too largely based on the prevalence and virulence of the phenomena under consideration, was incomplete. For there is

a fourth kind of presentative art, which has its own specific susceptibility to failure. This results from a manner of treatment that is at once imitative and individualized, and which stresses the artist's personal vision of the world. Now if such art is sufficiently impressive and persuasive, and yet very remote from the world we know, we are apt to accept it as a revelation of another world altogether. This may be the artist's own pretention, or merely the conclusion we draw. In either case its outcome is the attitude that can most descriptively be called *aesthetic mysticism*. What we delude ourselves into thinking we discover in such art is so foreign to all established meanings that it cannot be assimilated into the body of experience; it is so incoherent in its references, and so inconsistent with all of our systematic contexts, that it has no relevance for the world of everyday life or for our usual concerns. This seeming failure is transformed into a triumph by proclaiming that art discloses ineffable truths about some transcendent realm. The artist now becomes a seer, the aesthetic object becomes an occult symbol, and the ordinary man is recommended to become a disciple and devotee. This cult of artistic unintelligibility currently enjoys a wide vogue, the way for it having been well-prepared by the envoys of Surrealism, Futurism, Dadaism, and other such groups. Mysticism is not so prevalent as the other forms of aesthetic disease, if for no other reason than that its contagion requires a high degree of literacy. But it is perhaps the danger that most threatens artists and the aesthetically sensitive; for those who take art with real seriousness, and who cannot find a rational interpretation of the significance of art, mysticism will always be a lure.

It must be emphasized again that these modes of presentative art — the quadrants marked off by these axes — are not sharply separated, but merge into one another; and this is as much the case with pseudo-art as with true art. Every work of presentative art is influenced by each of these four tendencies:

it is at once imitative and expressive, individualized and conventionalized; it is a blend of all of these perspectives and intentions. And many of the best works of this type cluster around the node of these axes, lending themselves easily to different interpretations. In suggesting this analysis I have not meant to offer a schema within which every work of presentative art can be precisely located, but rather to indicate the various directions in which artists pursue particularity and the varying accounts that they give of this when they return from their quests.

III

Functional Art

5. This term is not too happy a one, but all others that suggest themselves seem worse: to speak of "applied" or "useful" or "instrumental" art is to borrow words that are so heavily loaded with meanings and associations as to prejudice the case beyond repair. The defining characteristic of functional art is the close commingling of the strictly artistic interest with either a theoretic or technological interest, or both. The artist, in the process of coming to grips with the actual character of some particular thing, also becomes deeply concerned with the relations in which this thing stands to other things and to ourselves; as, in the realization of his original aesthetic interest, he renders its object more vivid and articulate, this object evokes the scheme of things to which it belongs, and asserts its relevance to human affairs. The attention of the artist is forcefully called to these aspects of things, and he feels it necessary to deal with them on these terms. When this occurs, the work of art is devoted to the pursuit of other ends and values in addition to the purely aesthetic one of presentation: it is now a locus of various interests, and assumes a mixed character.

Within the very broad area of art that is determined by

this merging of interests, two general outcomes need to be distinguished. The strictly artistic interest in presentation may remain dominant, bringing within its orbit, in a subsidiary role, an interest in explaining or controlling things. Or the artistic interest may become subordinate to another principal interest, fall passively under its direction, and so become merely instrumental to another purpose than its own aesthetic one.

In the first case, what issues from the creative process is still quite clearly within the realm of what is customarily called fine art. The artist's primary and essential intent remains that of grasping and presenting the intrinsic character of things: he is fascinated by objects and events in the world, by the situations he encounters and the emotions these arouse, by his dealings with his fellow men and by the anxieties and aspirations he finds himself sharing with them. But the artist now joins to this a concern for the connectedness and the import of things. He realizes that particular things are not only what they are, and fascinating as such, but that they are also parts of systematic wholes, and are fraught with human significance. With this realization, he feels a responsibility to lend his talents to the mastery of these equally real aspects of things. He becomes something of a teacher and something of a reformer. He feels an urge to explain the world to men, and men to themselves, and then to remake both man and the world closer to the heart's desire.

It is not in the least surprising that this should happen. The more sharply we see things for what they are, the greater are our possibilities for understanding and dominating them. As an artist recognizes this enhanced power of comprehension and control, it is natural that he should be stirred to use it. Of course, this need not necessarily happen; the artist's attention may be so closely focused on particularity that he remains almost unaware of, and altogether uninterested in, the presence of things in the dimensions of the self and the world. But the artist's acute vision of particular things is apt to sharpen both

his discernment of the web of relations in which things are caught, and his realization of their human consequences, and his attention is led down these trails. In short, functional art has its source in the fact that the artist is always also a man, moved by all of the interests and concerns that are proper to man.

Within this genus of functional art that is also fine art there can be distinguished, at least in principle, two species, depending upon whether the secondary interest that is operative is technological or theoretic; though frequently both of these will be prominent, and the distinction will be difficult to draw in practice.

Where the technological factor enters in strongly, the artist is moved by a deep concern for the impact of the world upon man. He is acutely aware of the ways in which physical objects and events effect men, coloring their emotions in various ways, and furthering or frustrating their lives. He sees how men's personalities and careers are distorted or impeded by the molds into which society forces them. He realizes the harm or the good that follows for men from the purposes and attitudes and aspirations that play a leading role in their lives. Realizing all this, the artist seeks to intervene. He sets out to reinforce certain moods and sentiments, to inculcate certain values and ideals, and so to give a definite cast to man's character and conduct. He seeks to bring home to men the tragic consequences of their heedless or malicious — or even of their carelessly well-intentioned — interferences in the lives of their fellows, and so to persuade them to change their ways. He hopes to shock them by a ruthless exposure of conditions and circumstances, and so to rouse them to take action against these. Familiar cases of this species of functional art are the following: that whole large area of the drama that is called the "protest play,"[2] classic examples of which are Ibsen's

[2] For a brief but thorough analysis of this subject, and one that is relevant to other arts as well as drama, see an article by Monroe Lippman, "An

Ghosts and Irwin Shaw's *Bury the Dead*; much religious music, especially hymns and masses, as for instance Luther's "A Mighty Fortress"; such paintings as Picasso's *Guernica*, and the murals of Diego Rivera and Orozco; very many novels, such as Dickens' *Bleak House*, Trollope's *The Way We Live Now*, and Steinbeck's *The Grapes of Wrath*; much religious, domestic, and commemorative architecture; and a good deal of the dance, especially when this is at all ritualistic. In all such cases, the clear and intense vision of the artist arouses and illuminates his concerns as a total person, and leads him to assume the tasks of persuasion and reform. And so his work becomes an instrument to change the world as well as to present it.

The second species of functional fine art arises when the artist is motivated by a strong theoretical interest in the particular things he is dealing with. As he renders these things more distinct, they articulate not only themselves but also the fact of their connections with other things. They argue against the isolation he has imposed on them. They invite understanding as well as appreciation. The essence of this transition is the artist's coming to regard the thing he is presenting as an example, as a case in point, as an object lesson, rather than as the unique particular that he started with. He purposely abstracts and generalizes the character and meaning of this particular, and so makes what he says of it applicable to all similar particulars. In doing this, the artist becomes a critic and a teacher. This intention is probably ubiquitous in art: the artist, as a man, realizes that things are similar as well as unique, that they participate in common relations, that they follow general courses. So some carry-over from art to life — some application of what we learn from artistic particulars to the things we encounter in the world — is always probable, even if not explicitly intended. When the artist encourages this, his art

Analysis of the Protest Play," in *Southern Speech Journal* 31:127–132 (Winter 1955).

becomes functional as well as presentative. Examples of this type of art are such social satires and comedies of manners as those of Molière and Aristophanes; many of Shaw's dramas (and especially when read in conjunction with their prefaces); allegorical and satirical paintings, such as Breughel's *The Blind Leading the Blind* and Hogarth's *Mariage à la Mode*; historical romances, science fiction, and novels of social analysis.

The distinction between these two species, though clear in principle, is often tenuous and ambiguous when applied to actual works of art. Once an artist's interest has shifted materially from the particularity of things, then his interests in their import and their connectedness entail one another. As the probing of artistic talent discloses things more distinctly, these things assert more clearly and persuasively both their location in the world and their significance for man. Which of these facets of things becomes uppermost in the attention of an artist depends largely upon his temperament and attitude. But whichever dominates, both will be implicated. The artist can arouse a reforming zeal in men only by teaching and persuading them; and even the most tolerant or sardonic commentator on the human scene must feel some preferences and the urge to further them. This mixture of intentions, which is characteristic of all functional art, stands out most clearly in such classical satires and allegories as *Gulliver's Travels* and *Pilgrim's Progress*; and, more recently, in Franz Kafka's *The Castle* and *The Trial*. It is equally evident in that modern substitute for these, which can best be called "documentary fiction"; notable examples are Arthur Koestler's *Thieves in the Night*, Andre Malraux's *La Condition Humaine*, John Hersey's *The Wall*, and Arthur Miller's play *The Crucible*.

I mentioned earlier that there is a second general outcome that may result from this merging of interests: this is for the artistic interest to become subordinate to some other dominant interest, and so instrumental to some other purpose than its properly aesthetic one. When this occurs, the issue is what

is commonly known as "applied art." The artist here functions not strictly as an artist — not as a man who deals with things in his own special way and on his own terms — but as a craftsman whose trained talent is used in the pursuit of ends that he has not himself defined or chosen. Due to its ability to accentuate and clarify the actual character of things, art can greatly contribute to the exploitation of things in other ways and for other purposes. The vivid and forceful presentation of things is a powerful factor in teaching and persuading men: in stimulating their appetites, satisfying their senses, training their emotions, directing their aspirations, and determining their beliefs. So the support of artistic ability has always been sought by those who are in any way concerned with what men look at, desire, believe, and do. The skill of the artist has been invoked to make the articles of daily use more attractive, to ornament our surroundings, to attract and fasten the attention of people at desired points, to promote the teaching of children and the indoctrination of adults, to put obscure lessons in a simple and palatable form, and for a horde of other purposes. The artifacts that result from this subornation of artistic talent are familiar to us in the varied guises of craftsmanship, industrial design, commercial and advertising art, propaganda, didactic art, decorative art, and others.

The difference between these two great classes of functional art — between what is "fine" and what "applied" — is of course one of degree. The root of the distinction can be brought out by a simple question. Is the artistic interest in the presentation of particularity central or superficial, essential or instrumental, the end sought or the means employed to some other end? In the first case, artistic insight dominates the creative process and the work that issues from it: the artist achieves independently his grasp of particularity, exploring those aspects of the world that attract him, and attaining of them what vision he can; then he seeks to make

others see as he has seen, to lead them to his beliefs, to arouse in them his emotions and evaluations. All of this is subsidiary to his vivid grasp of the character of things and events, and is animated by his conviction that since this is what things are, then this is what they require of us. In the latter case, artistic insight is placed at the disposal of others: they determine the particulars upon which it is to be focused and the characteristics and aspects of these particulars that are to be emphasized. The content that the artist is to illuminate, and the impact that this is to have, are defined by theory or technology rather than by art. In a great many cases this criterion can be applied with ease and assurance. But in numerous others it cannot, and there would be disagreements as to the proper classification of many artifacts. Since the works of man are a complex of interests, this is to be expected. Functional art arises from the merger of human concerns in common undertakings, and the detailed pattern of such art follows from the intricate and continually varying interplay of these concerns.

IV

Formal Art

6. Formal art results from the always present and powerful tendency for the artistic intention to detach itself from its encounters with the world, to become absorbed in its own processes and purposes, and to center its attention upon its medium and its techniques. Such art frequently seems not to deal with any subject matter or have any content, and to be totally unconcerned with the presentation of anything beyond itself. This type of art appears in the familiar guises of absolute or pure music, abstract and nonobjective plastic art, formal design, and pure poetry. Specific examples are a Chopin prelude, a Hindemith quartet, a Calder mobile, a mosaic, a Ming vase, and the compositions and constructions of many

modern painters and sculptors, such as Kandinsky, Mondrian, Braque, O'Keeffe, Matisse, and Henry Moore. The thesis is now widely maintained that art of this kind — which is held to be the true or best or essential type of art — deals with a realm that is strictly its own, and has no bearing on life or the world as these exist independently of art: its meaning is sheerly intrinsic, and its value is exhausted by its material and formal properties. This view has been vigorously asserted by the adherents of the doctrine of significant form (especially Roger Fry and Clive Bell), by the many modern critics who emphasize plastic values, and by the followers of Gurney and Hanslick, with their hypotheses of a special musical faculty and special musical values.

Formal art is a complex and elusive problem, and it is further obscured by the vociferous inconsistencies of those who are its most ardent advocates. Theorists, artists, and critics insist at some moments that such art is completely self-contained, isolated from the everyday world and from the normal concerns of life, and appealing only to some special aesthetic or plastic or musical sense. At other moments these same men insist that such art is the expression of man's most vital and persistent emotions, and that it carries us to the heart of some ultimate reality that lies behind the superficialities we usually deal with. To resolve these contradictions, and to see why such fierce and conflicting allegiances occur, it is necessary to trace out the origin and the essential character of formal art.

Formal art arises when the artist becomes primarily interested in the medium he employs, and in the ways in which he can exploit this medium. Every artist has a passionate concern for his medium: the material that he works with — words or sound or stone or color — makes a vivid appeal to his senses; he is fascinated by the rhythms and harmonies and proportions that issue from certain arrangements of this material; he is intrigued by the patterns and structures that can

be imposed upon, or evoked from, it; and he is challenged by the recalcitrances and limitations with which it confronts him. All of this is a significant part of what makes a person an artist. Some of his deepest joys and satisfactions arise from what his medium spontaneously offers him and from what he can deliberately wrest from it. And it is only by being realized and embodied in some medium that his insights into particularity — which are the other significant element of his artistic endowment — can become complete and concrete visions.

When artistic talent first manifests itself, and as it matures, it always exhibits these two facets: it is extremely sensitive to the contents and the quality of its surroundings, and it is vastly absorbed in the sensuous and structural properties of some material order. Artists are both more strongly and more subtly aware of things and occurrences around them, and of what take places within them, than are most of us, at least as concerns the regions to which their sensitivity is attuned. And artists are intrigued by the intrinsic characteristics and relations of one or more of the media of expression and communication that the rest of us employ so casually and carelessly: to them, words or colors or bodily movements are sources of immediate value, instead of simply means to other ends. Artists are intensely stirred by what touches most of us but lightly. And artists enjoy what we merely use.

Every artist is a victim of the tension between these two aspects of his temperament. The world and his own emotions press upon his sensitivity and seek expression through his talent. At the same time, his physical medium fascinates his senses and challenges his skill. The ideal resolution of this tension between aesthetic insight and artistic technique — between meaning and medium — is one in which they contribute to one another without sacrifice of their distinctive characters. It is the conflict of these two appeals that is largely responsible for the uncertainty and vacillation that occur in much

serious and mature art: the artist tries to satisfy these two demands, he finds that this requires that one or both be qualified, he cannot bring himself to subordinate either to the other, and so he actually creates two works of art under the guise of one.

Finally, when this conflict becomes irreconcilable and demands a choice, the artist is apt to find it easier to come to terms with his medium than with his insights. The former has a structure and stability, as well as a fierce sensuous appeal, that both challenge and facilitate exploration, and continually yield surprised satisfaction. The latter, on the other hand, are tentative and elusive, often frustrating the artist's attempt to clarify them or disappointing his expectations even when he succeeds.

Hence artistic talent — and especially precocious talent — is apt to fasten upon its medium before it commits itself to its insights. Eliot and Auden have defined the youthful poet as a person who is in love with words; Kandinsky has told of his early fascination with the colors that ran from the tubes of his child's paint set and seemed to lead a life of their own; the picture of the infant Mozart reaching for the keyboard to call forth his beloved notes and chords has become a legend; and it is now almost necessary to a virtuoso's respectability that he should have listened enthralled at concerts while still a babe in arms. No artist can or should outgrow this devotion to his medium, which is both a rich source of artistic satisfaction in its own right and the indispensable vehicle to the satisfactions of a consummated artistic vision. Medium and vision — technique and insight — are necessary to one another; but the necessity is that of opposite poles. When the gap between these becomes so great that the artist despairs of leaping it, and when he feels that he can make his stand more effectively and rewardingly with his medium than with his vision, he turns to the primary cultivation of formal art. He goes in pursuit of the values that lie in the im-

mediate sensuous qualities of the material he works with, and in the richly varied patterns and designs into which he can work this material. He refines and intensifies his — and our — discrimination of the surface qualities that are inherent in words and sound and stone and color and line; and he brings these elements of his media into combinations that surprise us with their novelty, and delight us with their balance and movement.[3]

All fine art is rich in such formal values. A large part of the power of art lies in its appeal to our senses, to our feeling for form and structure, and to physiological processes that are pervasive and significant even though obscure. The delight of eye and ear and touch, the stimulation of our kinesthetic senses, the arousal of massive and profound organic feelings, and the excitement of discovering formal relationships and seeing a design fulfilled — all of this belongs to art largely through its embodiment of formal meanings. So formal art is a perfectly natural outcome of the aesthetic impulse and a perfectly legitimate product of artistic activity.

In this type of art, by definition, formal values predominate over presentative and functional values. At this point there arises the question that modern controversy has made inescapable: is there any art in which these latter modes of value are altogether obliterated? Is there any art in which there is no intention to present or express particularity, or to illuminate and contribute to our dealings with particular things? Is there any art that issues solely out of the resources of its medium and its creator's talent for design, and that owes nothing to the total personality of the artist and the impact of

[3] This interest in the medium and in the technical problems of artistic composition is often carried a step further and becomes strictly cognitive. The artist now functions as a theoretician, analyzing the procedures that he employs in artistic creation, explaining why he adopts them, what difficulties of treatment they raise, what advantages and disadvantages they offer. As examples of this class of "aesthetic intellectuals" there immediately come to mind such names as Henry James, Proust, Cézanne, Kandinsky, Schoenberg, T. S. Eliot, Allen Tate, Frank Lloyd Wright.

the world upon him? This question, I think, is meaningless, because based on a false disjunction: it presupposes an isolation of art from life — a retreat of the artist from the world to his medium — that is a logical absurdity as well as a contradiction of fact. Every work of art emerges from the experience of its creator, as well as from his dexterity; it reflects his capacity as a man as well as his talent as an artist. So it is to be expected that his art should embody what he has found significant in the world and urgent in life. Beethoven insisted that his compositions, which are frequently treated as the epitome of "absolute" or "pure" music, were intended to express and convey his reading of life's meaning. And Kandinsky and Mondrian have asserted that their non-objective paintings, which seem at first to be overwhelmingly formal, forsake the superficial realism of physical representation only in order to convey the sense and the emotional significance of a more ultimate spiritual reality.

But this whole dispute is artificial and unimportant. What is unquestionable is that there is much fine art in which the element of presented content or expressed emotion is quite overshadowed by that of structured matter. When we look at a painting by Renoir or Matisse, or at one of Naum Gabo's constructions, when we listen to a Boccherini quartet, when we read Swinburne's poetry, we are apt to be more conscious of the texture and design of the work than we are of any independent particular thing that is presented or any explicit emotion that is expressed. There is always some appeal to our funded experience: some pattern of familiar feeling will be evoked, even though obscure and amorphous, and this will attach itself to some remembered objects or circumstances. This is inevitable, for experience has sullied whatever innocence our senses and even our organic reactions may once have possessed. But in our appreciation of formal art these references are at the periphery of consciousness. What we chiefly attend to and delight in are the arrangement of color

and line and mass, the texture and contours of stone, the sound and rhythm and vague suggestiveness of words, the melodies and harmonies that sing in music.

In formal art, the isolation and self-sufficiency of the aesthetic object are exploited to the utmost. The artist composes a work that conveys its content largely by the structuring of sensuous-emotional materials and with a minimum of reliance on either arbitrary or traditional symbols, thus making it relatively independent of explicit references to our accumulated experience. The meaning and value of such art can be distinguished into three kinds. *First*, there is the possibility, attested to by many artists, of clarifying and embodying in this manner emotions that can be dealt with in no other way. Representational art inevitably elicits emotions in already organized and established blocks, or complexes; its ability to deal with our emotional life is at once fortified but also curtailed and obstructed by the associations with which the past has encumbered the objects and situations that comprise its subject matter. Formal art loses this support of the familiar. But it compensates for this sacrifice by the precision with which it can dominate perception and feeling; it can construct its objects in such a way as to control closely the emotions it evokes, and so can exhibit these in new contexts and arrange them in fresh patterns. *Second*, works of formal art offer us joys that are among the purest and most intense that life can yield. Our response to such art, being untrammeled by the concerns of the world, has a freedom and a scope that are rarely otherwise attained; we employ our senses, our feelings, and all of our faculties with no other purpose than the sheer enjoyment of their exercise. The result is a heightened sense of vitality and a feeling of unburdened delight. *Third*, the pursuit of formal artistic values is a powerful factor in extending and refining the media of the arts. Styles and techniques are apt to become closed and static; in doing so, they make the artist's task easier, but they also confine and limit

him. Formal art greatly encourages explorations of the resources of the various media, and experimentation with new modes of composition and design. By this cultivation, both the intrinsic values and the expressive powers of the arts are continually enlarged.

If formal values become too dominant, to the neglect of presentative and functional values — especially the former — the resulting art is apt to be sterile and shallow. Under this impetus, artists produce many works that are mere applications of the general principles of design, put together according to formula and amounting to no more than exercises in the use of techniques and rules. In the common criticism, these are works that have nothing to say and that do not arouse in us any depth and sharpness of feeling. We may be attracted and pleased. But our interest is chiefly in the dexterity with which a medium has been exploited, and in the practiced skill with which the principles of composition and design have been employed. As I have pointed out earlier, artistic talent is constantly exposed to this temptation to retreat to an artistic cosmos, and when it succumbs it is diverted from its proper goal. But the fact that this happens — and that it has been the prevalent error of modern artistic movements — should not be allowed to prejudice the case against formal art as a whole, nor to blind us to the real values that can be realized through such art. This would be equivalent to rejecting presentative art because it issues in many works that are banal and trivial, and to rejecting functional art because it often relapses into utilitarianism or didacticism. It has been precisely this fastening upon artistic failures, and the total stigmatizing of the principles and practices that led to them, that has done so much to obscure the understanding of art and to pervert its development. It is time to cultivate an attitude that is equally tolerant of the legitimate claims of presentative, functional, and formal values, and critical only of the abuses to which these will inevitably be put.

V

7. I shall not here do more than broach the questions of the relative value and the historical priority of presentative, functional, and formal art. As to the first issue, a cogent case can be made out for each of these types. The adherents of presentative art would maintain that since it is the need to grasp particularity that gives rise to art, it follows that art appears in its most proper sense when it is dedicated to this task. The adherents of functional art would maintain that since the human enterprise must be carried on in a coherent and synthetic manner, it follows that art is most truly fulfilling its task when it contributes to all three stages of this enterprise. The adherents of formal art would maintain that since art does in fact develop techniques and values that are strictly its own, it follows that it is in the perfection of these that art attains its fullest realization. The proper resolution of this debate, I think, would be in favor of art that contains all three of these factors and keeps them in balance.

As to the order of genesis of these types of art, it seems probable that the original occurrence of art was in its functional guise. And this in a double sense: not only was the earliest art a device by which man at once clarified his vision of things, extended his comprehension and control of things, and satisfied his sense of form; but this artistic activity was also closely merged with myth, religion, magic, and man's practical pursuits. Art begins as an undifferentiated element in the human enterprise. And the human enterprise begins as an unreflective and unpracticed attempt to come to grips with the world. Many of man's earliest artifacts are a close fusion of artistic, theoretic, and technological factors: they serve all of these purposes at once and without discrimination, and it is only in retrospect that these separate intentions can be distinguished. This is the case with much of what we now call myth, magic, and ritual. Slowly and hesi-

tantly, man separates out the particularity, the import, and the connectedness of things, realizing these as aspects of the world that can be treated to some extent apart from one another. So, gradually and tentatively, art, technology, and theory appear. These earliest works that can be identified with any sureness as art are a tight complex of presentative, functional, and formal values: they exhibit a vivid sense of the world, and an eagerness to seize and express the character of things; they show a strong concern to proclaim the order of nature and to propitiate the powers that be; and they manifest a fascination with the sensuous and formal elements that they contain. Once these values have been recognized, their development is cumulative and almost frenetic. Each of these possibilities is avidly explored, and where we know enough about a culture we can usually detect distinct movements toward realism, craftsmanship, and pure design, carried forward sometimes in close conjunction and sometimes by separate schools.[4]

These two questions have been discussed chiefly for the light they throw on the essential unity and the specific varieties of art. The field of art is constituted and unified by the fact that the aesthetic impulse, and the artistic intention in which it becomes conscious and purposeful, are focused upon particularity. Art is called into being by man's need to make vivid and articulate the particulars that experience first discloses only vaguely and tentatively. Art is nourished by the artist's persistence in eliciting the precise quality and structure of what he first senses only obscurely in his en-

[4] There is an interesting and richly illustrated documentation of the contemporary interplay of art, theory, and technology, with special emphasis on the influence of art, in *The Museum of Modern Art Bulletin* 17 (1949). This booklet, entitled *Modern Art in Your Life*, and prepared by Robert Goldwater and René d'Harnoncourt, affords convincing proof that, in its authors' words, "modern art is an intrinsic part of modern living." It is also a fascinating record of the continual exchange that is taking place among what I have called the presentative, functional, and formal modes of art.

counters with the world and with himself. What artists return with from this quest are presentative values, which extend man's vision of things and refine his sensitivity to their human repercussions.

But art always contains functional and formal values, as well as presentative ones. The field of art is diversified by the fact that these modes of artistic value occur in infinitely various proportions. Some art startles and holds us by the sheer clarity of the insight that it yields, as though things were for the first time really unwrapped and exposed before us. Some art does not remain content with such an insight, but uses it also as a device to lead us back to the world of familiar things with a quickened comprehension and a strengthened purpose. Some art so delights us with the guise in which its insight is embodied — with the sensuous qualities and the formal structure in which it appears — that our realization of the meaning, and even of the content, of this insight falls far into the background. The greatest art accomplishes all of this.

Finally, it should be remarked that the relative incidence of these values in a specific work of art is not determined solely by factors intrinsic to the work. Artistic values, like all others, are realized only in experience: objects "have" value only as they are fit to occasion experiences that realize value. So the prominence of presentative, functional, and formal elements in works of art is determined partly by the ways in which men receive these works. As the concerns of men change, art which was originally valued chiefly for the content it presents may come to be regarded in largely formal terms: quite clearly a modern gallery-goer does not see and feel in medieval religious paintings the presentative values that these held for their own contemporaries. Again, it often happens that principles and styles of design that are developed by artists interested strictly in their formal properties will later be exploited for their functional value in commercial and industrial pursuits, or will prove to have a marvelously subtle expres-

sive power that enables us to present what before escaped us. And the most familiar type of this phenomenon occurs when works which, in the intention of their makers and the regard of their time, contained a predominance of functional value come to be seen as embodying chiefly presentative and formal values. It is of this translation of practical artifacts into museum pieces that Thomas Hardy is speaking when he says of the ancient college buildings of Christminster: "They had done nothing but wait, and had become poetical."

Chapter XII

ART AND THE HUMAN
ENTERPRISE

I

1. This final chapter will be devoted to a brief discussion of several problems which reach beyond the special domain of aesthetics into the larger area of philosophy, where they have broad and important implications.

We can begin with the question of the kind or sort of value that belongs to aesthetic experience and art. Is aesthetic experience valuable in itself, simply because of the joy and delight that it yields, the sense of release and enchantment that it affords us? Or is it valuable because of the accretion that it leaves in experience as a whole, the increased effectiveness that it bestows on this? Does the value of art reside in its power to invoke experiences that are richly and intensely satisfactory, or in the contribution that it makes to our grasp of the world and our conduct of life? In technical terms, this question asks whether aesthetic experience is intrinsically or extrinsically valuable, and whether art has inherent or instrumental value. Is the appreciation of art an activity that is an end in itself, or is it a means to something else?

I think that this question — which has caused untold trouble and confusion in many other fields as well as in aesthetics — poses an altogether false disjunction. Every moment of experience has intrinsic value just as a lived occasion. This value may be positive or negative, and it can vary enormously in quality and intensity. But as a present occurrence, experi-

ence has value in its own right. As a part of a whole, as a step toward the future, every moment of experience has extrinsic value. Experience is not only a series of lived occasions, but also an instrument of life. What occurs in experience outlasts its occurrence: it vanishes as a separate moment, valuable in itself, but it is assimilated into the body of experience, and has value as making this a finer instrument of life.

As directly lived, aesthetic experience seems to be — it feels — extraordinarily complete, self-contained, and isolated. On these occasions, much more than on any others, time appears to stop and consequences not to ensue; so we slough off the concern that we usually feel for the self and the world, and focus our gaze on what is immediately present. When we are absorbed in a work of art, our attention is completely occupied and unified by what this work offers; its sensuous and emotional appeal, its formal properties, and its symbolic meanings cohere so closely that they merge together. The impact of this on consciousness is a powerful effect of internal sufficiency and external isolation. This effect is recognized and honored in a great many aphorisms that have been repeated so often that they have become artistic truisms: for instance, that "art renders ideas available to sense," or "realizes abstract concepts in concrete form," or "makes vivid to imagination what is usually grasped only by intellect," or "enables us to feel and apprehend immediately what otherwise we can only know indirectly." These and similar statements partake of rhetoric more than of logic: they bear eloquent witness to powers that art undoubtedly possesses, but they do little to explain these or to render them intelligible.

This explanation resides in the fact that the aesthetic image fuses so intimately the elements it contains. In aesthetic experience all of our resources are, so to speak, marshaled together and brought to bear at a point. Sense, feeling, and thought, as well as memory and imagination, are all called into play, and all are concentrated upon the particular thing that

the artist is presenting. Consequently, this thing exists in consciousness with an unparalleled depth and intensity.

What the artist discovers to us is an entity: it is his intention that we fasten upon and revel in the aesthetic object that he has distilled from his encounters with the world; he insists that his poem or painting or symphony is an object that makes no reference beyond itself and requires no further commentary. When the artist says this, he forgets the long process of gestation that has gradually and laboriously refined his work out of the raw materials of his experience. Likewise, when we are first struck by his work we are also apt to forget this; under the intense shock of first acquaintance we seem to be seized and held in an inexorable grip by the work of art. The poem or painting or music pervades consciousness, leaving no room for anything else. Any question of what lies behind the aesthetic object — of what it issued from and refers to — simply does not arise; nor does the question of interpretation, and so possible distortion, by us in responding to the work. The aesthetic transaction here, in the moment of discovery, has an immediacy and completeness that exclude all such considerations. Our senses are captivated and gladdened, our feelings are exhilarated, and we are altogether entranced by what the actual occasion offers. If we seek to describe the quality of such moments, this can best be done by saying that our attention is concentrated upon what is given. The aesthetic object seems both to absorb us in it and to isolate itself from the world, with the result that our encounter with it has the air of transpiring in a vacuum. It appears that our only contribution to the ensuing transaction is our attention, and that we attend only to what the art work gives us. So in the moment of discovery the intrinsic values of aesthetic experience are by far the most prominent, and art appears to be "its own excuse for being."

But this moment does not endure; and even while it lasts its quality does not accurately reflect its structure. For there

is no "given" that exists independently of our human universe of meaning; and this universe in turn derives from the natural universe of existence. Each fresh aesthetic discovery that we make is dependent upon the fabric of experience, and in turn enters into this fabric and contributes to its growth: that is, assimilation is just as real and significant a moment of aesthetic experience as is discovery. It stands to reason that the more intensely we live through an experience, the more powerful will be the repercussions of this upon the accumulated body of experience. The entities that are presented to us in art have great clarity and completeness: the characters that we meet in novels and dramas, and the adventures they pass through; the objects and scenes depicted in paintings; the emotions that are aroused by poetry and music, and are embodied in a way that is at once sensible and intelligible; the episodes and attitudes that architecture commemorates; the longings and the aspirations that are set forth in the measures of the dance — all of these impress themselves strongly upon us. Consequently, the experiences that we enjoy vicariously on behalf of these entities are more vivid and intense, more pervasive and compelling, than most of those that we undergo in our direct encounters with the world. More of our faculties are called into play, these operate more deliberately, we are more aware of the involvements among things, and we view what is occurring from a more detached and inclusive vantage point. These experiences thus have a powerful impact, and enter deeply into the body of experience: aesthetic particulars generate universal meanings and so exert a heavy influence on the way in which we see things and feel about them. When we have vividly appreciated a work of art, the part of the world with which it deals is no longer the same for us. In retrospect, and after assimilation has taken place, the extrinsic values of aesthetic experience are in the forefront, and art assumes the role of an agent of life and a contributor to the human enterprise.

Aesthetic experience, therefore, is always valuable both intrinsically and extrinsically; and every work of art has both final and instrumental value.[1] I have clearly paid a good deal more attention to the extrinsic than to the intrinsic values of the aesthetic life. But that does not indicate that I regard them as "higher," or more significant, or more valuable. I certainly do not mean to dismiss or neglect the quality of sheer joy and delight, of zest and elation, that colors aesthetic experience. There are two obvious and related reasons for this emphasis. In the first place, it is a function of the sort of book I have been concerned to write. I have wanted to analyze and explain the aesthetic life, rather than sing its praises. Secondly, a consideration of the intrinsic values of art, of the gladness and enchantment that it brings us, does not lie within the special competence of the philosopher. Analysis can hardly explain, and certainly cannot enhance, this quality; and it does not need to be justified or celebrated.

II

2. We turn now to the quite different problem of the adequacy of the doctrine here developed to account for the structure and content of the human enterprise as a whole. I have argued that the entire range of man's activities and artifacts — the complex process that we call culture — can be ordered by reference to the triadic scheme art — theory — technology. However, it might be objected that this interpretation is too rigid and categorical, with the result that there are many artifacts that it would be difficult to classify accurately, and important human activities that have no apparent place in this schema.

Because of the continual and intimate interplay of psychic components, the life of the mind is always a composite of

[1] This is even true, though it might not seem so, of extremely formal art, which at least exercises and refines our powers of experiencing even when it touches but lightly on our accumulated body of experience.

aesthetic, cognitive, and affective interests, and so exhibits no pure occasions. Accordingly, art, theory, and technology are not separate and autonomous areas. They are highly refined modes of activity, representing the culmination of our systematic attempts to deal with the particularity, the connectedness, and the import with which things challenge us. Men of different temperament and training, responding to the varying pressure of circumstances and feeling the need to master one or the other of these aspects of things, create artifacts that are notably distinct in character and impact even though they deal with a common thing: that is, with the same "subject matter." Thus, St. Paul, Dante, and Spinoza can all be said to have been concerned with what the latter called the problem of "God, man, and his well-being." I should say that St. Paul's *Epistles* are primarily works of technology: they exhort man to cultivate certain habits of body, mind, and soul, and they show how he can control his destiny and realize his good. *The Divine Comedy* is a work of art: it presents to man, in the most vivid and concrete manner, the various fates that he can prepare for himself. The *Ethic* is a work of theory: it seeks to elucidate the character and structure of the universe, conceived as flowing from the nature of God, and to explain to man the intricate web of relations that holds within the world and leads from the world to God. Another illustrative trio, which is perhaps closer to home, can be found in the *Communist Manifesto*, Arthur Koestler's *Darkness at Noon*, and Marx's *Das Kapital*. I think that in each of these cases the distinctness and the special nature of technological, artistic, and theoretic endeavors stands out sharply, alike in the intentions of these men, in the character of the artifacts they produce, and in the impact these have had.

But it stands out with equal sharpness that each of these modes of activity borrows from and contributes to the others. As there are no pure occasions in experience, so there are no pure occurrences among artifacts: these are the joint product

of man's three vital concerns, and many — if not most — of
them are dedicated to a plurality of purposes. In a good many
cases, one interest and intention sufficiently dominate the
creative situation to stamp the product specifically as theory,
art, or technology. *The Origin of Species, Principia Mathe-
matica,* Clerk Maxwell's papers on electromagnetism, Men-
deleev's construction of the periodic table of chemical ele-
ments, the *Summa Theologica,* and the *Critique of Pure Rea-
son* would be universally accepted as theoretical artifacts.
There would be similar unanimity in recognizing as art such
works as *Hamlet,* Beethoven's late quartets, the "Venus of
Melos," Rembrandt's "Night Watch," and W. H. Auden's
"For the Time Being"; while the London underground, the
George Washington Bridge, the liner *Queen Mary,* military
music such as "Anchors Aweigh" or "The Campbells are
Coming," and a roadmap would be generally admitted to be
technological products.

Yet even in these seemingly clear-cut examples a little re-
flection soon discovers overtones that come from alien areas.
Even these artifacts, firmly ensconced as they appear to be
in one special niche, depend upon results achieved in other
fields, and themselves have consequences, direct or remote,
for these other fields. Some artists, theorists, and technologists
work in a high state of "psychic isolation," closely intent upon
presenting, explaining, or controlling the things they are con-
cerned with. But much other work clearly manifests the mixed
motivation that lay behind it: as examples, one could cite
Locke's *Treatises on Civil Government,* Mendel's papers on
genetics, Ibsen's *Ghosts* and *A Doll's House,* Toulouse-
Lautrec's posters, Adam Smith's *Wealth of Nations,* St. Paul's
Cathedral, a Chippendale cabinet, and an illuminated manu-
script.

With this elaboration borne in mind, I think that the clas-
sification of psychic activities and cultural artifacts into the
three major categories of art, theory, and technology is ade-

ART AND THE HUMAN ENTERPRISE

quate and exhaustive.[2] But there is one further aspect of this problem that must be noticed: this concerns those organized human endeavors that appear too vast and monolithic to find any lodgment at all within this scheme. Emphasis has been placed upon the fact that the efforts of artists, theorists, and technologists mutually supplement and reinforce one another. Frequently man does not merely wait for this to happen; he sets the process of reciprocation in motion and directs it carefully. Man's attempt to deal with any of his persistent problems soon sweeps into its ambit these specialities, and arms itself with these talents. That is, the modes of activity and artifact that I have called art, theory, and technology are mobilized and integrated by various separate institutions. Thus all of the institutional efforts of man, such as government, religion, morality, industry, entertainment, have their artistic, theoretic, and technological aspects. Religion, for instance, finds its theoretic support and direction in the discipline of theology; it impresses upon man the particularity of its personages, its demands, and its promises by the artistic resources of ritual, music, poetry, architecture, vestment, sculpture, and painting; it exerts an effective influence over human behavior, shaping man's aspirations, soothing his anxieties, and con-

[2] A word might be said here about certain disciplines that this treatment seems to ignore. This involves the identification of subtypes and species of these major modes, and such extreme systematization easily issues in absurdities. But I would suggest that history — perhaps the most apparent "stray" from this schema — is a close compound of art and theory: it focuses sharply upon unique personalities and events — upon particulars — but it constantly seeks for the causal connections that determine these and for the general features that characterize them. History is made further ambiguous by the persistent intrusion of the technological factor: man is perennially interested in the uses to which history can be put, both in justifying the past and in predicting the future. History blends imperceptibly into the historical romance on the one hand and into theoretical studies of history itself, such as those of Vico, Spengler, and Toynbee, on the other. Similar intermediate areas have been discussed in dealing with functional art. The "applied sciences" and that recent phenomenon, "subsidized research," exhibit a merger of theory and technology. Finally, philosophy is of course a principal species of theory.

trolling his waywardness, by means of sermons, inquisitions and confessionals, the sacraments, missionary work, education, and evangelicism. Religion is the sum of these aims and efforts, and its strength is sapped when it neglects any of them. A similar organized complexity — or institutional synthesis — could be exhibited in all of man's principal endeavors.

Clarity in this matter can best and most briefly be achieved by a simple distinction. Most classifications of man's activities are based on a casual listing of the major problems that he encounters, and of the devices by which he attacks these; so we get the confused catalogue of myth, language, art, religion, morality, history, science, ethics, law, philosophy, economics, politics, and so on. Such catalogues are always haphazard and can never be exhaustive. The classification that is here proposed is based on the absolute character of any problem that man confronts. Because of the structure of the adaptive situation, and in response to the conditions of life, the human enterprise as a whole divides into the major endeavors of art, theory, and technology. And every organized segment of this enterprise, devoted to the pursuit of some limited but significant value, such as social order, salvation, material abundance, moral regeneration, the accumulation of knowledge, or physical health, develops its artistic, theoretic, and technological branches.

The life of the mind is a continual probing of the world with the specially sensitized antennae of art, theory, and technology; and it is equally a continual integration of these perspectives into a coherent grasp of the world. So any artifact of mind is apt to be a locus of all human interests and a carrier of all human purposes. Works of art consecrate theoretical and technological values as well as artistic ones; and artistic value resides in many objects that are not chiefly works of art.

III

3. In a similar vein, and in conclusion, I would insist upon the coordinate status of artistic, theoretic, and technological artifacts. They are equally natural, necessary, and vital. Where any one of them declines in quality, our transactions with things suffer. As the operation of psychic components is pervasive rather than periodic, so it is that the activities that issue from them are coeval phases of the enterprise through which we seek to circumscribe reality and consummate our dealings with it.

Man has always been haunted by the dream of absolute knowledge, of an acquaintance with things that would be certain and untainted. He has sought by various devices to assure himself that he could attain this: revelation, intuition, mathematical deduction, pure reason, and empirical inquiry are only the more famous and less aberrant of these would-be paths to certainty. But these paths, when followed rigorously and jealously, have led rather to absurdities and confusion. These constant rebuffs have periodically given rise to an attitude of scepticism and relativism: recognizing defeat, men have tried to turn this into victory by asserting its rightness and inevitability. Refuted in his proud claim to master things intellectually, man prides himself on the courage to accept his incapacity to know anything; and he boasts that mind imposes upon the world whatever structure it chooses, in a completely arbitrary and irresponsible manner.

These positions are equally absurd and groundless. Mind is not a privileged witness that affords us access to an esoteric region where all doubt ends, and all uncertainty ceases. Nor is mind a mere epiphenomenon, idly recording the results of its body's encounters with the world, and scanning these for its own amusement. Mind is not a mysterious and extra-mundane faculty, superimposed upon the natural endowment of man and dedicated to the strictly nonutilitarian pursuit of

"pure knowledge." But neither is mind a casual trespasser within nature, spinning out its theories without reference to actual conditions and arbitrarily imposing its own terms upon the world.

Mind is an agent of life and an instrument of adaptation. It is a totality of faculties and powers upon which man relies very heavily in his transactions with things. So the functions of mind are determined by the structure of the adaptive situation. There is no reason to suppose that mind is either a miracle or a vagary — that it yields either absolute truth or sheer fiction. There is every reason to believe that it is a device for directing the human enterprise, and that it is capable of yielding an adequate acquaintance with the environment in which life transpires.

What things are like in themselves, no one will ever know. We regard them from the perspectives that I have described as aesthetic, cognitive, and affective. We exploit — without ever exhausting — the dimensions of particularity, connectedness, and import that they offer to us. In doing so, we translate them into the vocabularies of image, idea, and emotion; we do this in order to sharpen our insight into the actual character of things, to enlarge our conception of the relations that hold among them, and to bind them to our purposes. The vehicles of this accomplishment are art, theory, and technology, which enable us to present, explain, and control things. After passing through these elaborate psychic processes, things emerge as entities, facts, and values. What I would insist upon is that these processes, and all that issues from them, are coordinate, and are continually impregnated by one another.

If we regard things only cognitively and affectively, and ignore their aesthetic aspect — if we deal with things only as facts and values, and neglect their character as entities — we meet only part of the challenge with which life confronts us. Theory gives us a great deal of information about the relations among facts: when we are born, there is a def-

inite probability that we will live out our three score years
and ten; if we marry at twenty-five, we can expect to raise
so many children, and the chances are such-and-such that we
will get a divorce; the motives that lead to murder can be
classified and tabulated, and the influence of environmental
factors in producing murderers can be analyzed; the geo-
logical conditions responsible for various types of landscape
can be explained; speculation can seek out the processes by
which God created man in His image; the principles of static
and dynamic balance can be mathematically elucidated; the
glandular functions that control emotion can be closely de-
fined; the childhood experiences and training that condition
the mature conscience can be explored.

Technology extends correspondingly our ability to control
the occurrence of values, and to use things for our own pur-
poses. Medicine can improve the quality of health and extend
the span of life; home economists and social workers can tell
us how to raise our children, and how to minimize the oc-
currence of a divorce (or how to procure one if that seems
preferable); schools, courts, and probation officers can re-
form and control criminal tendencies; engineers and gardeners
can exploit and transform a landscape in a variety of ways;
ministers and moralists can teach us how to live in a manner
agreeable to God; the Sperry Corporation builds gyroscopes
whose deviation from perfect balance is infinitesimal; psychia-
try can do a great deal to help us live on comfortable terms
with our emotions and our consciences.

But not all of the resources of theory and technology can
enable us to apprehend the particularity of things. Nor, es-
pecially, do these disciplines deepen and refine our sense of
the lived occasions that climax our encounters with things. It
is the peculiar contribution of art to the human enterprise
that it does sharpen and intensify our grasp of the objects that
the world contains and of the episodes of which life is com-
posed. Art presents to us, with great clarity and precision,

the trials and rewards, the successes and defeats, that we can expect from life; it exposes the prosaic features of wife, family, and home, as well as the crises of happiness and misery into which these may precipitate us; it shows us how murders are prepared, both in circumstance and intention; it opens to us the many-faceted visual possibilities of our surroundings; it gives us a realization of the fears and aspirations, of the feeling of unworthiness and the assurance of mercy, that have led men to worship God; it enables us to see and hear and feel — to experience in nerve and muscle — the intricately varied play of balanced elements; it brings alive the force and richness of our emotions, the restraints that they meet, and the issue of these conflicts.

Art has the unique faculty of preparing us for the onslaughts of life. It shows us what we can expect to meet in the world, and so it affords us the opportunity to rehearse our demands and expectations, to cultivate our attitudes and responses. Art enables us to experience the situations with which life confronts us before we are called upon to participate in them. And it gives us a more balanced and penetrating sense of these situations than we can possibly attain when we are directly concerned in them. Art purges the world of the more extreme bias of our own ideas and emotions. While it cannot show us things-in-themselves, it can report what these say when they speak to a sympathetic and discriminating sensitivity.

The purposes to which we are to devote our energies constitute our most important decisions. The episodes and adventures through which we are eager to live; the situations in which we seek to participate, and the roles we wish to play; the surroundings that we want to prepare for ourselves; the objects from which we seek support in our undertakings; the states of affairs that we endeavor to achieve and prolong — all of these are finally meaningful only in terms of their eventual human consequences. That is, they borrow their

importance from their reverberations in the experience of ourselves and others. The objects and situations and occurrences that absorb so much of our interest, and that we often regard as the ends of our efforts — marriage, children, a comfortable income, a secure job, a nice home, a trip, a visit to a theater or a friend, a new suit or automobile, social position, skills of various sorts — are really only means to the lived occasions that they make possible. As enjoyed in consciousness — as experienced by the ego or self or psyche — these occasions are *values.* As related to one another in temporal and causal sequences, they are *facts.* As being just themselves, with a certain content and character and texture, they are *entities.*

Theory and technology together greatly extend our ability to understand things as facts and to control them as values, and so to use them for whatever purposes we see fit. But it still remains for us to choose among these purposes. We have to select the values that we intend to realize, the occasions and experiences that we want to work into the fabric of our lives. We can do this with wisdom and discernment only if we have a clear vision of what these occasions offer to us and what these experiences are like. That is, we must apprehend values as entities. Otherwise our decisions are based merely on impulse and guesswork. If our choices are to be mature, they must have this illumination and discipline. And art is the only medium through which these can be attained.

Art introduces us to the varied possibilities that are implicit in life. It allows us to envision these, to measure them against our hopes and ourselves against their challenge, before we encounter them. Art exhibits the multiple facets of things, and the manifold varieties of experience that are apt to issue from our encounters with them. Marriage, children, home, career, power, possessions, talents — these are presented to us as entities that are latent with many outcomes. We see what they demand and threaten, as well as what they promise. We can thus obtain a foretaste of the actual course of the ex-

periences that climax our dealings with things, instead of merely projecting vain and unconsidered wishes. The insights that we obtain from art, and that are notable for their detachment and completeness, are a preparation for the issues that life calls upon us to resolve. By its persuasive presentation of the actual character of things and of lived occasions, art preserves us from both despair and disappointment: it purges us of idle hopes and supports our mature purposes. It is through theory and technology that we can dominate facts and achieve our chosen values. But it is through art that we are enabled to apprehend these values as entities, choose among them with acumen, and dedicate ourselves to their cultivation.

The panorama of man's artifacts is a continuum. It is so because as a whole these artifacts constitute a massive instrument of adaptation, an agent of life in its transactions with things. Man pays to everything he encounters a triple interest, compounded of aesthetic, cognitive, and affective moments. But man finds it advantageous sometimes to narrow and intensify his concern, and to push nearer to the core of the world by closing his perspectives. In doing so he creates works that are still three-dimensional, but that concentrate their mass at a point and drive in one chief direction. That is, he creates art, theory, and technology.

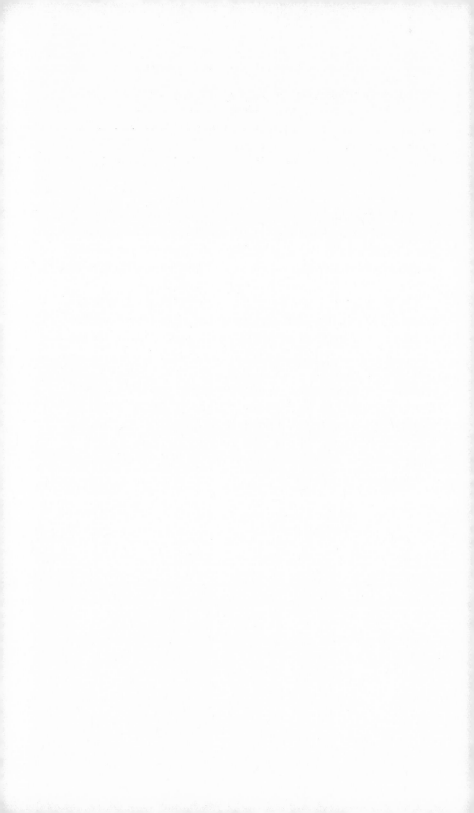

INDEX

INDEX

(Men and works referred to only for illustrative purposes are not indexed.)